W9-CZU-067

Art and Culture in
Nineteenth-Century
Russia

Art and Culture in Nineteenth-Century Russia

EDITED BY

THEOFANIS GEORGE STAVROU

INDIANA
UNIVERSITY
PRESS

Bloomington

Publication of this book was subsidized in part by the College
of Liberal Arts and the Graduate School of the
University of Minnesota.

Copyright © 1983 by Indiana University Press

Manufactured in the United States of America

Library of Congress Cataloging in Publication Data
Main entry under title:

Art and culture in nineteenth-century Russia.

"Result of two scholarly projects, a lecture series and a symposium, which were held at
the University of Minnesota in the fall of 1978 . . . organized by the University of
Minnesota Gallery with the Committee on Institutional Cooperation and the Ministry of
Culture of the U.S.S.R."—Pref.
Includes index.
1. Arts, Russian—Addresses, essays, lectures. 2. Arts, Modern—19th century—Soviet
Union—Addresses, essays, lectures. 3. Arts and society—Soviet Union—History—19th
century—Addresses, essays, lectures. 4. Nationalism and art—Soviet
Union—Addresses, essays, lectures. I. Stavrou, Theofanis George, 1934– . II.
University of Minnesota. University Gallery. III. Committee on Institutional
Cooperation. IV. Soviet Union. Ministerstvo kul'tury.
NX556.A1A74 700'.947 81-48634
ISBN 0-253-31051-2
2 3 4 5 87 86

CONTENTS

PREFACE

This book is the result of two scholarly projects, a lecture series and a symposium, which were held at the University of Minnesota in the fall of 1978 in connection with the exhibition "The Art of Russia 1800–1850" organized by the University of Minnesota Gallery with the Committee on Institutional Cooperation and the Ministry of Culture of the U.S.S.R. Indeed, the exhibition, which consisted of approximately 150 Russian works from several museums in the Soviet Union, was the occasion for a series of cultural events on nineteenth-century Russia that took place in the Twin Cities of Minneapolis and St. Paul from October 8 to December 6, 1978. These events included special features in the fields of theater, dance, music, and film and several courses on nineteenth-century Russian history and culture.

The public lecture series was made possible through a grant from the Rockefeller Foundation and consisted of ten presentations by prominent scholars on major topics of nineteenth-century Russian culture. The symposium focused on "Art and Society in Nineteenth-Century Russia," and was cosponsored by the University of Minnesota, the Kennan Institute for Advanced Russian Studies, the American Association for the Advancement of Slavic Studies, and the Committee on Institutional Cooperation. The original plan was that the proceedings from both the lecture series and the symposium would have been published in two separate volumes. For economic and other practical reasons it became necessary to merge the two projects into one volume consisting of all the symposium papers and half of the papers from the public lecture series. For their gracious understanding, I wish to express my appreciation to those colleagues whose essays are not included in this volume, despite their significance to the events at the University of Minnesota. These colleagues are: Professor Donald Treadgold, who offered the opening lecture, "The Russian Idea in the Nineteenth Century: Attempts at Definition"; Professor Paul Schmidt, who lectured on the "Russian Theater and the Ballet"; Professor James McClelland, who read a paper on "The Mystique of Nauka: Science and Scholarship in the Service of the People"; Professor Alan Ross, who spoke on Russian censorship; and Professor Alfred Senn, whose paper dealt with "Revolutionary Book Publishing as a Basis for a Counter-Culture."

In addition to the main participants at the symposium, it was possible to invite a number of scholars from several universities as informal discussants and observers. The presence of these colleagues added significantly to the symposium atmosphere. They were: Rick Asher, Malcolm Brown, Rena Coen, Lyndel King, Birute Lanys, Gerald Mikkelson, Sidney Monas, J. Kim Munholland, Marion Nelson, Janet Rabinowitch, Bernice Rosenthal, Alfred Senn, Sidney Simon, and Mel Waldfogel.

Two special guests were present at the two-day symposium. The first was the distinguished Soviet art historian, Professor Dmitrii Sarabianov from Moscow

State University, who was at the time visiting professor in the Department of Art History, University of Minnesota. The second guest was Dr. Joshua Taylor, Director, National Collection of Fine Arts. It was clear throughout the symposium that all the participants deferred to Dr. Taylor's judgment in matters of interpretation or on questions of comparative art history. He was a refreshing fountain of knowledge. It was with great sadness that we learned of his untimely death as this volume was nearing completion. As an expression of appreciation for his contributions in the world of art in general and to the symposium on "Art and Society in Nineteenth-Century Russia" in particular, this volume is dedicated to his memory.

In addition to financial support from the institutions mentioned above, this book would not have been possible without the initiative and collaboration of several individuals whom I wish to thank: Barbara Shissler, the exhibition's Special Director, who initiated the whole venture while Director of the University of Minnesota Gallery; her worthy successor, Lyndel King; Robert van der Wege, their Associate Director; colleagues in the Soviet Ministry of Culture, especially A. A. Butrova, A.-G. Khalturin, V. Litvinov, I. Barabash, and others who facilitated negotiations for the exhibition; John Bowlt, who served as Special Curator; Frederick M. Jackson, Director, Committee on Institutional Cooperation; the University of Minnesota Committee on the Russian Exhibition, as well as students, colleagues, and university officials; Professor J. K. Munholland for his valuable contribution during numerous discussions he and I had from conceptualization to completion of this project; Fred Lukermann, Dean of the College of Liberal Arts, for his generous support; Professor S. Frederick Starr for suggesting the idea of the symposium to be held at Minnesota in connection with the exhibit; Suzanne Cave, who helped with the organization of the lecture series and symposium and retyped the manuscript or parts of it several times; and, of course, the participants in both the lecture series and the symposium. Finally, my thanks go to my wife, Freda, who acted as a gracious hostess throughout these deliberations.

We have attempted to maintain consistency with regard to questions of style and transliteration; at the same time, the preference of individual contributors have been honored.

Theofanis George Stavrou

Introduction
Theofanis George Stavrou

In terms of cultural accomplishments, the nineteenth century was Russia's greatest century. Despite political, social, and economic problems, or perhaps because of them, imperial Russia witnessed an unprecedented expansion of its cultural frontier. Above all, it acquired "taste" through the development of a "high culture." The literate section of Russian society expanded appreciably, and from its ranks emerged an impressive array of bureaucrats, critics, writers, musicians, and artists whose impact has been felt beyond Russia ever since. It is quite common to refer to Russia in the nineteenth century as having gone through two "Golden Ages" of literature or, if one would put it more modestly, a golden age that covered most of the nineteenth century and a silver age that describes the literary and cultural scene during the reign of the last tsar. As has been frequently observed, the Russian national consciousness formed in the eighteenth century acquired philosophical underpinnings during the nineteenth, largely through this spectacular growth of a "high culture." Institutions of higher learning multiplied, training an increasing number of students throughout the century, and cities became cultural as well as political centers and symbols. Cosmopolitanism, or reaction to it—the result of study or travel abroad, the learning of foreign languages, especially French, and the impact of wars and European imports—was taken for granted among the educated elite.

In this great cultural experience, the first half of the nineteenth century, especially the reign of Alexander I (1801–25), claims a place of prominence, and its impact on the rest of the century is readily discernible. But, as we have been repeatedly reminded, there is little wisdom in periodizing history, especially Russian history, into neat chronological centuries. Thus the roots of all this cultural activity in the nineteenth

century can easily be traced to the eighteenth, Russia's crucial century, if not earlier. Peter the Great's attempts to modernize Russian society and institutions, whatever their limitations, had the effect of energizing and educating that society first in the art of war and gradually in the arts themselves. Modernization to a certain degree meant Europeanization or, better still, a confrontation with Europe in political, social, and cultural matters. Devoid of cultural inhibitions, Peter, the tsar soldier, met the European challenge. Above all, he expanded Russia's political, geographical, and cultural frontiers and set the pattern that, with some deviations, was followed by his successors, especially Catherine the Great, who dominated the last part of the eighteenth century as Peter had dominated the first. The emergence of Russia as a major European power constitutes one of the most significant political events of the eighteenth century. Yet Russia closed its eighteenth century in a state of cultural confusion, resulting chiefly from an imprudent assimilation, sometimes a slavish imitation, of Western, especially French, models of high culture. The nineteenth century sought, among other things, to modify this cultural confusion in imperial Russia and to replace it as much as possible with a comprehensive national cultural identity. The Russian government, that is to say the governments of the five tsars who reigned in the nineteenth century, was central to this process. In other words, despite the persistence of a certain cosmopolitanism or internationalism, Russia in the nineteenth century witnessed the emergence of cultural as well as political nationalism.

The essays in this book consider several manifestations of this cultural process in nineteenth-century Russia. They are divided into two categories. The essays in the first category treat the broad perspective of nineteenth-century Russian culture through the examination of significant issues such as the nature and role of the Russian intelligentsia, this period's cultural barometer; the rise and role of the cities, especially St. Petersburg and Moscow as cultural symbols; Russian literature, concentrating on the "Russianness of the Russian novel"; and accomplishments in the field of music, with special emphasis on the relationship between the development of the "native song and national consciousness."

The second category of essays concentrates on the relation between art and society during this period. The opening essay in Part Two addresses itself directly to that question, and while its emphasis is on the first half of the century, many of the arguments apply to the century as a whole. It is followed by a series of essays that elaborate many of the points mentioned therein, such as the evolution of Russian painting; the contacts of Russian painters with Europe, especially Italy, where they went for training and in "pursuit of light"; the attitude of the Russian

intelligentsia toward art; architectural taste in nineteenth-century Russia as revealed in the buildings of Moscow and St. Petersburg; the enrichment or embellishment of these cities and private homes with sculpture; the state of the decorative arts; the growth of the Russian graphic arts, especially caricature; and the nature of Russian folk art and its relationship to "high" art. This remarkable growth of culture and the interrelationship between art and society in nineteenth-century Russia have long fascinated historians and critics, who tend to view them as points of departure for the analysis and greater understanding of Russian history and institutions as well as for philosophical and existential inquiries of universal relevance.

This volume's assessment of Russian "high culture" in the nineteenth century begins with a discussion of the emergence and nature of that most heterogeneous and undefinable, though identifiable, group—the Russian intelligentsia. Besides contributing substantially to the growth of Russian culture, the Russian intelligentsia was itself a cultural phenomenon of considerable interest and crucial signficance. Its members articulated passionately Russia's frustrations and aspirations, and, as Nicholas Riasanovsky points out in his essay, "once an intelligentsia had been formed there was no turning back." Definitions of the intelligentsia abound, furnished with narcissistic generosity by its own members as well as by subsequent generations of historians. But what is worth repeating is that the intelligentsia was one of the by-products of Russia's drive for modernization. It was, in fact, the creation of the Russian state, on which in many ways it remained dependent up to the middle of the nineteenth century. This creation was partly the result of secular education, which accompanied modernization, and partly the result of the development of a spirit of inquiry, which ultimately led to the development of a critical stance, the indispensable characteristic of a true intelligent. It was not until the 1860s with the so-called new Enlightenment and its emphasis on materialism and social utilitarianism, that the peculiar type of the Russian intelligent, as usually defined and appreciated in the West, was formed. Until then, and in some cases, one could argue, up to the end of the century, the attitude of the Russian intelligentsia toward political authority and cultural orientation was at best ambivalent.

The history of the emergence and nature of the Russian intelligentsia is intrinsically fascinating, but more significant perhaps is the fact that it chronicles the deep involvement of the Russian government in the development of educational and cultural institutions, ranging from the building of entire cities, universities, and printing presses, to centers for the fine arts. While serving the needs of the educated section of Russian

society, these cultural institutions contributed to the further growth of the intelligentsia itself. Any way one looks at this phenomenon, and despite abundant self-criticism, members of the intelligentsia were the first to point to Russia's beauty and unique destiny. Whether Slavophiles or Westernizers, they were all in their own ways nationalists, and they concerned themselves with Russia's improvement and its role as a political and cultural catalyst on a national and global scale. Inasmuch as possible, it is important to appreciate the complexity and versatility of the intelligentsia's profile, since many of the Russian cultural phenomena of the nineteenth century reach us through its perceptions. Members of the intelligentsia in fact became cultural symbols themselves as well as transmitters of perceptions about culture in general and about art and its social relevance in particular.

Perhaps the most imposing cultural symbols of imperial Russia were its cities. The building of big symmetrical cities, symbols of political and cultural power and prestige, was part and parcel of the Enlightenment, which Russia borrowed from Europe in the eighteenth century. St. Petersburg, erected as the new Russian capital by Peter the Great, in time surpassed Moscow as the political and cultural center of the empire. The city that brought the West physically and with force into Russia, St. Petersburg symbolized all Western intrusions and challenged the traditional style of Muscovite life. As might be expected, then, that section of the Russian intelligentsia referred to as the Westernizers would have claimed St. Petersburg as the embodiment of Russia's greatness and the Slavophiles would have endorsed Moscow with equal enthusiasm. In some ways they did. But despite their respective senses of topophilia, it was characteristic of the ambivalence of the Russian intelligentsia that their attitudes toward these cities as cultural symbols were quite complex. In his essay "St. Petersburg and Moscow as Cultural Symbols," Sidney Monas traces manifestations of this fascinating and significant symbolism, from the first formal ode to St. Petersburg in 1718 by Buzhinsky to Solzhenitsyn's reaction upon visiting the same city in the 1960s. To be sure, these two cities symbolized distinctive life styles, but they also reflected the increasingly complex nature of Russian society in the course of the nineteenth century. Both cities, while symbolically antithetical, became emblems of national prestige, as expressed in the rebuilding of Moscow after the Napoleonic invasion in 1812 and the defense of St. Petersburg–Leningrad during the Second World War.

In addition to being symbols, Moscow and St. Petersburg were centers of political, social, and cultural activity. As such, they contributed to, as well as figured prominently in, the most readily identifiable cultural achievement of the Russians in the nineteenth century, their na-

tional literature. The content of Russian literature has remained central to the thinking of many readers and critics ever since it established itself as a major tradition or, as some have described it, as a social institution. This particular orientation may have been forced upon us chiefly because of the way the Russian novel emerged. As Donald Fanger explains in his essay, "On the Russianness of the Russian Nineteenth-Century Novel," "The rise of fiction in Russia . . . went in tandem with the rise of a special readership, the intelligentsia—that self-conscious minority of Russians who enjoyed the privilege of literacy and sought justification in seeing it as a means to the fulfillment of a moral duty." They expected something specific from their writers, and the writers obliged by concentrating on relevant themes of importance. Without abandoning this aspect of Russian literature entirely, Fanger articulates the view that the "form," that is to say the author's management of his narrative, rather than the content, is the peculiar characteristic of the Russian novel. He illustrates this thesis by examining three well-known classics—Pushkin's novel in verse, *Eugene Onegin;* Lermontov's novel *A Hero of Our Time;* and Gogol's *Dead Souls*— although he also finds this concern with form persisting in the works of Dostoevsky, Tolstoi, and Chekhov, with whom he concludes his analysis. He views these giants of Russian literature as writers who, by employing "a special variety of fictional discourse," lent a universality to the cultural enterprise of the Russian nineteenth century that would otherwise have been either inconceivable or at best short-lived.

About the time that new literary forms were taking shape in imperial Russia, Russian music was coming into its own, with the emergence of a nationalistic school of composers. A crucial turning point was the composition in 1836 of the first Russian opera, Mikhail Glinka's *A Life for the Tsar.* The trend reached its high point by the end of the century with the works of Balakirev, Tchaikovsky, Mussorgsky, Rimsky-Korsakov, and others. Yet, as Malcolm Brown reminds us, the foundations of this national music, as is true of so many other fields of artistic expression in nineteenth-century Russia, were laid during the reign of Alexander I. These developments in turn grew out of the musical accomplishments of the eighteenth century, when Russia, undergoing Westernization, had gradually witnessed the rise of a secular musical culture. The rise of a national consciousness rested on the discovery, preservation, and active use of native cultural ingredients. Native musical sources came from the musical heritage of the Orthodox church and from Russian folk songs. In his essay Brown traces the major role played by folk songs in the development of national music in Russia in the eighteenth and nineteenth centuries. The native song, from European as well as from Asiatic Russia, proved a most congenial genre for

self-expression and gradually invaded a variety of musical compositions and performances. It became a versatile tool in the hands of Russian nationalist composers, and it elated the Russian public as well as the intelligentsia, who saw in its new usage a source of national cultural strength and an expression of national genius.

The triumph of the native element or, better still, the healthy synthesis of Western musical borrowings and native elements in nineteenth-century Russian music, is part of the story of Russia's cultural maturity during the last two centuries—from imitation and imprudent assimilation to a critical evaluation. The same trend or evolution may be observed in the ballet, in the theater, and in literature. Elements borrowed from the West were transformed in Russian style and exported to an amazed Western world by the beginning of the twentieth century.

In this context, the introduction to Part Two of this volume, "Russian Art and Society, 1800–1860," by S. Frederick Starr, takes on special meaning. As Starr traces the manifestations of Russian secular art during the first half of the nineteenth century, one is struck by its complexity, which reflects the variety of borrowings from Europe throughout the eighteenth century. Architects, sculptors, painters, conductors, play directors, scholars, craftsmen, and objects of art had come to Russia from the breadth and length of Europe. Russia's polychromatic European mask persisted into the nineteenth century even though native colors were gradually becoming dominant. When Russians visited Europe for inspiration and enlightenment, they roamed widely. During the first half of the nineteenth century Russian artists and patrons of the arts flocked to Italy, where they lived and learned, a topic elaborated in Joshua Taylor's essay, "Russian Painters and the Pursuit of Light." Starr's essay provides the setting for the remaining chapters, which deal with a variety of related topics such as the attitudes of the intelligentsia toward art; city design and building; sculpture and the decorative arts; the graphic arts; and finally the realm of folk art. Starr also offers an insightful commentary on the question of partronage of the arts. In essence the state exercised a monopoly in the development of the arts until later in the century, when individual patrons from the merchant class emerged to challenge the state's domination. State monopoly, in determining the artistic climate of the period, expressed itself chiefly through the Imperial Academy of Arts, the official arbiter on the subject. The role and impact of the academy on the development of Russian art is controversial, but one is impressed by its accomplishments, especially since most of the important painters were trained under its auspices and worked within its jurisdiction despite occasional displays of resentment and resistance. The situation changed dramatically during the second half of the nineteenth century, when a more conscious effort

was made by artists to free art from the restriction of the academy and to engage it actively in social causes.

During the second half of the century Russia made extraordinary progress in art and, in the opinion of some critics, had caught up with the West and was about to overtake it. John E. Bowlt's discussion of the evolution of Russian painting is set in the context of cultural and social events, many of which were affected dramatically by Russia's confrontation with Napoleon in 1812 and by the political climate of the 1860s. Bowlt maintains that "an adequate appreciation of nineteenth-century Russian art can be achieved only on the basis of the realization that, by and large, the Russian artist was (and is) concerned with the tendentious and transformative purpose of art and not simply with formal or esthetic qualities." In dialectical fashion, Bowlt traces the development of major trends in painting. The introduction of secular artistic techniques and themes with an imposed discipline, as championed by the Imperial Academy of Fine Arts, serves as the thesis, which was sustained by such great masters as Kiprensky, Briullov, and Ivanov. Antithetical to this European dimension is the national ingredient, which became quite assertive in the life and accomplishments of painters such as Venetsianov, Soroka and Krendovsky. The national trend reached its high point in 1863, when thirteen artists left the Imperial Academy and encouraged the development of realism in Russian art. In Russian realism, which dominated the second half of the century, Bowlt sees the synthesis of Russia's artistic experiment. This synthesis, in turn, generated its own antithesis with the emergence of the Russian avant-garde artists at the beginning of the twentieth century. The struggle between established norms and spontaneity, between the Apollonian and the Dionysian, is at the heart of the central question of nineteenth-century Russian culture, which developed geographically and esthetically on the borderlands of European civilization. Russia remained a sort of Janus, gazing with equal perplexity both East and West as it strove to achieve a distinct cultural identity.

Quite naturally, the state and purpose of art in general, and of Russian art in particular, interested the Russian intelligentsia profoundly. Part of their role as "the conscience of the nation" was to seek to understand and direct the cultural explosion of their time. Elizabeth Kridl Valkenier discusses this question in "The Intelligentsia and Art." Concentrating on the second half of the nineteenth century, Valkenier expands on Riasanovsky's consideration of the emergence and nature of the intelligentsia. The expectations of the Russian intelligentsia with regard to art were similar to those with regard to other spheres of Russian culture—the search for a genuine expression of national spirit. In this search they asked crucial questions—about the "specificity" of

Russian life and culture during the 1840s; about the nature of Russia's institutions during the 1860s; about the relationship of Russian culture to society in the 1870s; and about "national peculiarities and accomplishments" during the 1880s. Following this outline, Valkenier studies representative critics such as Stasov and painters such as Fedotov and Perov, who reflected the prevailing definition of "Russianness." Despite differences, the majority of the intelligentsia and the painters under consideration endeavored to liberate art from classicism, the style imposed on it by imperial patronage and the rules of the academy. In the context of the political and social changes of the second half of the nineteenth century—reforms, revolutionism, and populism—Russian art caught up with literature and music in becoming a truly national institution.

Classicism, or neoclassicism, determined Russia's taste in "high culture," especially in architecture and sculpture, as it had for the rest of Europe in the eighteenth century, where a conscious effort was made to turn to the classical world of Rome and especially of Greece for inspiration and taste. To be sure, the Russians came to appreciate the classical rule chiefly through France in the eighteenth century and through Italy during the first half of the nineteenth century. The Russian Academy of Art reflected these influences, too, and it was natural to send its students to Italy, where, as Joshua Taylor points out, "Russian painters, sculptors, and artisans proved themselves no less capable than others of abiding by the classical rule of taste." But once in Italy, Russian painters experienced a liberation from the control of their own academy. The brilliant Italian light had a lasting impact on Russian painters from Matveev, Shchedrin, and Kiprensky to Briullov and Ivanov. They, and by extension Russian art, became part of a cosmopolitan venture by virtue of the Italian exposure, as earlier in the eighteenth century Russian artists had experienced something similar by virtue of the French connection. Both the French and Italian experiences of Russian artists contributed to the national synthesis that emerged during the second half of the nineteenth century.

Classicism or neoclassicism found its visible and in some ways most lasting expression in the Russian architecture and sculpture identified primarily with the design and buildings of the new capital, St. Petersburg. But even Moscow, the "Slavophile capital," had many of its prominent sections rebuilt in the new style after 1812. Albert Schmidt's essay on architecture in nineteenth-century Russia considers the philosophy, justification, and actual building of these two imposing cities in the context of both European tastes in architecture and Russian realities. Political and economic considerations accounted for the flourishing of these cities in the classical era as well as their temporary decline

during the second half of the nineteenth century. The growth of the Russian population and its increasing social and economic diversity contributed to the decline of classicism, as architects sought to accommodate the industrial and materialistic mood of the nation. But as Schmidt points out, the classic mode in architecture reemerged at the turn of the twentieth century and again in a rather monstrous form during the Stalin era. It may be argued that the monumentality of Russia's cities, impressive in size and rational and ordered in design, has historically corresponded in spirit with the political greatness claimed or aspired to by Russian political leaders, tsarist and Soviet.

A vital feature of the neoclassical architectural landscape was sculpture of the same type, the subject of Janet Kennedy's essay. Neoclassical sculpture came to Russia along with the other elements of Westernization and also developed under the careful scrutiny of the Academy of Arts. The academy sent able Russian students such as Ivan Martos to study the craft in Italy in the midst of classical antiquities; out of this experience came the works of sculpture that graced squares, gardens, public buildings, cemeteries, and private houses.

Although sculpture developed and indeed persisted as a permanent feature of the Russian landscape, it faced the assault of romanticism and, more specifically, of nationalism. Classical sculpture was regarded as unresponsive in terms of personal esthetic concerns or national objectives. It eventually came into competition with icon painting and other religious and national forms of art that witnessed a revival in the second half of the nineteenth century as part of the assertion of Russian consciousness.

Closely connected with Russian architecture and sculpture and sharing their pattern of growth and decline were the Russian decorative arts, which also flourished during the first quarter of the nineteenth century. As Paul Schaffer points out, Russian decorative arts produced during the first half of the nineteenth century were often of higher quality than those produced before or after. During this period one finds a creative blend of European influences and Russian responses to them. In the case of porcelain and glass, for example, the Russians effectively utilized Western technical innovations and vastly improved the quality of decorative objects. At the same time, certain native arts such as lacquer, bone, and steel work maintained their distinctly Russian character.

In addition to an esthetic receptivity toward art objects on the part of Russia's ruling and educated elites, two major factors contributed to the flourishing of the decorative arts in the empire of the tsars. The first was imperial patronage, as reflected in the various commissions to European craftsmen and, more importantly, in the establishment of the

Imperial Factory and other centers where this art began to take native root. The second was cheap serf labor, which was used extensively for this time-consuming occupation. The use of serf labor also explains the decline in decorative arts during the second half of the nineteenth century, when free or cheap labor was becoming a scarce commodity. In this respect the fate of the Russian decorative arts reflects political and social changes as well as shifts of cultural taste.

Related in some ways to the decorative arts are the graphic arts, which also experienced unprecedented growth in the nineteenth century and which reflect trends noticeable in other areas of artistic expression. The graphic arts came late to Russia and developed slowly because of the general backwardness of society, the high rate of illiteracy, and the lack of competent Russian engravers and etchers. As in many other areas, changing conditions in the nineteenth century encouraged the growth of this artistic genre. Within the context of the development of the graphic arts, John Bowlt discusses the emergence of Russian caricature, emphasizing its accomplishments during the reigns of Alexander I and Nicholas I, in spite of adverse circumstances.

By its very nature, caricature, like satire, is a deviation from established or accepted norms. Religious and artistic canons up to the beginning of the nineteenth century militated against caricature, and throughout the century censorship aimed at stifling it. The Napoleonic invasion of Russia gave Russian caricaturists an opportunity to direct their art not only against Napoleon but also against internal social and political problems. But caricaturists were always treading on thin ice. Still caricature survived, and, as Bowlt points out, "whether as a direct sociopolitical comment or as a critical paraphrase of the fine arts, [it] constituted an alternative and dissident tradition." In this respect, caricature functioned like some of the finest literary masterpieces of the period, which strove to outwit the censor while carrying a critical message.

The essays thus far have been concerned with aspects of "high culture," while placing "high culture" within its social context, and above all within the context of an emerging Russian national consciousness. National consciousness, if it is not to approximate artificial intellectualism, must take into consideration the nation's broader participation in areas of common concern. In this respect Russian artists and patrons of the arts could not ignore the popular arts for long, and a return to these folk traditions constituted a central element of Russian nationalistic expression in the nineteenth century. Furthermore, by the end of the century folk art was recognized as an integral part of the esthetic experience of the nation. It is quite appropriate, therefore, that this volume concludes with Alison Hilton's essay "Russian Folk Art and

'High Art' in the Early Nineteenth Century." Folk art was partly functional, but it was also decorative. Folk motifs were widely used, and their longevity was remarkable. Hilton discusses the historical evolution of the various types of folk art, from woodcarving and painting on wood to weaving and embroidery, arts that remained virtually free from outside influences until the eighteenth century. As in the case of the decorative arts, patronage and serf labor were instrumental to the development of folk art. The threat to folk art that came with the emancipation of the serfs and the rise of industrialization stimulated an interest in its preservation, and in this respect folk art became a social as well as an esthetic commentary on nineteenth-century Russian conditions.

The main influences that determined the character of the cultural accomplishments of nineteenth-century Russia were the European Enlightenment, romanticism, and realism—all of them secular in their philosophical world view. For this reason nineteenth-century Russian "high culture" was above all a secular culture, or that is the way it is generally presented. But even a secular culture cannot develop in a vacuum. Imperial Russia, despite its modernization and accompanying secularization, was still basically a religious society. Religion, chiefly that of the Orthodox church, continued to leave its mark on the social behavior of Russian society as well as on its esthetic sensibility. And this applied to all strata. In fact, it can be argued that this pervasive religious quality of Russian life served as a major integrative force. After all, during this same period, Orthodox churches continued to be built and icons painted, and from ecclesiastical seminaries emerged bureaucrats, revolutionaries, historians, cultural critics, writers, philosophers, and visionaries. A careful look at some of the lives and works of the individuals discussed in this book attests to the centrality of a religious view of life. In the final analysis, such a consideration makes for a more comprehensive understanding of the challenge that modernization offered and the Russian response to it, especially in the nineteenth century, when imperial Russia effected an amazing synthesis of national culture and consciousness.

PART ONE
RUSSIAN CULTURE

1

Notes on the Emergence and Nature of the Russian Intelligentsia
Nicholas V. Riasanovsky

> Je suis concitoyen de tout homme qui pense. . . .
> Lamartine[1]

LIKE OTHER complex and abstract concepts, that of the intelligentsia may well reflect on our efforts to understand reality more than on reality itself, and the resulting discussions and debates may illustrate, in the first place, the inadequacies of mental strait jackets of our own making. Still, from about the 1860s or at least the 1870s intelligentsia as both subject and object of thought and action became an inseparable part of imperial Russian history until the collapse of the old regime in 1917.[2] Perhaps a different kind of intelligentsia is very prominent in the Soviet Union today. Moreover, the concept has expanded beyond Russia, notably to embrace "historically backward" societies, ranging all the way from Germany and even France to old Asian and new African nations. No wonder that self-definitions and definitions of intelligentsia abound and that they excite controversy.

In the imperial Russian context at any rate, two traits seem to be most frequently ascribed to the intelligentsia: education and a certain critical or at least independent stance. The first separates it from the masses, the second from the established system, more precisely from the government and its "unthinking" or "self-serving" followers. Yet the two traits have not been treated in the same manner in the discussions and evaluations of the intelligentsia. Education has been, on the whole, a noncontroversial characteristic, accepted by all commentators, although arguments developed on occasion over the more appropriate education for the intelligentsia (e.g., humanistic versus scientific or technical) or its required level (with "semi-intelligentsia" as a lower category).

By contrast, the issue of the critical stance has been central to the debate on the intelligentsia. The word *intelligentsia* itself, from which the designation of an individual member, an *intelligent,* is derived, ap-

parently first entered the Russian language in the mid-nineteenth cen-
tury as an adoption of the Latin word—Latin was common in Russian
Orthodox seminaries—meaning "intelligence" or "mind." Or it repre-
sented a borrowing of the German term *Intelligenz* used as early as
1849 to designate a social stratum distinguished by education and a
"progressive" attitude. It came to denote the radicals and revolutionar-
ies of the reign of Alexander II and, more broadly, opposition intellec-
tuals. Although the history of the term remains not fully known, as well
as disputed, it does seem that its application widened with time. In the
official Soviet definition, intelligentsia refers simply to all "intellectual
workers," as distinct from industrial workers or peasants. But it is the
normative problem of who, by rights, belongs to the intelligentsia,
rather than the historical usage of the term, that has been crucial to the
debate. Was Rakhmetov the true model for the group? Or, if sleeping
on nails went too far for imitation, was it at least Rakhmetov's creator,
Chernyshevsky? Could all Russian revolutionaries and radicals, of
whatever persuasion, justly claim membership? It was the intelligentsia
broadly conceived as radicals that seven Russian intellectuals attacked in
1909 in a brilliant and seminal publication entitled *Vekhi,* that is,
Signposts or *Landmarks.* But what about the liberals, or the authors of
Signposts themselves, for that matter? Or even conservative intellectu-
als? Was Dostoevsky an *intelligent* when he wrote *The Possessed* and *The
Diary of a Writer?* Was Pobedonostsev? Witte? We are confronted, in
effect, by a wide spectrum of definitions, ranging from dogmatic and
revolutionary exclusiveness to the broad inclusion of "all intellectual
workers."

The broad approach is in many ways very attractive. It has the sup-
port of the enormous Soviet writing machine, and at the same time it
finds considerable endorsement in popular usage, for, while leaders of
Russian thought debated the special qualities that made one an *intelli-
gent,* the common people came to apply the term to all those with
education, for instance, all high school, or more exactly gymnasium,
students. Also, it has been argued that history opted for the broad
approach, as the evolution of the term on the whole indicates. Most
importantly, narrow definitions threaten to interpret erroneously a long
historical process in terms of a particular moment, rightly or wrongly
perceived, highlighted by Belinsky's protest, Dobroliubov's literary crit-
icism, or the battle over *Signposts.* On the other hand, still and all, no
amount of literacy or university training per se can produce an intel-
ligentsia, and it is impossible to understand that remarkable phenom-
enon simply as a chapter in the history of education or of "intellectual
labor." The ultimate of the broad approach is to resolve all problems
related to the intelligentsia by denying its existence. To put it different-

ly, it would seem that the critical or independent stance, call it aliena-
tion or merely a sense of separateness and distance, that has been cen-
tral to the intelligentsia controversy, is indeed, together with education,
a necessary component of the intelligentsia (the intelligentsia of impe-
rial Russia in the present case), although I, for one, would prefer to
view that stance in very broad and general terms. A brief look at history
may clarify matters.[3]

The modern Russian secular educated public was created by the re-
forms of Peter the Great and his successors. Its very *raison d'être* was
the turning of the country toward the West and Western Light. In Rus-
sian conditions, the government completely dominated that process. In
contrast to Western states, Russia in the eighteenth century lacked an
independent caste of lawyers, advanced private education, and a power-
ful church balancing the state or competing for the minds of men in the
modern world. More fundamentally still, the development of Muscovy
based on the service gentry and serfdom deprived the country of a
middle class of any prominence—of precisely that Third Estate which
was crucial to the Western Age of Reason. In Russia, the educated pub-
lic, especially at first but to a large extent even throughout the
eighteenth century and into the nineteenth, remained a small, thin, sec-
tarian layer, conscious at all times of its break with the past and its
separation from the masses. Its dependence on the government was
almost total; indeed one might argue that rather than merely offering
alliance to it, it fully identified itself with the government and its West-
ernizing policies.

It should be emphasized that for post-Petrine Russia the thought of
the Age of Reason, the new ideology of the government and the edu-
cated public, was both highly appropriate and very important. If an ap-
plication of reason held promise for the England of George III or the
France of Louis XVI, it could easily be considered the only, and at the
same time the most profoundly inspiring, hope in the much more
backward Russian conditions. If reason called for a break with the past
even in advanced European countries, Russia had in a sense already
accomplished the break, and, to stress the point, the gulf between the
new, reformed Russia and the ignorant masses increased throughout the
century. In no other state had custom and tradition been challenged so
directly and so bluntly in the name of reason and progress as they were
challenged by Peter the Great in Muscovy. As for criticism, while the
Russians did not have to worry about scholastic theology or, after the
establishment of the Holy Synod, about an excessive power of the
church in relation to state and society, the reforming emperor himself,
his assistants, and his successors found the essentially secular Western
outlook most congenial. Moreover, the critical approach of the Age of

Reason broadly conceived could scarcely desire a better field of application than Russia. In a country where for decades literate people could not be found for immediate state needs, an attack on ignorance required no justification. Criticizing the old was directly helpful to the new in Russia. Didacticism too acquired an enlarged scope in the land of the tsars. If the *philosophes* wanted to reform early modern European societies along certain lines, in Russia such a society had to be formed in the first place. Throughout the century much of the educational effort of the government went simply into teaching its subjects European manners and usages. On the whole, from gunnery to the Academy of Sciences, from vaccination to periodicals, both Peter the Great and Catherine the Great, in their very different ways, spent more time and effort teaching than any contemporary monarchs. In this respect, as in so many others, the two sovereigns did much to set the tone for the Russian culture of the Enlightenment. In other ways too the thought of the Age of Reason corresponded to Russian aspirations and needs. Cosmopolitanism, and certain proselytizing tendencies for that matter, proved extremely welcome to a country that wanted to join the European society of states. Even the trend toward religious tolerance found ready application in the increasingly multireligious and multicultural empire of the Romanovs.

The Russian autocracy itself received rich support from the thought and practice of the Age of Reason. A belief in the enlightened ruler as the source of progress deeply permeated the thought of the Enlightenment. Moreover, it has been argued, this belief was intrinsic to that thought. In other words, if a society was sunk in ignorance and prejudice and was to be pulled out of its stupor, it required an outside force to do the pulling. The enlightened despot was to be such a force, and his presence became more imperative as that of God grew more distant.[4]

It was within the intellectual framework of the Enlightenment that the small but growing Russian educated public lived and labored throughout the eighteenth century. On the whole it worked well and accomplished much. In the course of a hundred years the Russian language itself was developed from a semiarchaic and chaotic condition to Pushkin's standard and glorious modern idiom. At the same time, many educated Russians, no longer isolated in Muscovy, learned foreign tongues, to the extent that in the last part of the century French became the preferred language of the high and polite society in St. Petersburg and Moscow, as in other continental capitals. German intellectuals, for their part, made a particularly important and lasting contribution in the establishment of modern scholarship and science in Russia, highlighted by such events as the creation of the Academy of Sciences in 1725, of

the University of Moscow in 1755, and the periodic mounting of scientific expeditions to study the enormous empire. By the end of the century Russia had, with great foreign help but above all through the efforts of its new educated public, seemingly acquired everything—all the learned disciplines, the sciences, the arts, including the opera and the ballet, all the fashionable forms of literature, from love lyric to classical tragedy to novel to feuilleton, a periodical press, and a brilliant court. St. Petersburg had arisen and kept rising as one of the most majestic and classical cities of Europe. For more than thirty years the country had been ruled by a remarkable *soi-disant philosophe*.

The thought and the literature of the Russian Age of Reason emphasized common Enlightenment themes. Criticism dominated both the *belles-lettres* and the journalism of the epoch, which, in accord with the spirit of the times, easily blended into each other. From Kantemir's early satires to Krylov's immortal fables—which take Russian literature already into the nineteenth century—most authors, Catherine the Great herself prominently included, concentrated on castigating the vices and foibles of their ungainly countrymen. Similarly, most of them stressed the one effective weapon against the ignorance and darkness surrounding them: education. In fact, perhaps the greatest writer of the century, Fonvizin, treated virtually no other subject, while numerous other Russian intellectuals, exemplified by the indefatigable Novikov, also made the promotion of enlightenment their lifetime concern. Still another major theme of the Age of Reason found particular application in imperial Russia, that of enlightened despotism. A characteristic product of the thought of the Enlightenment, the concept of the enlightened despot had nevertheless little or no relevance for such countries as Switzerland or even England; by contrast, as already indicated, it was entirely appropriate to the state of the Romanovs, and it became fully dominant there. It permeated eighteenth-century Russian poetry no less than historiography, and Sumarokov's plays as much as Catherine the Great's *Instruction to the Legislative Commission*. Moreover, Lomonosov's praise of Peter the Great or Derzhavin's of Catherine the Great had, in spite of all the exaggeration and bombast, a certain authentic ring. To repeat, the ideology of enlightened despotism faithfully reflected the historical position of a vast country driven into modernization by an autocracy supported by a small and sectarian educated class, separated from the masses.

The intellectual hegemony of the ideology of enlightened despotism in the Russian Age of Reason acquires major importance in our search for the intelligentsia. In the latter part of the eighteenth century Russia already possessed a considerable number of educated and articulate intellectuals, a variety of educational and cultural institutions, and publi-

cation on a significant scale.[5] Furthermore, because of the very spirit and the fundamental intellectual assumptions of the age, these educated Russians were critically inclined, like their counterparts in other European countries. They deluged the presses with denunciations of the inequities around them, and at their best, as in the case of Fonvizin's *Minor*, these denunciations acquired lasting value as superb literature as well as effective social comment. And yet it would be premature to speak of a critical intelligentsia. The missing social-psychological element seems to have been precisely a perceptual and critical distance between the intellectuals and the government. One had to emerge from the shadow of enlightened despotism before one could clearly see and criticize it. It is in this regard that Radishchev does indeed deserve to be considered a forerunner of the Russian intelligentsia, for he virtually alone turned against serfdom, the ruler, and the entire establishment, placing his hopes in a republic. It is in this regard too that the Soviet insistence on petty government oppression of the educated public and on quarrels between intellectuals and the authorities attracts more than antiquarian interest.[6]

The total commitment of the Russian intellectuals of the Age of Reason to the government and its policies stemmed in large part from their numerical, social, and functional weaknesses. Deprived of middle-class support, the Russian educated public of the Enlightenment sociologically resembled more the earlier and feebler European-educated elites than their contemporaries in western and central Europe. Without an autonomous base, it depended on government assignments and functions, in everything from quasi-menial work to high poetic inspiration. Thus the greatest poet of the epoch, Derzhavin, was also prominent as courtier, court bard, and even minister of justice. The splendid modern Russian culture that came into its own in the first half of the nineteenth century has been characterized as a gentry culture, again matching it with earlier rather than contemporary developments in other countries. It was this historical lag and the central role of the government in the Russian historical process that the ideology of enlightened despotism fitted, or seemed to fit, so well. As Plekhanov remarked in dealing with Russian eighteenth-century ode writers:

> Our ode writers flattered beyond all measure. This, unfortunately, cannot be denied. But, in the first place, flattery in an ode was demanded by the custom of the time. It was a disgusting custom, but the contemporary readers and listeners knew that the exaggerated plaudits, contained in odes, had to be accepted *cum grano salis*. And the most important thing— precisely what I want to point out to the reader—the ode writers were adorers of autocratic power not only from fear but also out of conviction.

From it, and from it only, they expected the impulse for progressive development in Russia. How then could they fail to glorify it and sing it in their odes?[7]

The impact of the French Revolution and the tyrannical rule of Paul I, 1796–1801, checked the development of the Russian Age of Reason. But that age returned in full force, indeed with greater promise than ever, in the person and reign of Alexander I, 1801–25. The new Russian emperor, as much a product of the European Enlightenment as his grandmother, Catherine the Great, although of a later period of that Enlightenment, assisted by like-minded young advisers and friends, promised finally to bring light and reason to all his people, to abolish serfdom, to introduce mass education, and to establish a rational system of government. A devotee of enlightened despotism, he also tended to think ultimately in terms of a constitutional monarchy, thus sanctioning some popular participation in running the state. Alexander I was to have a remarkable reign, immortalized by the French invasion of 1812, the defeat of Napoleon, the entry into Paris, and the Congress of Vienna. Yet while the history of warfare was rewritten, empires collapsed, and regimes and boundaries changed again and again from the Iberian Peninsula to the Vistula, Russia itself remained unreformed. Except for some important improvements in education—not popular education, however—and certain other commendable measures, the empire of the tsars was much the same at the end of the reign as at the beginning. Autocracy and serfdom stood supreme. Then, following upon the emperor's sudden death, the radicals and liberals to be known as the Decembrists staged their rebellion (two rebellions, in St. Petersburg and in the south, to be more exact).

The Decembrist movement and the Decembrist rebellion deserve attention for many reasons, not the least of which is the concern of historians with the intelligentsia. Palace revolutions had abounded in imperial Russia in the first century of its existence. Alexander I himself had ascended the throne as a result of such a military coup, which deposed and killed his father, Emperor Paul I. But, similar in many ways in form, the Decembrist uprising was vastly different in substance from these earlier military overturns. It represented the culminating act of a genuine liberal and radical movement composed of some of the best-educated, most idealistic, and generally most promising Russian youth. It seemed that after a hundred years of government tutelage in enlightenment and progress, Russian society was finally taking matters into its own hands. The views of the Decembrists, often carefully considered and well developed, ranged from a belief in a conservative constitutional monarchy to Pestel's Jacobin republicanism. On the whole

they marked both an emphatic reaffirmation of the principles of the Age of Reason and an advance beyond mere reliance on a benevolent ruler.

And yet there is ambivalence surrounding the Decembrists and their position and role in Russian history. The actual defeat of the Decembrists was complete. More broadly speaking, they lacked all, or almost all, social support, both in their own landed class—which, especially in the case of the leaders, meant the highest levels of Russian society, the people who, in fact, ruled Russia—and in other classes, with which they had no effective links. Moreover, their own relationship to the government was extremely complex. Aristocrats and officers of elite regiments, many members of the movement belonged to the top of Russian society. They resembled friends and advisers of Alexander I in their social backgrounds, French culture, general education, and their ideology of the age of Reason. Progressive reforms and constitution-making preoccupied both groups. The early Decembrist societies naturally wanted to further the good intentions of the government. Even later, when philanthropic associations were becoming conspiracies, Alexander I made his famous comment on an informer's report to the effect that it was not for him to punish these men and these ideas. The provisional government to be formed after the Decembrist victory was to consist of liberal statesmen of the empire, notably Speransky. Indeed, the Decembrist movement, or rather many of its members, remained psychologically so close to the government and so permeated by the concept of enlightened despotism that their position was ambivalent to the end. This psychological ambiguity helps explain the critical collapse of the Decembrist leadership, especially in St. Petersburg, at the time of the uprisings. Colonel Prince Serge Trubetskoi, who had been elected "dictator" for the occasion, and his ranking assistants, Colonel Alexander Bulatov and Captain Alexander Iakubovich, all deserted the rebel cause. Trubetskoi and Bulatov swore allegiance to Nicholas I; Iakubovich offered his help to the emperor and generally behaved in the Senate Square in so bizarre a manner as to suggest a mental breakdown. Both Bulatov and Iakubovich might have come close to killing the emperor in the Senate Square. Later Bulatov committed suicide in prison. The Decembrists who did lead their troops in rebellion on the fourteenth of December showed a crucial lack of initiative during the hours of confrontation. It is generally agreed that their one hope of success lay in quick and decisive action; but nothing was done. And these were some of the bravest and most daring officers of Russia, heroes of Napoleonic wars. The psychological ambiguity must also account in large part for the collapse of the Decembrists during the interrogation and the trial, when so many of them confessed and repented

and also tried desperately to enlighten Nicholas I about the true condition of Russia so he would reform it.

Still, with all their ambivalences, hesitations, and weaknesses, the Decembrists did take the decisive step of advancing beyond enlightened despotism to rebellion itself. Simple logic might suggest that they would be followed by more autonomous, more powerful, eventually even successful champions of reason—that through the opposition, if not through the government, Enlightenment would finally triumph in Russia. But historical logic is seldom simple. The next opposition to challenge the state took a long time to form, and its members bore little resemblance to the spendid officers who failed in the Senate Square.

Many explanations have been adduced to elucidate the crooked course of Russian history. Much has been made of the repression introduced by Nicholas I, who replaced constitutional talk with absolute allegiance to autocracy. Other specialists, searching for a broader perspective, have declared that in any case the Age of Reason had been a mirage as far as Russia was concerned: the only question was how it would evaporate, not how it would triumph. Economic, social, and political conditions all militated against the advance of liberalism in the realm of the tsars. A change in the intellectual climate should certainly be included among the relevant factors. Enlightenment lasted long in Russia. Still, as the country entered the second quarter of the nineteenth century, views associated with European restoration and reaction and the seminal postulates of idealistic philosophy and romanticism were making inroads on the long-dominant *Weltanschauung* of the Age of Reason. The death of Alexander I and the Decembrist rebellion and its suppression served to emphasize dramatically a change of generations, ideologies, even intellectual worlds.

Romanticism lacked the unity of the thought of the Enlightenment. Linked on the one hand to the profundities, or pseudo-profundities, of German idealistic philosophy, it expressed itself, on the other, in sheer literary innovation, in a shift in literary taste. Without an agreed-upon social theory, a comprehensive economic doctrine, or a clear political message, romanticism has frequently been described as an embodiment more of feeling than of thought, a sensibility more than an ideology. Yet it possessed major intellectual content. It aimed to penetrate beyond the superficial cognition of mere reason to a deep understanding and full, integral knowledge, to move from an empirical *Verstand* to a transcendental *Vernunft*. Often it emphasized such subjective modes of cognition as intuition or imagination. In the last analysis, the philosopher or the artist carried within himself the secret of knowledge and creativity. The romantic age tended toward subjectivism in a still more fundamental, although frequently concealed, sense. In spite of Hume's

philosophical critique and the authentic vein of scepticism present in the Age of Reason, the *philosophes* lived generally in a secure intellectual world that they had inherited from earlier centuries: neither the physical reality of the universe nor the basic intellectual and moral values were seriously questioned. But in the long run, it was precisely this fundamental security that secularization and a reliance on the critical intellect had put in jeopardy. The romantic generation responded to the threat in several ways, most strikingly by apotheosizing the role of the creative individual. The ego in German idealistic philosophy or the thinker and the artist in romantic esthetics were in effect creating the basic values of life and even, one could argue, the physical world itself.

The terms of intellectual discourse also changed. Although the usual contrasts between cosmopolitanism and particularism, between an atomistic and mechanistic world and one of organisms and organic growth, between harmony and strife, or between present-mindedness and historism can all be overdrawn, they help illuminate the transformation of European thought. Especially important, in Russia as elsewhere, was the emergence of romantic nationalism. Not that eighteenth-century Russians lacked patriotism—or failed to address themselves to the issue of Russia and the West for that matter. But what used to be a pedagogical problem of learning and progressing according to the universal postulates of the Age of Reason became a metaphysical issue of establishing and asserting the true principles of the unique Russian national organism, of ensuring its historical mission. The titanically creative philosopher, poet, or artist of the romantic period was also the consciousness, almost an incarnation, of his nation; and it was the romantic concept of the intellectual and the nation that stood out in glaring light on the new European scene.

The thirties—and in Russia the 1830s began on the evening of 14 December 1825 and lasted until 1839 or 1840, or even a few years beyond that date—have been described as a period of silence in the history of Russian thought. Both the superficial, escapist literature typical of the times and the happy gendarme reports concerning the state of public opinion support this characterization. Yet, following the earlier and increasing penetration of German idealistic philosophy into Russian universities and the seminal views of the pioneer Society of the Lovers of Wisdom, the new *Weltanschauung* was permeating the Russian intellectual scene. In 1836 it exploded with the publication—made possible by a censor's mistake, to be sure—of Chaadaev's "First Philosophical Letter."[8]

Written originally in 1829, the "Letter" argued that Russia had no past, no present, and no future. It had never really belonged to either the West or the East, and it had contributed nothing to culture. In par-

ticular, Russia lacked the dynamic social principle of Catholicism, which constituted the basis of the entire creative and rich Western civilization. By contrast with that civilization, Russia remained "a gap in the intellectual order of things." Compared to Chaadaev's proclamation, Radishchev or the most radical of the Decembrists could be considered well-integrated members of society: in the new intellectual climate, alienation had suddenly reached its ultimate.

Chaadaev's outrageous formulation could not, of course, go unchallenged. The government, which was preaching and enforcing at the time the doctrine of Official Nationality, a derivative Russian version of the general European ideology of restoration and reaction bent on glorifying Russia and the Russian system, declared Chaadaev insane. Chaadaev himself soon changed his views, announcing in "The Apology of a Madman" that Russia had entered history and culture with Peter the Great—an honest change, in my opinion, for the original position was a psychologically unbearable one. Moreover, other outstanding young intellectuals joined the discussion.

The Slavophiles were a group of romantic thinkers, all of them landlords and gentlemen-scholars of broad culture and many intellectual interests, who, beginning in 1839, formulated a comprehensive and remarkable ideology centered on their belief in the superior nature and supreme mission of Orthodoxy and of Russia. Slavophilism expressed a fundamental vision of integration, peace, and harmony among men. On the religious plane it produced Khomiakov's concept of *sobornost,* an association in love, freedom, and truth of believers, which Khomiakov considered the essence of Orthodoxy. Historically, so the Slavophiles asserted, a similar harmonious integration of individuals could be found in the social life of the Slavs, notably in the peasant commune— described as "moral choir" by Constantine Aksakov—and in such ancient Russian institutions as the *zemskii sobor.* Again, the family represented the principle of integration in love, and the same spirit could pervade other associations of men. As against love, freedom, and cooperation stood the world of rationalism, necessity, and compulsion. It too existed on many planes, from the religious and metaphysical to that of everyday life. Thus it manifested itself in the Roman Catholic church, in Protestantism, and in the entire civilization of the West. Furthermore, Peter the Great introduced the principles of rationalism, legalism, and compulsion into Russia, where they proceeded to destroy or stunt the harmonious native development and to seduce the educated public. The Russian future clearly lay in a return to native principles, in overcoming the Western disease. After being cured, Russia would take its message of harmony and salvation to the discordant and dying West.

In its application to the Russia of Nicholas I the Slavophile teaching

often produced paradoxical results, antagonized the government, and baffled Slavophile friends and foes alike. In a sense, the Slavophiles were religious anarchists, for they condemned all legalism and compulsion in the name of their religious ideal. Yet, given the sinful condition of man, they granted the necessity of government and even expressed a preference for autocracy: in addition to its historical roots in ancient Russia, autocracy possessed the virtue of placing the entire weight of authority and compulsion on a single individual, thus liberating society from that heavy burden; besides, the Slavophiles remained unalterably opposed to Western constitutional and other legalistic and formalistic devices. Yet this justification of autocracy remained historical and functional, therefore relative, never religious and absolute. And while affirming autocracy in principle, it withdrew nothing from the condemnation of Peter the Great and the actual Russian government that was his work. Moreover, the Slavophiles desired the emancipation of the serfs and other reforms, and, above all, insisted on the "freedom of the life of the spirit," that is, freedom of conscience, speech, and publication. As Constantine Aksakov tried to explain to the government: "Man was created by God as an intelligent and a talking being."[9] Also, Khomiakov and his friends opposed such aspects of the established order as the death penalty, government intrusion into private life, and bureaucracy in general. "Thus the first relationship of the government and the people is the relationship of *mutual non-interference.* . . ."[10] No wonder the Slavophiles were suspect, and their publications never escaped censorship and prohibition for long.

The Westernizers were much more diverse than the Slavophiles, and their views did not form a single, integrated whole. Besides, they evolved rapidly and shifted their positions. Even socially the Westernizers consisted of different elements, ranging from Bakunin, who came from a gentry home very much like those of the Slavophiles, to Belinsky, whose father was an impoverished doctor and grandfather a priest, and Botkin, who belonged to a family of merchants. Yet certain generally held opinions and doctrines gave a measure of unity to the movement. The Slavophiles and the Westernizers started from similar assumptions of German idealistic philosophy, and indeed engaged in constant debate with each other, but came to opposite conclusions. While Khomiakov and his friends affirmed the uniqueness of Russia and the superiority of true Russian principles over those of the West, the other party argued that the Western historical path was the model that Russia had to follow. Russia could accomplish its mission only in the context of Western civilization, not in opposition to it. The Westernizers thus took a positive view of Western political development and criticized the Russian system. Contrary to the Slavophiles, they

praised the work of Peter the Great, but they wanted further Westerni-
zation. Also, whereas the Slavophiles anchored their entire ideology in
their interpretation and appraisal of Orthodoxy, the Westernizers as-
signed relatively little importance to religion, while some of them
gradually turned to agnosticism and, in the case of Bakunin, even to
violent atheism. To be more exact, the moderate Westernizers, such as
the popular professor of European history at the University of Moscow
Granovsky, retained religious faith and an essentially idealistic cast of
mind, while their political and social program did not go beyond mild
liberalism, with emphasis on gradualism and popular enlightenment.
The radical Westernizers, however, largely through Hegelianism and
Left Hegelianism, came to challenge religion, society, and the entire
Russian and European system, and to call for a revolution. Although
few in number, they included such major figures as the crucially impor-
tant literary critic Belinsky, the great émigré oppositionist and intel-
lectual-at-large Herzen, and "the founder of nihilism and apostle of
anarchy," Bakunin.

The quasi-total alienation from, indeed the rebellion against, Russian
government and society on the part of radical Westernizers capped a
complex and painful evolution. Apolitical in a fundamental sense, the
Russian romanticists of the 1830s and 1840s had exalted idealistic phi-
losophy, art, and friendship as against the crude and oppressive reality
surrounding them. Indeed they claimed that only the ideal was real.
Unable to maintain permanently this paradoxical position, Bakunin and
Belinsky in particular tried in the years from 1837 or 1838 to 1840 a
remarkable "reconciliation with reality": basing themselves on a narrow
and literal reading of Hegel's celebrated dictum that the real was the
ideal, they proceeded to affirm and even glorify Nicholas I and his
Russia. That solution to their intellectual and existential dilemma also
collapsed, and it was only after further evolution and eventual decom-
position of their idealistic thought that the radical Westernizers reached
sweeping negation. At times at least, Bakunin with his pandestruction
and Herzen with his personal despair remind the reader—always in
their own highly individual ways—of Chaadaev's "First Philosophical
Letter." But the much more numerous moderate Westernizers too were
unlike the intellectuals of the Enlightenment. They also had believed
the golden promise of German idealistic philosophy and discovered the
irrelevance of that philosophy to reality—all reality perhaps, Russian
reality certainly. They also were entirely out of step with the govern-
ment, which kept marching ("mark time march" may be considered the
appropriate command for the entire reign of Nicholas I) in defense of
the Petrine state understood in terms of European restoration and
reaction. Although a believer in God, an established academic figure,

and a moderate and modest person, all by contrast with his onetime close friend Herzen, Granovsky during the last years of his life apparently rivaled the editor of *The Bell* in despair.

Nor was the government concerned only with the Slavophiles and the Westernizers. In 1847 it arrested in Kiev a small clandestine group known as the Brotherhood of Cyril and Methodius, which had postulated, in line with romantic nationalism, the Messianic role of the Ukrainians and a free democratic federation of Slavic peoples centered in Kiev. And two years later it arrested in St. Petersburg members of a larger society, or discussion circle, formed around Butashevich-Petrashevsky and inspired, this time, by utopian socialism, in particular by the writings of Fourier. Beginning in 1840 and 1841 the gendarme reports referred to a change in the mood, to something being wrong with the Russian educated public.

What had happened? What were the reasons that terminated, or at least greatly impaired, the more than century-old alliance between the government and the educated public in Russia, transforming the apparently monolithic image of the eighteenth century and, still, of the 1830s, with the government in virtually complete control, into a picture of alienation and opposition? Most prerevolutionary Russian scholars directly blamed the government itself, and more specifically Nicholas I. With a characteristically liberal, and occasionally radical, bias, they saw the educated public, in particular its intellectual leaders, as bearers of light and the conscience of Russia. These leaders naturally supported progressive Petrine reforms, and they offered their strong backing to the activities of Catherine the Great and the projects of Alexander I, although in these last two instances they might have been misled and mistaken to some considerable extent. But with Nicholas I cooperation ceased. The new emperor refused to solve the pressing problems of the country. Notably, he would not abolish serfdom, and he established a regime of unbearable reaction, oppression, and militarism. The last harrowing years of his rule, which followed the revolutions of 1848 in many European countries, raised oppression to an insane pitch and made a fundamental break between the state and all aware and self-respecting Russians inevitable. One is reminded of Nikitenko's bitter comment that the main failing of the reign of Nicholas I consisted in the fact that it was all a mistake.[11] And yet, in spite of its apparent plausibility and its hallowed standing in Russian thought, the liberal view, at least in its simple form, fails to carry conviction. For one thing, the last years of Nicholas I's rule were probably more painful than decisive in the relationship between the government and the educated public in Russia because the split between the two had preceded their onset. More importantly, Nicholas I was not called the most consistent

of autocrats for nothing. The emperor's beliefs, aims, and policies remained essentially the same in the 1820s, 1830s, 1840s, and 1850s. It was the educated public that changed.

Nor was that change primarily one in social composition. In spite of a repeated Soviet emphasis on the democratization of intellectuals, there is little evidence of such a democratization before the reign of Alexander II and the emancipation of the serfs. Indeed, according to the Soviet periodization itself, the reign of Nicholas I belonged still to the feudal, hence landlord-dominated, period of Russian history, while in Lenin's own opinion the Russian liberation movement was then in its gentry phase. Moreover, whatever the exact numbers and distribution of nongentry intellectuals at the time, there is no reason to believe that they made the educated public more radical. There is even some fragmentary indication to the contrary, i.e., of a more radical inclination among students and other intellectuals from the gentry than among those from other classes.[12] The historian must, rather, seek clues in the evolving structure of intellectual life in the country.

Although the number of universities did not alter during the reign of Nicholas I—their founding, except for the earlier University of Moscow, constituted one of Alexander I's greatest accomplishments—at least they developed their work and became better established in Russian society and culture. Other institutions of higher learning and even more notably the secondary schools, the *gimnazii,* did increase in number, attracting ever more students. The Russian periodical press experienced a great expansion and differentiation reflecting much of the rich thought of the period. Writing and publishing in general became more professional and, obviously, acquired more readers. As most commentators have noted, and as we have had occasion to observe, the intellectual development of the time centered frequently in ideological circles, which left their indelible mark on Russian thought and culture. Herzen and others referred to a quickening of intellectual life and even, for some, an intellectual emancipation.

The intellectual landscape also changed. Russia was no longer a welcome junior member of the European society of nations of the Enlightenment, but one of the intensely competitive national romantic entities, generally disliked, despised, and denounced by the others. Such events as the Russian suppression of the Polish rebellion in 1831 and the Hungarian revolution against the Hapsburgs in 1849 gave a degree of verisimilitude to the hostile ideological image of Russia. Deep fissures on the inside matched the split on the outside. As we have seen, Russian intellectuals came to be divided among themselves, and they now also stood apart from the government. To be sure, the abandonment of the philosophy of the Enlightenment could be consid-

ered pure gain as far as Nicholas I and his associates were concerned, all the more so because it followed the Decembrist rebellion, which had demonstrated how far the Russian educated public could carry the principles of that philosophy. Metaphysics, religion, art, or poetry was bound to seem less of a threat in the eyes of the dedicated autocrat and his gendarmes than would have been an active interest of society in politics. Moreover, not only did the new *Weltanschauung* demote political and practical concerns but it contained within itself a strong affirmative and conservative bias. Historical, traditionalist, religious, and authoritarian arguments of the romantic age were used to define and uphold the doctrine of Official Nationality in its ramifications. Outside the government too affirmation and preservation were on the upswing, as was only natural when disciples of Schelling and Savigny replaced admirers of Voltaire and Rousseau in the intellectual leadership of Russia. As already noted, even Bakunin and Belinsky became passionate supporters of autocracy during their brief period of "reconciliation with reality." It was no mere coincidence that the Russian educated public did not mount a single violent attempt against the state throughout the entire age of romanticism and idealism, from the late Enlightenment of 1825 until the 1860s, when a neo-Enlightenment had become an active force.

Yet, as it turned out, the Russian government obtained its peace and the Russian educated public its more or less successful reconciliation with reality at an exorbitant price. The philosophy of the Enlightenment was probably the last truly unifying ideology of the Western world. In Russia, as elsewhere, it was followed by division and fragmentation, the common language of the rulers and the educated public replaced by a babel of tongues. The poignancy and the special tragedy of the Radishchev episode was due precisely to the fact that the critic and Catherine the Great belonged to essentially the same intellectual camp. Even the Decembrists had found it difficult to separate their intentions and actions from those of the government of Alexander I, and their emotional attitude toward their rulers had remained ambivalent to the end. But there was no way for the gendarme Benckendorff to understand the Slavophiles, or for Nicholas I the Petrashevtsy. The connection was no more. At the same time the thought of Russian intellectuals, and to a certain extent of the government too, was becoming, so to speak, increasingly unreal. While scholars still argue whether an implementation of Speransky's main proposals would have fundamentally changed the course of Russian history, or dispute the practical merits and demerits of Novosiltsev's constitution or those of the Decembrists, no such debate swirls around the Slavophile program, Butashevich-Petrashevsky's phalanx, or Bakunin's anarchism. A constitution, espe-

cially a moderate constitution, might have been well within the possibilities of the Russian imperial system in the first half of the nineteenth century; by contrast, the views of Khomiakov, or Constantine Aksakov, or Bakunin, or the orthodox Fourierist Khanykov constituted pure utopia. There was peace, indeed a dead calm, largely because the government and the intellectuals no longer had a common language for communication or common subjects to discuss. The Crimean War served to deepen the split between the government and the intellectuals and even the educated public as a whole.

To sum up, there was an intelligentsia in Russia by the end of Nicholas I's reign, in fact if not necessarily in name. Its members held views, sometimes complete ideologies, entirely independent and distinct from and often opposed to the position of the government. As we have seen, the very appearance of the new beliefs implied a criticism of the established mode of thought and often of the established order of things. Frequently the criticism became quite explicit, indeed reaching in the case of the early Chaadaev or the late Bakunin the ultimate in negation. It is also important to realize that the emerging intelligentsia had its functional basis in the universities, in the periodical press and publishing in general, and in private circles, not in direct execution of government assignments or in a conspiracy in the guard regiments. The classical problem of the government and the intelligentsia, of state and society, had been finally set, and, many would argue, the next major change came only with the communist victory in 1917.

Still and again, the developments in the intervening years proved to be anything but simple or straightforward. It must be emphasized that Russia had undergone two intellectual transformations in the second quarter of the nineteenth century: the change from the ideology of the Age of Reason to romanticism and idealism, and the disintegration of the new world view, or rather views. That last occurrence left little in the realm of ideas intact and less to bequeath. To be sure, the Slavophiles never abandoned their paradoxical position, but after 1860 few of them remained alive, and they were of slight consequence, except occasionally, as in the instance of Ivan Aksakov and Panslavism, as contributors to other ideologies. The Westernizers, by contrast, changed with the times and went in many directions, but in their evolution they exhibited best the disintegration of romanticism and idealism. That process, however, was all-pervasive. In Russian literature, beginning around 1840, realistic tendencies were replacing romanticism, prose poetry. In science, according to one estimate, Schelling's doctrines attained their greatest influence in 1836, declining rapidly in popularity after that date.[13] Here too Russia followed with some delay the general European trend. Before long, even Professor Michael Pav-

lov himself, immortalized by Herzen as the herald of *Naturphilosophie,* had abandoned idealism. Numerous other apostates included the seminal thinker of the original idealistic Society of the Lovers of Wisdom, Prince Vladimir Odoevsky. The Westernizers gave, in a sense, a concentrated expression to this entire process, and they brought out especially well its attendant protest, rebellion, and despair. The Petrashevtsy, for their part, disappeared into Siberia, and there was never again to be a primarily Fourierist group in Russia, although Fourierism can rightly be considered a component element of subsequent Russian radicalism.

What, then, did "the men of the sixties" receive from their predecessors, both in general and with particular reference to the emergence of growth of the Russian intelligentsia? One answer lies certainly in the institutional base itself, in the universities, the periodical press, book publishing, the circles for that matter, and other elements of Russian culture established and developed by preceding generations. Nor should one forget personalities. Certain dead "men of the forties," especially Belinsky, became symbols and examples to the rising Russian intelligentsia. It was precisely Belinsky's uncompromising rebellion against official Russia and, more broadly, against the world around him that made his image, permanently as it turned out, central for Russian intellectuals.[14] A few leading ideologists of the time of Nicholas I, Herzen and Bakunin foremost among them, continued to play very prominent roles in the new intellectual climate, although they could never become completely integrated into the climate. As to ideas proper, the most important heritage was probably the romantic concept of people and the related notions of populism, *narodnost'*, and the peasant commune. Formulated in Russia most emphatically, fundamentally, and effectively by the Slavophiles—although by no means by the Slavophiles alone—these concepts were carried and modified by Herzen, Bakunin, and others to affect the entire Russian radical movement clear to the revolutions of 1917 and beyond. Generally secularized and frequently presented in a pragmatic or social scientific manner, populist doctrines nevertheless repeatedly revealed the original idealistic and quasi-religious sweep.

"The men of the sixties" learned little from "the men of the forties" also because they were in rebellion against them, much as champions of romanticism had earlier assailed proponents of the Enlightenment. Whereas "the fathers" grew up, as we have seen, on German idealistic philosophy and romanticism in general, with its emphasis on the metaphysical, religious, esthetic, and historical approaches to reality, "the sons," led by such young radicals as Chernyshevsky, Dobroliubov, and Pisarev, hoisted the banner of utilitarianism, positivism, materialism, scientism, nihilism, and especially realism. "Nihilism"—and

also in large part "realism," particularly "critical realism"—meant above all else a fundamental rebellion against accepted values and standards: against abstract thought and family control, against lyric poetry and school discipline, against religion and rhetoric. The earnest young men and women of the 1860s wanted to cut through every polite veneer, to get rid of all conventional sham, to get to the bottom of things. What they usually considered real and worthwhile included the natural and physical sciences, simple and sincere human relations, and a society based on knowledge and reason rather than ignorance, prejudice, exploitation, and oppression. The casting down of idols—and there surely were many idols in mid-nineteenth-century Russia, as elsewhere—emancipation, and freedom constituted the moral strength of "the men of the sixties." Yet few in our age would fail to see the narrowness of their vision or neglect the fact that they erected cruel idols of their own.

The intellectual transformation in Russia formed part, once again, of a broader change in all of Europe that has been described, for example, as a transition from romanticism to realism. The remarkable directness, crudeness, and self-confidence of the nihilists and other Russian radicals stemmed largely from a new faith in materialism and a new cult of science. As has been pointed out with no special reference to Russia, it was at that time that science became an all-encompassing vision of the world through a linkage of previously separate disciplines, moreover a vision that could still be grasped by a high school student, and it was also at that time that science acquired an immediate usefulness through instant connection to technology.[15] Such popularizers of the new outlook as Büchner and Moleschott replaced Schelling and Hegel as rulers of Russian minds. Still, while there is no reason to separate Russia from Europe as a whole in this any more than in the preceding periods, the Russian development had its exaggerations and its peculiarities: in fact, it can be argued that in the "neo-Enlightenment" of the second half of the nineteenth century, just as in the Enlightenment proper, the Russians reproduced the original Western ideological model so faithfully and so starkly that their version bordered on caricature.

The *Weltanschauung* of the 1860s in Russia followed the death of Nicholas I, the catastrophic conclusion of the Crimean War, and the coming of Alexander II's reign of "great reforms" with the all-important emancipation of the serfs decreed on 19 February 1861. By contrast with the Decembrist fiasco and the resulting repression and stagnation that formed the background for romanticism in Russia, the government and the events were moving fast. The intellectual response was also quick. The rapid polarization of the Russian educated public in the early 1860s was one of the most striking and signifcant developments of the period. The usual explanation that radicalism was largely caused by

repression as well as by disappointment with "the great reforms" lacks precision, to say the least: it would appear that radical or revolutionary action preceded as often as it followed government measures, while it was much too early to judge the results of "the great reforms." In any case, in the new intellectual climate the radical opposition grew, and it was to have a checkered, complex, but in certain ways continuous history until the revolutions of 1917. On the other hand, it was during the early 1860s that such figures as Dostoevsky, Pobedonostsev, and Katkov moved sharply to the Right.

The radical and revolutionary movement, however, was by no means the only manifestation of the Russian intelligentsia in the second half of the nineteenth century. The reforms themselves, together with a general quickening of the economy, offered vast new opportunities to those people who were professionally trained and, to a lesser degree, to all educated people. Whereas Russia possessed about twenty thousand subjects with higher education in 1860, another eighty-five thousand went through institutions of higher learning in the next four decades.[16] There was also, finally, a certain democratization of intellectuals as well as a general decline of the landed gentry following the emancipation of the serfs. By the end of the century, the new Marxist teaching was competing effectively with the older populism for the allegiance of the Left, while liberalism grew steadily as a more moderate answer to Russian needs. After the Revolution of 1905, Russia even acquired a constitution, legal political parties, elections, and other accoutrements of European political life. Indeed, in the opinion of many specialists, the country in general and the intellectuals, the intelligentsia in particular, were following the classical Western scheme of development, when hit by the First World War and the revolutions of 1917—a complex and controversial subject, which I am not in a position to discuss in this brief piece. Moreover, at the turn of the century the intellectual climate was again changing in Russia, leading to what has been called a cultural Renaissance or the Silver Age and reshuffling, once more, the basic elements of intellectual orientation, outlook, and history.

These developments, however, take us past the nineteenth century and well beyond the emergence of the intelligentsia. To return to that emergence and to conclude, the Russian intelligentsia was a result of the reforms of Peter the Great and of the whole process of Westernization. It obtained from the West its indispensable education and the entire intellectual and cultural framework for its existence. But, in Russian conditions, the other necessary element for the formation of an intelligentsia, a certain autonomy, a critical and independent stance, proved very difficult to establish. Russian reality and the belief in enlightened despotism gave the Petrine state a virtually unbroken hegemony over the intellectuals throughout the eighteenth century and

in the first quarter of the nineteenth. Even the Decembrists remained, in spite of their desperate and tragic rebellion, psychologically and intellectually entangled with the image of the enlightened ruler and state. Only a further and more independent development of the Russian educated public in the second quarter of the century, together with the change in the intellectual climate from Age of Reason to romanticism, provided a sufficient distance between the intellectuals and the government and made it possible for an intelligentsia to emerge. That newly created tiny intelligentsia, brought up on German idealism and romanticism, quickly experienced a defeat or even collapse of its intellectual world as men and women of the sixties, with their simpler and more activist creed, swamped their "superfluous" predecessors of the forties. Yet, as I tried to indicate, there was some meaningful connection and continuity between the generations, exemplified in the triumphant cult of Belinsky. And once an intelligentsia had been formed, there was no turning back.

In a sense, an account of the very difficult emergence of the Russian intelligentsia is a study in the power of the Russian ruler and state—and every student of Russian history can write his own commentary on that power. In a very generous review of my *Parting of Ways,* an excellent historian criticized my treatment of the Decembrists. He accused me of a contradiction for writing, on the one hand, that "Many of [them] remained psychologically so close to the government and so permeated by the concept of enlightened despotism that their position was ambivalent to the end," and, on the other, that "the salient characteristic of the Decembrist movement was its rejection of autocracy and enlightened despotism."[17] The point is, of course, that both statements are correct, whatever the felicity or infelicity of expression. Nor did the matter disappear with the Decembrists. Working on the so-called state school of Russian historiography, I was repeatedly impressed by the crushing might of the Russian state and by how hard it was for Russian intellectuals to criticize that state from the outside. At about the same time I had several interesting conversations with a specialist on Granovsky who was particularly concerned that that sensitive liberal and Westernizer was also a monarchist unable to escape the framework of enlightened despotism.[18] There is little need to continue from instance to instance by way of repeated illustration on the subject of the Russian ruler and state and their relationship to the intellectuals, all the more so because other students of Russian history will have their own long lists. So, to finish with a more far-reaching observation than most: in a recent public lecture Professor Leopold Haimson interpreted the collapse of the Kadet leadership at the time of the great Russian Revolution as a result of a psychological trauma produced by the decline and fall of the state and especially of the emperor; in fact, he

spoke of a true psychological regression.[19] In other words—the comparison is mine, not Professor Haimson's—almost a hundred years after the tragedy in the Senate Square, at another critical point in Russian history, leaders of opposition again lost their self-control and all control over the events around them because they could not fully sever their ties with the image of the ruler.

That time at least the ruler was killed and the problem settled. Or was it really?

NOTES

1. Lamartine, "La Marseillaise de la paix," *Chefs-d'oeuvre poétiques* (Paris, 1920), pp. 255–61, quoted from p.258

2. For an outline of the topic of the Russian intelligentsia, with particular attention to the origins of the word and the concept, see especially: Martin Malia, "What Is the Intelligentsia?" *Daedalus,* Summer 1960, pp. 441–58 (the entire volume is entitled *The Russian Intelligentsia); Alan P. Pollard, "The Russian Intelligentsia: The Mind of Russia," *California Slavic Studies* III (1964): 1–32; the Introduction (pp. 3–22) to V. R. Leikina-Svirskaia, *Intelligentsiia v Rossii vo vtorori polovine XIX veka* (Moscow, 1971); Richard Pipes, " 'Intelligentsia' from the German 'Intelligenz'?: A Note," *Slavic Review* 30, no. 3 (September 1971): 615–18; Michael Confino, "On Intellectuals and Intellectual Traditions in Eighteenth- and Nineteenth-Century Russia," *Daedalus,* Spring 1972, pp.117–49; and, most comprehensively and in greatest detail, Otto Wilh. Müller, *Intelligencija: Untersuchungen zur Geschichte eines politischen Schlagwortes, Frankfurter Abhandlungen zur Slavistik,* Vol. 17 (Frankfurt, 1971).

3. Because of the limitations of space, I shall refer here only to my own works, which should serve to support many of the opinions dispensed rather freely in the present brief piece. Most relevant is *A Parting of Ways: Government and the Educated Public in Russia, 1801–1855* (Oxford, 1976), which in effect covers the eighteenth century as well as the first half of the nineteenth. Two books discuss two major specific topics, both of them of import for the emergence of the intelligentsia: *Russia and the West in the Teaching of the Slavophiles: A Study of Romantic Ideology* (Cambridge, Mass., 1952), and *Nicholas I and Official Nationality in Russia, 1825–1855* (Berkeley and Los Angeles, 1959). *A History of Russia,* 3d ed. (New York, 1977), provides an overall perspective. For other relevant studies of mine, see the bibliography of *A Parting of Ways.*

4. See, for instance, a reaffirmation of this view, with particular reference to more backward countries, in Lucien Goldmann, "La pensée des 'Lumières'," *Annales: économies, sociétés, civilisations,* year 22, no. 4 (July–Aug. 1967), pp. 752–79, especially pp. 768–69.

5. For the latest and fullest treatment of the last subject, see Dr. Gary Jon Marker's dissertation, "Publishing and the Formation of a Reading Public in Eighteenth Century Russia" (University of California, Berkeley, 1977).

6. In general, Soviet interpretations of the Russian Enlightenment empha-

size not cooperation with but struggle against the government on the part of the educated public. For my criticism of these interpretations, see *A Parting of Ways*, pp. 43–49. In the West, Professor Marc Raeff argued in an interesting, although ultimately unconvincing, manner for an alienation of the eighteenth-century Russian gentry from the state, entitling his book appropriately: *Origins of the Russian Intelligentsia: The Eighteenth-Century Nobility* (New York, 1966).

7. G. V. Plekhanov, *Istoriia russkoi obshchestvennoi mysli*, vol. III (Moscow, 1919), p. 32.

8. My fullest discussion of the "Letter," and in something of a comparative perspective, is in "On Lammenais, Chaadaev, and the Romantic Revolt in France and Russia," *The American Historical Review* 82, no. 5 (December 1977): 1165–86.

9. L. Brodskii, *Rannie slavianofily* (Moscow, 1910), p. 95. Both this quotation and the next one are taken from Constantine Aksakov's celebrated memorandum to Alexander II entitled "O vnutrennem sostoianii Rossii" ("About the Internal Condition of Russia"). The memorandum was published in Brodskii, op. cit., pp. 69–122.

10. Ibid., p. 80. Italics in the original.

11. Professor of Russian literature, censor, and prominent conservative intellectual of serf origin Alexander Nikitenko rendered this judgment in his diary in 1859, several years after the death of Nicholas I. A. Nikitenko, *Moia povest o samom sebe i o tom "chemu svidetel v zhizni byl." Zapiski i dnevnik. (1804–1877 gg.)*, 2d ed., 2 vols. (St. Petersburg, 1905), vol. I, p. 553.

12. In addition to the references in *A Parting of Ways*, pp. 270–73, I would like to cite two recent books: Daniel R. Brower, *Training the Nihilists: Education and Radicalism in Tsarist Russia* (Ithaca and London, 1975); and Alain Besançon, *Education et société en Russie dans le second tiers du XIXᵉ siècle* (Paris, La Haye, 1974). Besançon even argues that the classical image of the commoner intellectual (*intelligent-raznochinets*) was itself a gentry invention and preceded the effective appearance of these lower-class intellectuals.

13. Alexander Vucinich, *Science in Russian Culture: A History to 1860* (Stanford, 1963), p. 337.

14. The latest striking contribution to the great cult of Belinsky to come to my attention was that by Vladimir Soloviev in a speech of October 11, 1898, to the Philosophical Society, reported in Georgij Florovskij, "Zur Biographie Vladimir Solov'evs, *Kirche im Osten* 18 (1975): 20–33.

15. On the new European intellectual climate, and the cult of science in particular, see, e.g., the first three chapters (pp. 1–56) in Robert C. Binkley, *Realism and Nationalism, 1852–1871* (New York and London, 1935).

16. Leikina-Svirskaia, *Intelligentsiia v Rossii*, p. 70. One is reminded that: "The most down-to-earth definition one can give of the intelligentsia is to say that they were the 'student youth' trained in the various establishments of the 'Ministry of National Englightenment'," Malia, "What Is the Intelligentsia?" p. 454.

17. Professor John Keep's review in *Slavic Review* 37, no. 1 (March 1978): 124–25; quoted from page 125.

18. The specialist was Dr. Priscilla Reynolds Roosevelt, and the conversations took place at the University of Illinois in Urbana-Champaign in late July and early August.

19. The lecture, entitled "The Crisis of Russian Liberalism on the Eve of the First World War," was delivered in Berkeley, California, on June 1978. Also I discussed the issue with Professor Haimson after the lecture and on the following day.

2

St. Petersburg and
Moscow as Cultural Symbols
Sidney Monas

THROUGHOUT THE eighteenth and nineteenth centuries, St. Petersburg and Moscow served not only as cultural centers, each with its distinctive configuration of cultural institutions and sets of mores, but also as symbols, as cultural landmarks or signposts indicating deep issues at the very basis of Russian culture as a whole. Every capital city is in a sense a theatrical setting for the drama of power as the founders of the capital as capital would like to see it staged. Every capital city is in a certain sense a New Jerusalem, with its seat of power ensconced at an elevation located on a straight vertical line, the *axis mundi,* with that of the powers that rule the cosmos. Domestic subjects and foreign visitors alike must be awed by the exalted elevation and must somehow be made to see, in an imagery rendered visible and even palpable, the cosmic centricity of the axis on which the city turns. The architecture and the "grid" of each New Jerusalem is laid out with the plan of the cosmos, the idea of a very special destiny—at least as the local powers-that-be conceive it—very much in mind.[1]

Russia, as befits its divided soul, had two capital cities. In Russian literature, there is a certain tendency for those who see the one as Jerusalem to regard the other as Babylon, though there are Russian writers who regard them both as Babylon. It is almost as though the cities were made to be contrasted with each other, as Gogol suggested:

Moscow is feminine, Petersburg masculine. Moscow is all brides, Petersburg all bridegrooms. . . . Petersburg is an accurate, punctual kind of person, a perfect German, and he looks at everything calculatingly. Before he considers giving a party, he'll look into his pockets. Moscow is a Russian nobleman, and if he's going to have a good time, he'll go all the way until he drops, and he won't worry about how much he's got in his pocket. Moscow doesn't like halfway measures. . . . Petersburg likes to tease Mos-

cow for her awkwardness and lack of taste. Moscow reproaches Petersburg to the effect that he doesn't know how to speak Russian. . . . Russia needs Moscow; Petersburg needs Russia.[2]

Belinsky, on the other hand, and all of the Westernizers, though for a variety of reasons, insisted that it was Petersburg above all that Russia needed.

During most of the nineteenth century, growth favored St. Petersburg. Begun in 1703, active as the prime capital from about 1710, Petersburg did not become, in palpable mass of buildings and population, recognizably a city of European scale until the second half of the eighteenth century. Around the turn of the nineteenth century, the overall population of both cities was about the same—somewhere in the vicinity of a quarter million inhabitants. By 1811, Moscow had 275,000 people, Petersburg 300,000. As a result of the evacuation and burning of Moscow—the Napoleonic invasion—that city's population dropped precipitately to 161,000 by 1814, at which time the population of Petersburg, swelled by a large immigration from Moscow, was more than twice that. In 1830, as a result of the cholera epidemic, the population of Moscow dropped from 305,000 to 261,000, while the population of Petersburg declined relatively little, from 448,000 to 445,000. The difference is to be accounted for not only in terms of the higher death rate from the disease in Moscow, but probably also by the relative fluidity of the Moscow population, with a larger proportion of the noble, artisan, and other classes maintaining close ties with their family origins in the countryside. By mid-century, Petersburg passed the half-million mark, while Moscow supported a population of 350,000.[3] It was only in the last decade of the nineteenth century that Moscow began to catch up, and only in the twentieth century did it surpass St. Petersburg. Today, Moscow has about twice the population of Leningrad.

Contrary to Gogol's notion of Moscow being "all brides," the male population, as in all Russian cities, was heavily preponderant. But where the male-female ratio was almost 2:1 in Moscow, it was almost 3:1 in Petersburg. This preponderance of males reflects the presence of peasant-artisans and workers with unsevered village connections who were either unmarried or had wives and families still in the countryside. In Petersburg, it reflects as well the presence of thirty to fifty thousand soldiers. After the reign of Nicholas I and the Crimean War, with the diminution of the garrison, the ratio tended to decrease somewhat. Reflecting the abnormally high ratio of wifeless males, Petersburg always supported an exceptionally large population of prostitutes, with the attendant problems for public health and moral atmosphere.[4] Every

reader of *Crime and Punishment* will, of course, remember not only the heroine, Sonia, but also the whore with the black eye who kept her post outside the Crystal Palace.[5]

Moscow supported an unusually large merchant population, somewhere around 5 percent, equal to and at times surpassing the noble population of the city. Between 1814 and 1852 the artisan population increased in relation to the population as a whole from 11 percent to 18 percent. This growth, along with the strong merchant presence, reflects the growth of the textile industry in Moscow, the strongest component of Russian industrial production before the major industrialization drive of the 1890s.[6] Among merchants and artisans, the Old Believers were well represented. There were sizable Old Believer colonies in and around Moscow, in contrast to St. Petersburg, which Old Believers avoided like the plague.

As one would expect, a much higher proportion of the Petersburg population consisted of civil servants and the military. One should add to this a cosmopolitan cast—only 85 percent of the Petersburg population consisted of Great Russians. Not that the rest were all "foreigners"—along with the foreign residents, there were other peoples of the Russian Empire, especially from the Baltic. The cost of living in Petersburg had always been high relative to Moscow, and during the first half of the nineteenth century the cost of living doubled, making residence in Petersburg on a "Russian noble" scale truly an extravagance.[7]

Anyone who has read a Russian novel knows that St. Petersburg had the worst climate in the world, and that it was, during the nineteenth century, a kind of capital of tuberculosis—that symbolic disease against the romanticization of which, along with cancer, Susan Sontag has recently released the full power of her literary indignation.[8] Moscow's depredations from cholera in 1830 and 1848 have, however, left no comparable literary trace. The bad climate, the far northern location with its tricks of light (long hours of winter darkness and summer light, including the "white nights"), the periodic floods, the watery setting provided by the gulf, the five rivers, and the canals—the element of dream, revery, and hallucination—have entered into the stuff and substance of Russian literature. In the midst of this "natural" setting, there is a certain appropriateness to the nature of the city itself, which Dostoevsky called "the most intentional [*umyshlennyi*] city in the world,"[9] with its aspirations to symmetry and uniformity, its angular streets and deliberate perspectives, its "architectural ensembles" and immense squares, its horizontality, its lined-up façades, its stone and stucco buildings, its rococo parks, palaces, and government offices, its monuments and ornaments (four equestrian statues, including the famous Bronze

Horseman, by the end of the nineteenth century, where most European capitals had one or two; the horses rampant, the griffons, lions and eagles, all symbols of political power), and above all its *foreignness,* into which the *style russe* of the Church of the Blood, commemorating the assassination of Alexander II, was introduced as a kind of Disneyland old-Russian exoticism.

Moscow, on the other hand, has a relaxed, unbuttoned amplitude. It is *"bol'shaia derevnia,"* an overgrown village. There is no clear pattern to the streets, though the tendency is toward concentric rings with the Kremlin and Red Square at the center. The jackdaws sit on the crosses in the churchyards. The houses are largely dark and wooden, especially in *Zamoskvorech'e.* It is a "family" kind of place, and the accent is on domesticity. It is the marriage mart for daughters of the landed nobility (it was here that Pushkin's heroine and muse, Tatiana Larina, was brought by her family after her unhappy involvement in the countryside with Evgenii Onegin, to be married off finally to the old general who whisked her off to Petersburg). *Bol'shoi svet*—high society—exists much more on a family basis; there is no public world around which it can organize itself. The accent is on private life, the inclination inward. The houses have fences or walls around them; they are walled in, in the oriental manner. There are no cafés; life is lived not in the streets but at home. There are myriads of churches and churchyards, and though some, like those within the Kremlin walls, were designed and built by Italian architects, their style is in the Russian manner and redolent of old Rus'. Parks and palaces exist, but they are not lined up in massive ensembles. Everything runs higgledy-piggledy.

Moscow as a cultural symbol is the ideological home of the Slavophiles. It is linked to the past. Although some of its monuments are not very old, like the statue to Minin and Pozharsky in Red Square, it commemorates the patriotism of the seventeenth century that saved Moscow from the foreign invader during the Time of Troubles. Although much was lost in the fire of 1812, some buildings and monuments that linked the nineteenth-century city with the medieval past remained, and then there was the memory of the Napoleonic occupation itself—Rostopchin's speeches, the emptying out of the city, the great fire.

Most characteristic were the churches—at least one for every day of the year—and the ringing of the church bells. For the Slavophiles, Moscow was also a center of the church's activity, and reminiscent of the role Orthodoxy had played in Russia's past. It was the home of the Metropolitan of Moscow—for a good many years, the formidable Filaret—and not only did its churches and monasteries look like Russian religious establishments were supposed to look, but also it was a

constant reminder of the merging of religion with policy, of a supreme political role the church might yet play in Holy Russia.

Slavophile ideology doted on the family, too. Not only were the Slavophiles bound together as a group by close ties of kinship, but the family and the clan were central to their thinking. Scions of traditional Russian landowners, with estates in the heartland of Russia and houses in Moscow, they looked back on the old *dvorianstvo* (the Russian gentry) as a *rod* or clan, or a group of closely linked clans, and contrasted the family ways of the *rod* (as in *rodina*, or native land), with its warm, spontaneous patriarchal ways, to the cold and inhuman legal-bureaucratic, rigidly hierarchical administrative systems associated with the West. Some of the Slavophiles, like Khomiakov, were learned in the law, and some, like Samarin, were experienced and effective administrators. "Hierarchy" and "rationalization," rather than "law" or "administration," were the keys to their dislike of Petersburg—these elements were tokens of its foreignness, exemplifying the imported flavor of the central administration, in contrast to the spirit of *sobornost'*, or communality, that characterized the idealized institutions of their beloved Rus'. For the Slavophiles, the patriarchal-familial spirit of old Rus' had its capital in Moscow.[10]

Traditional, patriarchal customs, like the wearing of the beard, persisted in Moscow to a much greater degree than in Petersburg, which, with its male population of civil servants, soldiers, foreigners, and court followers, tended to be clean shaven or fashionably mustachioed. Above all, the merchants and artisans of *Zamoskvorech'e* sustained the wearing of the beard and traditional Russian garb. Apollon Grigoriev, not exactly a Slavophile, but like one an admirer of Moscow, sang praises too of the old Russian ways and dissoluteness—gypsies and the seven-stringed guitar. Aleksandr Ostrovsky, a severe moral critic of the obscurantism and tyranny often manifest in the ways of *Zamoskvorech'e,* nevertheless chronicled and dramatized those ways with poetic love of detail and a certain loyalty. Dostoevsky, on the contrary, though close to the spirit of the Slavophiles in many ways, and clearly regarding Petersburg as the Babylon of uprooted intellectuals and romantic dreamers, never seriously considered living anywhere but on the Neva.

For the Slavophiles, Moscow provided not only a link with the past, an idealized church-family town where they could link past and future in their vision of Russian national destiny, but also, in practical terms, a sanctuary. The Muscovite institutions that served them in this regard were the university and the Archives of the Ministry of Foreign Affairs. The latter provided them with a way of earning a living that did not require their presence in St. Petersburg. The university was the oldest and best in Russia and provided an atmosphere of learning and intellec-

tual intercourse that was both a good deal freer and less shallow than that of its counterpart in Petersburg.[11]

More than three decades before the Slavophiles "discovered" Moscow, and even before the French invasion, the poet-classicist Konstantin Nikolaevich Batiushkov, a preromantic steeped in Mediterranean culture, wrote his "Stroll About Moscow" (1811). This essay assumes the form of a letter written to a friend, accommodating random observations, descriptions, and comments on local customs in a fairly common form for the description of the life of a city. It begins with a description of the city in the late afternoon sun, as seen from the Kremlin. "He who stands in the Kremlin and can look out with cold eyes upon the gigantic towers, upon the ancient monasteries, upon magnificent *Zamoskvorech'e* without taking pride in his fatherland and without blessing Russia for it (and I say this boldly) is alien to all that is great, for he has been sadly deprived by nature from his very birth." In addition to the grandeur of the monuments and the view, there is the *representativeness* of Moscow, and for "representative" one may read as well "symbolic." Moscow symbolizes Russia. "Moscow is a signboard or an animated picture of our fatherland." Not only are there "crowds everywhere," but the crowds and the scenes display an extraordinary variety and the most dramatic contrasts.[12]

Descriptions of the variety and contrasts of big city life were to become a *topos* on nineteenth-century fiction and poetry. One thinks of E.T.A. Hoffmann's "Des Vetters Eckfenster," Poe's "Man of the Crowd," Gogol's "Nevsky Prospect," and the famous description of early morning St. Petersburg in the first canto of Pushkin's *Evgenii Onegin*—the latter two indicating that in Russian literature such descriptions were to become far more typical of Petersburg than of Moscow. Indeed, contrast and variety were *topoi* of metropolitan description even in the eighteenth century. Some of the contrastive pairings might occur in the context of a description of any large city—rich and poor, for instance, or new and old—yet some have a Muscovite-Russian particularity that is worth dwelling on:

A strange mixture of the ancient and the most modern buildings, of poverty and wealth, of European morals with the morals and customs of the orient! An amazing, incomprehensible confluence of superstition and vanity, and real glory and magnificence, of ignorance and enlightenment, of humaneness and barbarism. . . . Look: here, opposite the gap-toothed towers of ancient *Kitai-gorod* stands a charming home in the most recent style of Italian architecture. Into that monastery, built in the reign of Aleksei Mikhailovich, there enters a certain man in a long caftan, with a full beard, but there towards the boulevard, someone is making his way in a fashionable dress-coat. And I, seeing the traces of ancient and modern times, re-

membering the past, comparing it with the present, say quietly to myself:
"Peter the Great accomplished a lot, but didn't finish anything."[13]

While Petersburg was to be viewed by some as insubstantial, hollow,
an "unreal city," it never suggested to a writer that Peter the Great
"didn't finish anything," although Belinsky did point out that "any one
of Peter's successors might have condemned Petersburg to death."[14]
And it becomes clear from the rest of Batiushkov's essay and his major
emphasis that what he has in mind here that Peter "didn't finish" is less
in the realm of architecture than in that of manners and morals.

The essay contains a series of satirical sketches, some of them verging
on the grotesque, that form an interesting link between the works of
eighteenth-century satirists like Fonvizin and Aleksandr Sergeievich
Griboedov's masterpiece, "Woe from Wit," also set, and not by chance,
in Moscow. The subject may be the standard stock-in-trade of the
satirist: an affectation to refined (or fashionable or foreign) manners,
overlying an absence of morality, a cupidity, greed, and selfishness, bar-
baric appetites that are tokens not so much of the "old ways" as of a
kind of Levantine uprootedness, a moral never-never land. The country
bumpkin, investing his passion and his purse in the merely modish, in
the superficial emblems of foreign taste, the nobleman who pretends to
high culture while his acts betray his heartlessness and indifference to
those around him, the careerist who pursues his way up the ladder of
success with the most barbarous indifference either to duty or to what
lies humanly in his way—the discrepancy between manners and morals
becomes part of the Moscow literary setting. Batiushkov and
Griboedov, who were in hostile literary camps and professed to dislike
each other, each lighted instinctively on this theme. It was Aleksandr
Ostrovsky who later in his plays created the Muscovite type of the
samodur, the patriarchal domestic tyrant who, basing himself in
obscurantist fashion on the traditional ways of old merchant Russia, at-
tempted to extinguish "the ray of light in the kingdom of darkness."[15]

Three years after his "Stroll about Moscow," Batiushkov wrote "A
Stroll to the Academy of Fine Arts," a sketch composed in the same
format but set in St. Petersburg. It may be one of a number of
Petersburg sketches by Batiushkov, but it is the only one that has sur-
vived. Whereas the Moscow sketch stresses the coarseness of Musco-
vite manners and *byt* (everyday life), its Petersburg twin focuses on
esthetics—esthetic theories and criteria relevant to the Academy of
Fine Arts but also the esthetic splendor of Peter's city itself. For, while
in his private correspondence he sometimes complained of the hard-
ships of Petersburg ("It is an abyss that swallows up everything," he
wrote his sister about the cost of living there[16]), in his formal work, he

was the city's (and its founder's) panegyrist. Peter, he wrote, "having held the fate of half the world in his hand, took comfort from this great thought, that on the shores of the Neva, the tree of science would flourish hard by the vestibule of his power, and that sooner or later it would bring forth new fruits and mankind would be enriched thereby."[17] In general, it was Peter's activity on behalf of high culture, and the esthetic purity of Petersburg, in contrast to "ancient Paris" or "smoke-dimmed London"—its purity of style as the setting of progress—that Batiushkov admired. "Whoever's not been in Petersburg for twenty years will certainly not recognize it," he wrote. "He will see a new city of new people, new customs, new morals." Or, again: "How many wonders we see before us, and wonders created in so short a time, a century—in one brief century!"[18]

If the Slavophiles, from their point of view of proper Russian piety, tended to see Moscow as Jerusalem and Petersburg as everywhere betokening the city of the Antichrist, the Westernizers clearly preferred Petersburg, though with varying emphases, and for somewhat different reasons. Batiushkov, who long preceded the Westernizer-Slavophile controversy (belonging in its first form to the 1840s) may in a certain sense be said to have been a Westernizer, and with him it is "taste," esthetics, and its relationship to manners, and more profoundly to manners and morals, that inclined him to Petersburg, though he signed himself "a Muscovite." Both Aleksandr Herzen and Vissarion Belinsky, for somewhat different reasons, both preferred Petersburg, though Belinsky, with an odd twist for a Westernizer, makes a remarkable effort to redeem Moscow, while Herzen's preference for Petersburg is couched in his most sardonic manner.

While there is nothing original in Petersburg, Herzen writes, in Moscow, "everything, from the stupid architecture of St. Basil's to the taste of kalachi," is of extreme originality. Petersburg differs from the other cities of Europe only in that it is like *all* of them, and even the Russian churches there "have a Catholic look about them."[19] In Moscow, however, "you hear Orthodoxy in its copper voice." And, yes, there is something Babylonian, or at least Romish, in the Slavophile-apocalyptic sense, about Petersburg. It is in this sense that Briullov's famous painting of *The Last Day of Pompeii,* with its "terrible image of a mute and savage power that is ushering in destruction upon people" (cf. Bowlt, fig. 6.3), has something "Petersburgian" in its inspiration. "Nowhere," Herzen writes,

have I had so many doleful thoughts so often as in St. Petersburg. Oppressed by heavy doubts, I used to wander along its granite and was close

to desperation. I am obliged to Petersburg for those moments, and I have loved it for them, just as I have ceased loving Moscow for the fact that it does not even know how to torment and oppress. Petersburg will prompt any honorable man to curse this Babylon a thousand times. In Moscow, you can live for years and, except for near the Uspensky Cathedral, never hear an oath. That is why it is worse than Petersburg.[20]

The joy of Petersburg, in other words, is that it incites to rebellion, whereas for a well-heeled Moscow nobleman, that old Russian city whispers only peace and acquiescence, and for that, the revolutionary Herzen hates it. In his memoirs, written much later, Herzen also acknowledged the worth of the relative latitude and freedom of expression in the noble-intellectual salons of Moscow, the Slavophile sanctuary. Undoubtedly he felt more at home there.

Belinsky, on the other hand, while redeeming Moscow, indicates clearly why he prefers to reside in Petersburg. He writes a fine appreciation of Moscow's quaintness and domesticity, its "impulse to family comfort," its crooked and narrow streets, its "patriarchal family life," and its fenced-in, huge courtyards overgrown with grass and surrounded by outbuildings:

> The poorest Muscovite, if he's married, cannot go without a storage-cellar. If he rents an apartment, he worries more about the cellar where he'll keep his food supply than about the rooms where he'll live. . . . Or his own little house may be a hovel, but he will have his own yard, a few chickens, maybe a calf. The main thing is still the cellar. One finds such houses even on the best streets in Moscow. And one finds fine houses even on the worst streets. Anyone who has lived in Petersburg is as astonished by Moscow as a foreigner would be.[21]

Family ties are of the essence. Everyone has relatives, and the Muscovite has to remember the birth- and name-days of a hundred and fifty people. Moscow has an aristocratic character, established by the dignitaries who fled the rigors of Peter's presence and enhanced during the "golden age" under Catherine. Entertainments are lavish, and on the scale of the Thousand and One Nights.

Oriental splendor has its counterpart in a certain oriental somnolence and inwardness, with the emphasis more on comfort than on splendor or taste, even in the "great houses." Everyone, Belinsky writes, "lives in his own yard and walls himself off from his neighbor"—curtains on the windows, gates locked, a chained watchdog, everything somnolent; a fortress prepared to withstand a long siege, yet with the accent on family life everywhere, and the city as such almost invisible. Remarking on the splendid views, Belinsky introduces yet another comparison rem-

iniscent of the Middle East: "If there were minarets instead of churches, one might think oneself in one of those oriental cities that Scheherazade used to tell about."[22]

Not all of Moscow, for Belinsky, is backward-oriented. He does point out that the city's outskirts are surrounded by mills and factories that supply all of Russia with cloth. Since Moscow is centrally located, and railroads in Russia a thing for the future, Petersburg cannot compete. Here, little by little, Belinsky sees the spirit of the new stirring.

He dwells also on the university, Russia's oldest and best. Thus, the Petrine reforms have made Moscow at once "Oxford, Manchester and Rheims."[23] Scholarship, art, literature, education—in all of these Muscovite taste is superior. There is more space in which to grow. Yet promising young people either leave Moscow or lose their promise. Petersburg is the only arena for action, even literary action. In Moscow, the "talk about literature" is better than anywhere else, but they do not produce any there.

Petersburg, for better or for worse, is a city, while Moscow is not. The Petersburger rarely knows or cares who lives beside him. All are occupied with their own affairs. The street and public places, on the other hand, are alive in Petersburg as they are not in Moscow. And news matters. In Moscow, *Moskovskie vedemosti* comes out three times a week, and the Muscovite subscriber will pick up all three on Saturday—something unthinkable in Petersburg.[24] For the Muscovite merchant, a stout and stately horse and a stout and stately wife are the greatest blessings life has to offer. Petersburg, on the other hand, is always concerned with the fine points of tone and manner. Petersburg merchants are very different from their Muscovite counterparts. The mixing of European and Russian dress so often practiced by Moscow women would seem out of place in Petersburg. The Petersburger talks seriously only about "the service." The Muscovite, on the other hand, tends to think that the more serious man is, the less he talks in general, and the happier he is. In Moscow, the officials are still *prikaznyi*—in appearance, that is to say, there is nothing at all "official" about them. Petersburg, true to its concern for mode and style, true to its seriousness about officialdom, takes great pains to appear official even when it is not.

Petersburg has no "historic" monuments, yet it is in itself a monument, more like the cities of North America than like Moscow. Russian development is quite contrary to the European; that is, it proceeds from the top down, not from the bottom up. The *surface* has a much higher significance, a greater importance, than is commonly believed. In this sense, Petersburg cannot be dismissed as "superficial" or "hollow." Lomonosov imitated foreign modes, but Lomonosov led to Pushkin.[25]

It *appears* foreign and superficial, like the wearing of Western clothes, and there is struggle against it. Yet everything that lives is the result of struggle. And why is it, Belinsky asks, "that the only people in Russia who study anything, who read, who have a taste for the fine arts, dress in the European fashion?"[26] Petersburg is a model for all of Russia in everything that has to do with "form," from fashion and social tone to ways of piling bricks, to the finer points of architecture, from typographical fine points in printing to the substance of the Petersburg journals, which, for better or for worse, are the only ones in Russia that hold the public's interest. Above all, Petersburg demands action. "Petersburg," Belinsky concludes, "is fated always to work and do; and Moscow, to educate the doers."[27]

In nineteenth-century European fiction, the great metropolitan city is the magnet for the ambition of characters who tend to mirror the biography of Napoleon—i.e., the gifted provincial who arrives there to enact his dreams, his "great expectations," like Dickens's Pip or Balzac's Rastignac, only to find himself caught in the vanity of vanities, the pursuit of a will-of-the wisp whose substance becomes the more elusive as its outward glitter becomes more intensely present. As a scene for the realization of the ambitions of the provincial fledgling, Moscow plays scarcely any role at all in classical Russian literature. For the golden age of the Russian novel, Moscow, in this properly literary sense, is not a city at all. St. Petersburg is the only real city.

There all the standard themes are enacted: ambition fulfilled and unfulfilled; dissociation of sensibility; intellect and affect running different ways; schizophrenia; hallucination; talent corrupted and innocence led astray; mysterious underground networks that parallel the labyrinth of streets; bodies and souls bought and sold; the whore with a heart of gold and the golden beauty with the heart of a whore; the parade of contrasts—rich and poor, innocent and corrupt, old and new, beggar become king and king turned beggar. Moscow, on the other hand, remains, like the countryside, a family locale.

In almost every novel, story, and poem of major significance in Russian literature written from the 1830s on, whatever the theme, whatever the characters, whatever the particular talent of the author involved, the character of Petersburg remains remarkably the same. It is Babylon. It is a place whose role in cosmic history is clearly to be subsumed, the city of the Apocalypse, hollow and empty for all its outward splendor, the city of the Antichrist.

In the eighteenth century, on the other hand, at least as far as formal, printed literature is concerned, St. Petersburg was the very promise of heaven. From Buzhinsky, who wrote the first formal ode to St.

Petersburg still in Peter's lifetime, in 1718, to the spendid poems of Derzhavin celebrating "Felitsa" and her capital city, the *topoi* of such poems became quite standard, very much in the spirit of the *laudes Romae* of the Latin poets, and their Latin and vernacular imitators throughout the Middle Ages, though with one or two distinctive touches.[28] The city was a triumph of nature and art, a tribute to its founder, whom it personified. Where once there had stood an empty wilderness, now half the world came to pay tribute. Where once there had been an empty swamp, now proud palaces greeted the eye. Et cetera.[29]

The oral and manuscript folk literature contained quite a different picture of St. Petersburg, however. There the curse of Peter's first wife, shut up by him in a nunnery, that "Petersburg be empty," found its echoes and elucidations. The whore of Babylon, city of the Antichrist, place of the last end, curse of Satan: a haunted, illusory, hallucinated place, vanity of vanities, destined to vanish in smoke, or (more appropriately perhaps) under the wave. St. Petersburg is haunted by the political trial of the Tsarevich Aleksei, who died in the Peter-Paul fortress under torture, under suspicion of having taken up his mother's curse on Petersburg and of having conspired and consorted with those among the clergy and nobility who resisted the Petrine reforms.[30]

With Pushkin as a kind of transitional figure, and from the time of the appearance of Gogol's Petersburg stories, the printed literature takes up the folk motif and sustains it through the period of the symbolists, or at least until the turn of the twentieth century, when a new notion, introduced first through criticism of the architectural and visual arts, suggests not so much the negation of Babylon as the presence in Babylon of a certain cultural depth, richness, solidity—a dimension of human life that is to be respected and valued.

Perhaps the most startling turn that has taken place is a recent one. I would like to end by calling attention to a prose-poem written by Solzhenitsyn in the 1960s, called "City on the Neva." Aleksandr Isaevich Solzhenitsyn is considered by many, and I think to a large degree rightly, to be a Slavophile, and therefore one who might be expected to treasure Moscow for its traditionalist, conservative, religious, patriotic associations, and to despise St. Petersburg. It should be pointed out that Solzhenitsyn, who is from Rostov and native to neither city, visited Leningrad, from Moscow, probably for the first time shortly before he wrote this piece. In good Slavophile tradition, what appeals to Solzhenitsyn is that Leningrad, unlike Moscow, has *not* changed: "What a blessing that no new building is allowed here. No wedding-cake skyscraper may elbow its way onto the Nevsky Prospect, no five-story shoebox can ruin the Griboyedov Canal. There is no architect living, no

matter how servile and incompetent, who can use his influence to build on any site nearer than the Black River or the Okhta." What of its foreignness? "It is alien to us, yet it is our greatest glory! . . . All this beauty was built by Russians—men who ground their teeth and cursed as they rotted in those dismal swamps. . . ." It is suffering that somehow redeems the "city built on bones," that somehow makes of it a capital again, symbolic of the country as a whole: "And what of our disastrous, chaotic lives? What of our explosions of protest, the groans of men shot by firing squads, the tears of our women: will all this too—terrible thought—be utterly forgotten? Can it, too, give rise to such perfect, everlasting beauty?[31] The spiritual capital and the seat of power have changed places now; they are still not one.

NOTES

1. Joseph Rykwert, *The Idea of a Town: The Anthropology of Urban Form* (Princeton, N.J.: Princeton University Press, 1976); Lewis Mumford, *The City in History* (New York: Harcourt, Brace, 1961), especially chapter 12; Mircea Eliade, *Cosmos and History: The Myth of the Eternal Return* (New York: Harper Torchbooks, 1954).

2. N. V. Gogol, "Petersburg Notes for 1836," quoted by V. G. Belinskii, *"Peterburg i Moskva"* ("Petersburg and Moscow"), in *Polnoe sobranie sochinenii* (Complete Collected Works; hereafter cited as *PSS*), vol. 8 (Moscow: Akademia Nauk, 1955), p. 411.

3. *Ocherki istorii Leningrada* (Essays on the History of Leningrad), vol. 1 (Moscow-Leningrad: Akademia Nauk, Institut istorii, 1955), pp. 506–49; *Istoriia Moskvy v shesti tomakh* (History of Moscow in Six Volumes) (Moscow: Akademia Nauk, 1952–57), vol. 3, pp. 43–46, 292–306, vol. 4, pp. 161–73.

4. *Ocherki istorii Leningrada*, vol. 1, pp. 447–505.

5. N. K. Antsiferov, *Peterburg Dostoevskogo* (Petrograd: Brokgaus-Efron, 1923).

6. *Istoriia Moskvy*, vol. 3, pp. 198–230.

7. *Ocherki istorii Leningrada*, p. 509.

8. Susan Sontag, *Illness as Metaphor*, (New York: Farrar, Straus & Giroux, 1978).

9. The familiar phrase about Petersburg is from *Notes from Underground*. On the imperial sculpture of St. Petersburg, see V. V. Nesterov, *L'vy steregut gorod* (Lions Watch the City) (Leningrad: Khudozhnik, RSFSR, 1972).

10. On the Slavophiles, see Nicholas Riasanovsky, *Russia and the West in the Teaching of the Slavophiles* (Cambridge, Mass: Harvard University Press, 1952); Abbott Gleason, *European and Muscovite* (Cambridge, Mass: Harvard University Press, 1972); S. Lukashevich, *Ivan Aksakov, 1823–1886* (Cambridge, Mass: Harvard University Press, 1965); P. K. Christoff, *An Introduction to Nineteenth Century Russian Slavophilism* (The Hague: Mouton, 1961); A. Gratieux, *Le mouvement slavophile* (Paris: Congar, 1953).

11. *Istoriia Moskvy*, vol. 3, pp. 478–502.

12. K. N. Batiushkov, *Sochineniia* (Works) (Moscow: Izd. Khudozhestvennoi Literatury, 1955), pp. 308–309.

13. Ibid., pp. 307–308.

14. Belinskii, *PSS*, vol. 8, p. 388.

15. This is the title of one of Ostrovsky's best-known plays.

16. Batiushkov in a letter to his sister, April 18, 1810, quoted by N. V. Fridman, *Prozo Batishkova* (Batiushkov's Prose) (Moscow: Nauka 1965), p. 109.

17. Quoted by Fridman, *Proza Batiushkova*, p. 107.

18. Ibid., p. 111.

19. A. I. Gertsen, *Sobranie sochinenii v tridtsati tomakh* (Collected Works in Thirty Volumes) (Moscow: Akademiia Nauk, 1954), vol. 2, p. 37. In *My Past and Thoughts: The Memoirs of Alexander Herzen* (New York: Alfred A. Knopf, 1968), vol. 2, pp. 389–425, Herzen is much kinder to Moscow, and appreciative of the relatively free spirit of its aristocratic tradition.

20. Ibid., p. 41.

21. Belinskii, *PSS*, vol. 8, p. 390.

22. Ibid., p. 391.

23. Ibid., p. 405.

24. Ibid., p. 398.

25. Ibid., p. 395.

26. Ibid., p. 396.

27. Ibid., p. 413.

28. Ernst Robert Curtius, *European Literature and the Latin Middle Ages* (London: Routledge & Kegan Paul, 1953), pp. 157–59.

29. See N. K. Antsiferov, *Dusha Peterburga* (The Soul of Petersburg) (Petrograd: Brokgaus-Efron, 1922; reprinted Paris: YMCA Press, 1978).

30. See the haunting twentieth-century novel on this subject by Dmitry Merezhkovsky, *Peter and Alexis* (New York: Putnam, 1906).

31. Alexander Solzhenitsyn, *Stories and Prose Poems* (New York: Farrar, Straus & Giroux, 1974), pp. 252–53.

3

On the Russianness of the Russian Nineteenth-Century Novel
Donald Fanger

THE VOGUE of the Russian novel in the West began nearly a century ago and reached its apogee in the years following the First World War. That it rested on an impression of radical novelty (most often construed as the artless expression of a mutant "Slavic soul") may be sufficiently indicated by a few quotations.

Here is Max Beerbohm on the genius, "national and also universal," of his composite writer, Kolniyatsch:

> I say that Kolniyatsch's message has drowned all previous messages and will drown any that may be uttered in the remotest future. You ask me what, precisely, that message was? Well, it is too elemental, too near to the very heart of naked Nature, for exact definition. Can you describe the message of an angry python more satisfactorily than a *S-s-s-s?* . . . First and last, he was an artist, and it is by reason of his technical mastery that he most of all outstands. Whether in prose or in verse, he compasses a broken rhythm that is as the very rhythm of life itself, and a cadence that catches you by the throat, as a terrier catches a rat, and wrings from you the last drop of pity and awe.[1]

That, of course, is parody, but its terms are uncomfortably close to those used by Emile Hennequin in 1889 to describe his countrymen's astonishment at the novels of Dostoevsky. French readers, Hennequin reports, "recognized in these rough [*frustes*] books the supreme gift of arousing new emotions; they sensed in them a soul savage and sombre interpreting the spectacle of life and the agitation of souls in sensations that were primitive or barbarously [*sic*] subtle." Dostoevsky, "that obscure and Slavic soul," presented characters who were "carnal, wild, violent, brutal, and unintelligent [!]"—qualities that were "latent in

[the] rough nature, more animal than spiritual," of the author, who all the same contrived somehow to produce works "which are more treatises on ethics and on humanity than interesting novels"![2] The critic himself here seems to exemplify the condition of Dostoevsky's French reader at the time: "You read, panting, distracted, unable to analyze or reflect—to such an extent does this monstrous world seize and *grip* you."[3] That viewpoint is still to be met with. Thus the current (1973) edition of *Cassell's Encyclopedia of World Literature* continues to characterize Russia's contribution to the novel by declaring: *"not only was the country not normal, but the heroes of the novels were not normal either:* the brothers Karamazov or the prince of *The Idiot* could not be said to represent human nature. . . . In a way, a kind of superhuman power in the construction of character put both Tolstoy and Dostoevsky's creatures outside the novel proper . . . although no one can say to what world they belong."[4]

Even writers more scrupulous and sympathetic have felt impelled to use similar language. Thus the Vicomte de Vogüé—whom Edmund Wilson credits with offering the first serious presentation of Russian literature to the West—introduced Dostoevsky by exclaiming: "Here comes the Scythian, the true Scythian, who is going to revolutionize all our intellectual habits."[5] Vogüé, in the words of one commentator, "loved the Russian novel doubly, first for itself and then as opposed to the French novel" of his time, whose realism, in his view, left no room for the "animating breath" of spirit.[6] Something of the same might be said of Virginia Woolf, whose hortatory praise makes use of a like vocabulary:

> Indeed, it is the soul that is the chief character in Russian fiction. Delicate and subtle in Tchekov, subject to an infinite number of humours and distempers, it is of greater depth and volume in Dostoevsky, liable to violent diseases and raging fevers, but still the predominant concern. Perhaps that is why it needs so great an effort on the part of an English reader to read *The Brothers Karamazov* or *The Possessed* a second time. The "soul" is alien to him. It is even antipathetic. It has little sense of humour and no sense of comedy. It is formless. It has slight connection with the intellect. It is confused, diffuse, tumultuous, incapable, it seems, of submitting to the control of logic or the discipline of poetry. . . . Moreover, when the speed [of fictional events] is . . . increased and the elements of the soul are seen, not separately in scenes or humour or scenes of passion as our slower English minds conceive them, but streaked, involved, inextricably confused, a new panorama of the human mind is revealed.[7]

One might easily extend the list of such comments to include those of D. H. Lawrence, who found the secret of Russian fiction to lie in "the phenomenal coruscations of the souls of quite commonplace people";

Matthew Arnold, who denied that *Anna Karenina* was literature at all, declaring it to be rather "Life"; Thomas Mann, who echoed Arnold in more measured terms; and many others who have tried to account for the impact of this extraordinary fiction. "But," as Virginia Woolf notes in the closing lines of her essay, "the mind takes its bias from the place of its birth, and no doubt, when it strikes upon a literature so alien as the Russian, flies off at a tangent far from the truth."[8] What, then, have Russians had to say on the subject?

Of all those who addressed the question at the close of the nineteenth century, the indefatigable scholar Semyon Afanas'evich Vengerov (1855–1920), in Beerbohm's phrase, most outstands. A preliminary essay on "The Fascination of Russian Literature" (1911) argued that Russian realism differed from that of the West chiefly because Russia had no dominant bourgeoisie; thus one of the central themes of Western fiction, the pursuit of success, occupies the most minor of places in Russian writing, Russian characters being more concerned with making a life than with making a living. Russian literature, Vengerov observes, treats the theme of personal happiness as being "either criminal, if it is achieved at the expense of others, or, in the best of situations, vulgar."[9] In his view the quest repeated in the great Russian novels takes place on a higher level, which accounts for the particular tonal range they evince:

> The psychology of renunciation, of voluntary asceticism, the refusal of a bourgeois [*meshchanskii*] world, gives grounds for a particular self-respect and emotional satisfaction. But, naturally enough, this cannot create joyful moods. Hence another source of the fascination of nineteenth-century Russian literature, which I would term its Great Sorrow.

The Russian spirit tends to create "the mournful type of beauty": "The Russian literary genius can be concretely imagined only as being stern-featured, with eyes feverishly directed into the mystical distance."[10]

Vengerov's book of 1911, *The Heroic Character of Russian Literature,* is even more clearly a piece of lofty special pleading, equally remarkable for what it conveniently leaves out of consideration and for what it proclaims but cannot demonstrate.[11] The Russian novel is portrayed there as an instrument of moral education, a source of inspiration for the pursuit of liberty, equality, fraternity, justice, and soulfulness. In Vengerov's work, as in a spate of fairly recent Soviet works on the distinctive national quality of Russian literature,[12] one finds a more consistent tendency to indulge in collective self-congratulation (and to use the nineteenth-century novel as a stick for flogging "modernism")

than to pursue serious critical argumentation. Surveying such material prompts a suspicion that the question of what is Russian about the Russian novel is an essentially procrustean one, asked most often by those who have not only a special reason for asking but an answer already in mind—and that it may be, if posed in an objective spirit, fundamentally intractable because it fits no discipline.

It does, however, border on many, the most important of which is cultural history. One can speak fruitfully and concretely about the peculiar nature of the institution of literature as it developed, largely around the novel, in nineteenth-century Russia. One can register the conditions in which literature appeared, recalling the words of the minister of education, Uvarov, that "among the rights of a Russian subject, the right of written communication with the public is not included," the latter being "a privilege which the Government can grant and rescind as it sees fit."[13] One can chronicle the often incredible workings of the censorship, and speculate on what it did for the novel in Russia.

Here again the most famous formulation is Vogüé's, from the foreword to *Le Roman russe*. What is directly and publicly expressible in other countries in a variety of forms and circumstances, he finds, in Russia is funneled into imaginative literature: "Ideas pass only when concealed in the flexible threads of fiction; but there they all pass; and the fiction which shelters them takes on the importance of a doctrinal treatise."[14] There is surely a large truth here, but one that is easily misunderstood, for Vogüé's language suggests a full complicity, in which writers smuggle messages into their works and readers, so to speak, unwrap them. The radical critic and publicist Chernyshevsky (whom Vogüé echoes almost verbatim in the passage cited) had put the matter somewhat more clearly when he wrote that mid-nineteenth-century Russian literature "absorbs virtually the entire intellectual life of the people," adding that if English novelists, who might have expressed their social concerns in other forms, nonetheless chose to put them into their fiction, "then our fiction writers and poets must feel their responsibility in this regard a thousand times more strongly."[15] Here the emphasis falls more clearly (and unequally): it is the needs and preoccupations of a particular kind of reader which the writers *ought* consciously and on principle to serve.[16] This reader was in many ways the censor's twin; and though he was disposed to embrace what the latter wished to excise, he was no less avid in seeking it between the lines of novels and no less likely to make free with textual evidence in order to find it.

The rise of fiction in Russia, that is to say, went in tandem with the rise of a special readership, the *intelligentsia*—that self-conscious

minority of Russians who enjoyed the privilege of literacy and sought justification in seeing it as a means to the fulfillment of a moral duty. In Isaiah Berlin's phrase, these were "citizens of a state within the state, soldiers in any army dedicated to progress, surrounded on all sides by reaction."[17] It is their point of view which the leading critics molded and expressed, and generations of Russians were raised on it. Thus at the time of the First World War Ivanov-Razumnik, in his *History of Russian Social Thought,* could call Russian literature "the Bible of the Russian intelligentsia"—a position expressed no less memorably by the writer Korolenko, who identified his true homeland as "Russian literature first of all." Solzhenitsyn has a character echo this peculiarly Russian phenomenon by observing (in *The First Circle*) that "we have always looked upon a great writer as a second government" (*gosudarstvo:* literally, "state"), i.e., as a rival for the custodianship of truth and moral authority. Trotsky, true to this common view, gave it even broader expression by observing how, around the first third of the nineteenth century, "reality began to live a second life in Russia, in both the realistic novel and comedy."[18]

The traditional Russian reader, then, as a member of the intelligentsia, is responsible for the dominant view of the Russian novel in his own country and abroad. As critic he expressed it, as simple consumer he tended to confirm it. His reading and misreading habits, his assumptions, sensitivities, and blind spots constitute a subject at once crucial to an understanding of the special function of literature in nineteenth-century Russia and open to the kind of detailed empirical study it has yet to receive.

And yet, even if we had such a study, it would be more relevant to the reception and (albeit in lesser degree) to the production than to the products themselves of Russian fiction. For most of the major writers produced the better part of their art *in spite of* the censors and the civic-minded intelligentsia critics, complaining time and again of the bias and reductionism with which both groups read their work, the ease with which the primary complexities of literature got ignored in favor of its nonliterary relevance, real and putative. Thus Gogol, who first articulated the role of the writer in nineteenth-century Russia as moral authority, whose artistic and nonartistic writings alike went far toward catalyzing a national community, shared his dismay evenhandedly. Shortly before his death in 1852 he characterized the actions of the censorship as "enigmatic to the point where one begins willy-nilly to suppose it to be harboring some criminal intent and plot against those very regulations and that very policy by which (judging from its words) it purports to be guided."[19] But he suffered no less from the contention of ideological parties among his readers, each of which created its own

Gogol to further its own ends.[20] Dostoevsky was to echo this double
discomfort, wondering whether the censors who mutilated *Notes from
Underground* were not "in a conspiracy against the government," even as
he struggled against the radicals' reduction of art to an instrument of
direct propagandistic utility.[21] Similar testimony, with varying empha-
ses, can be found in Turgenev, Tolstoi, and Chekhov. It is summed up
in Tolstoi's insistence that "if I wanted to express in words all that I
meant to say through [*Anna Karenina*], I would have to write the same
novel I wrote, from the beginning."[22] What Tolstoi stresses here is the
irreducible complexity of the greatest realistic fiction, its enigmatic
purport—and, by implication, its *capaciousness* in the hands of its
Russian creators. This last in turn suggests a hitherto unstressed ap-
proach to the distinctiveness of "classic" Russian fiction, and one that is
all the more promising because it begins by respecting the centrality of
literary *art*.

An earlier Tolstoian text provides the clue. "What is *War and Peace?*"
he asks in the draft of a preface to that work:

> It is not a novel, still less an epic [*poema*], less still a historical chronicle.
> *War and Peace* is what the author wanted to and was able to express, in the
> form in which it got expressed. Such a statement of an author's disregard
> for the conventional forms of a work of art in prose might seem imperti-
> nent, if it were deliberate and if there were no examples. The history of
> Russian literature from the time of Pushkin on, [however,] not only offers
> many examples of such a deviation from European form, it does not pro-
> vide even a single example of the opposite. From Gogol's *Dead Souls* to
> Dostoevsky's *Dead House,* in the modern period of Russian literature there
> is not one work of art in prose even slightly better than average that could
> fully fit into the form of a novel, epic or story.[23]

In alternative drafts he elaborates the same point:

> The work offered here comes closest to being a novel or a tale, but it is not
> a novel, since I am utterly unable to set certain limits to my invented
> characters—e.g., a wedding or a death, with which the interest of the nar-
> ration would be cut off. I couldn't help thinking that the death of one
> character only stimulated interest in other characters, and a wedding more
> often than not seemed the beginning rather than the end of an interesting
> story. Nor can I call my work a tale, since I am incapable of making my
> characters act only for the purpose of proving or clarifying any single
> thought or complex of thoughts.[24]

> * * *

> Publishing the beginning of this work, I do not promise either a con-
> tinuation or an ending. We Russians, generally speaking, do not know how

to write novels in the sense in which that form is understood in Europe, and the work offered here is not a tale, since no single idea informs it, nothing is proved, no single event is described. Even less could it be called a novel, with a starting-point, a constantly complicated interest, and a happy or unhappy denouement, with which the interest of the narration is liquidated.[25]

Dostoevsky is on record with a similar point of view about the Russian avoidance of plot, and with a similar conclusion: "Our novelists are first of all poets, and novelists secondarily."[26]

For present purposes, these declarations are significant in three respects: (1) They stress the dignity of the novel, equal to that of poetry, as a vehicle of *artistic* expression, thereby stressing as well the primacy of esthetic ideas in the Kantian sense.[27] Moreover, they (2) call attention to the *formal eccentricity* of the Russian novel, as carrier of such ideas,[28] and (3) they make clear the shared sense of a striking historical continuity, i.e., a tight and conscious *tradition.* Elaborating on these points will allow us to avoid secondary questions involving the peculiar modes and social arrangements on which Russian fiction drew in the last century, and, without denying their importance, to concentrate on a more immediate one, which might be phrased as follows: *What literary features account for our sense, in the last, cosmopolitan quarter of the twentieth century, that the greatest names in nineteenth-century Russian fiction (Pushkin, Lermontov, Gogol, Dostoevsky, Turgenev, Tolstoi, Goncharov, Leskov, Saltykov, Chekhov) form a group easily distinguishable as such from their West European and American contemporaries?*

The answer, I would suggest, might be sought first of all in form, seen both as enabling factor and as the outstanding constant of the tradition in question. To the frequent complaints in the 1820s and 1830s that there was as yet no Russian literature worthy to stand as "an expression of a mighty and virile people," a response first appeared in the form of three masterpieces which together constituted the foundation on which the tradition was to rest.[29] Each of them stresses its generic anomaly—Pushkin's novel in verse, *Eugene Onegin* (1823–31); Lermontov's novel, *A Hero of Our Time* (1840), originally subtitled "A Composition"; and Gogol's *Dead Souls* (1842), whose subtitle, "Poema," dominated the title page of the first edition.

The nature of plot in *Eugene Onegin* is skeletal, to say the least; revolving around Tatiana's love for the title character, it is, up until the concluding chapter, built around three meetings, in none of which she is allowed to utter a word.[30] Moreover, the novel continues significantly beyond the climactic point at which this story is abruptly abandoned.

Here is stanza 48 of the last chapter in Charles Johnston's excellent translation:

> She went—and Eugene, all emotion,
> stood thunder-struck. In what wild round
> of tempests, in what raging ocean
> his heart was plunged! A sudden sound,
> the clink of rowels, met his hearing;
> Tatyana's husband, now appearing . . .
> But from the hero of my tale,
> just at this crisis of his gale,
> reader, we must be separating,
> for long . . . for evermore. We've chased
> him far enough through wild and waste.
> Hurrah! let's start congratulating
> ourselves on our landfall. It's true,
> our vessel's long been overdue.[31]

What follows is a series of stanzas in which the poet addresses his reader and speaks openly—as he has throughout—about the contrivance of what he calls this "free novel" (*svobodnyi roman*).

Until our own century, it was the habit of Russian critics either to concentrate their attention on the central characters or to emphasize the capaciousness of social observation in the novel's digressions. Thus G. A. Gukovsky echoes Belinsky's approach from a century before:

Already the very *quantity* of themes and materials from everyday life makes Pushkin's novel different in principle from the literature that preceded it. In *Eugene Onegin* there pass before the reader series of everyday phenomena, details descriptive of ordinary life, things, clothing, flowers, meals, customs, types, sketches relating to the aristocratic Petersburg intelligentsia of the early nineteenth century, to high society, to the Petersburg life of various classes, to Moscow and its traditional gentry ways, balls, literary men and so on; to the country—beginning with landowners and ending with peasant boys and girls, to provincial cities; in *Eugene Onegin* all regions and parts of Russia are shown, all the layers of its population [etc.]. . . . By the sweep of the material from life, custom, and history, *Eugene Onegin* really appears to us to be an encyclopedia of Russian life of the beginning of the nineteenth century.[32]

It remained for twentieth-century critics to elaborate a counterview by taking up Pushkin's concluding emphasis on his having created a "free novel." Thus to the notion of the work's being an encyclopedia of Russian life, the counterclaim has been that it could more properly be termed a *literary* encyclopedia, given the frequent discussions of prosaic and poetic genres, the mention of Russian and European writers, dead

and alive, and the inclusion in the text of Pushkin's own ideas and plans (not to mention the incorporation of his own creative autobiography). From this it follows that the nuance and complexity of a long prose novel are here transposed, the complex action occurring not so much between characters as between the author and his work, the author and his characters, the various levels of reality invoked, and the very elements of poetry and prose. The freedom to which Pushkin alludes, in this argument, is ultimately the freedom to move from level to level in accomplishing the transposition in question. And it involves a notion of character that is similarly open-ended: Pushkin's protagonists are not types but literary constructs that give the illusion of being psychic entities at once enigmatically individual and capable of continually surprising the reader through the revelation of new aspects of their being.[33]

The author's creative freedom, in other words, is manifested in the management of his narrative: in the downgrading of the role of story, in the construction of character, and in the open-ended shape of the completed work (which both denies and affirms its completion). The effect is an enhanced illusion of life, as Yuri Lotman has recently argued. The paradoxical strategy is "to overcome literariness as such"—by devising an artistic text (i.e., something organized) that would imitate nonartistic (i.e., unorganized) reality: "to create a structure that would be apprehended as the *absence* of structure."[34] The way to achieve this very difficult task lies in continually transcending structure by making it manifest and subjecting it to overt discussion, thereby baffling the reader's conventional expectations and giving the work "the character not only of a 'novel about people' " but of a "novel about a novel"—i.e., about writing a novel, reading a novel, and about the impulses and values that characterize both activities.[35] This amounts to an opening out into "real life," through the reader's involvement with an unusually complex experience provoked by the text, and with the architect of that involvement (in a whole series of roles).[36]

The achievement of Pushkin's novel was thus to accommodate an unprecedentedly broad spectrum of concerns, from specifically historical, cultural, and literary matters to questions of psychology, philosophy, and the problematics of creation itself. For this reason, *Eugene Onegin* has more than once been seen as containing in embryo the subsequent unfolding of the Russian novel.[37] One might say that Pushkin's historic achievement here proved paradigmatic because, by ignoring generic distinctions and by exploiting the advantages of both poetry and prose, it licensed maximalist ambitions in the next generations of Russian writers.

Gogol's *Dead Souls* is a case in point. There has been much discussion

of the fact that the basic situation for this novel was "ceded" to its author by Pushkin himself, but surprisingly little attention has been paid to the way Gogol's *treatment* of that situation betrays an incomparably more significant debt. Gogol advertises the novelty of his work by inverting the Pushkinian formula: where *Onegin* bore the subtitle "a novel in verse," the subtitle of *Dead Souls* astonished readers by insisting that Gogol's prose novel was in fact to be read as an epic (*poema*). A comic novel with a serious burden, built around the merest semblance of plot (which, upon inspection, vanishes to leave only a collection of miscellaneous details[38]), Gogol's work introduces the moralizing concern with "soul" into the Russian novel. Its overarching theme is the amorphousness, characterlessness, meaninglessness, and purposelessness of specifically Russian life in the first place, but also of life in general, as a challenge to the novelist. Thus *Dead Souls* abounds, like *Onegin* before it, in what are traditionally called lyrical digressions—though they are even less digressive (because there is less in the way of the story to digress from) than their Pushkinian counterparts. These switchings of level have two broad functions: they connect the apparently trivial narrative detail with categories of more obvious import, and they proclaim the difficulty and dignity of the writer's role in creating such a work. As in *Onegin,* the reader's vicarious experience—his reliving of the relations between characters—is less significant than his experience of the entire text as enigmatic exhibition and moral provocation. In the famous final paragraph, Chichikov's departing troika undergoes a visionary transformation to represent Russia as it races into the future, ending the book not with a resolution but with a cloudy series of rhetorical questions, a prestidigitator's triumph, as Nabokov calls it. Yet Dostoevsky could articulate what many sensed about the book: that it "overwhelmed the mind" with the most profound questions and "the most disturbing thoughts."[39] It did (and does) so, one must stress, precisely by the way it challenges the reader's expectations of what a novel should do and sets him in search of the elusive import of his experience.

To put it another way, *Dead Souls* parallels the achievement of *Onegin* by demonstrating the power of fiction as carrier of the most complex meaning. Beyond the telling of a story, each work, like an op-art painting, allows broad choice of organizing aspect. One can see the latter in form, in lyrical allegory, in texture and dynamics of narrative discourse, or in any of the explicitly discussed themes. All are plausible candidates for primary emphasis, though none is unequivocally dominant.

A Hero of Our Time offers yet another variant of the novel as puzzle and provocation, and betrays a similar debt to *Onegin.* This, as has been frequently remarked, is evident already in the name of the protagonist

and in the treatment of the central love relationship.[40] Constructed as a linked series of stories whose meaning is greater than the sum of its parts, Lermontov's novel is, like the two already discussed, a joining of fragments in which crucial information about the protagonist's life and background is omitted. For the rest, its novelty comes from the consistency of realistically complex psychological portraiture; the book is dominated by a passion for analysis. Indeed, it prefigures Dostoevsky with its claim that "passions are only ideas in the first stage of their development," and transforms current literary forms by making them not only subserve a single end—the tracing of one significantly enigmatic subjectivity—but represent as well a philosophical inquiry into the implications of extreme individualism, a life lived without a higher sanction.[41]

As for Dostoevsky, his links to all three of his great predecessors are direct and obvious. From Pushkin he takes the notion of "free" character, undetermined by past experience; from Lermontov he takes subtlety of analysis and the inseparable compound of idea and feeling, as well as the problematics of individualism. And his "polyphonic novel," as described by the Soviet scholar Bakhtin, might well be regarded as a transposition of the key traits of Gogolian narration from the level of representation to the level of the represented; thus Dostoevsky, effacing as far as possible the persona of the narrator, had his characters enact that orchestration of conflicting "voices" which the Gogolian narrator reserved to himself.[42] As in the novels of all three of his predecessors, there is in Dostoevsky's major works no final, privileged "word" by which to gauge the author's position on the issues in question. This may be seen already in the ruminations of the writer of *Notes from Underground,* and in the challenge to the reader with which they end; the cloudy furturity that hangs over the arbitrary termination of that work is also a feature of such later masterpieces as *Crime and Punishment* and *The Brothers Karamazov.*

It is from Pushkin, Gogol, and Lermontov that Tolstoi takes the license for his own kind of maximalism as novelist and his own analysis of the fluidity of character. He approaches literature, in the words of Boris Eikhenbaum, "as if there had never been any before, rising gradually from the area of self-observation to that of invention."[43] His first literary experiment, "A History of Yesterday," shows the process at work and contains the characteristic statement that for a proper analysis of the ostensibly unremarkable events of a single day, "there would not be enough ink in the world to write it or compositors enough to print it."[44] Each individual is portrayed by Tolstoi as a microcosm and at the same time as a potential center for an infinite network of relations; no phenomenon could be understood outside its place in a series of such

networks. Hence the great novels, *War and Peace* and *Anna Karenina,* rather stop than conclude, producing the effect of an art that works like nature (Matthew Arnold, Thomas Mann), an impression that "the world is writing, the world in all its variety" (Issac Babel)[45]—and so exemplifying in yet another way the structural principle first embodied in Pushkin's novel in verse.

I am attempting no more than to indicate some of the headings under which detailed examples of tradition at work—construed first of all in formal terms—might be elaborated. Other examples could be adduced, among them those of Turgenev, Goncharov, and Leskov—though current Western opinion, with varying degrees of injustice, tends to consider their novels as lesser phenomena alongside the giants mentioned above. But Western opinion does put Chekhov in the company of the greats, and it may be appropriate to end this survey by pointing to his place in the line I have been sketching. Chekhov comes out of Turgenev and Tolstoi, reacting against them and so establishing his right to stand in their company. His cultivation of the short-story form is part of that reaction. He replaces Turgenev's extended nature descriptions with a poetry of laconic notation;[46] he offers his version of the central situation of *Anna Karenina* within the confines of a single story, "The Lady with the Pet Dog," whose ending excludes any possibility of invoking generalizations about retribution (as Tolstoi had done with the epigraph to his novel):

> Then they spent a long time taking counsel together, they talked of how to avoid the necessity for secrecy, for deception, for living in different cities, and not seeing one another for long stretches of time. How could they free themselves from these intolerable fetters?
> "How? How?" he asked, clutching his head. "How?"
> And it seemed as though in a little while the solution would be found, and then a new and glorious life would begin; and it was clear to both of them what was to be most complicated and difficult for them was only beginning.

Tolstoi himself objected that these characters, "thinking that they have gone beyond good and evil, have actually remained this side of good and evil."[47] Judging Chekhov in terms of his own standards, of course, he missed the point. For Chekhov continues the tradition through his rejections—specifically, by cultivating his own radically unconventional form, which is to say, by denying the conventions of his predecessors in the interests (the same interests *their* new forms had served) of freedom to embody what he perceived as the most important truths. For Chekhov, too, makes maximalist demands on art in the service of some-

thing beyond it, though he expressed this maximalism paradoxically, by choosing the most modest form of prose fiction, the short story—and then shortening it even further: "In my opinion, once a story is written, one should cross out its beginning and end. That is where we writers of fiction falsify most of all. . . . And briefly, one must speak as briefly as possible. . . ."[48] The principled reason behind this attack on convention came from the tradition itself. One need only recall the nonendings of *Eugene Onegin, Dead Souls, War and Peace,* and *The Brothers Karamazov* to see the provenance of Chekhov's declaration that "there is no need for any plots. Life doesn't have plots; in life, everything is mixed together—the profound with the shallow, the great with the trivial, the tragic with the ludicrous." Chekhov's contribution was to remain so faithful to this belief as to call the very distinctions into question, so that his best work illustrates with unexampled clarity Santayana's dictum: "Everything in Nature is lyrical in its ideal essence, tragic in its fate, and comic in its existence." Gorky was right to protest admiringly that Chekhov was "killing realism," i.e., exhausting its last remaining technical possibilities, purifying it by refusing (in Charles Du Bos's words) to overdramatize or to regard life as if it were only a problem. The result was—by another paradox—that he renewed Russian fiction as an instrument of *poetic* implication (cf. "The Huntsman," "The Student," the "little trilogy," "The Bishop").

It has been the purpose of these remarks to suggest that what is distinctive in the Russian nineteenth-century novel may be, in the first place, a *special variety of fictional discourse* (by no means confined to long narratives, or even to prose), elaborated by men who thought of themselves not as "novelists" but as writers. Henry James, failing to perceive the novel form in all that amplitude of ambition, called their products "fluid puddings." Yet the metamorphoses of the "free novel" as Pushkin first exemplified it are the sign of a tradition in the making. "Never," as Dostoevsky observed near the end of his life, "in any literature, did there appear so many gifted writers as in Russia,—all along, without intervals."[49] The writings alluded to in this paper all appeared within the lifetime of Leo Tolstoi (1828–1910)—which means that the major Russian writers were, broadly speaking, coevals. As such they were intensely aware of participating in a common cultural enterprise; that is, they had designs on their readers (and on themselves) in the name of a Russian cultural identity whose crystallization was still in process. Hence the profound sense of a presence haunting the days of their narratives. The phrase comes from V. S. Pritchett, who explains of their characters:

There lies on those persons, even on the most trivial, the shadow of a fate more richly definitive than the fate of any individual human being. Their feet stand in time and history. Their fate is corporate. It is the fate of Russia itself, a fate so often adjured with eloquence and nostalgia, oftener still with that medieval humility which has been unknown to us since the Renaissance, and which the Russians sometimes mystically identify with the fate of humanity itself. . . .

It was a great advantage to the Russian novelists that they were obliged to react to the Russian question; a great advantage, too, that the Russian question was to become a universal one: the question of the rise of the masses.[50]

This points us toward theme again, and I would not deny the importance of the themes that have so often been emphasized as the heart of the Russian achievement in fiction. But I would emphasize, as I have tried to do here, that all the great themes of Russian fiction—its "content"—derive their power from the fundamentally new forms that were devised to accommodate them. "This indeed," as Tolstoi insisted, "is one of the significant facts about a true work or art: that its content in its entirety can be expressed only by itself."

If that seems to leave us with separate works again, it is only appropriate: they survive our generalizations, even as they invite them. But we may also and legitimately be left with a sense that the works in question share an unprecedented breadth of aspiration—which, in ways I have tried to suggest, their authors had to invent *structures we now think of as Russian* to fulfill.

NOTES

1. Max Beerbohm, "Kolniyatsch," in his *And Even Now and A Christmas Garland* (New York: E.P. Dutton, 1960), p. 33.

2. Emile Hennequin, *Ecrivains francisés* (Paris, 1889), pp. 179–84.

3. Céleste Courrière, *Histoire de la littérature contemporaine en Russie* (Paris, 1875), p. 322.

4. Denis Saurat, "Novel," in *Cassell's Encyclopedia of World Literature,* 2d ed., I (1973), 430; my italics.

5. Melchior de Vogüé, *Le Roman russe,* 4th ed. (Paris, 1897), p. 203. What makes these words particularly striking is the fact that shortly before applying them to Dostoevsky, Vogüé had used them in a newspaper article to introduce Tolstoi! See F. W. J. Hemmings, *The Russian Novel in France* (London: Oxford University Press, 1950), p. 34.

6. A. Hermant, *La Vie littéraire,* Première Série (1918), p. 143; quoted in F.

W. J. Hemmings, *The Russian Novel in France, 1884–1914* (London: Oxford University Press, 1950), p. 30. On the spiritual superiority of Russian realism, see Vogüé's "Avant-propos" to his *Le Roman russe,* esp. xliv.

7. "The Russian Point of View," in Virginia Woolf, *The Common Reader,* First Series (New York: Harcourt Brace, n.d.), pp. 182–84.

8. Ibid., p. 187.

9. S. A. Vengerov, "V chem ocharovanie russkoi literatury XIX veka," in his *Sobranie sochinenii,* IV (Petrograd, 1919), 21.

10. Ibid., pp. 22–23.

11. S. A. Vengerov, *Geroicheskii kharakter russkoi literatury* (St. Petersburg, 1911). For a trenchant attack on such effusions, see the review by A. G. Gornfel'd, "Literatura i geroizm," in his *O russkikh pisateliakh,* I (St. Petersburg, 1912), 262–92.

12. E.g., N. Ya. Berkovskii, *O mirovom znachenii russkoi literatury* (Leningrad: Nauka, 1975); B. Bursov, *Natsional'noe svoeobrazie russkoi literatury* (Moscow-Leningrad: Sovetskii Pisatel', 1964; revised edition 1967); E. N. Kupreianova and G. P. Makogonenko, *Natsional'noe svoeobrazie russkoi literatury* (Leningrad: Nauka, 1976).

13. Quoted in M. N. Kufaev, *Istoriia russkoi knigi v XIX veke* (Leningrad, 1927), p. 103.

14. Vogüé, *Le Roman russe,* p. xi.

15. N. G. Chernyshevskii, "Ocherki gogolevskogo perioda," in his *Estetika i literaturnaia kritika* (Moscow-Leningrad, 1951), p. 338.

16. See Donald Fanger, "Gogol and his Reader," in *Literature and Society in Imperial Russia, 1800–1914,* ed. William Mills Todd III (Stanford: Stanford University Press, 1978), esp. pp. 61–75.

17. Here, then, is one enormous difference between the Russian literary situation and that of, say, France in the nineteenth century: where the serious French writer felt an increasing alienation from his society and the mass readership it was producing, the Russian writer, for all his frequent despair at tendentious misreadings, was engaged in a quest for union with his readership that rested on agreement about the extreme importance of the literary enterprise and its extra-literary ramifications. Gogol increasingly came to view literary art as a kind of communion; so, in their differing terms, did Dostoevsky and Tolstoi. And it would not be hard to demonstrate how Turgenev's narrator most often stands as a kind of model of what a cultivated citizen might be (ego and super-ego both)—a model that Chekhov enlarged by purifying. Here the profile of each writer's "ideal reader," as stipulated demonstrably in his texts, might form the basis of a fascinating and still unwritten chapter of Russian cultural history.

18. Ivanov-Razumnik, *Istoriia russkoi obshchestvennoi mysli,* fourth ed., I (St. Petersburg, 1914), 14; V. G. Korolenko, *Sobranie sochinenii v desiati tomakh,* V (Moscow, 1954), 275–77; Leon Trotsky, "Gogol: An Anniversary Tribute" (1902), in *The Basic Writing of Trotsky,* ed. Irving Howe (New York, 1963), p. 318.

19. N. V. Gogol', *Polnoe sobranie sochinenii* (Leningrad: Akademiia nauk SSSR, 1937–52), XIV, 240.

20. Ibid., XII, 437.

21. On the censors' treatment of *Notes from Underground,* see Dostoevsky's letter to his brother Mikhail of 26 March 1864, quoted in F. M. Dostoevskii, *Polnoe sobranie sochinenni v tridtsati tomakh,* V (Leningrad: Nauka, 1973), 375.

On his defense of art against the utilitarians, see his article "Mr. ——bov and the Question of Art," in F. M. Dostoevsky, *Occasional Writings*, trans. David Magarshack (New York: Random House, 1963), pp. 86–137.

22. Letter to N. N. Strakhov, 23 and 26 April 1876; in L. N. Tolstoi, *Polnoe sobranie sochinenii*, Jubilee Edition (hereafter cited as *PSS*), LXII (Moscow, 1953), 268.

23. "Neskol'ko slov po povodu knigi *Voina i mir*," *PSS*, XVI, 7.

24. Ibid., p. 55.

25. Ibid., p. 54.

26. Quoted in V. V. Vinogradov, *Problema avtorstva i teoriia stilei* (Moscow, 1961), p. 516.

27. "By an aesthetic idea I mean that representation of the imagination which induces much thought, yet without the possibility of any definite thought whatever, *i.e., concept*, being adequate to it, and which language, consequently, can never quite get on level terms with or render completely intelligible. It is easily seen that an aesthetic idea is the counterpart of a *rational idea*, which conversely, is a concept which no *intuition* (representation of the imagination) can be adequate" (*Critique of Aesthetic Judgment*, trans. James Creed Meredith [Oxford: Oxford University Press, 1952], pp. 175–76).

28. Cf. J. Hillis Miller's succinct formulation: "The most important themes of a given novel are likely to lie not in anything which is said abstractly, but in significances generated by the way in which the story is told" ("Virginia Woolf's All Souls Day," in *The Shaken Realist: Essays in Modern Literature in Honor of Frederick J. Hoffman*, ed. Melvin J. Friedman and John B. Vickery [Baton Rouge: State University Press, 1970]. p. 101).

29. The quotation is from P. A. Viazemskii, "O Kavkazsom plennike, povesti soch. A Pushkina" (1822), in his *Polnoe sobranie sochinenii*, I, 75. For more on this historical situation, see Donald Fanger, *The Creation of Nikolai Gogol* (Cambridge, Mass.: Harvard University Press 1979), chapter 2. On the three works in question as foundation of the nineteenth-century Russian novel, see D. E. Tamarchenko, *Iz istorii russkogo klassicheskogo romana* (Moscow-Leningrad, 1961), and Waclaw Lednicki, "The Prose of Pushkin," in his *Bits of Table Talk on Pushkin, Mickiewicz, Goethe, Turgenev and Sienkiewicz* (The Hague: Martinus Nijhoff, 1956), esp. p. 32, note 79.

30. See A. L. Slonimskii, *Masterstvo Pushkina* (Moscow, 1959), pp. 318–19; and G. A. Gukovskii, *Pushkin i problemy realisticheskogo stilia* (Moscow, 1957), pp. 268ff.

31. Alexander Pushkin, *Eugene Onegin*, trans. Charles Johnston (New York: Viking, 1978), p. 218.

32. Gukovskii, *Pushkin i problemy realisticheskogo stilia*, pp. 140–41.

33. The points here summarized are argued at length by Leon Stilman in his "Problemy literaturnykh zhanrov i traditsii v 'Evgenii Onegine' Pushkina," in *American Contributions to the Fourth International Congress of Slavists* (The Hague: Mouton, 1958), pp. 321–68, and by Yuri Tynianov, "Pushkin," in his *Arkhaisty i novatory* (Leningrad, 1929), esp. pp. 276ff.

34. Iu. M. Lotman, *Roman v stikhakh Pushkina "Evgenii Onegin"* (Tartu: Tartusskii gos. un-t, 1975), p. 45.

35. Ibid. pp. 79–80.

36. For a subtle discussion of the interrelations of life and art in *Onegin*, see William Mills Todd III, *"Eugene Onegin:* 'Life's Novel'," in *Literature and Society in Imperial Russia* (cf. note 16, above).

37. See, e.g., Lednicki, "The Prose of Pushkin," p. 21; and Lotman, *Roman v Stikhakh Pushkina,* p. 107.

38. On the role of detail, see Andrei Belyi, *Masterstvo Gogolia* (Moscow-Leningrad: OGIZ, 1934), pp. 83ff and 103. See also Fanger, *The Creation of Nikolai Gogol,* chapter 7.

39. F. M. Dostoevsky, *The Diary of A Writer,* trans. Boris Brasol (New York: George Braziller, 1954), p. 277 (April 1876).

40. See, for example, D. N. Ovsianiko-Kulikovskii, *Istoriia russkoi intelligentsii,* I (Moscow, 1908), 112ff; Henry Gifford, *The Novel in Russia* (London: Hutchinson, 1954), pp. 30–32.

41. On Lermontov's use of current literary forms, see Boris Eikhenbaum, *Lermontov* (Munich: Fink, 1967), pp. 148ff. On the philosophical dimension of the book, see I. Vinogradov, "Filosofskii roman M. Iu. Lermontova," in *Russkaia klassicheskaia literatura: Razbory i analizy,* ed. D. L. Ustiuzhanin (Moscow, 1969), pp. 156–85.

42. See M. M. Bakhtin, *Problems of Dostoevsky's Poetics,* trans. R. W. Rotsel (Ann Arbor: Ardis, 1973). The argument for a Gogolian derivation is made at greater length in my article "Influence and Tradition in the Russian Novel," in *The Russian Novel from Pushkin to Pasternak,* ed. John G. Garrard, forthcoming from the Yale University Press.

43. B. Eikhenbaum, *Lev Tolstoi,* I (Leningrad, 1928), 42.

44. "Istoriia vcherashnego dnia," in *PSS,* I, 279.

45. Thomas Mann, "Anna Karenina," in *Essays of Three Decades* (New York: Knopf, 1947), p. 177; Isaac Babel, *You Must Know Everything* (New York: Farrar, Straus and Giroux, 1969), p. 214. On the network of relations of Tolstoi, see Donald Fanger, "Nazarov's Mother: On the Poetics of Tolstoi's Late Epic," *Canadian-American Slavic Studies* 12, no. 4 (Winter 1978): 571–82.

46. Ilya Ehrenburg compares Chekhov's description of a lightning flash ("To the left it was as if someone had scratched a match across the sky") with Turgenev's: "The sky was filled with constant flashes of lightning, muted, long, as if many-branched; they did not so much as tremble and twitch, like the wings of a dying bird" (*Perechityvaia Chekhova* [Moscow, 1960], p. 87).

47. Diary entry for 16 January 1900; in *PSS,* LIV, 9.

48. Quoted in Ehrenburg, *Perechityvaia Chekhova,* p. 86.

49. *The Diary of a Writer,* p. 583.

50. V. S. Pritchett, "The Russian Day," in his *The Living Novel* (London: Chatto & Windus, 1954), p. 220.

4

Native Song and National Consciousness in Nineteenth-Century Russian Music
Malcolm Hamrick Brown

MIKHAIL GLINKA (1804–57), "the father of Russian music," composed the first Russian opera, *A Life for the Tsar,* in 1836, and thus laid the foundation for a Russian *national* music whose voice would reach full resonance only during the latter part of the nineteenth century in the celebrated works of Tchaikovsky and the composers of the so-called Mighty Coterie *(Moguchaia Kuchka).*

This aphoristic characterization of nineteenth-century Russian music history has persisted among Western musicians and music historians because of a continuing ignorance of the fundamental research done by Russian-music specialists, both native-born and foreign, during the past half century. Our discussion here, founded on this fundamental research, proposes to trace the emergence of national consciousness in Russian music and to establish the historical context in which Glinka could appear as the founder of a self-consciously nationalist school of composers in Russia.[1]

The dominant position of the Russian Orthodox church in pre-Petrine Russian cultural life promoted a skepticism toward secular art in any form that endured into the eighteenth century. Even folk music, though never suppressed, had suffered periodic ecclesiastic ire, while secular music of the art tradition had simply never struck root in the inhospitable soil of Russia's pietistical culture. But conditions changed quickly in the wake of Peter the Great's reforms at the start of the eighteenth century. Imperial ukase suddenly accelerated Russia's long-standing practice of borrowing selectively from Western technology, and the influx of Western ways swept in as well the trappings of Western culture. Soon, newly clean-shaven and peruked courtiers were dancing to *menuet, polonaise,* and *anglaise* at the Western-style court balls in St. Petersburg. In 1711, Peter issued directives on the establishment

of military "staff orchestras" along the German model, to consist of bands of nine "oboists" (the generic name for all military musicians) and sixteen drummers. Such bands soon participated fully in military life, accompanying the troops in battles and maneuvers, as well as playing for the quasi-military ceremonials at court. Ten years earlier, the venerable Chorus of the Sovereign's Singing Clerics *(Khor gosudarevykh pevchikh d'iakov)*—composed, as custom dictated, of mature male voices—had been transformed at Peter's behest into a court choir that included both men and boys in the European manner. Peter moved the choir from Moscow to St. Petersburg in 1703 and included it in the royal entourage on his trip in 1717 to Poland, Germany, Holland, and France, where he impressed his European hosts with the prowess and beauty of Russian male voices. Then in 1721, Karl Friedrich, Duke of Schleswig-Holstein, claimant to the hand of Peter's elder daughter, Anna, arrived in St. Petersburg with his court *Kapelle*—the first sizable group of highly trained German musicians to find residence at the Russian court. They performed at balls and official celebrations, gave chamber music concerts, and soon acquainted the Russian court with such contemporary European masters as Corelli, Telemann, and Keiser. A number of these musicians, including the *Konzertmeister* Johann Hübner (1696–c. 1750), eventually entered the service of the Russian court, remaining in St. Petersburg even after Peter's death.

Opera, the genre that would dominate secular art music in Russia to the end of the eighteenth century, appeared only in the 1730s. On 26 February/9 March 1731, an Italian troupe previously engaged in Dresden at the court of the Saxon elector, Friedrich August (who was also King of Poland), inaugurated a series of musical and theatrical presentations at the court of Empress Anna. The troupe's repertoire consisted mainly of short plays in the style of the *commedia dell'arte* with musical *intermezzi* performed between the acts. (The style of the latter closely resembled nascent *opera buffa* of the sort exemplified by Pergolesi's *La Serva padrona*.) A second Italian theatrical company brought more *intermezzi* to the Russian court in 1733. But such light-hearted entertainment could scarcely satisfy the imperial pretensions of Russian court life. *Opera seria* was needed. In 1735 Empress Anna summoned Francesco Araja (1709–c. 1770) from Italy to direct a newly assembled Italian troupe capable of mounting *opera seria;* this troupe formed the nucleus of the first Imperial Court Opera. Araja soon satisfied his patroness with a grand production of his own *La Forza dell'amore e dell'odio,* on 29 January/9 February 1736, in a specially built opera house in St. Petersburg. Araja held his post only until 1738 but later accepted reappointment from Empress Elizabeth in 1744; he remained in Russia this time until 1759—long enough to see more and more talented Russians

among the musicians at court. The spectacle of *opera seria* could be sustained only by augmenting the imported musical forces with native players and singers—the latter usually drawn from the court choir, which had started to participate regularly in opera performances during Araja's first term as *Kapellmeister* (the German term was used at the Russian court). Indeed, the cadre of native performers had grown sufficiently large and competent by mid-century to mount an opera in Russian to an original Russian libretto—Araja's *Cephalus and Procris* *(Tsefal i Prokris)* on a text by Alexander Sumarokov (1718–77), which premiered on 27 February/10 March 1755.

After Araja, foreigners (predominantly Italian) continued to occupy leading positions in Russian musical life to the end of the eighteenth century: Hermann Friedrich Raupach (1755–62, 1768–78), Vincenzo Manfredini (1758–69, 1798–99), Josef Starzer (1760–70), Baldassare Galuppi (1765–68), Tommaso Traetta (1768–75), Giovanni Paisiello (1776–84), Carlo Canobbio (1779–1800), Giuseppe Sarti (1784–1802), Gennaro Astaritta (1784–89, 1795–1803), Domenico Cimarosa (1787–91), and Vincente Martín y Soler (1788–1806). But native Russian composers were already taking their first tentative steps in the 1770s. On 26 August/6 September 1772, the first known Russian vernacular comic opera was performed at Tsarskoe Selo, the imperial summer residence. The work, *Anyuta (Aniuta),* is known today from its libretto by Mikhail Popov (1742–c. 1790). Neither musical score nor parts survive, and the composer remains unidentified, although Vasily Pashkevich (c. 1742–97) has often been advanced as a credible candidate. At one point in the text, the character Filat is instructed to leave the stage singing the folk song "Fair-face, chubby-face" *(Belolitsa-kruglolitsa),* which suggests the possibility that the musical score may have amounted to little more than a pastiche of contemporary folk and popular songs. French comic opera, which had secured a place at the Russian court by the mid-1760s, undoubtedly served as the model, since mature *opera buffa* returned to the court only on 3/14 February 1779, with a performance of Paisiello's *Filosofi immaginarj.* By that late date, *opera buffa* had been enjoying great success in the public theaters of St. Petersburg and Moscow for a number of years, but the imperial court continued up until about 1780 to demand from Italian composers the ceremonial pomp and self-aggrandizing metaphor of *opera seria.*

During the second half of the eighteenth century, social support for music spread beyond the imperial court, first into the circles close to the court, then into the wider realm of aristocratic society. Wealthy nobles, emulating the court, set up domestic orchestras, choirs, and opera theaters staffed largely by serfs trained by foreign professionals. (The musical establishments of Prince Pyotr Volkonsky [1776–1852],

Count Nikolai Sheremetev [1751–1809], and Count Alexander Vorontsov [1741–1805] achieved particular renown.) Amateur music-making became an expected component of genteel education. Entrepreneurs opened theaters and sponsored concerts for a paying public. Giovanni Battista Locatelli (1715–85) brought his private Italian *opera-buffa* and ballet troupe to St. Petersburg in 1757, and following great success there, he opened a theater in Moscow in 1759. A number of years later, public theaters offering a varied bill of drama, opera, and ballet were founded in Moscow (1776) by Michael Maddox, an Englishman, in collaboration with Prince P. V. Urusov, and in St. Petersburg (1779) by Karl Knipper, a German. Russia's secular music culture had clearly struck root at last.

The first French comic operas on the Russian stage in the 1760s took many operagoers by surprise. After attending one, a contemporary reacted with dismay: "We have become accustomed to a grand and imposing spectacle with music in the Italian [i.e., *opera-seria*] style, while here, but for the simplest music and simplest settings, but for smithies, blacksmiths, and goings-on about blacksmiths, there was nothing."[2] Indeed, with its reliance on popular folk and folklike tunes, spoken dialogue, and simple plots featuring peasants and scenes from village life, French comic opera could scarcely have been further removed from the conceits of court-sponsored *opera seria*. Here was the perfect model for a *Russian* vernacular comic opera. (Italian *opera buffa* provided less apt a model because of its greater musical sophistication—usually newly composed music and *sung* dialogue [i.e., *recitativo*], with plots often set in an upper-class milieu, even when they concerned lower-class characters.) Motivated by the attitudes of the French Enlightenment, the vanguard of Russian culture, led by Empress Catherine herself, found the habits, customs, and temperament of simple folk "enchanting." Folk song perfectly embodied the peasant spirit, and aristocratic Russians started to delight without embarrassment in the indigenous beauty of their native music. Its potential for creating a vernacular comic opera of distinctly Russian flavor was quickly recognized by composers, both native-born and foreign.

The burgeoning interest in folk song among the higher strata of Russian society toward the end of the eighteenth century soon lent incentive to systematic collection, and the first printed transcriptions started to appear. Precedence belongs to Vasily Trutovsky (c. 1740–1810). In 1761, Empress Elizabeth appointed him Court Singer and *Kammerguslist* (i.e., a player of the Russian folk instrument the *gusli,* a kind of psaltery; the German name was used at court in preference to the Russian *gusliar,* which means "*gusli* player"), suggesting that the European interest in folk music was already sanctioned in the highest circles.

Trutovsky published Part One of his pioneering four-part *Collection of Russian Rustic Songs with Music* in 1776 (*Sobranie russkikh prostykh pesen s notami* [St. Petersburg, 1776–95]).[3] A more systematic approach was adopted by Nikolai Lvov (1751–1803) and Jan Bogumir Práč (?–1818) in their collaborative *Collection of Russian Folk Songs with their Tunes; Music Arranged by Jan Práč* (*Sobranie narodnykh russkikh pesen s ikh golosami. Na muzyku polozhil Ivan Prach* [St. Petersburg, 1790]). The abundance of traditional melodies in these collections made them a primary source for composers well into the nineteenth century. Indeed, the Lvov-Práč volume probably experienced the greatest social resonance of any music publication in eighteenth-century Russia (especially considering its numerous reprintings in the nineteenth century). A list of the composers, both in and out of Russia, who drew on it would include Beethoven, Rossini, Sarti, Martín y Soler, Pashkevich, and virtually all of the declared Russian nationalists, starting with Glinka.

Vernacular comic opera occupied first place in the output of the embryonic Russian School of the eighteenth century. The genuine prototype (*Anyuta* notwithstanding) premiered in Moscow on 20/31 January 1779: *The Miller-Magician: Trickster and Matchmaker* (*Mel'nik-koldun, obmanshchik i svat'*) by Mikhail Sokolovsky (c. 1756–?) to a libretto by Alexander Ablesimov (1742–83). *The Miller-Magician* owed much to Vasily Maikov's (1728–78) Russian adaptation of Jean-Jacques Rousseau's *Le Devin du village*, which had been set to music by one Johann or Josef Kerzelli and presented as *The Village Soothsayer* (*Derevenskoi vorozheia*) in Moscow some two years before (the exact date is unknown; the overture and various songs and interludes arranged for "clavier or piano" were published in Moscow in 1778—the first operatic pieces to be printed in Russia). The Sokolovsky-Ablesimov treatment captivated the public's fancy in an unprecedented fashion, remaining in the repertoire continuously until 1821 and becoming thereby a reference standard for the genre. The distinguished native Russian composers of the late eighteenth century—Pashkevich, Evstignei Fomin (1761–1800), Dmitry Bortniansky (1751–1825)—refined the musical content and polished the operatic forms, while expanding the range of subject matter, but the genre's identifying features remained the same as in *The Miller-Magician:* spoken dialogue, songlike numbers (the majority based on genuine folk melodies), and stories set in the everyday milieu of common folk.

The utilization of genuine Russian folk melodies in vernacular comic opera represented no more than a convention to Russian composers in the late eighteenth and early nineteenth centuries—a convention that had little impact on their determination to command the language and forms of contemporary European art music. Likewise, when Russian

folk tunes were first taken as themes for variation cycles, their presence amounted to little more than charming curiosity—a bit of local color that barely hinted at the way folk song would eventually free the imagination of native Russian composers from European modes of musical thought. Vasily Trutovsky once again gets credit for publishing the first known *Variations sur les Chansons Russes pour le Clavecin ou Forte-piano* (St. Petersburg, 1780), which contains two sets of variation cycles. The tunes came from his own folk-song collection—a lyric leisurely or melismatic song *(protiazhnaia pesnia)*,[4] "At the Fine Husky Fellow's" *(U dorodnogo dobrogo molodtsa)* and a dance song *(pliasovaia pesnia)*, "In the Woods Hatched a Host of Mosquitos" *(Vo lesochke komarochkov mnogo urodilos')*. Ivan Khandoshkin (1747–1804) followed the next year with *Chansons russes variées pour violon et basse* (Amsterdam, 1781), and then two years later with his first publication in Russia—*Six Old Russian Songs with Variations for Solo Violin and Alto-Viola (Shest' starinnykh ruskikh* (sic) *pesen' s prilozhennymi k onym variatsiiami, dlia odnoi skripki i alto-violy)*. At the turn of the century, variations on Russian folk tunes constituted the most popular genre of purely instrumental music produced by both natives and foreigners resident in Russia (the latter included Johann Gottfried Wilhelm Palschau [1741–1815], Johann Wilhelm Haessler [1747–1822], and John Field [1782–1837]). In a few of these early sets, especially those by native composers, a distinctive quality of "Russianness" can be discerned. The process of variation itself corresponds more closely than any other formalized compositional procedure to one of the traditional ways of musical thinking found among Russian folk musicians and expressed in actual folk performance practice. This may account in some way for the preeminence of variation cycles in the instrumental output of native composers.

By the beginning of the nineteenth century, gifted native composers had also tried their hands at instrumental and vocal genres in which the quality of Russianness emerged scarcely if at all. Bortniansky and Maxim Berezovsky (1745–77), both of whom spent many years in Italy, cultivated a European type of sacred choral concerto that nevertheless reveals some traces of the seventeenth-century tradition of Ukrainian-Russian so-called part singing *(partesnoe penie)*. Józef Kozłowski (1757–1831), who was born in Poland but settled in Russia in 1773, established the polonaise in Russia as both a gala, ceremonial piece and a favored salon genre; the polonaise eventually accrued specific connotations within its Russian milieu, along with distinctively new stylistic elements, and during the nineteenth century came to be considered a characteristically and recognizably "Russian" musical genre. A type of vocal salon piece called the *Rossiiskaia pesnia* or "Russian song" (as distinct from songs or arias to French or Italian texts)

seems to have made its earliest appearance in Grigory Teplov's (1711–79) *Idleness Midst Labor (Mezhdu delom bezdel'e)*, the first printed collection of "Russian songs" by a Russian composer to texts by Russian poets (St. Petersburg, n.d., but probably not before 1751; second and third printings occurred in 1759 and 1776). These songs, in three-part texture, reveal many traits in common with the fashionable European vocal salon music of the era, although some residue of style may survive in them from the three-part lyric *kant* found in Russia, the Ukraine, and Belorussia during the seventeenth and early eighteenth centuries. More to the point, however, the "Russian song" spawned an offshoot that evolved in the songs of Kozłowski and Fyodor Dubiansky (1760–96) at the end of the eighteenth century—the "Russian romance," a genre that, like the polonaise, came to be considered characteristically Russian in the course of the nineteenth century without (again, like the polonaise) relying on folk-song citation per se. Finally, a number of Russian composers at the turn of the century had produced European-style sonatas, fugues, chamber ensemble pieces, and the like, but however adept these might be—and in the case of Bortniansky and Khandoshkin, they were indeed adept—they possessed no perceptible quality of Russianness.

The first generation of Russian composers to feel inclined toward a *national* expression could imbue their works with a recognizable quality of Russianness only by reference to sound images associated with Russia's two ancient and indigenous musical practices—folk music and music of the Russian Orthodox church. The lineage of both stretched back to historic traditions outside the borders of the Russian state, but centuries of geographical and cultural isolation had insured their evolution along distinctively Russian lines. Although these practices had evolved to quite different purposes and functions, some degree of mutual influence inevitably occurred—each left imprints on the other. Russian composers experiencing the first faint flush of national consciousness found folk music the richer stimulus to their musical imagination. As musical nationalism developed into a self-conscious, articulate, and aggressive movement during the course of the nineteenth century, folk music remained the nationalist composer's primary touchstone. Proximity to this touchstone came finally to be considered the *sine qua non* of the nineteenth-century Russian nationalist school of composition.

The theater remained at the center of attention for the majority of Russian composers in the nineteenth century, but subject matter and musical language changed radically. Folk-epic stories and fairy-tale fantasies that stressed the supernatural began to attract them, betraying interests in common with the European romantics, while the political

events that culminated in the War of 1812 inspired them to compose patriotic works on themes from Russian history. Vernacular comic opera lost much of its ethnic focus and penchant for social satire, tending instead toward farce and an often saccharine idealization of peasant life such as can be seen in Alexei Titov's (1769–1827) *Yam, or the Post Station (Iam, ili Pochtovaia stantsiia)* (1805), *The Village Sociable (Posidelki)* (1807), or *The Bride's Wedding Party, or Filatka's Marriage (Devishnik, ili Filatkina svad'ba)* (1808). Fantasy opera came to Russia in 1803 with a production of *The Dnieper River Nymph (Dneprovskaia rusalka)* — a Russian adaptation by Nikolai Krasnopolsky (dates unknown) of the Austrian composer Ferdinand Kauer's (1751–1831) *Das Donauweibchen,* with added musical numbers by Stepan Davydov (1777–1825). The work had already enjoyed great success in Vienna and Berlin. Recast to reflect Slavic folklore, it proved a triumph in St. Petersburg. A year later, a sequel appeared with added musical numbers by Catterino Cavos (1775–1840; his forty years in Russia, 1799–1840, surely qualify him as a "naturalized Russian"). Continued success led to two later incarnations — *Lesta, the Dnieper River Nymph (Lesta, dneprovskaia rusalka)* (1805) and *The Nymph (Rusalka)* (1807). The latter two were composed entirely by Davydov, who relied extensively on folk song for characterizing the protagonists and their locale. Davydov imbued his scores with a heightened romantic expressivity, making the pictorial and descriptive episodes some of the earliest examples of romantic "tone painting" in Russian music (e.g., the overture to the 1805 *Nymph* depicts a thunderstorm). The *rusalka* tetralogy became the prototype of nineteenth-century Russian fairy-tale opera.

Not only did Cavos compose some of the earliest popular fairy-tale operas — *The Invisible Prince (Kniaz'-nevidimka)* (1805) and *Ilya the Hero (Il'ia-bogatyr')* (1806) — but his *Ivan Susanin* (1815), to a libretto by Prince Alexander Shakhovskoy (1777–1846), written under the immediate impressions of the War of 1812, represents the finest early example of Russian historic opera. Its dramatic choral scenes with music in folk style are especially distinguished. Twenty-one years later, Cavos would conduct the premiere of another opera based on the same event in Russian history — Glinka's *A Life for the Tsar (Zhizn' za Tsaria)* (1836). The assertion might be made without exaggeration that the paradigms of all later nineteenth-century Russian opera were established in works composed between 1800 and 1815.

Other musical theatrical genres also contributed to Russia's incipient national school. The so-called divertissement *(divertisment),* a folk-vernacular entertainment, gained great popularity between 1810 and 1830 with its simple plots enlivened by songs and dances in folk style. Many were based on patriotic subjects connected with the War of 1812,

such as Cavos's *The Home Guard, or Love for the Fatherland (Opolchenie, ili Liubov' k otechestvu)* (1812) or Davydov's *Triumph of Victory (Torzhestvo pobedy)* (1814–15). The Russian vaudeville *(vodevil')*, a genre similar in character to the divertissement, also enjoyed much success with the public during the 1820s. A touring French troupe had introduced the vaudeville to Russia in 1800; as its popularity spread, Russianized versions of texts and plots appeared, but with the French tunes retained. Cavos composed the earliest known original Russian vaudeville to a libretto by Shakhovskoy, *The Cossack Poet (Kazak-stikhotvorets)* (1812), which typifies the genre—an anecdotal situation narrated in spoken dialogue with simple songs consisting of verse couplets set to strophic tunes (often well-known melodies) in folk style.

The vaudeville *Grandma's Parrots (Babushkiny popugai)*, presented at the Bolshoi Theater in St. Petersburg in 1819, launched the musical career of Alexei Verstovsky (1799–1862). Scion of an enlightened aristocratic family, Verstovsky grew up in musical surroundings. His father maintained a serf orchestra and owned a music library of considerable size for the period. Young Alexei and his brother Vasily participated from childhood in amateur music-making. At age ten, Alexei publicly performed piano works of John Field and Jan Dušek. After the War of 1812, the family settled in St. Petersburg, where Verstovsky studied at the institute attached to the Corps of Transport Engineers *(Institut korpusa inzhenerov putei soobshcheniia)* during 1816–17 and entered civil service on graduation. Nevertheless, music remained his first love, and at various times he studied piano with Daniel Steibelt and John Field, violin with Franz Böhm and Ludwig Maurer, and composition with Johann Gottfried Miller. He moved easily into St. Petersburg's artistic society, becoming fast friends with the composer Aliab'ev (about whom more later) and such influential figures in the theater as Pimen Arapov (1796–1861), Nikita Vsevolozhsky (1799–1862), and the playwrights Prince Shakhovskoy and Nikolai Khmelnitsky (1791–1845). Verstovsky moved to Moscow in 1823, where he was appointed Inspector of Music for the Moscow branch of the Imperial Theaters Directorate (1825), then Inspector of Repertoire (1830), and finally Manager of the Moscow branch (1848–60). His position in the mainstream of Russian cultural life brought him into contact with such literary notables as Alexander Pushkin (1799–1837) and Alexander Griboedov (1795–1829). Access to the intellectual circle of Prince Vladimir Odoevsky (1803–69), Sergei Aksakov (1791–1859), Mikhail Zagoskin (1789–1852), and Stepan Shevyryov (1806–64) acquainted him with the current sociocultural debates over the controversial issue of Slavophilism.

As Verstovsky secured power and authority, both as composer and administrator, during the thirty-five years of what has been called the

"Epoch of Verstovsky" in Moscow's theatrical life, he gained a reputation as a tough-minded, despotic manager but also earned respect for his personal dedication to the job at hand and for his exceedingly high artistic standards. One of his contemporaries, the playwright Alexander Ostrovsky (1823–86), wrote of him:

> We know very well the unbounded admiration felt by all artists for . . . persons of discriminating tastes. Verstovsky was just such a connoisseur in the art of the theater. All the performers craved his criticism—feared it, yet heeded it gratefully and with confidence. It never entered an artist's head to resent Verstovsky for addressing him *thou* [*ty*], especially when Verstovsky then praised him. Artists who performed in his presence (and he was at the theater every day) paid little heed to the applause of the public, but waited to see what he would say when he came backstage at intermission.[5]

Verstovsky devoted his compositional energies to the theater above all, producing in most of the theatrical genres of the period (except ballet)—vaudeville, opera, melodrama, "dramatic cantata," as well as various sorts of prologues, musical *tableaux,* and *intermezzi.* The enormous success of *Grandma's Parrots* led to some thirty more vaudevilles (a number in collaboration with other composers, especially his friend Aliab'ev). Having gained confidence as a composer for the theater in his vaudevilles, he turned to opera with *Pan Twardowski* (1828), which one critic declared "a new, heartening phenomenon never before encountered on the Russian stage. *It is ours, it is the first Russian opera!*"[6] Doubtless such enthusiasm was engendered partly by the fact that Verstovsky had produced a serious work imbued with romantic drama and musical substance quite unlike the vernacular comic operas or fairy-tale operas of earlier native Russian composers. But *Pan Twardowski* was derivative of Polish legend (refracted through the story by Zagoskin, who also wrote the libretto), and only in his second opera, *Vadim, or the Awakening of Twelve Sleeping Maidens (Vadim ili Probuzhdenie dvenadtsati spiashchikh dev)* (1832) did Verstovsky begin to suggest that quality of Russianness so crucial to evoking national consciousness. Based on the second part of Vasily Zhukovsky's (1783–1852) *Twelve Sleeping Maidens (Dvenadtsat' spiashchikh dev)* (a kind of "German legend" metamorphosed into a Russian folk tale), the libretto gave Verstovsky an opportunity to compose music for scenes portraying the by-gone world of the ancient Slavs, their rites of spring and choruses of peasant maidens, their folk dancing and epic feasts, all of which anticipated the content and style of nationalist works to come. Verstovsky composed four more operas, reaching the apex of his inspiration in *Askold's Tomb (Askol'dova mogila),* produced on 15/27 September 1835—almost exactly a year

before Glinka's epoch-making *A Life for the Tsar*. *Askold's Tomb* clearly bears the imprint of contemporary European "romantic nationalism"—many of its musical and scenic characteristics seem strikingly reminiscent of Carl Maria von Weber's *Der Freischütz,* while the tone and content of Zagoskin's libretto (adapted from his novel *Askold's Tomb),* with its evocation of Kievan Rus' at the time of Vladimir the Blessed, betray the then-current romantic vogue for "reconstructed" history in the manner of Sir Walter Scott. Although Russian folk-song elements often condition the character of the opera's music (especially that associated with the Russian minstrel *(skomorokh)* Torop), Verstovsky never quite managed to exploit the potential of folk song to buttress the score's nationalist imagery. His musical idiom derived essentially from the nineteenth-century Russian vernacular song—the "Russian song" and the "Russian romance," which may be quite appropriately described as "urban folk songs" and which frequently incorporate identifiable elements from the older rural folk-song tradition. But for all this, Verstovsky's musical language retained its fundamentally European accent. His operas reflected a kind of mild Slavophilism no doubt acquired in his intellectual circle and adapted to his artistic purposes— not as an urgent testament but as an expedient proposition.

Verstovsky's friend and frequent collaborator on vaudevilles, Alexander Aliab'ev (1787–1851), probably shared his colleague's mild Slavophilism during the early years of their association, though later, as a collector and arranger of Russia's non-European folk music, his feelings surely intensified. The anti-Western feeling provoked by Napoleon's invasion of Russia resurged after the Polish uprising of 1830, encouraging a pro-Asian sentiment that Aliab'ev clearly shared. Born in Tobolsk, east of the Ural Mountains, where his father held the post of governor, Aliab'ev's special interest in the folk music of Russia's Asiatic peoples may have stemmed in part from youthful associations. Despite the provincial setting, musical life in the Aliab'ev home included appearances by local amateur musicians and concerts by a serf orchestra. Then in 1796 the family moved to St. Petersburg and thence to Moscow in 1804, where Alexander's love for music turned more decisively toward a lifetime commitment. Two waltzes for piano, his first publication, appeared in 1810, published by Weissgreber in Moscow.[7] Aliab'ev's close friendship with Verstovsky, possibly dating from the time when both were studying with Johann Gottfried Miller (Miller's dates are unknown), would prove a valuable professional asset during the 1820s because of Verstovsky's connections with the Moscow branch of the Imperial Theaters Directorate.

The War of 1812 prompted Aliab'ev to enlist as an officer in a hussar regiment. He took part in a number of skirmishes and battles, was

wounded in action and decorated for bravery, and finally shared the glory of marching into Paris with the victorious Russian troops. After the war, he settled for a time in St. Petersburg, where he resumed composing (mostly "Russian romances" on texts by contemporaries, including Pushkin, Zhukovsky, and Baron Anton Delvig [1798–1831]) and established ties with the vanguard artistic and intellectual leaders of the capital city. He and his friend Verstovsky often joined in the play readings at Prince Shakhovskoy's, which brought together such literary notables and devotees of the theater as Pushkin, Baron Delvig, Griboedov, the novelist-poet-critic Alexander Bestuzhev-Marlinsky (1797–1837), the writer of fables and sometime dramatist Ivan Krylov (1769–1844), and the writers and playwrights Nikolai Kmelnitsky, Pavel Katenin (1792–1853), Andrei Zhandr (1789–1873), and Nikita Vsevolozhsky (who would one day organize the Decembrist society "The Green Lamp" [*Zelënaia lampa*]). But Aliab'ev felt drawn to Moscow and returned in 1823, the same year Verstovsky settled in the old capital. He quickly found a place at the center of the city's artistic life through his association with Verstovsky and other cultural leaders such as the arts patron Count Mikhail Vielgorsky (Wielhorsky) (1788–1856), who lived in Moscow from 1823 to 1826, the composer Osip Genishta (1795–1853), and Prince Odoevsky. Verstovsky's influence as an enthusiast of the theater must have had some bearing on Aliab'ev's turn to vaudevilles, a number of which he composed in collaboration with Verstovsky. Then a dramatic event in his private life changed everything: early in 1825, Aliab'ev was accused of murdering a man with whom he had argued over cards. Although medical evidence suggested that the man had died of a chronic disease and not from physical violence, Aliab'ev was arrested and imprisoned for nearly three years. Finally in 1828 he was sentenced to exile in Siberia with the loss of his title and all personal rights. Exiled at first to Tobolsk, the city of his birth, he obtained permission in 1832 to travel to the North Caucasus region for health reasons, where he spent more than a year in Stavropol, Piatigorsk, and Kislovodsk. Here Aliab'ev became acquainted with the music, dances, and instruments of the Caucasian peoples, undertaking to transcribe songs of the Circassian, Kabardinian, Georgian, Azerbaijanian, and Turkmenian tribes. A chance meeting with the noted Ukrainian folklorist Mikhail Maximovich (1804–73) led to a collaboration that produced the first printed collection of Ukrainian folk songs—a collection that played as significant a role in the development of Ukrainian music as the Trutovsky and Lvov-Práč volumes played in Russian music.[8] His request to remain longer in the Caucasus denied, Aliab'ev was transferred in the fall of 1833 to Orenburg, at the foot of the South Ural Mountains. Now his new-found fascination led him to

seek out the music of the indigenous Central Asian and Trans-Volga peoples; he transcribed Bashkir and Kirghiz songs and even composed a symphonic overture on Bashkir folk themes. This was followed in 1834 by a collection entitled *The Caucasus Singer (Kavkazskii Pevets)* (Aliab'ev himself seems to have published it, arranging for it to be lithographed by F. Bartoldi in Moscow and sold there by the Music Store of Gresser & Miller[9]). The songs here may be considered the prototype of a genre that would be assiduously cultivated by the coming generation of nationalists—the "Asiatic song." These pieces depend not on folk-song quotation but on Aliab'ev's free interpretation and transformation or paraphrase of the music he gathered among the peoples of the Caucasus. The pitch and rhythmic elements that distinguished the songs of Russia's non-European peoples offered Aliab'ev and his nationalist successors a repository of musical structures utterly unlike any in the Western tradition. Small wonder that these Eastern elements figured so prominently in that vision of a "special destiny" for Russian music shared by Balakirev and his nationalist league—a vision that idealized Russia's Asiatic heritage in music no less than the Slavophiles idealized it in moral philosophy.

Through the intercession in 1834 of the governor-general of Orenburg, Aliab'ev was granted permission by Tsar Nicholas I to live with his relatives, but he was denied access to either of the capital cities and had to register with the local police at his place of residence. He immediately moved to the Moscow Province, then slipped into the city, where he remained illegally for a time. But news of his presence there reached the tsar, who promptly had him consigned to Kolomna, a city some seventy miles southeast of Moscow. Finally, in 1843, he was allowed to settle in Moscow under police supervision, but without the right to appear in public.

Toward the end of his confinement in Kolomna, Aliab'ev began his last opera. He had completed two many years before and was at the moment already well along in yet another one (of six in all, two remained unfinished at the time of his death). But Bestuzhev-Marlinsky's tale of *Ammalat-bek* seized his imagination with its vivid account of cultures in confrontation amidst the romanticized images of the rugged Caucasian wilderness. Russia had claimed control over the northern foothills and slopes of the Caucasus Mountains with the annexation of Georgia in 1801, but efforts at pacification of the territory extended into the mid-nineteenth century and would end only with Shamil's surrender in 1859. Thus Bestuzhev-Marlinsky's theme spoke with powerful immediacy to Aliab'ev, both because of its currency and because of his personal knowledge of the region and its proud, independent peoples. The musical substance of the score would be fashioned from

the authentic songs he himself had transcribed. Aliab'ev finished the opera in 1847, but his dream of seeing it staged was thwarted. He even appealed to Alexander Dargomyzhsky (1813–69) for intercession with the Imperial Theaters Directorate, but the bureaucracy refused to budge. Verstovsky's role in this affair remains obscure, although by now he was office manager of the Moscow branch of the directorate.

Despite Aliab'ev's interest in folk music during the last two decades of his life and the significant impact that interest had on the works singled out for discussion here (especially their anticipation of the concerns that would motivate Aliab'ev's *declared nationalist* successors), the embodiment of national consciousness in music remained an essentially incipient component of his creative expression. His *oeuvre* encompassed all the genres found in Russian music of the 1820s–40s: vaudevilles and operas, cantatas, choruses, more than thirty works for orchestra and wind band (symphonies, overtures, marches, dances of various sorts, including polonaise, mazurka, waltz, and quadrille), chamber music, piano pieces, and more than 150 "Russian songs" and "Russian romances." Most of his output—certainly the symphonic and chamber works—reveals a fundamental dependence on European stylistic norms unqualified by features that might distinguish them from the Western mainstream. Only his "Russian songs" and "romances" occasionally seem to reflect the melodic contours and scale formations of his native Russian folk music, although at the same time the frequent juxtaposition of parallel major and minor, the unexpected enharmonic modulations and mediant relationships, the expressive use of altered chords and dramatic unisons *all* suggest the equally profound influence of Schubert's *Lieder*. A few of his pieces—the "Russian song" "The Nightingale" *(Solovei)*, the chorus "From a Distant Land" *(Iz strany, strany dalëkoi)*, the "Russian romance" "The Beggar Woman" *(Nishchaia)*—gained such widespread popularity throughout Russia and became so thoroughly absorbed into the people's consciousness at all levels of society that they attained the virtual status of "folk songs." But authentic folk song, for all its importance to Aliab'ev at significant moments and in particular works, remained at the periphery of his creativity, whereas for his contemporaries Alexander Varlamov and Alexander Gurilyov, it occupied a position closer to the center.

Varlamov and Gurilyov introduced a new current in Russian vocal chamber music of the 1830s–40s. Both found the "Russian song" and "Russian romance" the most congenial genres for self-expression. Both sought inspiration in the Russian folk-song tradition, though most often indirectly—refracted through the tradition of the "urban folk song." Both descended from a social milieu closer to the common folk than to the aristocracy, perhaps making folk music more of a reality to them than to composers from more privileged backgrounds.

Alexander Varlamov (1801–48), son of a retired noncommissioned military officer, enjoyed few musical advantages at home, though he taught himself to play violin by ear. Noting the lad's enthusiasm for music, family friends persuaded the father to sign ten-year-old Alexander into the custody of the Imperial Chapel Choir in St. Petersburg, where he worked and studied from 1811 to 1819. Although singing was his first responsibility there, instrumental music continued to attract him: he carried on the violin, started guitar, and eventually studied both piano and cello as well. His lovely preadolescent voice secured assignment among the soloists in the choir, calling him to Bortniansky's attention. The famed *Kapellmeister* took personal interest in the youngster's future, encouraging and advising him, according to Varlamov, who years later credited Bortnianky with teaching him everything he knew about vocal artistry,

In 1819 Varlamov was assigned as *regent* (precentor) to the Russian Embassy Church at The Hague in the Netherlands. His stay in Holland and Belgium (1819–23) introduced him to the richness of European musical life and marked his first public appearances as a chamber concert singer and guitar soloist. Returning to St. Petersburg in 1823, he taught singing in a theatrical school but managed in 1829 to secure an appointment to the Imperial Chapel Choir. Still he found it difficult to support his family on his modest income from the post, and he continued to teach voice on the side in schools and private homes. In 1832 he accepted appointment as assistant to the *Kapellmeister,* then as staff composer at the Moscow Imperial Theaters. In the latter capacity, he wrote incidental music to various types of theatrical productions (most of the music has not survived, though individual songs and romances originally composed for some of the productions were sometimes published separately).

The new Moscow of the 1830s–40s, rising vigorously from the ashes of the old, threatened to eclipse St. Petersburg with its surge of cultural activity. Whether from genuine sympathy for official ideology— Orthodoxy, Autocracy, Nationality—or newly aroused Slavophiliac sentiment, Moscow seemed permeated by a sense of national consciousness and pride in her Russian heritage—a heritage so distinct from that of St. Petersburg. Small wonder that the musical part of that heritage should receive special attention in the city's cultural life. Not only was folk song performed and enjoyed at every level of society, but composers began more and more to cultivate a folk-song style in their "Russian songs" and "Russian romances," freely interpolating authentic folk elements into these genres and thus distancing them still further from the contemporary European art or salon song.

Varlamov found Moscow's cultural atmosphere highly congenial. The full range of its rich musical life interested him, from the fashionable art

of the Imperial Theaters to the popular songs of gypsy singers heard at local cafés. He became fast friends with Alexander Gurilyov, a young composer of like mind and similar interests. Both found stimulus to their creativity in the poems of Nikolai Tsyganov (1797–1831). Tsyganov, a noted actor in Moscow's Maly Theater, incorporated in his poems many of the structural and thematic features of folk verse; he also approximated the often ingenuous lyric imagery of his model, along with such familiar motifs as the harshness of fate for the common man—or woman, since many of his poems recount the almost ritualistic events of pain or sorrow in the life of peasant women. Of nine songs contained in Varlamov's *Music Album for 1833* (*Muzykal'nyi al'bom na 1833*), dedicated to Verstovsky (privately published, Moscow, 1833), four were on poems by Tsyganov, including "Mama, Don't Sew Me a Red Sarafan" *(Ne shei ty mne, matushka, krasnyi sarafan).*[10] "Red Sarafan" was to become one of Russia's all-time hits, "sung by every social class—in the parlors of noblemen as well as in the shanties of peasants,"[11] in the words of Nikolai Titov (1800–75), Varlamov's contemporary and a noted composer in his own right. Tsyganov's poem deals with one of the most widespread themes in Russian folklore—the plight of the maiden whose carefree existence must inevitably come to an end with marriage. Although Varlamov's music to the poem reveals less connection with authentic folk sources than Tsyganov's text, the song actually appeared in some later nineteenth-century published collections of Russian folk music without Varlamov's name, as if it really were a genuine folk song.[12]

Moscow also introduced to Varlamov the performance tradition of gypsy singers—a tradition that he helped to translate into the genre of the "Russian gypsy song." He attempted in his gypsy songs to re-create the profuse emotionalism, the taut rhythmic flexibility, and the exuberant energy of the gypsy performers who enjoyed such great popularity among all classes of Russian society during the nineteenth century.

In 1843, after having served nearly twelve years in the Moscow Imperial Theaters, Varlamov was compelled to resign. Verstovsky may have played some part in this. Jealous of his position in the Moscow branch of the directorate and neurotically self-centered, he could not abide any threat to his preeminence as a composer or a musical power in Moscow. Moreover, his hostility toward Varlamov is documented in contemporary memoirs.[13] During the Moscow years Varlamov had unquestionably established his name in Russian music: he had published over one hundred "Russian songs" and "Russian romances," issued a music journal—*The Aeolian Harp (Eolova arfa)* (1834–35)—appeared successfully as an orchestral and choral conductor and as a concert singer renowned especially for performances of his own songs, and se-

cured a reputation as a teacher of singing whose method had been cod-
ified in a widely circulated *Complete School of Singing (Polnaia shkola
peniia)* (Moscow, 1840), dedicated to the memory of his teacher
Bortniansky.

At the beginning of 1845, Varlamov moved back to St. Petersburg,
hoping to gain reappointment at the Imperial Chapel Choir, but politics
at court blocked his chances. He gave singing lessons and concerts to
augment his modest pension from the Imperial Theaters, but his large
family and his own impracticality combined to keep him in continual
financial need. He sought distraction from personal hardship in St.
Petersburg's stimulating artistic-literary life, which brought him into
contact with the poet-critic Apollon Grigoriev (1822–64), a devotee
and connoisseur of Russian folklore, who may have given him the idea
for his last major musical project—the publication of one hundred
Russian folk songs harmonized by himself. For a musician whose indi-
viduality had evolved in direct proximity to the rural and urban tradi-
tions of Russian folk song, such an undertaking seemed especially
appropriate: as a performer he had always included folk song in his
repertoire; as a teacher he had sought to cultivate a Russian school of
singing based on a thorough analysis of the Russian folk *melos* and its
authentic performance traditions; as a composer he had developed a
personal musical language whose stylistic precepts reflected the princi-
ples of creativity peculiar to Russia's native music.

Varlamov's best "Russian songs" in folk style (mostly to texts by
Tsyganov, Alexei Kol'tsov [1809–42], and Alexei Timofeev [1812–
83]) closely paralleled the authentic prototype, often suggesting varia-
tions on familiar modes. Two basic types could be identified—the lei-
surely spun-out lyric song *(protiazhnaia pesnia)* and the brisk, energetic
dance song *(pliasovaia pesnia)*. The *protiazhnaia pesnia* in particular re-
vealed Varlamov's indebtedness to the Russian folk-song model, with its
growth process based on (1) the assemblage of an extended melody in
stages from an initial growth figure or *popevka,* whose characteristic
intervals were subject to varied repetition according to traditional *for-
mulaic* patterns, (2) the nonlinear recurrence of the assembled melody,
again by varied repetition of its constituent melodic figures, and (3) the
elaboration of the melodic line by *formulaic* ornamental melismas at ex-
pressive moments in an otherwise prevailingly syllabic setting of the
text. Such original songs as "Ah, Time, thou precious Time" *(Akh ty,
vremia, vremechko)* and "Why, dear Grass, hast thou yellowed so early?"
(Chto ty rano, travushka, pozheltela?) proved so effective in their evoca-
tion of the folk spirit and in their appeal to a wide public, that they
came to be thought of during the later nineteenth century as the true
property of the people and an authentic part of their folk-song heritage.

Only forty-three of the projected one hundred folk songs were actually published in a collection called *The Russian Singer (Russkii pevets)* (St. Petersburg, 1846). Varlamov died of laryngeal phthisis in 1848 before he could finish a second volume. In the preface to the published volume, he wrote: "Our native song has long remained forgotten on the lips of common folk, and were it permitted to appear midst the highest estates, then only in artificial guise capriciously prescribed by inconstant and fickle fancy. . . ." Going on, he insisted that for his collection he had presented "the song [in its] native simplicity, as the people created it."[14]

Varlamov's contemptuous reference to native song "in artificial guise" may well refer to the continuing popularity in Russia's *haut monde* of variations on folk songs—a genre that entertained amateurs of the privileged class throughout the nineteenth century. Yet his friend and companion in dedication to the genres of the "Russian song" and "Russian romance"—a compatriot equally close to the traditions of both rural and urban Russian folk song—produced a few restrained and tasteful piano variations on native folk tunes, as well as some brilliant virtuoso sets on popular "Russian songs," including some of Varlamov's. Alexander Gurilyov (1803–58), son of the renowned serf musician Lev Gurilyov (1770–1844), grew up in the exceptionally rich musical environment of Count Vladimir Orlov's (1743–1831) country estate *Otrada* (Delight) near Moscow. Alexander's father, a student of Sarti's, served as composer and music instructor, as well as conductor of the serf orchestra, reputed to be one of the finest in Russia. Lev began training his son early, and the boy's progress on violin and viola, started at age six, soon secured the youngster a chair in the orchestra. Later he would play viola in the quartet of Prince Nikolai Golitsyn (Galitzin) (1794–1866), a gifted amateur musician who was a correspondent and patron of Beethoven's.[15] The famous musicians of the era often performed at *Otrada,* among them John Field, who may have given piano lessons to the young Gurilyov. In any case, the piano more than any other instrument attracted him, and Field's style of composition and manner of performance profoundly influenced the development of Gurilyov's superior pianistic talent.

In 1831, after Count Orlov's death, the Gurilyov family received its freedom, and Alexander was registered as a "burgher" in the category of "craftsman" (a lower-middle-class designation) with the Moscow Board of Trade. (As with all children of serfs who were trained as musicians, he had been trained in a craft as well as in music.) Gurilyov's future friend Varlamov moved to Moscow the very next year, and the eventual friendship of the two young Alexanders would contribute mutually to their professional careers. Both sought inspiration in Russian folk music, admired good choral singing, and avidly absorbed the

traditions of Moscow's renowned gypsy singers. By the early 1840s, Gurilyov's "Russian songs" and "Russian romances" had established his name as a composer, his concert appearances had earned him a reputation as one of Moscow's best pianists, and his teaching had attracted a large class of private students. Even so, financial difficulties beset him throughout his life, forcing him at times to work long hours as a music proofreader in addition to everything else.

Gurilyov's collection of *Forty-Seven Russian Folk Songs (Sorok sem' russkikh narodnykh pesen)* for voice and piano (Moscow, 1849) provides important insight into his conception of folk music—insight that illuminates as well the manner in which the folk tradition manifests itself in Gurilyov's original compositions. Although the title specifies "folk songs," without further qualifications, the collection contains songs of comparatively recent urban origin alongside songs of the ancient rural folk tradition, both arranged in a contemporary style that features harmonizations and accompanimental patterns reminiscent of the fashionable romance. Gurilyov also introduces elements adapted from the performance style of the current popular gypsy singers, who frequently included traditional Russian folk songs in their repertoire, modifying the melodic figures or *popevki* with melismatic interpolations, dramatic accents, and vocal effects of various kinds intended to heighten expressiveness. Gurilyov attempts to achieve similar results in his arrangements. Considering the choice of songs, the scope and variety of types, and the "period style" of their arrangements, Gurilyov's collection amounts virtually to an encyclopedia of what Russians were singing in the 1830–40s.[16]

Like his friend Varlamov, Gurilyov clearly considered "folk song" a rather broad and flexible designation for songs "popular among the folk," whatever their origin. Since a demand existed for such songs, those that had achieved popularity—whether they were authentic folk songs, more recent urban songs, or newly composed songs—became the models for his own output. Just as the somewhat sentimental style of the popular "Russian romance" infiltrated his collection of *Forty-Seven Russian Folk Songs,* it infiltrated his own "Russian songs," making them much more salonlike than those of Varlamov. Not that he excluded the rural folk-song influences of the sort Varlamov had so successfully been able to incorporate; rather, Gurilyov attempted to synthesize the two almost contradictory traditions. For example, he could accommodate his penchant for waltz rhythms (so pervasive in all contemporary salon genres) quite comfortably to the well-liked pseudo-folk verse of Alexei Kol'tsov, whose texts he often set (as did Varlamov). One of the traditional meters of Russian rural folk poetry was based on a pentasyllabic foot with the stress on the third syllable:

Ĭz pŏd k̆amĕshk̆a, ĭz pŏd b̆elŏv̆a,
Frŏm bĕneáth ă stŏne, 'neăth ă shíny̆ stŏne,
P̆rotĕkál rŭch̆ei bĕl sĕrébr̆enŏi,
Gŭshed ă lĭttle brŏok brĭght aňd sílv̆ery̆.[17]

This metrical scheme, illustrated here in an authentic bit of Russian folk verse, appears so frequently in Kol'tsov's poetry that it has sometimes been called "Kol'tsovian meter." Gurilyov would take one of Kol'tsov's pseudo-folk verses, such as *The Maiden's Melancholy* (*Grust' devushki*), set in motion a simple waltz accompaniment, then infuse the melodic line with structural conventions from Russian rural folk song, thus creating a hybrid genre as distinctively Russian sounding as songs more obviously reliant on folkloric sources.

Although less influential in their own time, as well as later, than his eighty-eight "Russian songs" and "Russian romances," Gurilyov's piano variations on Russian folk tunes added to the reservoir from which the avowed nationalists would draw elements to nurture their movement. Despite Varlamov's slighting reference to native song "in artificial guise," the techniques developed by composers of folk-song variations in the first half of the nineteenth century anticipated the procedures refined by their successors.

Unlike his concert variations on tunes from contemporary operatic successes (e.g., his set on themes from Donizetti's *Lucrezia Borgia*) or popular "Russian songs" and "Russian romances" of his era (e.g., those on Varlamov's "Wakest Her Not at Dawn" [*Na zare ty eë budi*]), which so clearly reflected the John Field school of virtuoso pianism, Gurilyov's folk-song variations suggested more the character of teaching pieces. He may well have composed them for his students and thus felt constrained to limit virtuosic elements. His variations on "This Is Not White Snow" (*Ne bely to snegi*), "All around the Village, Katinka" (*Po vsei derevne Katin'ka*), "Ah, on the sea"[18] (*Akh po moriu*), "The Neighbor Had a Hut"[19] (*U soseda khata byla*), and those which he contributed to his father's set on "What Happened to the Maiden" (*Chto devushke sdelalos'*) reveal an imaginative exploitation of contrasting pianistic textures and sonorities, despite their modest technical demands.

Our discussion of the increasing importance of native rural folk music to Russian urban culture during the first half of the nineteenth century and the growing body of newly composed, protonationalist art music correlative to it would be incomplete without recognizing the activities of Daniil Kashin (1770–1841) and Ivan Rupin (1792–1850), both of whom gained great fame as concert performers and collectors of Russian traditional folk song. Kashin, born a serf, studied first with the *Kapellmeister* of Gavril Bibikov's (?–1812) serf orchestra, then later with

Sarti. One of the first Russian musicians to make a success of public performance, his career as pianist and conductor spanned from 1790 to 1830. He received his freedom in 1799, at which time he became associated with Moscow University, where he arranged concerts, conducted the orchestra, taught music, and composed choral and instrumental music for ceremonial occasions. His profound interest in folk song antedates the national surge of patriotism engendered by the War of 1812. In 1806 he wrote in the preface to his first publication containing folk songs collected and arranged by himself:

> The love and affection of Russians for everything national [*otechestvennyi*] induces Mr. Kashin to publish *The Journal of National Music* [*Zhurnal otechestvennoi muzyki*]. In it will be included, first of all, ancient music on old Russian [epic] tales. . . . The music of these tales consists of rarities precious to every Russian. . . . Mr. Kashin, hoping that his journal might become in some sense a history of and a memento of gradual changes and successes for Russian song, earnestly beseeches the gentle person who loves music to honor us with his information about native tunes and texts for this journal.[20]

Kashin published twelve issues of the journal between 1806 and 1809, making available the first printed examples of Russian epic songs, the *byliny*, along with numerous other arrangements and many folk-song variation sets. These quickly won the public's favor, in part because of frequent concert performances (many by Kashin himself), which stimulated wide interest and prompted amateur performances. Kashin's major contribution to the body of folk music accessible to the urban population appeared with publication of the two-volume *Russian Folk Songs* (*Russkie narodnye pesni*) (Moscow, 1833–34; 2d ed., 3 vols., Moscow, 1841). His arrangements, like those of Gurilyov, are tinctured by the contemporary romance, although he declared of his approach: " . . . [I] aimed, in particular, to preserve the melody of our splendid songs, to add nothing to foreign. . . ."[21]

Rupin, born a serf like Kashin, attracted attention as a child for his exceptionally beautiful voice. Sent to Moscow as a young man to study with the Italian Pietro Muschietti (dates unknown), he quickly earned a reputation as a master of *bel canto,* but his lack of the requisite physical attributes prevented him from making a career as an opera singer. After gaining his freedom, he moved to St. Petersburg, where he studied composition and expanded his activity as a concert singer, using the pseudonym "Rupini." His performing repertoire included his own "Russian songs" and "Russian romances" (some fifty survive), as well as Russian folk songs in concert arrangements by himself, which featured elaborate vocal *colorature* in the conventional *bel canto* manner. He restrained this "concert" exuberance, however, in his published folk-song

transcriptions, reproducing the traditional *formulaic* melodic figures with greater precision and more careful text underlay than did such earlier collectors as Trutovsky or Lvov-Práč.[22] His first volume of folk songs—*A Collection of Twelve Russian National Songs (Sobranie dvenadtsati natsional'nykh russkikh pesen)*, "arranged for fortepiano with voice and chorus, published by the teacher of singing I. A. Rupini" (St. Petersburg, Part 1, 1831; Part 2, 1833)—presented each song in two arrangements, one for soloist with a guitarlike piano accompaniment and another for three-part chorus (reminiscent of the Russian lyric *kant* style). The success of this collection led to another equally successful one, *Seven Russian Folk Songs (Sem' narodnykh russkikh pesen)* for voice with piano accompaniment, which also included variations for piano alone (St. Petersburg, 1836). Although he continued to contribute individual folk-song arrangements to anthologies and music journals, he published no further collections of his own.

Neither Kashin nor Rupin carved out their niches in nineteenth-century Russian music by means of incisive creativity. Their importance derives rather from their roles as central participants in and contributors to the burgeoning folk-song movement that spread through Russian urban culture between 1810 and 1840 and nurtured a national consciousness whose consequences became increasingly manifest in the expanding repertoire of Russian art music both before and after mid-century.

Because folk song has been made the touchstone for testing emergent national consciousness within the mainstream of Russian music during the first half of the nineteenth century, perspective on the full range of original musical activity by Russian composers in that period has inevitably been restricted. Still, proximity to this primary source of "nationality" served as the crucial gauge (though, admittedly, not the sole one) by which the self-proclaimed generation of nationalist composers and critics would continue to measure the Russianness of a work. The central importance of this gauge can be validated by sampling critical reaction to Mikhail Glinka's path-breaking *A Life for the Tsar* (1836).

Nikolai Melgunov (1804–67), member of the Society of the "Lovers of Wisdom" (*Obshchestvo liubomudriia*) and an influential music critic, writer, and composer, wrote of Glinka's achievement: "He understood the meaning of the words 'Russian music' [and] 'Russian opera' differently from his predecessors. He did not limit himself to more or less imitating the folk *melos, . . .* he opened up an entire system of Russian melody and harmony drawn from folk music itself and not comparable to any one of the previous schools."[23] The radical social critic Vissarion Belinsky (1811–48) observed that in *A Life for the Tsar* one can see

"the striving to utilize in cultured (uchënaia) music elements of folk music," and ratified the results by declaring, "that is fine and good, a promise and a guarantee for a bright future."[24] Prince Vladimir Odoevsky, staunch believer in the redemptive role of Russia in world civilization, announced jubilantly:

> . . . the question about the importance for art in general and for Russian art in particular of a *Russian* opera, a *Russian* music, indeed, of a *national* [*narodnaia*] music in general, has been answered in this opera. . . . The composer has plumbed deeply the character of Russian melody. Richly gifted, he has proven by brilliant example that Russian melody—already, of course, plaintive, joyous, bold—can be elevated to tragedy. . . .
> In Glinka's opera has appeared that which was so long sought but never found in Europe—*a new principle in art,* which inaugurates in art history a new era: *the era of Russian music.*[25]

Nikolai Gogol (1809–1852), master of Russian literature and mystic seeker of the way to Russia's "special destiny," foresaw the fate of Russian music prophesied in Glinka's work: "What an opera could be composed from our national melodies! Show me a people who have more song. . . . Glinka's opera is only a glorious beginning."[26] Pushkin, inspired voice of a generation, proclaimed his homage in a graceful pun that played on the Russian meaning of *glinka*—a diminutive of the word for clay, *glina:*

> Sing Russian choir the rapt refrain,
> The newest novelty relay.
> Our Glinka's not just petty clay—
> Rejoice! He's finest porcelain!
>
> *Poi v vostorge, russkii khor,*
> *Vyshla novaia novinka.*
> *Veselisia, Rus! Nash Glinka—*
> *Uzh ne Glinka, a farfor!*[27]

From the perspective of nearly 150 years, 1836 appears as a kind of watershed in Russian cultural history, marking the point when currents that would course together only during the second half of the century started to separate from the cultural mainstream of the earlier era. *A Life for the Tsar,* like Halley's Comet the year before, was widely acclaimed as a harbinger of profound change. The next year, Pushkin's luminous genius was senselessly extinguished, but only after he had given Russia her first important novel. *The Captain's Daughter* (*Kapitanskaia doch'*) (1836). Gogol's mordant comedy *The Inspector General* (*Revizor*) (1836) culminated the early phase of a career that would

reach its apex only six years later in the masterful *Dead Souls* (*Mërtvye dushi*). Preaching profound change in the sacred cause of Russia's "special destiny," Pyotr Chaadaev's (1794–1856) first *lettre philosophique* (1836) demanded radical rejection of both Russia's past and present, thus launching the opening salvo in the often bitter debates between the Slavophiles and the "Westerners." Karl Briullov (1799–1852) exhibited his monumental *The Last Day of Pompeii* (*Poslednii den' Pompei*) (1833), prompting speculation that his painting prophesied the decline of the West and implied the coming preeminence of Russia.

In music, Glinka occupied the crucial position. On the one hand, he represented the final flowering of that movement toward national consciousness whose roots extended back into the eighteenth century; on the other, he represented the first fruit of the declared nationalist school of composers whose full harvest would yield only during the latter part of the nineteenth century. He shared that aspiration to a "special destiny" that constituted the undercurrent of Russian thought as his century passed its midpoint—an aspiration that would culminate toward the end of the century in a remarkable generation of composers, whose creative authority and originality would demand recognition by the West and would validate decisively Russia's claim for equality, if not preeminence, in the community of Western music.

APPENDIX

Readers of English who do not know Russian often mistakenly believe that the Russian patronymic is a middle name, i.e., a second *given* name, such as one frequently encounters in the English-American cultural tradition. Moreover, the conventions of written English advocate that persons mentioned in context be identified by their given name or names, rather than by initials alone, as commonly happens in Russian writing. Patronymics, therefore, have been omitted from references to Russian names in the text of this essay. Still and all, a patronymic may be crucial to establishing the identity of someone in Russian history. For the convenience of the historian of Russian culture, the list following provides full name and patronymic for the native Russians mentioned in the essay.

 Ablesimov, Alexander Onisimovich (1742–1783)
 Aksakov, Sergei Timofeevich (1791–1859)
 Aliab'ev, Alexander Alexandrovich (1787–1851)
 Arapov, Pimen Nikolaevich (1796–1861)
 Belinsky, Vissarion Grigorievich (1811–48)
 Berezovsky, Maxim Sozontovich (1745–77)

Bestuzhev-Marlinsky, Alexander Alexandrovich (1797–1837)
Bibikov, Gavril Ilich (?–1812)
Bortniansky, Dmitry Stepanovich (1751–1825)
Briullov, Karl Pavlovich (1799–1852)
Chaadaev, Pyotr Iakovlevich (1794–1856)
Dargomyzhsky, Alexander Sergeevich (1813–69)
Davydov, Stepan Ivanovich (1777–1825)
Delvig, Baron Anton Antonovich (1798–1831)
Dubiansky, Fyodor Mikhailovich (1760–96)
Fomin, Evstignei Ipatovich (1761–1800)
Galitzin. *See* Golitsyn
Genishta, Osip Osipovich (1795–1853)
Glinka, Mikhail Ivanovich (1804–57)
Gogol, Nikolai Vasilievich (1809–52)
Golitsyn, Prince Nikolai Borisovich (1794–1866)
Griboedov, Alexander Sergeevich (1795–1829)
Grigoriev, Apollon Alexandrovich (1822–64)
Gurilyov, Alexander Lvovich (1803–58)
Gurilyov, Lev Stepanovich (1770–1844)
Kashin, Daniil Nikitich (1770–1841)
Katenin, Pavel Alexandrovich (1792–1853)
Khandoshkin, Ivan Evstafievich (1747–1804)
Khmelnitsky, Nikolai Ivanovich (1791–1845)
Kol'tsov, Alexei Vasilievich (1809–42)
Krasnopolsky, Nikolai Stepanovich (dates unknown)
Krylov, Ivan Andreevich (1769–1844)
Lvov, Nikolai Alexandrovich (1751–1803)
Maikov, Vasily Ivanovich (1728–78)
Marlinsky, pseud. of A. A. Bestuzhev
Maximovich, Mikhail Alexandrovich (1804–73)
Melgunov, Nikolai Alexandrovich (1804–67)
Odoevsky, Prince Vladimir Fyodorovich (1803–69)
Orlov, Count Vladimir Grigorievich (1743–1831)
Ostrovsky, Alexander Nikolaevich (1823–86)
Pashkevich, Vasily Alexeevich (c. 1742–97)
Popov, Mikhail Ivanovich (1742–c. 1790)
Pushkin, Alexander Sergeevich (1799–1837)
Rupin, Ivan Alexeevich (1792–1850)
Shakhovskoy, Prince Alexander Alexandrovich (1777–1846)
Sheremetev, Count Nikolai Petrovich (1751–1809)
Shevyryov, Stepan Petrovich (1806–64)
Sokolovsky, Mikhail Matveevich (c. 1756–?)
Sumarokov, Alexander Petrovich (1718–77)
Teplov, Grigory Nikolaevich (1711–79)
Timofeev, Alexei Vasilievich (1812–83)
Titov, Alexei Nikolaevich (1769–1827)
Titov, Nikolai Alexeevich (1800–75)
Trutovsky, Vasily Fyodorovich (c. 1740–1810)
Tsyganov, Nikolai Grigorievich (1797–1831)
Urusov, Prince P. V. (dates unknown; given name and patronymic unknown)

Varlamov, Alexander Egorovich (1801–48)
Verstovsky, Alexei Nikolaevich (1799–1862)
Vielgorsky, Count Mikhail Yurevich (1788–1856)
Volkonsky, Prince Pyotr Mikhailovich (1776–1852)
Vorontsov, Count Alexander Romanovich (1741–1805)
Vsevolozhsky, Nikita Vsevolodovich (1799–1862)
Wielhorsky. *See* Vielgorsky
Zagoskin, Mikhail Nikolaevich (1789–1852)
Zhandr, Andrei Andreevich (1789–1873)
Zhukovsky, Vasily Andreevich (1783–1852)

NOTES

1. Among this fundamental research, a few books were indispensable, constantly at hand during the preparation of the present essay. I acknowledge them first:

Findeizen, Nikolai Fёdorovich, *Ocherki po istorii muzyki v Rossii s drevneishikh vremёn do kontsa XVIII veka* (*Essays on the history of music in Russia from the most ancient time to the end of the XVIII century*), 2 vols. (Moscow & Leningrad: Muzsektor, Gos. Iz-vo, 1928–29);
Ginzburg, Semёn L'vovich, comp. & ed., *Istoriia russkoi muzyki v notnykh obraztsakh* (*History of Russian music in musical examples*), 3 vols. (Moscow: Muzyka, 1968–70);
Istoriia russkoi muzyki (*History of Russian music*), vol. 1, ed. Aleksei Ivanovich Kandinskii et al., 2d ed. (Moscow: Muzyka, 1973), hereafter cited as *IRM;*
Mooser, Robert Aloys, *Annales de la musique et des musiciens en Russie au XVIIIme siècle*, 3 vols. ([Geneva]: Mont-Blanc [1948–51]), and *Opéras, intermezzos, ballets, cantates, oratorios joués en Russie durant le XVIIIme siècle*, 3d ed., rev. (Basel: Barenreiter [1964]);
Muzykal'naia entsiklopediia (*Encyclopedia of music*), 5 vols., ed. Iurii Vsevolodovich Keldysh et al., vols. 1–4 (Moscow: Sovetskaia entsiklopediia and Sovetskii kompozitor, 1973–78 [vol. 5 has not yet been published]), hereafter cited as *ME;*
Shteinpress, Boris Solomonovich, and Izrail' Markovich Iampol'skii, authors and compilers, *Entsiklopedicheskii muzykal'nyi slovar'* (*Encyclopedic dictionary of music*) 2d ed., rev. & enl. (Moscow: Sovetskaia entsiklopediia, 1966);
Vol'man, Boris L'vovich, *Russkie notnye izdaniia XIX —nachala XX veka* (*Russian music publications of the XIX to the beginning of the XX centuries*) (Leningrad: Muzyka, 1970), hereafter cited as Vol'man II, and *Russkie pechatnye noty XVIII veka* (*Russian printed music of the XVIII century*) (Leningrad: Muzgiz, 1957).

A number of other books not cited in later footnotes also deserve mention for their important contribution to an understanding of the period under discussion:

Alekseev, Aleksandr Dmitrievich, *Russkaia fortepiannaia muzyka, ot isto-kov do vershin tvorchestva* (*Russian piano music, from its sources to its creative summit*) (Moscow: Akademii nauk SSSR, 1963);

Aseev, Boris Nikolaevich, *Russkii dramaticheskii teatr ot ego istokov do kontsa XVIII veka* (*Russian dramatic theater from its sources to the end of the XVIII century*) (Moscow: Iskusstvo, 1977);

Brodskii, N. L., *Leteraturnye salony i kruzhki, pervaia polovina XIX veka* (*Literary salons and circles, the first half of the XIX century*) (Moscow & Leningrad: Academia, 1930);

Cheshikhin, Vsevolod Evgrafovich, *Istoriia russkoi opery (s 1674 po 1903 g.)* (*History of Russian opera [from 1674 through 1903]*) (St. Petersburg: Iurgenson, 1905);

Glumov, Aleksandr Nikolaevich, *Muzyka v russkom dramaticheskom teatre* (*Music in the Russian dramatic theater*) (Moscow: Muzgiz, 1955);

Gozenpud, Abram Akimovich, *Russkii opernyi teatr XIX veka* (*Russian opera theater of the XIX century*), vol. 1: 1836–1856 (Leningrad: Muzyka, 1969);

Iampol'skii, Izrail' Markovich, *Russkoe skripichnoe iskusstvo* (*Russian violin art*) (Moscow & Leningrad: Muzgiz, 1951);

Istoriia russkogo dramaticheskogo teatra (*History of the Russian dramatic theater*), 7 vols., ed. Iu. A. Dmitriev et al., vols. 1–3 (Moscow: Iskusstvo, 1977–78);

Keldysh, Iurii Vsevolodovich, *Russkaia muzyka XVIII veka* (*Russian music of the XVIII century*) (Moscow: Nauka, 1965);

Livanova, Tamara Nikolaevna, and Vladimir Vasil'evich Protopopov, *Opernaia kritika v Rossii* (*Opera criticism in Russia*), vol. 1, parts 1 and 2 (Moscow: Muzyka, 1966–67);

Raaben, Lev Nikolaevich, *Instrumental'nyi ansembl' v russkoi muzyke* (*The instrumental ensemble in Russian music*) (Moscow: Muzgiz, 1961).

2. Quoted in Abram Akimovich Gozenpud, *Muzykal'nyi teatr v Rossii ot istokov do Glinki* (*Musical theater in Russia from its origins until Glinka*) (Leningrad: Muzgiz, 1959), p. 83.

3. I take this opportunity to acknowledge the generosity of my distinguished colleague, musicologist and lexicographer Nicolas Slonimsky, who read through the entire typescript of my essay and made a number of helpful suggestions for improving it. He proposed "rustic" as the most appropriate translation of the Russian adjective *prostoi* in the title of Trutovsky's collection.

4. I am indebted to my friend Simon Karlinsky—scholar, literary historian, and musician—for suggesting "leisurely" as an apt translation for the Russian *protiazhnaia*, which literally means "protracted" or "drawn-out." Professor Karlinsky's suggestion conveys the mood and pacing of such songs very well indeed. But my esteemed colleague Richard Taruskin has suggested what I believe to be an equally appropriate translation, "melismatic," which has the advantage of conveying yet another important style feature of these *protiazhnaia* songs, their highly embellished vocal lines. Unable to choose between these two translations and incapable of coming up with a better one myself, I use them both.

5. Quoted in *IRM*, pp. 312–13.

6. Quoted in Aleksandr Semënovich Rabinovich, *Russkaia opera do Glinki* (*Russian opera before Glinka*) (Moscow: Muzgiz, 1948), p. 166.

7. Vol'man II, p. 12.

8. Maximovich's collection of Ukrainian folk-song texts appeared in 1834, accompanied by a separate volume [*tetrad' 1*] that contained Aliab'ev's arrangements of tunes noted down by Maximovich. See Boris Solomonovich Shteinpress, "Pervyi muzykal'nyi sbornik ukrainskikh narodnykh pesen (istoriko-kriticheskii ocherk)" ("The first music collection of Ukrainian folk songs [a historical-critical essay]"), in *Golosa ukrainskikh pesen, izdannye Mikhailom Maksimovichem. Aranzhirovka Aleksandra Aliab'eva (Voice-parts of Ukrainian songs, published by Mikhail Maximovich. Arranged by Alexander Aliab'ev)*, ed. B. S. Shteinpress (Moscow: Muzgiz, 1961).

9. Vol'man II, p. 194.

10. Varlamov himself probably arranged the publication. It was so successful that a second printing came out the next year, 1834. See Vol'man II, pp. 192–93.

11. Quoted in *IRM*, p. 354, but erroneously attributed to A. N. Titov, who died in 1827. Undoubtedly the initials were simply transposed, and Nikolai Alexeevich Titov is correct.

12. *IRM*, p. 363.

13. Ibid., p. 356.

14. Quoted by N. Listova in her introduction to A. Varlamov, *Romansy i Pesni, polnoe sobranie (Romances and Songs, complete edition)*, vol. 4 (Moscow: Muzyka, 1976).

15. Through Golitsyn's initiative the world premiere of the *Missa solemnis* took place in St. Petersburg in 1824. Golitsyn commissioned Beethoven to write the overture "Consecration of the House," op. 124, and the three string quartets, opp. 127, 130, and 132, all of which were dedicated to him.

16. *ME*, Vol. 2, p. 110.

17. This folk-song text was originally published in the second edition of the Lvov-Práč collection, but comes here from V. M. Beliaev's modern edition of the Lvov-Práč volume (Moscow: Muzgiz, 1955), p. 204. The translation is mine.

18. Vladimir Il'ich Bunimovich (pseud. Muzalevskii) identifies this and the following variation set as undoubtedly by Alexander Lvovich Gurilyov, even though the title page of the printed copy of both reads "N. Gurilyov." See V. I. Muzalevskii, *Russkaia fortepiannaia muzyka (Russian piano music)* (Leningrad & Moscow: Muzgiz, 1949), n. 1, p. 220.

19. See n. 16 above.

20. Quoted in Vol'man II, pp. 40–41.

21. Ibid., p. 43.

22. *ME*, Vol. 4, p. 754.

23. Quoted in *IRM*, pp. 395–96.

24. Quoted in Aleksandra Anatol'evna Orlova, *Glinka v Peterburge (Glinka in Petersburg)* (Leningrad: Lenizdat, 1970), pp. 103–104.

25. V. F. Odoevskii, *Muzykal'no-literaturnoe nasledie (Musical literary heritage)*, ed. G. B. Bernandt (Moscow: Muzgiz, 1956), p. 119.

26. N. V. Gogol', *Sobranie sochinenii v semi tomakh (Collected works in seven volumes)*, vol. 6, ed. S. I. Mashinskii et al. (Moscow: Khudozhestvennaia literatura, 1967), p. 195.

27. A. S. Pushkin, *Polnoe sobranie sochinenii (Complete works)*, vol. 3, part 1: *Stikhotvoreniia 1826–1836; Skazki (Poems 1826–1836; Stories)*, ed. M. A. Tsiavlovskii et al. (Moscow: Akademiia Nauk, 1948), p. 490. The translation is mine.

PART TWO

RUSSIAN ART AND SOCIETY

5

Russian Art and Society,
1800–1850
S. Frederick Starr

SECULAR ART in Russia came of age in the early nineteenth century. An enterprise that had heretofore embraced only a limited number of artists now involved hundreds working in many fields. Pushing output upward were thousands of reasonably sophisticated consumers, where earlier there had been only isolated individuals and institutions. And as demand for contemporary art increased, the number of Russian artists producing high quality work grew; the best of them for the first time attracted the attention of *cognoscenti* abroad. By mid-century educated Russians understood that their culture had just experienced an extraordinarily fertile era and already were referring to it as their "Golden Age." To this day scholars are asking why it occurred, and under what circumstances.

How does one account for the appearance of a Briullov, Pushkin, or Glinka, or, more modestly, how should the world in which they worked be characterized? Various theories are readily at hand, ranging from the supposedly inspiring climate created by the victory over Napoleon in 1812 to the more recondite conception of a politically repressed nation of Hamlets, charged with noble ideals but doomed to art as a surrogate for public action. Propping up such theories is a framework of analysis that imposes clarity on the confusion of the era by seeing the welter of forces in terms of simple dualities. Academic art is juxtaposed with free art, the tsarist "state" with a supposedly autonomous "society," metropolis with province, classicism with romanticism, cosmopolitanism with nationalism.

In defense of such notions, it must be admitted that many of the artists and writers on art in Russia at the time conceived the art world in such terms. This is not surprising, of course, since the tendency to seek a Manichean dualism in all reality was a common feature of Russian and

European thought of the age. Yet each of these polarities confuses as much as it explains. On the one hand, each admits of too many exceptions to be useful. On the other hand, they all fail to take into account the manner in which seemingly opposed tendencies in art and society became so deeply bound up with one another as to make trivial any effort to separate them neatly for purposes of analysis.

RUSSIA'S MANY EUROPES

The reality of Russian artistic life in the early nineteenth century is far too complex to be encompassed by such formulae. Even the title "Russian Art, 1800–1850" suggests a coherence that the reality belies. For example, by what traits can one identify a given work as "Russian" in a period in which art in Russia continued, as it had in the eighteenth century, to be remarkably subject to West European influences? Indeed, no current in the fine arts, music, or decorative arts of Russia in the years 1800–50 is without close analogues elsewhere in Europe. The specific foreign countries or cities from which the Russians drew inspiration at any given time can usually be identified.

The eighteenth century ended with the earlier Gallomania in eclipse, thanks to the French Revolution and the unbending Francophobia of Paul I. Jacques-Louis David was scorned in St. Petersburg for having supported the radicals—and later for having "sold out" to Napoleon. Meanwhile, France was all but closed to visitation by "pensioners" from the Academy of Arts in St. Petersburg.[1] French influence bloomed again during the early years of Alexander I's reign, thanks both to the Parisian orientation of the young tsar and several of his circle of advisors and to the presence in St. Petersburg of great numbers of highly cultured political emigrés from Paris. The appointment of the Frenchman Boieldieu to a high musical post long held by Italians symbolized this brief episode. The turn to Italy that occurred in the new century, however, was not abrupt and was not occasioned by the Napoleonic invasion. Italian music (Paisaello, Galluppi, Manfredini, etc.) had long been à la mode in both St. Petersburg and Moscow; such architects as Rastrelli, Rinaldi, and Quarenghi had all been well established at the tsar's court; and the sculptor Canova had already won a broad Russian following through the patronage of the Russian ambassador in Vienna, Count Andrei Razumovsky. The parade of Russian painters to Italy (discussed by Joshua Taylor in chapter 7) was well advanced when Alexander Egorov and Vladimir Shebuev arrived in Rome in 1804 and was to continue unabated to mid-century.[2]

For all its popularity among Russians, Italy did not monopolize the West European influences upon Russian art in the early nineteenth cen-

tury. Germany in particular made its presence strongly felt in Russian artistic life. Thanks to the patronage of Nicholas I, the great Berlin architect Schinkel undertook several court commissions in St. Petersburg, while the architect of the Pinotek in Munich, Leo Klentze, was selected to design the new Hermitage.[3] Nicholas I, whose artistic interests will concern us later, gave encouragement to the German painter Franz Krueger in the same years when Alexander Ivanov in Rome was consorting with Johann Friedrich Overbeck and the German Nazarenes.

If one is to speak of the rise of Germany and Italy as factors in Russian artistic life and the eclipse of France, the point must be qualified by noting the tendency of different arts to draw selectively upon different West European sources. Architecture, for example, remained solidly under French influence down to the rise of eclectism in the 1830s. Alexander I personally sponsored the publication of Claude-Nicholas Ledoux's epochal experiments,[4] prompted the emigration of Ledoux's student, Thomas de Thomon, and appointed Auguste Montferrand as chief architect for St. Isaac's, the national cathedral in St. Petersburg. Graphics meanwhile felt the impact of England more strongly, partly because of the early development there of modern techniques of reproduction.

Did the considerable West European impact of Russian art call forth so strong a reaction as to justify today the use of the polarity of Slavophiles and Westernizers? Not really. To acknowledge the Italianness of Silvestr Shchedrin's landscapes is not to deny their Russianness, the less so since Shchedrin's introduction to Italian painting was the deliberate work of his Russian teachers and the result of policies of the national-minded tsarist government. Nor were Western influences in the visual arts countered by a school calling for the return of an "indigenous" language, as occurred in literature when A. S. Shishkov's thoroughly reactionary "Group of Lovers of the Russian Word" campaigned for the reintroduction into Russian of terms with purely Slavonic roots. Shishkov's wife, incidentally, was of Dutch Protestant descent, and saw to it that their son had a French tutor.[5]

TEMPORAL DIMENSIONS

If the term "Russian Art" suggests a distinctness from the rest of Europe that was rarely sought and never achieved, the periodization 1800–50 suggests a defined phase in the history of Russian art that did not, in fact, exist. Except for the supplementary statutes added in 1802 to the character of the Academy of Arts,[6] not one major development in Russian artistic life corresponds even roughly to the turn of the

eighteenth century. The rise of national and historical themes in Russian painting, literature, and music antedates the 1812 campaign by at least a generation; sentimentalism was no longer new in 1800; and the classicism to which the more national currents are sometimes seen as a response continued to thrive with renewed vigor for another two decades, albeit in a more Latinized form than before.

This less dramatic chronology suggests that Russian art responded less deeply to diplomatic shifts than is often supposed. And in fact, the major turning points in the formal development of Russian art in the early nineteenth century correlate poorly, if at all, with events in the political realm. The very important shift toward Christian pietism in the first three decades and the related growth of sentimental portraiture and "spiritual" music occurred at first without government patronage;[7] the abortive Decembrist revolt of 1825 left little imprint on the visual arts, though more on letters. Most important, perhaps, the supposedly repressive regime of Nicholas I did little to alter the fundamental directions that Russian artistic values were taking anyway, as we shall see later in this discussion. Indeed, the only political event that left a clear stamp on Russian art was the Revolution of 1848,[8] which unleashed much of the dissatisfaction that had long existed under the surface of "Biedermeier" Russia. But since these revolutionary events occurred outside Russia, one is compelled to suggest the proposition that political events in France and elsewhere had a greater impact on Russian art than did political events in Russia itself. Yet even this overstates the case for politics as a preoccupation of Russian cultural figures. In this respect it is revealing that Nikolai Karamzin, the sentimentalist writer and spokesman for the nationalism that was eventually to make itself felt in Russian art, visited France at the height of the Revolution but failed in his travel memoirs so much as to mention the events boiling around him![9]

A further complexity that must be borne in mind when considering the chronology of Russian artistic developments is the relatively late appearance in Russia of a defined classical movement and the relatively early emergence there of sentimentalism and romanticism. Suffice it to note that practically the entire corpus of classical literature was translated into Russian only in the last three decades of the eighteenth century, only a few years before sentimentalism made itself felt during the 1790s. This peculiarity of timing caused the two movements to commingle with one another in diverse arts, even while maintaining a thematic distinctness from each other. Thus, the effort of I. Vitalii and others during the 1810s and 1820s to imbue classical sculpture with a more "romantic" emotionalism parallels the effort by students in the academy's genre classes to achieve a folkish exterior simply by clothing

classical sketches with peasant garb. Such a technique was most suc-
cessfully applied by the sculptor I. P. Martos in his archly classical
monument to the seventeenth-century peasant liberators of Moscow,
Minin and Pozharsky (1818; cf. Kennedy, fig. 10.9).[10] This curious
compound of styles and techniques did not long survive, however, and
was denounced by the critic Nikolai Nadezhdin in 1833,[11] after which a
merger of more diversified approaches occurred with the rise of eclec-
ticism.

THE WORLD OF ART

If the reality of Russian artistic life in the early nineteenth century is
not to be grasped by simple dualisms or by the myth of an artistic iden-
tity distinct from Europe as a whole, let alone by the application of
some chronology derived from the realm of politics, how can it be ap-
proached? One useful step is to identify the broader environment of
patronage and consumption in which artists of all types functioned—
what the Moscow critic Sternin refers to as the "artistic culture" of
Russia under Alexander I and Nicholas I.

The contours of this world are suggested by demographic data from
the era. One is struck, first, by the very small educated population
toward which high culture was directed. Given the fact that Russia's
"nobility" or gentry was a service class, comprising practically everyone
holding any position of responsibility, its numbers approximate the
scale of this elite. In the 1830s the nobility numbered only 720,000, or
about 1½ percent of the population.[12] Discounting children and elders,
one can speak of only a few hundred thousand men and women with
any strong likelihood of access to the fine arts. Keeping in mind, also,
that three-quarters of the gentry owned fewer than the one hundred
serfs required to maintain a noble family year-round in a typical prov-
ince like Smolensk,[13] the numbers of persons with the time and re-
sources to indulge in high culture dwindles further. On top of this, the
noble population was so deeply mortgaged to the state that its oppor-
tunities for lavish expenditure on art shrank yet further. Though it is
significant that few gentry complained of a "crisis of serfdom,"[14] approx-
imately two-thirds of their serfs were in hock by mid-century, when
Pavel Fedotov painted his satirical *An Aristocrat's Breakfast*. The
Demidovs, Shuvalovs, Panins, Samoilovs, Lopukhins, and Gagarins
painted by Karl Briullov were exceptions to the general rule, a minute
class within a class. All were among the 3,500 magnates (male and
female) who owned 40 percent of Russia's serfs.[15]

Before turning to the possibility of merchant patronage in the arts,
we should take note of the concentration of consumers of high culture

in a very few urban centers. The total urban population of Russia dou-
bled in the period under study, but in 1850 was still under 10 percent
of the population. Most "cities" were really large villages and filled with
peasants and petit bourgeois (*meshchane*). Only St. Petersburg, with a
population of 470,000 in 1840, and Moscow, with 349,000 were really
metropolises, their closest rival being Odessa, with 60,000.[16]

THE THINNESS OF PROVINCIAL CULTURAL LIFE

Such figures as these suggest the unlikelihood of there existing a strong
and independent provincial artistic milieu in Russia at the time. We
shall return later to the tenuous status of the various provincial art
schools. But for now it should be noted that the overwhelming majority
of provincial artists in Russia in the early nineteenth century were icon
painters, and that all but the most successful secular painters had to
devote considerable amounts of time to ecclesiastical commissions.[17]
These, along with the growing number of orders for merchants' por-
traits, constituted the daily fare for nearly all provincial artists. Against
this background, the refusal of the master of the serf painter Grigori
Soroka to give him his freedom may have had the effect of shielding
Soroka from the pathetic and uninspiring world of the small-town
commercial dauber.

In the absence of provincial centers, the chief emporia for art and
decorative objects were the fairs that dominated rural trade in Russia
down to mid-century. Several thousands of these exchanges were held
throughout Russia, the greatest of them, at Nizhni Novgorod, being the
largest such fair in Europe. Though the most avant-garde art was to be
flaunted at the Nizhni fair by the end of the century, in the period
under study the fairs were, for the most part, dominated by peasant
crafts, cheap Western-style goods, and products designed to meet the
traditionalist tastes of the local populace.[18] Not until the establishment
of the so-called Wanderers movement in the 1860s did artists with
big-city tastes look to the fairs as outlets for their work.

MERCHANT WEALTH LOOKS TO RUSSIAN ART

In contrast to the plight of the gentry, the beginnings of merchant
wealth were becoming evident by the 1850s, particularly in Moscow.
For various reasons, however, these fortunes were yet to have the im-
pact on the arts that they were to exert in the age of the Mamontovs,
Morozovs, Shchukins, and Riabushinskys. For one thing, these com-
mercial factories were still quite young: Savva Morozov had bought his
freedom from serfdom only in 1820 and the Mamontovs' railroad for-

tune was yet to be built. Moreover, merchants were still effectively excluded from public life at the highest levels, both by government policy and by their own peculiar psychology. Those manufacturers and merchants who were accumulating vast fortunes in the early nineteenth century and whose sons were to champion nationalistic art a generation later for the most part still inhabited the closed and traditionalistic world of Muscovite commerce. Many were puritanic Old Believers and haughtily wrapped their kaftans about themselves as they spurned the gentry's alien cultural affectations.[19]

There were exceptions, however, and their emergence helps account for the decline of the cult of classical antiquity in art. The Moscow industrialist Fedor Chizhov was among those who traveled to Italy in the 1840s but scarcely paused to inspect the classical antiquities before sweeping up his friend Alexander Ivanov and making a tour of the seats of Byzantine Slavic culture in Istria, Dalmatia, and Montenegro. K. T. Soldatenkov also linked up with Alexander Ivanov, who assisted him in building up his formidable collection of Russian and Western art. P. M. Tretiakov began his collection of paintings in the same years, in imitation of the tsars' Hermitage collection, but soon shifted his attention from Flemish masters to works by Russian artists.[20] Finally, in St. Petersburg the banker Stieglitz was in a position by the 1840s to hire the very expensive Academy of Arts master Fedor Bruni to do a series of panels on Russian themes for his new palace on the English Embankment.[21]

THE RISE OF THE DECORATIVE ARTS

If the commercial world of Moscow and other cities did not yet exert the overwhelming influence on Russian art and patronage that it would later, it nonetheless proved decisive in certain areas of the decorative arts. Indeed, Russia's emerging middle-class milieu helped shape both the demand and supply for applied arts. On the demand side, the doubling of Russia's urban population between 1800 and 1850 called for an enormous expansion in the production of furniture, glassware, and other objects of domestic use (see chapter 11 by Paul Schaffer). In the same period, thousands of peasants, many of them serfs, entered commerce and won modest fortunes that could be used to acquire esthetic symbols of their worldly success. At the lowest level, this created a market for the printed cotton fabrics and cheap lithographs that quickly drove handweaving and the more traditional woodcuts (*lubki*) from the homes of the Russian peasant or petit-bourgeois. At slightly higher levels, this enrichment generated an enormous demand for products that had heretofore been confined to use by the more wealthy merchants and gentry.

Foreign suppliers were unable to meet this burgeoning demand for decorative arts for two reasons. First, the cost of transportation to Russia was so high as to be prohibitive for all but the fanciest luxury goods. Second, Russia's financial position after the Napoleonic Wars became so shaky that the government imposed a heavy tariff on all imported goods.[22] Tariff levels remained high throughout the period, rising to peak levels in the wake of the poor harvests in the early 1840s. The resulting protection was an unexpected boon for Russia's domestic manufacturers of decorative objects.

THE RUSSIFICATION OF THE DECORATIVE ARTS

At first the demand for applied arts was met largely through foreign craftsmen and entrepreneurs who settled in Russia. Thus, in the field of gilt bronze, names such as Chopin, Schreiber, Strange, Nichols and Plincke, and Krumbuegl dominated the field.[23] Gradually, though, Russians moved into this lucrative area, with the result that in the manufacture of porcelain china the new firms in the post-Napoleonic era were owned by such persons as A. G. Popov (f. 1806), M. S. Kornilov (f. 1835), and N. S. Khrapunov (f. 1812). Equally important, the foreign masters who introduced the various crafts were soon assimilated or replaced by Russians, much the way German brewmasters in Mexico have been supplanted by Mexicans. By 1840, nearly all of the 350 workers at the Francis Gardner porcelain factory in Moscow were Russians, and the Gardner family itself had become thoroughly Russified.[24]

In nearly all the decorative arts it was the North Germans who dominated the field at first and set taste in Russia. Among the leading furniture makers were such figures as David Roentgen, Charles Meier, Heinrich Hambs, and A. K. Piek. Such makers set styles that were emulated by Russians, and particularly by serf craftsmen, whose activity was increasingly prominent down to the emancipation in 1861. By the 1830s, though, the shift to native craftsmen was advanced to the point that the Moscow merchantry felt sufficiently confident to mount their own "Exposition of Russian Manufactures."[25] Repeated in 1843 and in 1845, these exhibitions surprised even as knowledgeable an observer as the Westphalian Baron von Haxthausen with the extent and quality of Russian-made decorative arts.

POPULARIZING THE FINE ARTS

During the third and fourth decades of the nineteenth century, Russians did more than ever before to disseminate information on the fine arts to the educated populace. As a result, an enterprise that had

heretofore been known only to small numbers of patrons now entered the consciousness of large parts of the educated public. A variety of factors combined to bring about this result.

First, Russia's university system expanded rapidly with the foundation of St. Petersburg University (1817), the University of Kazan (1804), Kharkov University (1805), and St. Vladimir's in Kiev (1834). While this did not in itself create art lovers, it did develop a reading audience that was eager for enlightenment in the humanities and social sciences. Such journals as the *Telescope (Teleskop)*, the *Moscow Telegraph (Moskovskii Telegraf)*, or the *Library for Reading (Biblioteka dlia chteniia)* regularly included essays on art, which did much to force the world of art upon the consciousness of thousands of educated Russians. The establishment in 1838 of provincial newspapers by the Ministry of Internal Affairs had much the same effect, and on a national scale, although for the first years the *gubernskie vedemosti* ventured no further from official topics than occasional pieces of local history.

Much could be said about the shortcomings of Russian art criticism down to the decade of the 1840s, when the confrontation of romantic currents with the emerging "Natural School" thrust the field to the center of debate at the universities and in the "fat journals" generally. Suffice it to observe that Winkelmann was never translated in full, and the heated arguments over Schiller, Schelling, and the Schlegels were often conducted on the basis of the most imperfect knowledge of their works. Yet to dwell on such facts would be to undervalue the importance of what was achieved. During the half century before 1840, the Russian language was enriched with a vocabulary of art terms that for the first time permitted discussion of the most abstruse notions of contemporary Western criticism. Through the rapidly growing publishing industry this new language of esthetics was disseminated to a large audience and made available for public discourse.[26] The analogous efforts of Ralph Waldo Emerson and his fellow Bostonians in the same area seem crude by comparison.

The dissemination of information on the arts and the spread of art appreciation still had definite limits in the decades under study, though these are hard to establish precisely. If precise records exist as to the number of persons who attended exhibitions and cultural events in Russia during the first half of the nineteenth century, they have yet to be made available for study. In the absence of such precise documentation, we must resort to the voluminous impressions recorded by contemporaries. To be sure, there are numerous references to enthusiastic crowds at public exhibitions. Thus, an anonymous critic visiting the annual show at the Academy of Arts in 1820 complained about the "throng gasping from the closeness," at the same time noting that the

hall was packed with "sailors, carters, lackeys, and women."[27] Since most of the critic's readers also lived in Petersburg and could readily verify his report for themselves, it is unlikely that he would have dared to exaggerate greatly. Yet in the same period Russia's first journal devoted exclusively to the arts, the *Journal of Fine Arts (Zhurnal iziashchnykh iskusstv)* died within a few years of its foundation in 1807, notwithstanding the substantial disguised subsidy it received through being published on state-owned presses.

The establishment of concert halls and public galleries cannot necessarily be taken as evidence of popular interest in the spectacles offered by such institutions. The old building of the Bolshoi Theater in Moscow was outfitted at great public expense on the very eve of 1812. Noting the great cost of the work, the mayor of Moscow, Count Rostopchin, observed ironically that still more funds were needed in order to purchase some 2,000 serfs who could be assigned to the theater to play the role of audience. Nor was the public so much more zealous in St. Petersburg. Notwithstanding the crowds observed at the academy in 1820, the arts there were far from commanding the mass audience that was considered normal in those western and central European capitals with a large middle class. J. G. Kohl, a German visitor to the imperial capital in the early 1840s, had this to say about the crowds at the recently opened Hermitage:

> The Hermitage is not greatly frequented, as foreigners as well as natives must procure tickets. These are given indeed without difficulty, yet even this little obstacle is sufficient to keep numbers away. Love of ease is, after vanity, the great impulse in all our actions, or at least to all our omissions. There are in St. Petersburg a number of families of the educated classes who have never visited the Hermitage; and how little is gained compared with what might be, even by those who do? When we look at the listless faces of the sight-satiated public, lounging past the pictures, we cannot help asking ourselves how so many painters could ever attain such extraordinary renown. Where is the enthusiasm for their works, the rapture they inspire? For four thousand paintings reflecting half the natural world and mankind, a two hours' saunter; for thirty thousand engravings, a few minutes; for three rooms full of statues, as many passing looks. . . . The most admired objects here are beyond all doubt the crown jewels, and other valuables arranged in a separate cabinet with them.[28]

In this context it is perhaps interesting to note that the Hermitage was generally listed in Russian guidebooks under imperial palaces rather than under learned institutions.[29]

Such impressionistic evidence is no substitute for the close sociological analysis that the Russian art public of the early nineteenth century

requires and deserves. It does suggest, however, that the fine arts in Russia in this period were the property of the limited group of sophisticated and well-placed persons who were in a position to patronize them without regard for whether their initiative would immediately be seized upon by a broader public. As one would expect, Western-style esthetic culture penetrated Russian society from the top down through a process that was only beginning in the early nineteenth century.

THE NORTHERN PALMYRA

Against the background of the social and geographical concentration of artistic literacy, it is scarcely surprising that St. Petersburg should have been the magnetic pole of the Russian art world throughout the reigns of Alexander and Nicholas. The relative standing of St. Petersburg was enhanced by the state of decline into which Moscow fell during the first decades after the 1812 fire. Though reconstruction was fast and complete,[30] "society" never fully came back to Moscow and turned instead toward St. Petersburg. In 1834–40 lordly Moscow claimed only 15,700 noblemen of all ages, male and female, slightly less than the number of merchants listed in the census.[31] Pushkin poignantly observed the decline of many of the great aristocratic houses of the old capital, mourning the abandoned palaces choked by weeds, or their transfer to the hands of merchants.[32] In spite of Moscow's claims to moral leadership—claims that parallel those of Boston against New York in the same period—Moscow was falling hopelessly behind St. Petersburg in all those fields that depended upon the patronage of a wealthy elite. Karl Briullov could therefore easily afford to avoid Moscow entirely until his thirty-sixth year; few artists in any field chose to reside in Moscow if they had the possibility of access to the more glamorous society of the "Northern Palmyra."

It is hard to appreciate today how young a city St. Petersburg was in 1800. Founded a scant century earlier, the capital had possessed few of the amenities of a major European center for more than fifty years. Most of the major palaces had been constructed by 1800, but such landmarks as the enlarged Admiralty, the Stock Exchange, the General Staff, the Senate and Synod, the Alexander Theater, the Public Library, St. Isaac's, or the Kazan Cathedral were yet to be constructed. Construction undertaken during the reigns of Alexander I and Nicholas I outshone all other architectural work in Russia in terms of both scale and grandeur. To be sure, massive construction was under way in Moscow after the 1812 fire, and such provincial towns as Odessa, Kazan, Kostroma, and Kaluga were largely built or reconstructed during these same years. But one need only compare the majestic ensembles of

Rossi or Giliardi with the Biedermeier intimacy of Moscow's rebuilt quarters to appreciate the extent to which Petersburg claimed the government's attention and resources.

To the extent that other cities boasted major public works during the period, they were carried out in accordance with models drafted and approved in the capital. As with Catherine II's ambitious effort to regularize the planning of Russia's provincial centers, the thrust of architectural activity outside St. Petersburg in the early nineteenth century was to create little St. Petersburgs. Thus, architecture became a major vehicle for the dissemination of specific cultural ideals to the provinces.[33]

THE ROLE OF THE STATE

St. Petersburg set standards of taste that were slavishly emulated elsewhere in Russia, just as the artistic predilections of Paris were accepted as law for the rest of France. True, the merchants of Moscow exhibited greater independence in this sphere than the other urban classes, but until mid-century they did so more by withdrawal than by assertion. Only the peasantry seemed immune to the dictates of St. Petersburg and, in remote regions, at least, produced artistic forms that reflected local traditions and circumstances.

The analogy of St. Petersburg to Paris as a tastemaker in a highly centralized system is appropriate, but within specific limits only. In Paris, after all, there existed a large, independent, politically active, and culturally assertive bourgeoisie. In Moscow by 1830 the merchants slightly outnumbered the gentry, but in St. Petersburg there were 42,900 nobles and only 6,800 merchants, many of them of modest means. The rest of the population was made up of a large group of petit bourgeois, a still larger group of recently urbanized peasants, and some 13,000 foreigners (2.9 percent of the population).[34] Since most of the nobility of St. Petersburg were living from state salaries received through either the army or the mushrooming civil service, one can say that with the exception of the handful of genuine grandees, most of St. Petersburg's culture makers were on the state's payroll.

The implications of this fact for the social history of art are not insignificant. Russian artists in all fields were, as a group, far closer to their government than was the case in any West European nation. Faculty at the Academy of Arts received civil service rank, and their students' stipends were viewed virtually as state wages. Both academy and university students were accordingly expected to wear civil service uniforms. The composer Glinka was the tsar's *Kapellmeister,* the poets Griboedov and Tiutchev were both diplomats, and many other artists followed careers in the military. Art was by no means a lucrative calling,

so the best that most artists hoped to achieve was a secure niche within a government-sponsored cultural institution, a government-sponsored sojourn abroad, or a favorable marriage.

The absence of a well-funded "private sector" in the arts explains why many claims about the supposed independence of cultural institutions from governmental tutelage must be discounted. Ivan Pnin, founder of Russia's first art journal, was a full-time employee of the Ministry of Public Enlightenment, and both his arts journal and his *St. Petersburg Journal* (*Sanktpeterburgskii zhurnal*) were personally subsidized by the tsar.[35] When the Philharmonic Society was founded in St. Petersburg in 1802, it, too, received direct and indirect court subvention.[36] To be sure, there existed various independent groups, such as the Masonic lodges (to 1818), certain successful private publishing houses, or Count N. P. Rumiantsev's circle of scholars and artists who explored Russian antiquities at their meetings at the count's great Moscow library (which he later gave to the Ministry of Public Enlightenment). But the Society for the Encouragement of Artists, which sent Ivanov and so many of his peers to Rome, was certainly not among them. True, it received funds from various grandees, but most of them were also closely connected with the court. It also claimed the support of the tsar and was subject, in all its actual decisions, to the complete control of the Academy of Arts.[37]

TSARS AS PATRONS

To refer to the Russian "state" is to make abstract something that, in the early nineteenth century, was still a concrete phenomenon embodied in the person of the tsar. Notwithstanding the sixfold increase in the size of the bureaucracy under Nicholas I,[38] the tsar remained, at least to the 1840s, the personal and highly visible master of his patrimony. Because of this, it is the more important to enquire into Nicholas's tastes in art and to examine the manner in which he exercised his paternal authority in that field.

It need scarcely be said that Nicholas "The Stick" has a bad image. It is true that he volunteered to serve personally as Pushkin's censor, that he tossed out categorical judgments in many areas of the arts of which he had scant knowledge, and that he used the full might of his office to bring about artistic conformity to the national ideals that he espoused. We will have to examine those ideals more closely, of course, but for now it must be emphasized that whatever damage Nicholas is purported to have inflicted on the artistic enterprise, he took the arts more seriously than did any other Russian tsar with the exception of Catherine II, and that in certain areas he demonstrated considerable knowledge and up-to-date judgment.

Since these points were made a half century ago by the Russian
scholar M. Polievktov, it is unnecessary to do more than remind the
reader of Polievktov's argument:

> The personal tastes of the Emperor Nicholas in the sphere of literature are
> of little interest, and the government's attitude towards literature during
> his reign was expressed exclusively in prohibitions. But things stood differ-
> ently in the visual arts. Nicholas unquestionably understood art and in one
> field, namely architecture, he was himself a competent specialist. His love
> for art was crowned with a series of positive governmental measures and
> undertakings directed towards the support of artistic and architectural ac-
> tivity. Nicholas was the last autocrat in the full sense of the word, and his
> reign was the last epoch in which there existed an official art.[39]

Several aspects of Nicholas's patronage of art and architecture have
already been mentioned: his support for the grand architectural projects
carried out by Rossi in St. Petersburg; his personal selection of the
Berlin architect Schinkel to construct a chapel at the royal estate of
Peterhof near Petersburg; his decision to establish the Hermitage as a
public museum after the same proposal had been shelved by his prede-
cessor for eight years; his selection of Leo von Klentze as architect for
the new Hermitage. Other examples could be added. Thanks to
Nicholas's intervention, new collections were added to the Hermitage
in 1829, 1831, 1836, 1845, and 1850 through purchases in France,
Italy, and Germany.[40] In an effort to return the Academy of Arts to its
former status as a responsibility of the crown, Nicholas brought it
under the Ministry of the Imperial Court in 1829 and increased support
for it. In 1845 he undertook a trip to Italy, where his itinerary was
largely determined by his desire to visit the principal artistic and ar-
cheological centers and to assess *in situ* the work of Russian artists
there.[41] That his judgments sometimes raised eyebrows is not surpris-
ing; it should not be forgotten that many who met him were astonished
by the apparent genuineness of the tsar's interest in the arts.

Nicholas's insistence that the architect K. A. Ton design the great
Cathedral of the Savior in Moscow in the Russo-Byzantine style has
often been cited as evidence of his narrow devotion to chauvinism in
art. But if Ton's cathedral marked a high point of the nationalist revival,
other projects patronized by the tsar indicated that his tastes were more
diverse. Thus, Benois's stable in Peterhof is in the English Norman
style, Rossi's Petersburg ensembles are severely classical, Stack-
enschneider's new palaces in Petersburg are in the Renaissance style,
and Nicholas's own suburban dacha near St. Petersburg is in the modest
Italian villa style that the tsar did so much to popularize in Russia. In
architecture as well as in painting, Nicholas's taste was cosmopolitan

and eclectic, a fact that was implicitly criticized by his contemporary the novelist Gogol when he penned an attack on eclecticism in all its forms.[42]

There is little doubt that Nicholas's support for the visual arts stemmed from his conviction that the autocratic tsar should be a tastemaker in all things. But in appointing his daughter, the Grand Duchess Mariia, as head of the Academy of Arts in 1852, in expanding the government's support for artists studying and working in Italy, and in instituting numerous other measures, the tsar went far beyond what was required simply to extend his political program into the area of culture.

THE PERVASIVE ACADEMY

The ideal of an autocracy exercising leadership in all areas of national life was most clearly manifest in art through the activities of the Academy of Arts. Drawing analogies with England and France, Soviet and Western scholars have tended to conceive the academy under Alexander and Nicholas as a haven for all the most retrograde forces in Russian art, an institution that all true artists were bound to oppose. There is some basis for this view if the argument is confined to the 1840s, when Alexander Ivanov denounced the academy as "a survival of the last century."[43] Under the directorship of the Duke of Leuchtenberg, the academy lost much of the dynamism that it had possessed during the long decades of A. Olenin's stewardship (1817–43) and, before that, under A. S. Stroganov (1800–11). But to an extent that has no parallel in the West, the Imperial Academy of Arts exercised leadership in all aspects of Russian art and architecture.

A glance at any listing of Russian painters in the first half of the nineteenth century will reveal that, with few exceptions, they were all the products of the academy's training programs, whether in St. Petersburg or Italy. Even such "dissidents" as Fedotov and Taras Shevchenko were products of the academy's studios, just as their successors among the "Wanderers" were to be. One reason for the absolute dominance of the academy as a training institution was the absence in the early nineteenth century of independent alternatives. Indeed, every one of the "independent" studios that are generally cited as nests of latent or actual opposition to the academy were in fact closely linked with the school on the Neva. Thus, Venetsianov's classes in St. Petersburg, where Soroka, Krendovsky, and others received training, were intended to be a supplement to the academy's efforts and were coordinated in all important respects with the academy's teaching program.[44] That these classes produced some excellent genre painters but no painters of national epics or scenes of classical heroism simply reflects

Venetsianov's emphasis on one of the chief divisions of the academy at the expense of the others.

Much the same can be said of the provincial schools of art. The first private art school in Russia was that of A. V. Stupin at Arzamas.[45] It is tempting to depict this as a rural island of esthetic independence in the sea of autocratic taste, but the image does not fit. Stupin, a former icon painter, spent two years at the academy in St. Petersburg and returned to Arzamas loaded with gifts of paintings and drawings by his former professors and colleagues. Within seven years after establishing his "independent" school, Stupin had submitted a detailed report on his efforts to disseminate art to the provinces, for which he was rewarded with the title of "Academician" and the honor of having his school placed under the protection of the academy, which was soon translated into free text books, more academic paintings from the St. Petersburg professors, and monetary gifts from the academy and from the tsar. In gratitude Stupin returned regularly to show off his students' work in the halls of the academy.

The academy took seriously its responsibility to guide the development of painting throughout the country. When Stupin's initiative was copied in Voronezh, Kozlov, and Saransk—in each case by graduates of the academy—the Academy of Arts was quick to bring the new schools under its protection and, where useful, to provide recognition, advice and monetary support.[46] The only school that achieved any strong independent identity was the Moscow School of Painting, Sculpture, and Architecture, founded in 1843. But in this case, too, there was no intention of "liberating" Russian art from the sinister control of the academy. On the contrary, the founders of the Moscow school saw themselves as carrying out much the same program in the old capital that the academy was implementing in the new.[47] Along with every other provincial art school, the Moscow School's entire program was closely regulated by the academy according to principles set down in the academy's charter of 1802. Hence, to impose on the 1840s the contrast between the two institutions that was to become so evident by the end of the century would be an anachronism.

The national scope of the academy's responsibility, authority, and influence can be gauged with particular accuracy in the field of architecture. From the time of its foundation down to the middle of the nineteenth century, the Academy of Arts exercised direct control over the process of design and execution of every major state-sponsored architectural project in Russia. Special commissions staffed by its professors monitored the planning of new ensembles in the capital and approved standard building designs for provincial centers. The academy,

in short, was the only union, and the Russian state a closed shop. Hence its professors could virtually dictate the design and execution of the Kazan Cathedral and St. Isaac's, down to the last icon. To be sure, its control did not extend to private construction, but until mid-century there was so little free capital for major private construction projects that this limitation meant very little in practice. Also, by virtue of the high visibility of governmental projects, the style in which they were executed was naturally adopted by architects engaged in private practice. In the period under study, the peasantry alone showed itself immune to the influence of the academy's esthetic ideals.

THE SOCIAL STATUS OF ARCHITECTS AND PAINTERS

From the foregoing, one might surmise that Russia's painters and architects were remarkably subservient to official dictates. While this is certainly true, the reasons in each field were very different. Architecture in early nineteenth-century Russia was an aristocratic art. Many leading architects were foreigners, and nearly all of Russia's better architects were either born noblemen or had been ennobled in recognition of their distinguished service to the throne. While few owned serfs, nearly all kept large domestic establishments with five or more servants.[48] Their wealth did not render them independent, however, all being to varying degrees dependent upon state patronage for their livelihood. This meant that for all practical purposes the principal architects of St. Petersburg were as closely tied to the state as a serf might be to his lord.

Painters came from the opposite end of the social scale, and for the most part owed their social advancement to the academy. Venetsianov was the son of a poor Moscow merchant, Borovikovsky and Chernetsov the sons of icon painters, Khrutsky the son of a poor priest, Platshov and Matveev the sons of soldiers, and Fedotov the son of a low bureaucrat. Ivanov and Shchedrin were the sons of artists, as was Briullov, but this did not liberate them from the dependence that was part of the culture of painting in Russia. Recent research has shown how even amidst the agitation of the 1860s students at the Academy of Arts were far more quiescent than their contemporaries at Petersburg University or even at the more democratic Medical-Surgical Academy.[49] Lacking any tradition of middle-class independence from the state, Russian painters were the less inclined to view autonomy as a prerequisite for an artist. If Aivazovsky considered his post as painter to the Naval Ministry as somehow demeaning to him as an artist, he left no indication of it, notwithstanding his own background in a rather entrepreneurial Armenian merchant family.

ARTS, CRAFTS, AND THE ABSENT AVANT-GARDE

During the first half of the nineteenth century, painting in Russia was only beginning to establish itself as a profession, as opposed to a craft. The raising of the age of matriculation in the academy's preparatory program from nine to twelve in 1819 and the eventual closing of the preparatory program in 1843 can be seen as efforts to elevate the professional level. Against this background, the refusal of the academy's director, Olenin, to permit lords to send serfs for training can be seen as another part of a general campaign to transform painting from a craft to a profession.

That this process of professionalization remained incomplete for all but a handful of renowned painters, notably Briullov, helps explain why the concept of an avant-garde had no place in the Russian visual arts in the period under consideration. The French utopian, St. Simon, placed artists at the very forefront of his world of intellect, along with scientists and industrialists. No analogous claims were made for artists in Russia, the nearest exception being Ivanov, and then only in the 1840s. Architecture attracted far more visionary thinkers than did painting. Vitberg's monument to the 1812 campaign to be built on Moscow's Sparrow Hills, Ulybishev's "Dream" of a liberal metropolis, Ivanov's visionary temples, and the young engineer Dostoevsky's conception of an idealized urban world all exceed in utopian boldness anything conceived by Russia's painters and sculptors.[50]

Neither painters nor sculptors nor architects in Russia inhabited the sort of bohemian *demi-monde* that in Paris was so fertile a ground for the nurturing of grandiose self-images and political opposition. Private salons were dominated by concern for the written world and music, while coffeehouses were all but nonexistent.[51] Russian art produced no Goya or Delacroix during the first half of the nineteenth century, and even the satire of the 1840s was as often as not issued with the imprimatur of an autocracy eager to keep its own bureaucracy in check.

To what extent does the quiescence of Russian painters reflect the influence of Nicholas's censorship? During the period of the so-called Cast Iron Statute of 1826 and the Censorship Terror after 1848, the risk of repression for satirical or oppositionist art was doubtless enormous. But by 1828 the Cast Iron Statute had been replaced with a more mildly paternalistic law administered by a former university rector, Prince A. K. Lieven, whom a recent specialist on the period has described as a kind of "foster father of the arts and sciences."[52] Lieven seemed little concerned over the problem of content in the visual arts, and the absence of evidence for the existence of any repressed stratum of socially *engagé* art down to 1848 suggests that his inattention to the field was justified.

OFFICIAL NATIONALISM AND THE ARTS

Approaching the problem from the other side, let us ask whether Russian artists were impelled by any positive vision fostered by the autocracy during the reigns of Alexander and Nicholas. As any perusal of representative collections of paintings of the period will indicate, *most* artists devoted themselves to the same range of themes and sought to employ the same formal methods that held sway elsewhere in Europe. Yet this occurred within a definite framework in which civic virtue was stressed and rewarded above all other qualities. The charter of the Academy of Arts stressed civic virtue and rewarded it through a precise system of remuneration for artists. Only historical painters could receive the title of Rector or Professor, while portraitists could not advance beyond the level of Academician or Councellor. Differentials in pay for the two genres were at a ratio of 5:3.[53] Especially after 1809, genre painting began to acquire new prestige as its folkish and nationalistic significance came more fully to be appreciated. And in truth, was there anything less civic about a painting depicting "A Russian Peasant Lad Rising in the Morning" or "A Recruit Parting From his Family" than a theme from Russian history? Both of the former subjects were required of academy students between 1812 and 1818.[54]

The official ideology that was to inspire the work of Russia's artists was systematized during the reign of Nicholas I under the triple rubric of "Autocracy, Nationality, and Orthodoxy." Each element of this trinity corresponded to a specific artistic medium and genre. Thus, the idea of autocracy was to be set forth in historical canvases and monumental sculpture, generally in classical idiom. A full generation before Count Sergei Uvarov systematized the theory of Russian autocracy and over a decade before Nikolai Karamzin published his monumental *History of the Russian State,* the Academy of Arts in 1802 was setting before its students such themes as "The Baptism of Vladimir," "The Arrival of Riurik," "Breaking the Tatar Yoke," or "Peter the Great's Love of the Fatherland as Shown at the River Pruth."[55] In part because of its associations with the Roman empire, the sculptural style of late antiquity was considered especially appropriate for depicting themes relating to autocracy and was successfully applied to the monument of Dmitri Donskoi erected in Moscow in 1818 or the statues of Russian military heroes of 1812 placed before the Kazan Cathedral. Classicism in architecture—actually the romantic classicism of contemporary France—was also mobilized for edifices relating to autocracy. But, as we have seen, this linkage gradually broke down and was replaced by the ideologically more appropriate association of Russian autocracy with Byzantine imperial architecture, an association that was explored

through the rise of Byzantine studies in the 1820s and first manifest in Ton's Church of St. Catherine in St. Petersburg.[56]

"Nationality" as conceived by Uvarov's official ideology was to be expressed in art through genre painting and the patronage of native arts, and in music through folkish lieder, symphonic works à la von Weber, and "Russian" opera. The rise of genre painting lagged behind the burst of sentimentalism in literature in the 1790s but was an accomplished fact by 1812.[57] Pnin expressed his desire to extend the ideal of nationality to the stage through the establishment of a national theater in Russia.[58] This actually occurred during the reign of Nicholas, when folkish ideals penetrated every aspect of Russian art that had previously been untouched.

At its best, this element of Official Nationality inspired works of the highest calibre, Glinka's *A Life for the Tsar* being a conspicuous example. Also, the myth of nationality that found expression in art was supported by what grew to be a formidable body of scholarship, beginning with Polevoi's *History of the Russian People* (1833), continuing with the publication of the *Digest of Laws* (*Svod zakonov*), and extending to the rise of ethnographic study by the end of Nicholas's reign. As in other parts of Europe, however, the spirit of nationality in Russia also gave rise to a staggering volume of *kitsch,* particularly in the decorative arts, and to an emphasis upon programmatic, as opposed to formal, elements in all the arts.

Orthodox Christianity, the third element in Nicholas's trinity, was to be extolled through the work of Russia's thousands of icon painters, who updated their techniques during the period and created a style that was immensely popular in its time, though scorned by critics today. Ecclesiastical architecture and the music of the liturgy also felt the strong support that only an established church can provide. Indeed, art inspired by Christian themes flourished to an extraordinary degree in Russia during the early nineteenth century. A substantial body of critical writings paralleled and supported this activity, with the essays of Kamensky, Shevyrev, and the Slavophiles being only the most conspicuous examples. As a result, one is not surprised to find such otherwise diverse artists as Ivanov, Vorobiev, Bruni, and Briullov all devoting major works and years of their creative lives to the exposition of biblical themes.[59]

THE POPULARITY OF OFFICIAL NATIONALITY

This, then, is the ideological tripod upon which the doctrine of Official Nationality was erected. It is superfluous to point out that Russian artists demonstrated their interest in each of these principles long before

the Minister of Public Enlightenment, Count Uvarov, organized "Official Nationality" into a coherent set of principles. That the government did not create *ex nihilo* the ideals that were to suffuse Russian art in no way diminishes the importance of its official doctrine, however. On the contrary, it explains why so many artists found themselves able to work within that doctrine. Unpopular as the notion may be to those who conceive of art largely in terms of romantic individualism, the overwhelming majority of Russian artists found themselves quite able to work productively within the framework of Official Nationality, at least to the 1840s. As one recent authority on the reign of Nicholas I has written, Uvarov's formula "expressed sentiments which appealed to the majority of Russians and which, in fact, formed an integral part of their lives and outlook."[60] It was comforting to be able to view one's own society as a secure island, while, as Briullov, Odoevsky, Gogol, and other artists and writers implied, the rest of Europe was dying.

THE COLLAPSE OF OFFICIAL NATIONALITY IN ART

Why, then, did the officially sponsored effort to impart coherence to the entire artistic enterprise in Russia ultimately fail? This can be explained in part through the spread of atrophy and opportunism, developments that eventually beset any successful intellectual movement. Stated differently, Official Nationality in the arts ceased to be new by the 1840s, leaving, as the novelist Turgenev later recalled, " . . . a whole phalanx of people, talented to be sure, but on whose talent lay the general stamp of rhetoric and superficiality corresponding to that great but largely external strength [e.g., the state] of which they served as an echo. Such people appeared in poetry, painting, journalism and even on the stage."[61]

The process by which the enthusiastic civic impulse of the first decade of Alexander's reign was transformed into the crass boosterism of the 1840s can be more readily described than explained. One factor that cannot be ignored is the way in which the national ideology as it applied to the arts came to exclude as much as it embraced and hence narrowed the range of symbolic language available to officially accepted artists. This affected all three elements in Uvarov's trinity.

Russian autocracy embraced romantic classicism in architecture, painting, and sculpture during the last decades of the eighteenth century. Until the late 1820s, though, Russian artists proceeded on the assumption that classicism was an ideologically neutral language of forms that could be used to express diverse ideals, Russian autocracy being only one among them. The classical heritage could be invoked for other purposes as well, as Pushkin implied when he wrote that "At

heart I am a Roman; the spirit of freedom boils in my breast."[62] Nor did this necessarily conflict with accepting the leadership of an enlightened monarch. During the early decades of the nineteenth century, then, the classical ideal was used by artists and writers simultaneously to express a wide range of affirmations, which were for the time seen as compatible with one another. By the early 1830s this had changed, and classicism was viewed increasingly as the mode of art appropriate to a cosmopolitan monarchy but not to a specifically Russian autocracy or a folkish nation-state. When Briullov criticized the historian Karamzin for presenting "all tsars and no people,"[63] he was voicing a critique that had long been advanced both by democratic opponents of autocracy and by those wishing to ground autocracy on a more ethnic ideal. Both currents were hostile to classicism in any form.

Nationalism and the artistic movements that reflected it were far stronger by 1850 than the ideal of autocracy and classicism. But the link forged between nationalism and sentimentalism was rapidly eroding under the impact of the "Natural School" that made itself felt in both painting and literature. No longer preoccupied with the mystic union between tsar and people, artists began treating the people in a less mystic, more ethnographic and "realistic" fashion, after the latest West European taste. Thanks to this, sentimental folkishness in art, with its implied political conservatism, had all but vanished by mid-century.

Like the idea of nationality, Orthodox Christianity certainly did not cease to inform the work of Russian artists by mid-century, but the character of its influence was altered with the decline of Official Nationality. A burst of millenarian sectarian activity in the early 1840s[64] accompanied the growth of critical intellectual enquiry at the seminaries of St. Petersburg, Kazan, and elsewhere. While all this may in fact have greatly strengthened Christian piety in Russia, it caused alarm among those who had enlisted the church in the government's campaign to stabilize Russian society amidst the turmoil of European events. The result was to polarize Christian impulses in art between those who accepted the autocracy's Caesaro-Papism and those who did not. Thus, the contrast in the late nineteenth century between the painter Repin and the composer Tchaikovsky embodies a split that was all but nonexistent as late as 1830 but that rapidly widened thereafter.

The two aspects of Russian art of the first half of the nineteenth century that were to endure over the following generations were, first, the rhetoric of civic spirit and, second, the reality of deep engagement with the major currents of West European art. Russian art came of age in the early nineteenth century in a period of intensive artistic interaction with Europe as a whole. Like European artists elsewhere, however, Russia's artists sought to define some element in the content of their

work that was uniquely their own. To some extent they succeeded, though more often than not through the use of forms that were the common property of artists throughout Europe. As we have seen, this tension between form and content, between art and society, was little evident in the work of the first decades of Alexander I's reign. Thanks in good measure to the failure of Nicholas I to create and sustain a unified, "organic," and official art in Russia, the split had opened by 1835 and was to broaden steadily thereafter. In the last analysis, this rising tension between form and content, between art and society, was one of the principal legacies of the 1800–50 era to Russian art of a later age.

NOTES

1. N. Kovalenskaia treats this issue in *Russkii klassitsizm: zhivopis', skulptura, grafika* (Moscow, 1964), pp. 272 ff.

2. See their report of 1804 in *Severnyi vestnik*, 1804, No. 3, pp. 359 ff; partially quoted in Kovalenskaia, pp. 272–73.

3. Iu. M. Denisov, ed., *Ermitazh: istoriia i arkhitektura zdanii* (Leningrad, 1971).

4. Claude-Nicholas Ledoux, *L'Architecture considerée sans le rapport de l'art des moeurs et de la législation* (Paris, 1804).

5. Peter K. Christoff, *The Third Heart: Some Intellectual-Ideological Currents and Cross Currents in Russia 1800–1830* (The Hague, Paris, 1970), p. 28.

6. The 1802 additions to the charter are reproduced in "Privilegiia, ustavy, i shtaty Imp. Akademii khudozhestv, 1764–1912 gg.," in S. Kondakov, *Iubileinyi spravochnik Imp. Akademii khudozhestv* (St. Petersburg, 1914), vol. I, pp. 1766 ff.

7. See A. N. Pypin, *Religioznye dvizheniia pri Aleksandra I* (Petrograd, 1916).

8. The impact of 1848 in Russia is considered in A. S. Nifontov, *Rossiia v 1848 godu* (Moscow, 1952). This is not to deny, of course, that blatantly political themes were treated by Russian graphic artists. See T. V. Cherkesova, "Politicheskaia grafika epokha Otechestvennoi voiny 1812 goda i ego sozdateli," in *Russkoe iskusstvo XVIII —pervoi poloviny XIX veka; materialy i issledovaniia*, ed. T. V. Alekseev (Moscow, 1971), pp. 11–47.

9. V. Sipovskii explains Karamzin's neglect of the Revolution in terms of his other preoccupations at the time rather than his politics: *Karamzin kak avtor pisem russkogo puteshestvennika* (St. Petersburg, 1899).

10. On I. P. Martos, see M. Alpatov, *Ivan Petrovich Martos, 1752–1835* (Moscow, Leningrad, 1947); on I. P. Vitali, see T. Iakirina and N. Odnoralov, *Vitali 1794–1855* (Moscow, Leningrad, 1960).

11. N. I. Nadezhdin, *O sovremennom napravlenii iziashchnykh iskusstv*, (Moscow, 1833); see also N. Kozmin, *Nikolai Ivanovich Nadezhdin* (St. Petersburg, 1912), pp. 231 ff.

12. Jerome Blum, *Lord and Peasant in Russia from the Ninth to the Nineteenth Century* (Princeton, 1961), pp. 375.

13. I. I. Ignatovich, *Pomeshchichie krestiane nakanune ikh osvobozhdeniia,* 3d ed. (Leningrad, 1925), p. 93.

14. For a thorough summary of this issue, see Daniel Field, *The End of Serfdom, Nobility and Bureaucracy in Russia, 1855–1861* (Cambridge, London, 1976), pp. 22–35.

15. A. G. Troinitskii, *Krepostnoe naselenie v Rossii po 10-oi narodnoi perepisi: Statisticheskoe issledovanie* (St. Petersburg, 1861), pp. 65 ff.

16. See A. G. Rashin, *Naselenie Rossii za sto let* (Moscow, 1956), pp. 89–91.

17. See G. G. Pospelov, "Provintsialnaia zhivopis' pervoi poloviny XIX veka," in *Istoriia russkogo iskusstva,* vol. VIII, book 2 (Moscow, 1964), p. 345.

18. William M. Blackwell, *The Beginnings of Russian Industrialization* (Princeton, 1968), pp. 73–76.

19. On the process of secularization among traditionalist merchants, see Blackwell, pp. 151 ff.

20. See Alfred M. Rieber, "The Moscow Entrepreneurial Group: The Emergence of a New Form in Autocratic Politics," *Jahrbücher für Geschichte Osteuropas,* 1977, no. 1, pp. 12 ff.

21. *Istoriia russkogo iskusstva,* vol. VIII, book 2 (Moscow, 1964), p. 119.

22. Walter McKenzie Pintner, *Russian Economic Policy Under Nicholas I* (Ithaca, 1967), p. 244.

23. These works are addressed in N. Levinson and L. Goncharova, "Russkaia khudozhestvennaia bronza; dekorativno-prikladnaia skulptura XIX v.," *Trudy Gos. istoricheskogo muzeia,* XXIX (Moscow, 1958).

24. For a catalogue and brief description of the principal manufacturers see Marvin C. Ross, *Russian Porcelains* (Norman, 1968), and A. Saltykov, *Russkaia keramika, posobie po opredeleniiu pamiatnikov materialnoi kultury XVIII-nachala XX vekov* (Moscow, 1952).

25. See particularly the exhaustive catalogue of the third of these exhibitions, *Ukazatel' tretei v Moskve vystavki rossiiskikh manufakturnykh izdelii 1843 goda* (Moscow, 1843).

26. The appearance in Russian of such works as P. P. Chekalevskii's *Rassuzhdenie o svobodnykh iskusstv,* St. Petersburg, 1792, and A. A. Pisarev's *Predmety dlia khudozhnikov,* St. Petersburg, 1807, did much to foster this development. For an excellent overview of such publications, see Baron N. Wrangel, "Russkie knigi aleksandrovskoi epokhi po iskusstvu," *Starye gody,* July–September 1908, pp. 559–65.

27. Kovalenskaia, p. 255.

28. J. G. Kohl, *Russia, St. Petersburg, Moscow, Kharkoff, Riga, Odessa* (London, 1844), p. 110.

29. See, for example, *Opisanie Sankt. Petersburgai uezdnykh gorodov Sankt-Peterburgskoi gubernii* (St. Petersburg, 1839).

30. The process of reconstruction is detailed in A. A. Fedorov-Davydov, *Arkhitektura Moskvy posle otechestvennoi voiny 1812 goda* (Moscow, 1953).

31. Rashin, pp. 119–26.

32. A. S. Pushkin, "Puteshestvie iz Moskvy v Peterburg," in *Polnoe sobranie sochinenii,* 1949, vol. II, p. 246.

33. G. K. Lukomskii, *Arkhitektura russkoi provintsii* (Moscow, 1916). On the patterning of provincial cities after the capital, see E. A. Beletskaia, '*Obraztsovye*' *proekty v zhiloi zastroike russkikh gorodov XVIII–XIV vv* (Moscow, 1961).

34. Rashin, p. 126.

35. I. Pnin, *Sochineniia,* ed. V. Orlov (Moscow, 1934), pp. 256–57.

36. V. F. Odoevskii, *Muzikalnoi literaturnoe nasledstvo* (Moscow, 1956), p. 105.

37. On Nicholas's subsidy to the society, see M. Polievktov, *Nikolai I, biografiia i o'..,r tsarstvovaniia* (Moscow, 1918), p. 250. The society also raised funds through lotteries and the sale of prints. T. V. Alekseeva, Introduction to *Istoriia russkogo iskusstva,* ed. I. E. Grabar, vol. VIII, book 1 (Moscow 1963), p. 41.

38. S. Frederick Starr, *Decentralization and Self-Government in Russia, 1830–1870* (Princeton, 1972), pp. 9–25.

39. Polievktov, *Nikolai I,* p. 248.

40. Ibid., p. 251.

41. While planned with reference to Italian art, Nicholas's Italian trip was occasioned by concern over the empress's health, rather than by his artistic interests per se. (Polievktov, pp. 196–97).

42. Iu. Kliucharev, "Statia Gogolia ob arkhitekture nyneshnego vremeni," *Arkhitektura SSSR,* 1952, no. 2, p. 21.

43. L. Réau, "Un Peintre romantique russe: Alexandre Ivanov," *Revue des études slaves* XXVII (1951): 229.

44. M. Urenius, in *A. G. Venetsianov i ego shkola* (Moscow, 1925), stresses Venetsianov's academic links, while more recent Soviet critics have attempted to separate his interest in genre painting from the academy's own involvement in that field. Cf. T. Alekseeva, *Khudozhniki shkoly Venetsianova* (Moscow, 1958).

45. On A. V. Stupin, see N. Vrangel, "A. V. Stupin i ego ucheniki (Arzamasskaia shkola zhivopisi)," *Russkii arkhiv,* 1906, pp. 432–48; and P. Kornilov, *Arzamasskaia shkola zhivopisi pervoi poloviny XIX veka* (Moscow, 1947).

46. The academy's ties with these schools is detailed in N. Iavorskii, "Akademiia Khudozhestv i khudozhestvennoe obrazovanie Rossii v XIX veke," in *Akademiia khukozhestv SSSR, 200 let. Desiataia sessiia* (Moscow, 1959).

47. N. Dmitrieva, *Moskovskoe uchilische zhivopisi, vaianiia i zodchestva* (Moscow, 1951), especially ch. 1.

48. V. Ia., "Arkhitektory v professionalnoi statistike," *Stroitel,* 1897, no. 1–2, pp. 23–34.

49. Elizabeth K. Valkenier, *Russian Realist Art. The State and Society: The Peredvizhniki and Their Tradition* (Ann Arbor, 1977), pp. 17 ff.

50. On A. L. Vitberg's project, see "Zapiski Akademika Vitberga, stroitelia khrama Khrista Spasitelia v Moskve," *Russkaia starina,* 1872, bk. 1, pp. 16–32; bk. 2, pp. 159–92; on A. D. Ulybishev's "Dream," see M. V. Nechkina, *Dvizhenie dekabristov,* 2 vols. (Moscow 1955), I, p. 203; on A. Ivanov's temples see James H. Billington, *The Icon and the Axe; An Interpretative History of Russian Culture* (New York, 1970), pp. 343–44; Dostoevsky's architectural fantasies are considered by Adele Lindenmeyr, "Raskolnikov's City and the Napoleonic Plan," *Slavic Review,* March, 1976 pp. 37–47.

51. Kohl observed that Petersburg coffeehouses were unfrequented except by tourists, and that Beranger's was "small and lifeless," *Russia, St. Petersburg,* p. 210. See also M. A. Aronson, *Literaturyne sdony i kruzhki* (Moscow, 1929).

52. W. Bruce Lincoln, *Nicholas I: Emperor and Autocrat of All the Russias* (London, 1978), p. 238. See also Baron N. Wrangel, S. Makovskii, A. Trubnikov, "Arakcheev i iskusstvo," *Starye gody,* July–September 1908, pp. 439–47.

53. For full details on this hierarchy of genres, see P. N. Petrov, *Sbornik*

materialov dlia istorii Sankt-Peterburgskoi imp. Akademii khudozhestv za sto let ee suschestvovaniia (St. Petersburg, 1864), pp. 67 ff.

54. Kovalenskaia, pp. 277–79.

55. "Minin and Pozharskii," "The Summoning of Prince Pozharskii," "The Coronation of Tsar Michael Fedorovich," "Russian Maidens Were Heroines," and "The Varangian Prince" were among the more common themes through which artists celebrated Russian nationality, both before and after the doctrine of "Official Nationality" was promulgated.

56. Konstantin Ton, *Proekty tserkvei, Sochinennye arkhitektorom E.I.V. professorom arkhitektury imp. Akademii khudozhestv Konstantinom Tonom* (St. Petersburg, 1838). Ton's Byzantinisms rapidly gave way to a more self-consciously Russian idiom, especially after Nicholas I published I. M. Snegyrev's *Pamiatniki Moskovskikh drevnostei* (Moscow, 1845).

57. The false notion that genre painting is somehow democratic in politics is subjected to just criticism by G. Iu. Sternin in *Istoriia russkogo iskusstva,* ed. I. E. Grabar (Moscow, 1964), vol. VIII, book 2, p. 23.

58. Ivan Petrovich Pnin, "An Essay on Enlightenment with Reference to Russia," in *Russian Intellectual History, an Anthology,* ed. Marc Raeff (New York, 1966), pp. 157–58.

59. See, for example, M. G. Nekludova, "Bibleiskie eskizy A. A. Ivanova," in *Russkoe iskusstvo XVIII—pervoi poloviny XIX veka,* pp. 48–155. For rich documentation on the strength of Orthodox Christianity during the reign of Nicholas, see N. F. Dubrovin, "Materialy dlia istorii pravoslavnoi tserkvi v tsarstvovanii imperatora Nikolaia," *Sbornik imperatorskogo russkago istoricheskago obshchestva,* CXIII (St. Petersburg, 1912).

60. Lincoln, *Nicholas I,* pp. 238 ff. This should be contrasted to Nicholas Riasanovsky's less positive view in *Nicholas I and Official Nationality in Russia, 1825–1855* (Berkeley, 1967), pp. 269 ff.

61. I. S. Turgenev, *Literaturnye i zhiteiskie vospomininiia* (Leningrad, 1934), p. 88.

62. S. S. Volk, *Istoricheskie vzglaidy dekabristov* (Moscow, 1958), p. 160.

63. Quoted by F. Solntsev, "Moia zhizn i khudozhestvenno-arkheologichiskie trudy," *Russkaia starina,* 1876, no. 3, p. 628.

64. A. I. Klibanov, "K kharakteristike ideinykh dvizhenii v srede gosudarstvennykh i udelnykh krestian v pervoi treti XIX v.," in *Iz istorii ekonomicheskoi i obshchestvennoi zhizni Rossii,* ed. L. V. Cherepnin (Moscow, 1976), pp. 155 ff.

6

Russian Painting in the Nineteenth Century
John E. Bowlt

ALEKSANDR A. IVANOV (1806–58), the religious painter, once declared in the 1840s: "We have no predecessors."[1] This sentiment was shared by many Russian artists, writers, and critics in the nineteenth century, not least by the democratic thinkers Vissarion Belinsky and Alexander Herzen. But Ivanov and his colleagues also sensed that, because of its youthful vigor, Russian art was on the threshold of an unprecedented prosperity. Their presentiment of an artistic renaissance in Russia was linked to a broader and recurrent demand for universal social and political change in Russia, one voiced by many artists, especially by the realists of the 1860s–80s. An adequate appreciation of nineteenth-century Russian art can be achieved only on the basis of the realization that, by and large, the Russian artist was (and is) concerned with the tendentious and transformative purpose of art and not simply with formal or esthetic qualities.

A central question to be asked in any discussion of nineteenth-century Russian art is why, after centuries of remarkable accomplishment in the ecclesiastical arts, Russia suddenly began to shift her energies to the *znatneishie iskusstva* (the very splendid arts), and how, within only a hundred years or so, she managed to attain a high professional level in easel painting, civic architecture, and the graphic arts. Of course, it is generally agreed that the era of Russia's civility was inaugurated by Peter the Great through his program of Westernization in the early eighteenth century. Peter sponsored many architectural projects, he laid the foundations of Russia's industrial development, he connected Russia with the political mainstream of Europe, and—the inspiration for many artists and writers—he founded his "window on Europe," the city of St. Petersburg, in 1703. Peter was interested more in technology than in the fine arts, and he was concerned above all with

shipbuilding and the timber trade—with economic planning. Still, to some degree Peter can also be considered as the first imperial patron of the arts in Russia: he purchased Old Masters such as Brueghel, Rembrandt, and Rubens during his travels through Europe and commissioned many Dutch, German, French, and Italian artists and architects—the first of many cultural immigrants from the West to St. Petersburg, Moscow, and other centers—to help with his reconstruction of Russia.

At this stage in the history of Russian art, there begins an uneasy recognition and processing of Western artistic ideals, often compounded by a spontaneous return to national traditions such as icon-painting. This duality of perception, symbolized by the ongoing rivalry of "Western" St. Petersburg and "Eastern" Moscow, was maintained well into the nineteenth century and can be identified with the coexistence of, for example, Karl P. Briullov (1799–1852) on the one hand, and Aleksei G. Venetsianov (1780–47) on the other. Indeed, Russia of the eighteenth and nineteenth centuries depended upon cultural extremes of the most curious kind—"captive Turkish women and Russian landlords, French phrases learnt by village *muzhiki,* barefoot Akulinas in Greek costumes and Doric temples constructed in the sleepy forests of Kostroma."[2] But however provincial, however tentative her artistic endeavors in the eighteenth century, Russia prepared herself for a great artistic efflorescence as her artists and architects—consciously or unconsciously—tried to catch up and, in some cases, to overtake the Western schools. The portraits by Vladimir L. Borovikovsky (1757–1825), Dmitrii G. Levitsky (1735–1822), and Fedor S. Rokotov (1736–1808) of the late eighteenth century easily withstand comparison with those by their French, Italian, and English predecessors and contemporaries. Perhaps the greatest exponent of the Western artistic ideal in Russian painting was Borovikovsky, as is demonstrated by his portraits such as *Mariia I. Lopukhina* of 1797 (fig. 6.1). The virtuoso technique, the idealization of subject, the ceremonial format—all these features betray a traditional Western approach derived from a classically inspired esthetic. Borovikovsky was an excellent portrait painter, but there is little here to suggest that he was Russian or particularly different from the English masters: when we look at the Lopukhina portrait, we are, essentially, looking at the school of Gainsborough and Reynolds.

As might be expected, Russia's recognition of the European academic styles of the late eighteenth century left an appreciable mark on her subsequent artistic development well into the nineteenth century. Russia's loyalty to the classical idea explains, in part, certain artistic phenomena identifiable with the early nineteenth century: the emphasis

on compositional design and draftsmanship, the preference for the por-
trait and historical genres and the corresponding neglect of landscape
and the *intérieur,* the eager appreciation of Raphael and Poussin but the
less immediate concern with Caravaggio and Correggio, and the very
ambigious attitude toward the Flemish and Dutch schools.

The staunchest defender and, eventually, depraver of the classical
idea in Russia was the Imperial Academy of Fine Arts established in St.
Petersburg in 1757 under the Empress Elizabeth and opened as a teach-
ing establishment in 1763 under Catherine the Great. Most of the more
familiar artists and architects active in Russian art in the first half of the
nineteenth century were affiliated in some way or another with the
Academy of Fine Arts. Even painters, sculptors, and architects who crit-
icized the academy, such as Venetsianov, still acknowledged its unassail-
able position and looked to it for inspiration and guidance. Generally
speaking, the St. Petersburg Academy occupied a place of power more
exclusive, more autocratic than that of its French and English counter-
parts, at least until the 1820s. Subsequently, the St. Petersburg
Academy lost some of its impulse and, like most official institutions,
rejected the advance of any new movement that deviated from its
norms. The initial success of the academy as a pedagogical institution
and as a dictator of artistic fashion in Russia was ensured by the aware-
ness and intelligence of its protectress, Catherine the Great. The in-
fluence of Catherine's personality on the development of Russia's art
and letters has yet to be recognized in full: she commissioned Grimm in
Paris, Reifenstein and Mengs in Rome, and many others "to keep an
eye open for all sales";[3] she entered into an extensive correspondence
with the literary and artistic luminaries of Europe; she acquired the li-
braries of Diderot and Voltaire; and she supported the *pensionnaire* sys-
tem that enabled academy graduates to study abroad.[4] Moreover,
thanks to Catherine's individual tastes, Russian aristocrats experienced a
rapid and wholehearted conversion to French culture, and, before
1789, they spent as much time in Paris as they did in St. Petersburg—if
not more. By the end of the eighteenth century the Sheremetevs, the
Shuvalovs, the Stroganovs, and the Yusupovs had replaced the English
lord as the Croesus and patron of the muses in Paris.

From the 1770s onward, the general cultural orientation in Russia
was a French one, an esthetic bias that was maintained publicly and
privately until at least the accession of Nicholas I in 1825. Many actions
and events in Russia confirmed this: for example, in 1797 Paul I ap-
pointed the Comte de Choiseul-Gouffier President of the St.
Petersburg Academy (until 1800); many of its faculty at that time were
French artists, often of secondary talent; the splendid architectural
ensembles of St. Petersburg were often designed by French architects;

and some of the celebrated paintings and sculptures of this time relied on French prototypes. To understand the successes and failures of early nineteenth-century Russian art, we must recognize the extent to which French culture affected the psychology of the Russian artist—which is not to say that he served his apprenticeship unswervingly or never outwitted his mentor. Actually, the results of this inculcation were not always beneficial, and, from the very beginning, the academy's European system fell afoul of Russian imperfections and misunderstandings. Students came to class drunk. Delivery of supplies was so erratic that one professor was forced to travel to the Black Sea to find pencils; a German teacher of anatomy waited in vain for a skeleton for three years and finally gave up and returned home. Some of the imported instructors were frauds, including the Paris pâtissier who was hired to teach architecture.[5] Such episodes may be in part apocryphal or at least exaggerated, but they do reflect the unease with which Western ideas were accepted by the Russians.

The curriculum of the St. Petersburg Academy embraced all humanistic subjects—the classics, languages and literatures, history, geography, and, of course, the fine arts. Although the composition and direction of the academy changed from time to time, especially under the presidency of Aleksei N. Olenin (1763–1843); president 1817–43), a rigid system of tuition was always maintained. During his term of study (normally fifteen years), a student attended lessons given by French, German, and Italian professors or by Russian professors who had returned from study abroad. Most of the important Russian artists of the early nineteenth century were trained at the academy: Briullov and Fedor A. Bruni (1799–1875) enrolled in 1809, Aleksandr Ivanov in 1817, Orest A. Kiprensky (1782–1836) in 1788, and Silvestr F. Shchedrin (1791–1830) in 1800; Vasilii A. Tropinin (1776–1857) became an auditor in 1798. As in other academies, art instruction depended essentially on life drawing and from plaster casts of antiquities and from professors' drawings. Life drawing constituted the foundation of the academic system, something that accounts for the very high level of draftsmanship among nineteenth-century Russian artists. True, artists outside the academy such as Soroka sometimes possessed a finer sensitivity to the expressive qualities of paint and texture, but the graduates of the academy, especially Briullov, Bruni, and Kiprensky, had a remarkable grasp of the intricacies of perspective and anatomical proportion, even in their adolescent years. Often the drawings are superior to the paintings, rivaling the graphic expertise of Ingres. Such is the case with Aleksei E. Egorov (1776–1851) and Bruni. Indeed, some of the more rhetorical paintings of the early and mid-nineteenth century in Russia such as Briullov's *The Last Day of Pompeii* (1830–33)

and Aleksandr Ivanov's *The Appearance of Christ to the People* (1837–57) are colored designs rather than paintings (a condition no less characteristic of contemporary French art).

This cultivation of line and linear composition on the part of the academy teachers and students encouraged—or was encouraged by—the traditional choice of models—Leonardo, Claude Lorrain, Poussin, and, first and foremost, Raphael: "Raphael among painters," declared Kiprensky, "is the Alpha and Omega."[6] Caravaggio, Correggio, and Titian were considered to be inferior and Rubens simply unskilled. As late as the 1830s, Russian pensionnaires rarely took the trouble to visit Venice to see the Titians, and when Ivanov went there in 1834 with the express aim of acquainting himself with Titian, he was criticized harshly by his colleagues. They argued that such artists, and many modern artists too, such as the German romantics, were unable to draw properly and were tampering with the rules of academic design.

In the early 1840s the painter and pupil of Briullov, Fedor A. Moller (1812–75) wrote to Ivanov that the "French limit themselves to defining the general effect . . . so, justifiably, their paintings can be called large studies."[7] In 1846 the critic Nestor V. Kukol'nik (1809–68) asserted that the "Russian school [of painting] is, in general, the continuation of the Italian school."[8] Moller and Kukol'nik could have arrived at these conclusions only after major changes in Russia's cultural life, i.e., changes that undermined the earlier hegemony of French taste. During the 1820s–40s Russia's artistic allegiance to Italy became very strong—demonstrated simply by the fact that the prominent artists of the time, Briullov, Bruni, Ivanov, Kiprensky, were, or had been, living in Rome for long periods. What caused this dramatic shift from Paris to Rome? How was it that the poet Prince Petr Viazemsky could declare that in Italy "one can even do without happiness. . . . People live in the heavens there"?[9]

Naturally, the Russians shared the current European fashion for things Italian, although there are other, specific reasons for this new direction in Russian taste. Above all, the reaction against the domination of French culture may be interpreted as a symptom of mounting dissent within the existing order and conventions of Russian society, just as the Decembrist revolt of 1825 marked the climax of a period of unrest. Dissatisfaction with the status quo—social, political, cultural—was apparent in Russian intellectual circles even in the 1790s. The sudden increase in Masonic lodges in St. Petersburg at that time was, to some degree, indicative of opposition to the rational philosophy of the Enlightenment and of a search for a more mystical, more individualistic world view. Many artists, architects, and writers of the time, such as Konstantin Batiushkov, Borovikovsky, Nikolai Karamzin,

Levitsky, Andrei N. Voronikhin (1760–1814), and, later, Aleksandr O. Orlovsky (Orlowski) (1777–1832), were members of lodges with names like Elizabeth or the United Friends and the Dying Sphinx, and the symbols of the lodges often accompanied the portraits of contemporaries. The Masons did not contemplate violent revolution, and they were appalled at the ravages of 1789 in France. Rather, they considered philanthropy as the social panacea and, ultimately, believed that popular, national unity could be accomplished in Russia. Indeed, hopes for social and artistic changes ran high with the advent of the new century and with the accession of Alexander I in 1801.[10]

Of particular relevance to this context is the Free Society of Lovers of Literature, the Sciences, and the Arts founded in St. Petersburg in 1801. The Free Society, which included some Masons among its members, set out to play the role of public enlightener, sponsoring lectures such as "An Attempt to Define the Elevated in the Fine Arts" and "The Literary Fable of Antiquity and Its Use by Artists." The Free Society also advocated unorthodox, even radical political views: for instance, Ivan Pnin, editor of *S. Peterburgskii zhurnal* and one of the more active intellectuals in the Free Society, spoke of the need to abolish serfdom in one of his philosophical essays.[11] Several prominent artists were affiliated with the Free Society, including Andrei I. Ivanov (1777–1848), the caricaturist Ivan I. Terebenev (1780–1815), and the sculptors Samuil I. Gal'berg (1787–1839) and Ivan P. Martos (1754–1835). The Free Society propagated its cause through various magazines of the time, such as Mikhail Kachenovsky's *Vestnik Evropy* (St. Petersburg, 1821–23) and Vasilii Grigorovich's *Zhurnal iziashchnykh iskusstv* (St. Petersburg, 1923–25), and, perhaps even more effectively, through the numerous salons that flourished in St. Petersburg, Moscow, and other cities during the first half of the nineteenth century. Writers, artists, and philosophers gathered regularly at the homes of Nikolai A. L'vov (1753–1803), Olenin, Vladimir F. Odoevsky, etc., and frequented the "Sundays" of Fedor P. Tolstoi (1783–1873), and, later, the "Wednesdays" of Kukol'nik, declaiming poetry, debating political issues, sketching, and making music.[12]

At the beginning of the nineteenth century, Russian intellectual society rapidly divided into many factions, and new artistic philosophies evolved, questioning the rectitude of the classical idea, proposing alternative systems, and contributing to the formation of a more romantic tendency. Typical of this new movement was Aleksei R. Tomilov (1779–1848), an artillery engineer and Mason who also took a keen interest in the fine arts. The "last purely Russian Maecenas," as Baron Nikolai N. Vrangel later called him,[13] Tomilov supported unconventional views, which he expounded in various tracts such as *Mysli o*

zhivopisi (ca. 1810). Questioning the canons of classical art as inter-preted by Anton Raphael Mengs and Johann Joachim Winckelmann (whose *Geschichte der Kunst des Altertums* was a key component of any Russian library), Tomilov gave much thought to the new artistic phenomena. He asserted that the artist must go beyond mere imitation of nature, that "feeling" and the "imagination" must be of primary im-portance in art, and that the artist had the right, therefore, to communi-cate his own intuitive response.[14] Furthermore, Tomilov indicated that the work of art was the embodiment of the subjective, individualistic impulse—a perception that was close to that of the German romantics and also that of a number of Russian intellectuals of the 1810s and 1820s, e.g., Wilhelm Küchelbecker. Küchelbecker maintained that the artist should be concerned not with the prose of life but with the har-monious combination of "inspiration" and "charm."[15] For Küchelbecker the first protagonist of this idea was Raphael, the first antagonist—Rubens.[16]

In spite of the philosophical innovations of the 1810s, the traditions of academic art were so well entrenched in Russia that a clear exposi-tion of the romantic tendency in art was not published there until 1825—Aleksandr I. Galich's *Opyt nauki iziashchnego.* Novalis and Schlegel were known and respected in Russia, but their ideas had little immediate effect on the visual arts there. The more conservative "art critics," who tended to be either poets or artists manqués, such as Grigorovich, Karamzin, and Kukol'nik, neglected contemporary devel-opments in Russian art and, in the 1810s–30s, continued to uphold the criteria of certain of the Old Masters, above all, Raphael. Many years passed before Kukol'nik could bring himself to admit that Raphael might not meet modern criteria of art.[17] But by then the romantic era was in decline, and the idols whom he and the classicists had disre-garded had long been established as paragons of good taste.

Still, the philosophical enquiry of the 1810s and 1820s initiated by Tomilov and his colleagues did not go completely unheeded by artists, and innovations in pictorial style and content became evident. The world of antiquity remained a primary theme, but now its ruins were treated as backdrops for epic events, as in Briullov's *The Last Day of Pompeii,* or for lyrical contemplation, as in Kiprensky's *Portrait of the Poet Vasilii Zhukovsky* (1816), and its heroes were reembodied as Rus-sians, as in Terebenev's caricatures "The Russian Scaevola" (cf. fig. 12.2) and "The Russian Hercules" (both of 1812). The romantic notion of "incompleteness," of transience and mutability, now influenced the way some Russian artists conceived and designed their paintings: for exam-ple, in his portrait of Zhukovsky, Kiprensky deliberately left the hand unfinished so as to evoke a sense of spontaneity and immediacy. The

psychological portrait and the self-portrait also became centers of attention, while the official or parade portrait, popular in the late eighteenth century, fell out of favor. Also typical of this process of change was the fact that artists like Ivanov and Kiprensky began to formulate their own artistic systems, imbuing their ideas with an absolute and fanatical power.

Of course, romantic ideas affected all the Russian arts of the 1820s–30s, but it would be an exaggeration to conclude that there was a distinctive romantic movement in Russian painting and sculpture. One reason for this is simply a geographical one: those artists who merit the description romantic—Briullov, Kiprensky, and to some extent Venetsianov—lived much of their lives away from St. Petersburg and the "official" direction of Russian art. Briullov and Kiprensky preferred the exotic milieu of Rome, and Venetsianov felt more at ease in the Russian countryside. Ultimately, their actions prompted the establishment of a new tradition, an alternative to that of the academy, one that gained momentum as the nineteenth century progressed. However, before the Russian colony in Rome and the Venetsianov school can be examined, mention must be made of a single political episode that exerted a profound influence on all walks of Russian life—the War of 1812.[18]

When the Grande Armée crossed the Russian frontier on 23 June 1812, the manners of the Russian bear proved to be not so very French as his previous behavior might have indicated. The influence of French culture had persisted during the first years of the nineteenth century, inspired to some extent by Alexander I's personal taste, but this influence was not indelible. For a brief moment the Napoleonic invasion gave an emotional cohesion to a nation that, in the 1800s, was showing clear signs of dissent and division. As would happen at the beginning of World War I in 1914, the external enemy now replaced the internal one. "Let there be one sentiment in all hearts," wrote an observer in 1812, "let there be one cry on everyone's lips—Revenge!"[19]

Artists responded to the events by producing caricatures against Napoleon or panegyrics to the Russian army.[20] Napoleon was pictured as the Antichrist, Alexander as Apollo, and the classical motifs were used to good purpose in order to invest the Russian cause with the appropriate symbols of heroism and righteousness. For example, Kiprensky undertook a number of patriotic works, including drawings of *Alexander I and Minerva* and *Kutuzov Advancing into the Temple of Glory*. Something like 200 caricatures of Napoleon and his army were printed during the period 1812–14 in Russia, introducing Russia's first professional political caricaturists, including Terebenev and Venetsianov. De-

spite all these parodies and satires, it was Napoleon, rather than the French people as a whole, who was the target of abuse. Moreover, on his two triumphal entries into Paris in 1814 and 1815, Alexander I made it quite clear that he had only one enemy and that the French people were not to be harassed or punished. Contemporary reports and prints indicate that the Russian troops did, indeed, fare well with the French citizens, especially with the *parisiennes:* once again Russians assimilated French culture, although not always of the highest order.

Even after 1812 French artists continued to reside in St. Petersburg. In 1815 Henri François Riesener, a pupil of Jacques-Louis David, came; in 1816 Richard de Montferrand came with his plans for St. Isaac's Cathedral; in 1835 the battle painter Adolphe Yvon became a professor at the academy, contributing much to the stylistic development of Ivan K. Aivazovsky (1817–1900), Russia's leading maritime painter. As the French critic Louis Réau has stated rather patronizingly, even the captured French cannons, displayed in the Kremlin, bore inscriptions in French.[21] As for the Russian studio artists, they tended to concentrate on triumphal, commemorative subjects: Olenin designed fifteen medallions, Fedor Tolstoi embarked on an ambitious scheme of twenty-one sculptural allegories of military events; the architect and painter Aleksandr L. Vitberg (1787–1855) began construction of a commemorative Cathedral of Christ the Savior located on the Sparrow Hills from which Napoleon had looked down on Moscow. The imposing Cathedral of the Savior designed by Konstantin A. Ton (1794–1881), constructed during 1837–81, was meant as a monument to Russia's conquest of Napoleon. But perhaps the most impressive artistic outcome of the war was the creation of the so-called Gallery of 1812 in the Winter Palace—an assemblage of 332 portraits of Russian military heroes supervised by the English artist George Dawe.

The Russian decorative arts of this period also took on a new confidence and assertiveness, even though they still owed a good deal to the French. The Russian *style Empire* was heavier and more ornate than its French counterpart, although particular motifs were common to both interpretations. It should be remembered, however, that the application of Graeco-Roman and Egyptian images such as the sphinx, the lyre, and the faun was also prompted by Russia's close association with, and admiration for, Greek and Middle Eastern art since at least the time of Catherine the Great. This traditional orientalism, especially evident in Russian culture of the 1820s–40s, accommodates many works of art and literature, from malachite caskets resting on sphinxes to mahogany chairs with gilded serpents, from Pushkin's poem *The Fountain of Bakhchisarai* to the pair of sphinxes on the embankment of the Academy of Arts.[22] These solid artifacts of the Alexandrine era express

Russia's new self-awareness and optimism: Russia the conqueror was now on an equal footing with the nations of Europe.

In contrast to the eras of Catherine the Great and Alexander I, the reign of Nicholas I (1825–55) was a time of political reaction, extreme Slavophilism, and curtailment of civil rights. The Decembrist revolt of 1825 and its cruel consequences harbingered the many unpleasant episodes that were to occur under Nicholas I. But this was also a time of cultural and intellectual prosperity—the late 1820s–30s saw the creation of literary masterpieces by Gogol, Lermontov, and Pushkin, the foundation of a genuine school of Russian music led by Glinka, and the execution of some of the most celebrated of Russia's paintings, such as Briullov's *The Last Day of Pompeii,* Ivanov's preliminary studies for *The Appearance of Christ to the People,* Kiprensky's *Portrait of Pushkin* (1827), and Venetsianov's *Spring. Plowing* (1830s). After decades of obedience to Western directives, the Russian artist now seemed to have acquired a new conviction of purpose. Foreign artists still came to Russia, but Nicholas's favorite artist was German, not French—Franz Krüger, principal representative of the Biedermeyer style. Russian artists still traveled abroad, but they now preferred Rome, and if, in the old days, the academy *pensionnaires* had gone to Paris as submissive students, venerating their French mentors, they now arrived in Rome as professional artists, respectful of the Old Masters but skeptical of contemporary Italian artists. Rarely, if ever, did Briullov, Ivanov, or Kiprensky express interest in their Italian supervisors and colleagues.

Russian artists in Rome found themselves to be part of a large international community: both Briullov and Kiprensky were acquainted with Ingres, who was in Italy in 1806–24 and 1835–41; Ivanov was at one time close to Overbeck. Moreover, the colony was augmented by writers, philosophers, and musicians. Gogol, for example, lived mainly in Rome between 1836 and 1848 and was especially close to Ivanov. Besides meeting within their own émigré section in the northern part of Rome not far from the Piazza del Popolo, the Russians congregated regularly at favorite cafés, especially the Caffè Greco, and, beginning in 1839, at the brilliant salon of Princess Zinaida A. Volkonskaia, "le Corinne du Nord."

Apart from private patronage, especially of Russian aristocrats living in Rome, there were two ways in which a Russian artist could become a *pensionnaire* in Italy—through the St. Petersburg Academy program or through the Society for the Encouragement of Artists (later Arts), a private and then imperial organization established in 1820 to assist art students financially. In the 1820s both the academy and the society urged their protégés to uphold the classical tradition by concentrating on Leonardo, Mengs, Raphael, Vasari, and Winckelmann and to regard

innovations with suspicion. One representative of the society advised Ivanov to keep to the Old Masters, since "Romanticism is destroying both art and literature," and was highly indignant at the fashionable tendency to treat the watercolor and the sketch as legitimate, independent media.[23]

Pensionnaires came to Rome normally for three years and were assigned to the care of prominent artists living in Rome, e.g., Vincenzo Camuccini (a follower of David and head of the Accademia di San Luca after Canova) and the Danish sculptor Bertel Thorvaldsen (whose portrait Kiprensky painted in 1833). Some *pensionnaires* quickly succumbed to the pleasures of Bacchus and Venus, and the most disturbing rumors circulated concerning the unconventional behavior of certain Russians. In 1840, therefore, Nicholas I decided to bring order to the Russian colony and established a special commission to take charge of the artists there. In 1845 Nicholas I himself arrived to take stock of the situation.

Even though Olenin, President of the Academy of Arts, was not keen on long residences abroad ("We do not intend to people foreign territories with our artists," he once declared[24]), many artists went to Italy during the 1810s–40s, including Petr V. Basin (1793–1877); Bruni; the Chernetsov brothers, Grigorii G. (1802–65) and Nikanor G. (1805–79); Grigorii G. Gagarin (1810–93); Samuil I. Gal'berg (1787–1839); Fedor M. Matveev (1758–1826); Moller; Silvestr Shchedrin; Ton; Aleksei V. Tyranov (1808–59); and Maksim Vorob'ev (1787–1855). But by far the most original artists of the colony in Rome were Kiprensky (arrived 1816), Briullov (1823), and Ivanov (1830).

When Kiprensky arrived in Italy, he was thirty-four years old and already a mature artist. A pupil of Grigorii I. Ugriumov (1764–1823) and Gabriel François Doyen at the St. Petersburg Academy, Kiprensky had moved rapidly from the classical canon to a freer, more "romantic" vision. In St. Petersburg he had known Tomilov, and frequented Olenin's salon, and had cultivated a deep interest in the work of Rembrandt and Rubens. Kiprensky was a born artist. His first portraits—e.g., one of his father, Shvalbe (1804), the self-portrait with paint brushes (1808), and one of the dashing Evgenii Davydov (1809)—were of a caliber equal, if not superior, to that of the work of his Italian periods (1816–22, 1828–36). Perhaps his contemporaries can be forgiven for mistaking the Shvalbe for a Rembrandt! Much of Kiprensky's painting of the 1830s represented a distinct decline, as the "king of painting"[25] tried desperately to restore an image fast tarnishing.

Kiprensky's sojourn in Italy seems to have affected his initial style very little. His idiosyncratic viewpoint from below the horizon (cf. his portrait of Karl I. Al'brekht of 1827), his esthetic treatment of the color

black, his attempts to harmonize bare canvas and superimposed paint, and his attention to texture were components of his artistic system from the beginning, well before he resided in Rome. Moreover, most of Kiprensky's celebrated portraits were painted outside Italy, either before he left St. Petersburg or back in Russia during 1823–28. These included the remarkable Pushkin portrait of 1827, commissioned by the poet Anton A. Del'vig in St. Petersburg in the spring of that year. Most observers, including Pushkin himself, agreed that the painting bore a close resemblance, even though Nikolai A. Polevoi, the critic and contemporary of Pushkin advised that "Pushkin's physiognomy is so well defined, so expressive that any good painter can catch it; at the same time it's variable and unstable so that it's difficult to imagine that a single portrait of Pushkin could provide an authentic conception of it".[26] In the evolution of Russian painting, Kiprensky's portraits made an original and vital contribution. In the European chronology, however, Kiprensky's portraits arrive rather too late to merit universal, unqualified appreciation. Kiprensky concentrated on the psychological portrayal of his sitter, he removed the obvious pose, and he attended to the question of the sitter's age (he painted children as if they were children, not as adults). But by the early 1800s, these qualities were not novel, for the French artists Girodet, Gros, and Ingres had already introduced them, and perhaps we can understand François Gerard's comment on one of Kiprensky's contributions to the Paris Salon of 1822: "Cette peinture n'est pas de notre siècle."[27]

Whether or not Gerard's opinion was valid, Kiprensky helped to bring Russian art into the international arena. As Ivanov said when Kiprensky died: "Shame on those who abandoned this artist. He was the first to make known the Russian name in Europe."[28] Indeed, Kiprensky was the first Russian artist to have a self-portrait commissioned for the Uffizi Gallery. Kiprensky's real reputation must rest on his superb drawings, especially his graphic portraits, e.g., those of Tomilov (1813) and of Princess Sof'ia S. Shcherbatova (1819; fig. 6.2). In such works Kiprensky seemed almost to realize his dream to "destroy the line that divides nature and art."[29] That Kiprensky used the drawing as a powerful, independent discipline is evident, for example, from his album of 138 sketches dating from ca. 1807, one of the most intriguing monuments of nineteenth-century Russian art. Although they lack the clarity and order of Géricault's and Vernet's drawings of approximately the same period, these varied sketches of antiquities, animals, and heads reveal a great mastery and energy of design.

Kiprensky served as an immediate bridge between the classical and romantic tendencies in Russian art. He was a product of the St. Petersburg Academy and never really rejected its fundamental canons

of taste. Indeed, Kiprensky's technical precision was astounding, and he himself even envisioned an artistic system whereby the artist would be able to produce "total illusion."[30] At the same time, Kiprensky was familiar with the ideas of Novalis, Schelling, and Schlegel, and he admired the French and German romantic painters. In his own portraits Kiprensky paid particular attention to individual psychology as well as to the pathetic fallacy—as in his portrait of Zhukovsky. Of course, these dynamic portraits reflect Kiprensky's own ebullient temperament, which must have adapted itself to the strict academic system only with great reluctance. Certain biographical facts—that he murdered his mistress by burning her in turpentine and then married her thirteen-year-old daughter, that he made fakes of Titian and Tintoretto, proffering them to the St. Petersburg Academy, and that he painted many self-portraits, none of which resembled him—demonstrate the quixotic and passionate character of this first-rate artist.

Throughout his life, Kiprensky complained that financial considerations forced him to paint portraits and that he was denied the opportunity to undertake historical themes. No doubt he envied the fate of Russia's most successful "Western" artist, Karl Briullov, a painter who also lived in Italy for much of his life. In contrast to Kiprensky, Briullov was a very different artist, outgoing where Kiprensky was introverted, exuberant where Kiprensky was somber, and not surprisingly, welcomed in society where Kiprensky was not. Briullov (the name is from the French Brudeleau) arrived in Rome in 1823 and immediately attained popularity both as an oil painter and as a watercolorist. During his two residences in Italy (1823–24, 1850–52), Briullov produced about 100 portraits, his most successful genre, although his celebrated *Last Day of Pompeii* (fig. 6.3), commissioned by Count Anatolii N. Demidov, is a fine example of historical painting, comparable to Delacroix's *Massacre at Chios* or Géricault's *Raft of the "Medusa,"* even though its composition is from Poussin (cf. *The Plague at Ashdod*). Gogol described the picture as "one of the brilliant phenomena of the nineteenth century. It is the radiant resurrection of painting...."[31] Whether or not it was as superlative as Gogol thought, *The Last Day of Pompeii* was certainly a product of its time: excavations at Pompeii had been in progress since the mid-eighteenth century, inspiring numerous paintings; Giovanni Pacini produced his opera of the same name in Rome in 1825; and Bulwer-Lytton published his novel *The Last Days of Pompeii* in 1834 (Russian translation published in 1836). It has been suggested that Briullov took the idea for his painting from Raphael's (or, rather, Romano's) fresco *Fire in the Borgo* at the Vatican, although the sensuous, tactile rendition of the figures betrays Briullov's closer allegiance to the Mannerists, especially Parmigianino. Like the novel of

Bulwer-Lytton, Briullov's *Last Day of Pompeii* enjoyed an immediate — and fleeting — success, honored in Rome, Florence, Paris, and then St. Petersburg, and it inspired numerous copies and paraphrases.

Some nineteenth-century Russian commentators tried to interpret the tension between the Pompeiians' powerful physiques and their imminent destruction as a symbol of Russia's destiny, i.e., of what they felt must be the imminent termination of the autocratic rule of Nicholas I. After all, they argued, his reign began under the bloody augury of the Decembrist revolt in 1825, and the democratic thinker Herzen identified *The Last Day of Pompeii* precisely with this environment of terror.[32] Perhaps the painting did hold a prophetic meaning, and the cataclysm about to annihilate the noble Pompeiians might be taken as a prediction of the subsequent destruction of Imperial Russia. In the same context, it is not too farfetched to draw a parallel between Briullov's depiction of the Pompeiian tragedy and Gogol's description of Russia's landowning class, sick at heart and dying, that he used in his novel *Dead Souls,* also a work of the 1830s.

Briullov's *Last Day of Pompeii* and his grand portraits of the 1830s–40s have a drama and panache that contrast sharply with the dry stereotypes of the lesser academicians and *briullovtsy* such as Gagarin and Moller. Still, as in the case of his French counterparts like Gerard and Gros, Briullov's painting is not always *painting.* His pictures rely on maximum literary content: we read him before we see him. Of course, Briullov did produce some beautiful artifacts that depend on understatement and restraint, for example, his male portraits, such as the one of the writer Aleksei A. Perovsky (1787–1836) of 1836. His portraits of women were generally more opulent and, as in the case of *The Last Day of Pompeii,* tended to reveal the artist's technical bravura rather than the character of the sitter, as in the case of the portrait of Mariia I. Alekseeva (née Trofimova) of 1837. At the same time, some of these portraits cannot fail to impress by their brilliance: the *Portrait of Princess Elizaveta P. Slatykova* of 1841 is perhaps the most imposing portrait of Briullov's later period, combining the physical profusion of the oriental environment (the leopard skin, the tropical plants, the peacock feather) and the sensitive, equivocal mood of the sitter.

A third major representative of the Western esthetic in Russian art is Aleksandr Ivanov, an eccentric, fanatical painter who regarded art as a medium of deep moral and religious experience. Ivanov had little in common with his Russian colleagues in Rome, and he tended to lead a withdrawn, monastic way of life. The son of Andrei Ivanov, a professor at the St. Petersburg Academy, Aleksandr Ivanov arrived in Rome with a solid academic training and with a deep admiration for Raphael, Leonardo and Poussin. Ivanov left Russia in 1830 and returned home

only in 1858, but, despite this long absence, despite his great love of Italy and his antipathy toward the St. Petersburg establishment, Ivanov remained profoundly "Russian"—particularly in his messianic, apocalyptic philosophy of art. Together with Belinsky, Herzen, and other democratic thinkers of Russia's "remarkable decade" (1838–48), Ivanov wished to reform mankind, and he regarded art as a sure weapon in the struggle for social transformation.

Briullov was a brilliant member of the international artistic elite, but, as Turgenev once said, he was a "phrase-monger with no ideal in his soul, a drum, a cold and raucous rhetorician."[33] Ivanov, on the other hand, was guided by a fervent belief in Russia, a religious fanaticism that Gogol and perhaps Dostoevsky also shared. Ivanov put forward his ideas in a curious essay entitled "Mysli, prikhodiashchie pri chtenii biblii," which he wrote in 1847. Here Ivanov argued that the Slavic peoples would be the bearers of a Golden Age, when "mankind will live in complete peace, when wars will cease and eternal peace will be established. . . . All branches of the human intellect . . . will attain their full development, particularly historical painters."[34]

So as to hasten the dawn of this Golden Age, Ivanov worked on a huge canvas (540 × 750 cms.) entitled *The Appearance of Christ to the People* (fig. 6.4) between 1837 and 1857. The prototypes of this painting were entirely Western, ranging from the Raphael/Romano *Transfiguration* at the Vatican to various works by Poussin and the Nazarenes, and its composition owed very little to the indigenous traditions of Russian art. Although many works of Ivanov's academic period pertained to biblical subjects, several circumstances dictated his choice of the theme of the appearance of the Messiah. Above all, Ivanov was profoundly impressed by the Raphael frescoes at the Vatican; in Padua he discovered Giotto, in Florence, Giotto and Masaccio, and in Venice, Titian. Exposure to the large format, to the particular resolution of space and distance in the mural, contributed much to Ivanov's own conception of *The Appearance*—perhaps the tragic weakness of his masterpiece lies in the fact that it is an easel painting and not a fresco.

Shortly after arriving in Rome, Ivanov made the acquaintance of Overbeck, leader of the Nazarenes. During the 1830s and 1840s Ivanov often met with Overbeck, regarding him as an artistic and philosophical mentor and, no doubt, concurring with him that "Russia . . . has put on a dress-coat too soon."[35] Like Overbeck, Cornelius, von Carolsfeld, and other Nazarenes, Ivanov turned back to the early Renaissance, particularly to Fra Angelico, hoping to find inspiration for a spiritual revival. Ivanov sensed that his magnum opus was intimately connected with this mission. Ivanov himself regarded Moscow as the Third Rome and the Russian people as humble and pure in heart—

worthy of the Second Coming. We note that Gogol, a great Russian patriot, is included in the procession, as is Ivanov himself. Furthermore, the very tendentious nature of *The Appearance* relates to the general Russian preference for narrative, didactic art—as Belinsky remarked in 1840: "Art must serve mankind, not mankind art."[36] Still, as the years passed, as the preliminary designs increased from 228 in 1839 to 400 in the early 1850s, Ivanov lost interest in his grand picture. In 1855 Ivanov confessed sadly to Herzen that "my work—my large painting—is, in my eyes, sinking ever lower";[37] and Herzen admitted that Ivanov himself was an anachronism.[38] When *The Appearance* was finished in 1857 and exhibited the following year at the St. Petersburg Academy, it had only a moderate success and was eclipsed, ironically, by an even larger canvas—Yvon's *Battle of Kulikovo.*

Far from creating a revolution in Russian society, as Ivanov had hoped, *The Appearance* did not even affect the course of Russian art. Turgenev was justified in regarding this picture as the product of a period of decline, a period when painting was "poetry, philosophy, history, and religion" (but not painting).[39] For us today, the primary interest of *The Appearance* lies in its external associations—in the acerbic correspondence between Ivanov and the impatient Society for the Encouragement of Artists, in the comments made on the picture by visitors to Ivanov's studio in Rome ("An excellent start!" said Nicholas I in 1845),[40] in the careful researches that Ivanov conducted in his striving for ethnographical and historical accuracy, and in the many fine landscapes and figure studies for the painting. These circumstances do not disguise the fact that *The Appearance* is a mediocre work, and a major reason for its failure is that by the 1840s Ivanov himself had evolved toward new methods and subjects. For example, he began to give increasing attention to painting directly from nature, using the urchins of Rome and Naples as his models. Also, Ivanov experimented with the rhythmical principle that he found in the frescoes of Giotto and Piero della Francesca, producing a series of unorthodox watercolors known as *The Biblical Studies,* which he based on episodes from David Strauss's *Das Leben Jesu.* Historians have noted the formal parallels between *The Biblical Studies,* William Blake's illustrations to Dante, and the metaphysical paintings of the German romantics, although there is no evidence to suggest that Ivanov had studied these works. The softness, the "mellifluousness" of Ivanov's biblical watercolors distinguish them immediately from the drier, narrative style of his earlier painting and, as a matter of fact, bring them close to the symbolist art of Viktor E. Borisov-Musatov (1870–1905) and Mikhail A. Vrubel (1856–1910) at the turn of the century. It was precisely in their time that Ivanov was rediscovered and recognized as a precursor of the modern movement.[41]

Both *The Appearance of Christ to the People* and *The Last Day of Pompeii* stand in opposition to a genre that, during the 1830s and 1840s, was attracting increasing attention in Russia: the *intérieur*. The move from outside to inside produced a series of remarkable paintings, among which should be mentioned Fedor Tolstoi's *Interior* (1830), *A Suite of Rooms* (1830s–40s) by Kapiton A. Zelentsov (1790–1845), Soroka's *Study at the House of Ostrovki* (1844) and *Encore, Encore!* (1851–52) by Pavel A. Fedotov (1815–52). Critics have not given sufficient attention to the establishment of the *intérieur* as a legitimate genre in Russian painting of this period and have tended to concentrate on the concurrent evolution of the Russian landscape school. While artists such as Venetsianov and Soroka made a valuable contribution to this discipline and, in general, provided a national Russian alternative to the anonymous academic style, their endeavors were paralleled by a renewed interest in the everyday, domestic life of the Russian family, especially of the middle and lower classes. It is tempting to regard this "internalization" as the reflection of the more withdrawn, more intimate mood of Russian society after the exuberance of the Napoleonic period. On the one hand, the simple *intérieurs* of Tolstoi, Soroka, and Zelentsov evoke a sense of nostalgia for a more serene era long departed; on the other hand, a painting such as Fedotov's *Encore, Encore!* (fig. 6.5) seems to depict a private but anguished landscape—a closer examination of the individual self.

Artists such as Fedotov, Tropinin, and Venetsianov and his pupils (Evgraf F. Krendovsky [1810–53], Fedor M. Slaviansky [1816–76], Soroka et al.) constituted a domestic art movement in Russia, as opposed to the more international school of Briullov, Ivanov, and Kiprensky. They combined labored interpretations of academic conventions with a spontaneous feeling for color, texture, space. If Briullov, Ivanov, and Kiprensky marked the culmination of the Western idealist tradition in Russia, Fedotov, Tropinin, Venetsianov, and their colleagues were the beginning of a new esthetic, which was often vulgar, unconventional, and even iconoclastic.

Sometimes the ingenuousness of the native Russian talent was still disguised and spoiled by the academy, an imposition that resulted in artistic compromise, and Tropinin was typical of this process. A serf who was "midway between cook-cum-confectioner and personal lackey,"[42] Tropinin was sent by his master to train at the St. Petersburg Academy in 1798, and he soon began to paint à la Greuze and à la Doyen. Tropinin's portraits are often primitive paraphrases of the French originals. On the other hand, the Russian subjects that Tropinin preferred, such as the casual portrait of Pushkin (1827), the ample Natal'ia Zubova (1834), and several versions of a self-portrait against a

view of the Kremlin (fig. 6.6), are charming descriptions of everyday Russian dress and manners. Whatever his faults, Tropinin encouraged a forceful reaction against the autocracy of the academy by introducing mundane subjects such as a washerwoman, a peasant boy, or a lace-maker, which, a few years previously, would have been considered un-worthy of artistic concern. We can understand why one fashionable Moscow socialite cancelled her portrait from Tropinin after learning that his name was not "Tropini" but "Tropinin."[43]

Although Tropinin digressed from the academic norms, it was Venet-sianov and his pupils who transferred art, so to speak, from its cos-mopolitan to its provincial status. Venetsianov came from a Moscow merchant family. In 1807 he moved to St. Petersburg, where he at-tended the studio of Borovikovsky and performed various duties in the civil service. Venetsianov was a critic and theorist, but his claim to fame rests on his genre paintings—paintings in which he tried to paint not "à la Rembrandt, à la Rubens, etc., but simply, as it were, à la Nature."[44] Of course, it is evident that Venetsianov's work was influenced both by Dutch genre painters and by French and Belgian masters such as Fran-çois Marius Granet, Hubert Robert, and David Teniers. For example, Venetsianov himself recalled how he was deeply affected by the internal lighting of Granet's painting *Le choeur de l'église du monastère des Capucins de la Place Barberini* in the Hermitage: "We saw . . . a depiction of objects—not just similar, but exact, alive, not painted from nature, but depicting nature itself."[45] An immediate result of this experience was Venetsianov's *Threshing Floor* of ca. 1821, an interior rendered in deep perspective, symmetrically organized, and, like the Granet, illuminated by a light that seems to come from within.

Venetsianov painted the *Threshing Floor* and his lyrical country scenes of the 1820s and 1830s such as *Spring. Plowing* (fig. 6.7) on his estate in Tver Province, where he retired in 1819. It was there and at his St. Petersburg home that Venetsianov established and patronized his art school for the less privileged members of society. Several of his out-standing students, such as Slaviansky and Soroka, had been born into serfdom and without Venetsianov's help would have found it difficult to train as professional artists. The school lasted until Venetsianov's death in 1842, but its time of flowering was the late 1820s–early 1830s, when up to seventy students were registered. Venetsianov opposed the aca-demic system by eroding the traditional perimeters of the genres, by his very choice of students (some of whom, however, attended the academy simultaneously), by his concentration of Van Dyck, Rem-brandt, and Ruysdael instead of the Italian primitives, by his emphasis on the need to paint from nature, and by his own intimate portraits and peasant scenes. Even so, Venetsianov never broke his ties with the

academy and always respected its authority. He sent his own and his students' works to the academy's public exhibitions and, toward the end of his life, tried hard to secure a professorship there.

Venetsianov and his colleagues endeavored to move art from past to present, from high class to low, from city to country. The primary exponent of this "antithetical" development was Soroka, one of Venetsianov's favorite students.[46] In his domestic portraits, homey interiors, and local scenes such as *View of the Moldino Lake* (1840s–50s) the air is still, observation replaces analysis, flatness and horizontality replace the three-dimensional illusionism of the academic style, proportions and perspectives are awry, inaction replaces action. How different is Soroka's simple *Fishermen* (1840s) from *The Last Day of Pompeii*—and how close it is, curiously, to George Bingham's *Boatmen on the Missouri* (1846). This resemblance is not completely accidental, for the local artists of mid-nineteenth-century Russia and America were attempting, consciously or unconsciously, to break with the impersonal influence of the European academy. Both sides, in seeking a national identity for their art, chose mundane subjects such as fishermen, farmers, tradesmen, ordinary people going about their work. The naïve, awkward style that accompanied these themes was perhaps more the result of deliberate reaction against academic strictures than of artistic illiteracy.

Thanks to Venetsianov, a school of Russian landscape painting was established, and the achievements of the famous landscapists of the 1860s–80s such as Ivan I. Shishkin (1831–98; fig. 6.8) can be traced to him. To a considerable extent, this new artistic orientation affected the teaching system at the so-called Moscow Art Class, which was founded in 1832 as the Moscow Nature Class and, in 1843, became the Moscow Institute of Painting and Sculpture, the alma mater of many talented artists. It is not fortuitous that many members of the Russian avant-garde in the 1900s and 1910s were students at the Moscow Institute.

Venetsianov, his students, artists of the Arzamas School, and to some extent Fedotov and Tropinin, predetermined the subsequent development of Russian art toward the realism of the 1860s–80s. Increasing disenchantment with the academy's continued reliance on classical prototypes foreign to the demands of modern life, and the increasing awareness of alternative artistic criteria defined by Fedotov and Venetsianov reached a climax in 1863 with the secession of thirteen art students, led by Ivan N. Kramskoi (1837–87), from the St. Petersburg Academy. The ostensible reason for this mutiny was the academy's selection of a mythological theme for the Historical Section of the Annual Gold Medal Competition, the *Feast of the Gods in Valhalla*. Students argued that such a subject was divorced from contemporary social and political demands, and, as a sign of protest, they resigned from the

academy after their request for a change of theme had been rejected. However, it should be remembered here that a topic quite relevant to the "accursed questions" of the 1860s—*The Liberation of the Serfs*—was stipulated concurrently for the Genre Section of the competition. Consequently, we should interpret the secession not as the result of discontent with a particular topic, but as the outcome of many conditions and the culmination of a long period of tension: the practical causes for the action of the thirteen students can be traced not only to the more radical mood of the younger generation of academy students but also to the dissemination of the sociopolitical and esthetic programs of Chernyshevsky, Dobroliubov, and Pisarev.[47]

The revolt at the academy engendered two principal results. First, it introduced a new artistic orientation, realism, to Russian art, and second, it undermined the exclusive authority of the academy, which subsequently entered a decline until its partial reformation in the 1890s. Of course, even before 1863, a few painters and sculptors such as Fedotov and Vasilii G. Perov (1833–82) were conscious of the fundamental ills of Russian society and had described subjects such as the corruption of the clergy (Perov's *Easter Procession in the Country* of 1861 [cf. Valkenier, fig. 8.2]), the inferior social position of woman (Fedotov's *The Major's Betrothal* of 1850–52), or the position of political exiles (*The Prisoners' Halt* of 1861 by Valerii I. Yakobi [1834–1902]). In many cases, these artists were aware of the social thinkers and progressive writers of their time—a connection that, inter alia, led to the creation of many striking portraits such as Perov's *Dostoevsky* of 1872 and Kramskoi's *Tolstoi* of 1873. Occasionally, these portraits were outward commentaries rather than psychological revelations, prompting the artist and critic Alexandre N. Benois (1870–1960) to speak of their "materialism,"[48] but by and large they were moving interpretations of prominent intellectuals of the time and constitute one of the memorable accomplishments of the realist epoch.

Many other artists soon joined the original group of thirteen revolutionaries, but a registered, titled group was not established until 1870 with the so-called Society of Traveling Exhibitions (the Wanderers or Travelers). The Wanderers organized annual exhibitions from 1871 through 1918 and again briefly in the early 1920s. Although they quickly declined into Victorian sentimentality, some of them tried sincerely to use art as a medium of social criticism. The most successful practitioner of this doctrine was Il'ia E. Repin (1844–1930), whose moving episodes from everyday life, such as *The Volga Boathaulers* (1870; fig. 6.9) and *They Did Not Expect Him* (1884), were painted to a very high standard. Repin's portrayals of people, whether individuals, such as the *Portrait of the Composer Musorgsky* (1881), or crowds, such as

the *Religious Procession in Kursk Province* (1880–83), are among the most "real" of his paintings.[49]

To some extent, Repin shared the general fate of Russian realism in the visual arts, for, although he began as a radical artist in the 1860s, he lost the impetus and novelty of his vision by the 1890s. He refused to acknowledge the discoveries of later groups such as the World of Art and the Blue Rose, and he even joined the teaching staff of the St. Petersburg Academy—the very institution that he had opposed. Still, during the 1870s and 1880s Repin and his colleagues were a vital force in Russian art thanks not only to their own artistic activity but also to the practical and ideological support from their leading apologist, Vladimir V. Stasov (1824–1906).

Through his many books, articles, and reviews, Stasov propagated the esthetic ideas of the Wanderers, championing diverse artists such as Nikolai N. Ge (1831–94; fig. 6.10), Shishkin, and Vasilii I. Surikov (1848–1916) as well as Russia's greatest battle painter, Vasilii V. Vereshchagin (1842–1904; fig. 6.11), who, although not a member of the Wanderers, was a staunch supporter of the realist program. Like Repin, however, Stasov could not accept the artistic innovations of the early 1900s and even criticized those younger members of the Wanderers who digressed from the established line, such as Konstantin A. Korovin (1861–1939; fig. 6.12) and Isaak I. Levitan (1860–1900) with their interpretations of impressionism. The Wanderers were also indebted to the art collector and patron Pavel M. Tretiakov (1832–98), who acquired paintings and sculptures by most of the realists. It was on the basis of his private collection, donated to the City of Moscow in 1892, that the Tretiakov Gallery was formed.

The Wanderers should be remembered not only as the advocate of an artistic perception alternative to that of the Academy of Arts but also as a testing ground for new, potential talents. The regular exhibitions attracted many young artists, such as K. Korovin, Levitan, Mikhail V. Nesterov (1862–1942), Valentin A. Serov (1865–1911), and the Vasnetsov brothers, Viktor M. (1848–1926) and Apollinarii M. (1856–1933), and gave them valuable professional experience. Perhaps the most inventive and most "Russian" of these latter-day Wanderers was Levitan, whose silent evocations of the Russian landscape (fig. 6.13) bring to mind the contemplative, lyrical poetry of the symbolists, especially Aleksandr A. Blok. Serov should also be mentioned here, because his many portraits, especially those in pencil and charcoal, constitute an entire gallery of writers, patrons, and fellow artists of the Silver Age (fig. 6.14).

Whatever the defects of the Russian realists, they were the avant-garde of their time and, by opposing the conventional, academic can-

ons, they exerted a decisive effect on the development of Russian art. Even when we place them in a more universal context and see their accomplishment rivaled by the works of Daumier, Gavarni, and Menzel, we should not forget the radical influence of their contribution to the culture of their own country. Still, this is not to say that a "nonrealist" trend did not also exist in the later nineteenth century in Russia. One of its proponents was Arkhip I. Kuindzhi (1842–1910), who, although a member of the Wanderers between 1874 and 1879, hardly concerned himself with the realist credo and favored a much more lyrical, subjective interpretation. Kuindzhi's rejection of the narrative themes used by the realists and his exclusive attention to the evocation of mood, his audacious spectral contrasts and luminous effects (exemplified by his famous *Birch Grove* of 1879; fig. 6.15) point forward also to the symbolist generation and even to the avant-garde with its advocacy of "painting as an end in itself."

Other artistic developments at this time also helped lay the foundation for the spectacular renaissance of the Russian arts during the Silver Age. Particular mention should be made of the popular decorative arts and crafts, which by the 1860s had entered a state of decline as a result of the harmful effects of Russia's rapid industrialization. The process of urbanization was leading to a mass exodus of peasants from the countryside to the towns, with the resultant abandonment of the domestic arts: icons, handmade fabrics, and woodcarvings began to be replaced by factory-produced wares and, consequently, an entire cultural heritage was suddenly faced with extinction. Some of the Wanderers, particularly Vasilii D. Polenov (1844–1927), Repin, Surikov, and V. Vasnetsov, used peasant artifacts and rituals in their pictures of historical and national subjects, and this focused public attention on Russia's indigenous culture, even though the problem of how to rescue and rejuvenate this culture still remained. Fortunately, there were a few enlightened individuals who were aware of the plight of the national arts and who also wished to establish a closer link between the fine arts and the popular crafts. Paradoxically, these individuals were themselves in some measure responsible for the degradation of peasant art inasmuch as they owned or financed elaborate industrial and transportation complexes: of particular importance in this endeavor were Savva I. Mamontov (1841–1918) and Princess Mariia K. Tenisheva (1867–1928).[50]

In 1870 Mamontov acquired a country retreat called Abramtsevo, not far from Moscow, and decided to open an artists' colony there. Mamontov and his wife, Elizaveta Grigor'evna (1847–1908), were very interested in the Russian arts and crafts, and they were well aware of the arts and crafts movement in Europe. By 1880 Mamontov had es-

tablished an artists' collective that was united by a common concern with Russian art, literature, and music. The colony encompassed many artists, including Polenov, his sister Elena D. Polenova (1850–98), Repin, and V. Vasnetsov. Apart from studio paintings and sculptures, the Abramtsevo artists produced designs for furniture, icons, utensils, embroidery, etc. based on traditional motifs, thereby contributing to the establishment of the neo-nationalist or neo-Russian style— supported in turn by K. Korovin, Nesterov, Vrubel, Mariia V. Yakunchikova (1870–1902), and many others. The same style was practiced by artists working at Princess Tenisheva's estate called Talashkino, near Smolensk. Although Talashkino did not start to function as an art colony until the late 1890s, important artists worked there, including Aleksandr Ya. Golovin (1863–1930), Sergei V. Maliutin (1859–1937), Nikolai K. Rerikh (1847–1947), and Vrubel. The neo-nationalist style formulated at Abramtsevo and Talashkino exerted an immediate influence on all the decorative arts in Russia, especially book illustration and stage design. For example, K. Korovin and Vrubel designed a number of productions in the new style for Mamontov's Private Opera (founded in 1885), establishing the departure point for the revival of the Russian decorative arts that reached its apogee with the designs for Diaghilev's Ballets Russes between 1909 and 1929.

The most original, most powerful of the artists associated with Abramtsevo and Talashkino was Vrubel.[51] Vrubel was a painter, a sculptor, and designer, but his most talented works were his monumental canvases (fig. 6.16) or panneaux treating of historical and mythological themes. Vrubel's inventive imagination manifested itself in pictures such as *The Bogatyr'* (1899) and *Demon Downcast* (1902) and in his panels for Aleksei V. Morozov's house in Moscow (1896–98), which included renderings of the theme of Faust and Mephistopheles. Even in the small graphic works such as his illustrations to the jubilee edition of Lermontov's writings in 1890–91, Vrubel's individuality enforced its presence, and although he was indebted to Art Nouveau and the neo-nationalist style, Vrubel cultivated an idiosyncratic approach, especially in his fragmentary treatment of the surface—something that prompted critics later on to describe Vrubel as the first Russian cubist.[52] Indeed, because of his innovations, Vrubel served as an important link between the realism of the 1870s and the first stage of the avant-garde in the early 1900s—in broader terms, between figurative and nonfigurative art.

Although Vrubel cannot be accommodated within any one particular group or category, he was closely associated with the symbolist ideology and with the World of Art society—phenomena of Russia's fin-de-siècle culture. Championed by the critic and impresario Sergei P. Diaghilev

(1872–1929), the World of Art artists such as Benois and Konstantin A. Somov (1869–1939) argued that art should fulfill an esthetic, not an ethical, role, that Russian art should become part of the international scene, and that beauty was to be found in the expression of the artist's subjective impulse, not in objective truth. Many ideas that were later developed by the artists of the avant-garde were formulated by the symbolists—for example, the notion of abstract art was one consequence of the symbolists' evocation of mood at the expense of concrete description; their concern with the *Gesamtkunstwerk* looked forward to the constructivists' interest in total design; and their many statements about "musicality" and "internal harmony" obviously contributed to Kandinsky's concept of the "inner sound."[53] In fact, the accomplishments of the avant-garde are unthinkable without the preparatory support of the symbolist movement in the late 1890s and early 1900s.

In 1846 Kukol'nik wrote: "In our fatherland painting has no past."[54] Fifty years later such a statement was no longer valid, for within that short period Russia had made extraordinary progress in art; she had, indeed, caught up with the West and was about to overtake it. The genius of Vrubel and of the artists of the subsequent generation, such as Kazimir S. Malevich (1878–1935), Kandinsky, and Vladimir E. Tatlin (1885–1953), seems, at first glance, to have little in common with the art of predecessors such as Briullov, Fedotov, Ivanov, Kiprensky, Repin, and Venetsianov. But just as Ivanov regarded art as one component of a universal philosophy for transforming the world, so the artists of the avant-garde also hoped to "suprematize" and "constructivize" all aspects of reality. For all their weaknesses—eclecticism, haphazard development, grotesque exaggeration of Western ideas—the nineteenth-century Russian artists created a solid and distinctive school of art. Slowly but surely, the intense artistic personalities of Russia's nineteenth-century masters broke through the heavy imposition of Western influence and, as the nineteenth century advanced, Russian art came increasingly to draw upon its own resources. Evidently, Benois had this in mind when, in 1894, he wrote the following comment on nineteenth-century Russian painting for Richard Muther's *Geschichte der Malerei im XIX Jahrhundert:*

From parasitic works of borrowed sentiment Russian painting rises to national, barbaric strength, utterly wanting in the discipline that comes of taste; and out of this evil originality it rises again, and, in individual cases, highly refined and well-balanced performances are produced—works in which the spirit of the people is felt none the less to vibrate. That is more or less the course of development which has been run through in the nineteenth century.[55]

NOTES

Russian and Soviet scholars have given much attention to the development of Russian art in the nineteenth century. Of particular interest are the following sources:

Alexandre Benois, "Russia," in *The History of Modern Painting,* ed. Richard Muther (New York: Dutton, 1907), pp. 236–85. First published in German as *Geschichte der Malerei im XIX Jahrhundert* (Munich: Kunstverlag, 1894).

V. Friche, ed., *Russkaia zhivopis' XIX veka* (Moscow: Ranion, 1929).

O. Liaskovskaia, *Plener v russkoi zhivopisi XIX veka* (Moscow: Iskusstvo, 1966).

N. Moleva and E. Beliutin, *Russkaia khudozhestvennaia shkola pervoi poloviny XIX veka* (Moscow: Iskusstvo, 1963); *Russkaia khudozhestvennaia shkola vtoroi poloviny XIX-nachala XX veka* (Moscow: Iskusstvo, 1967).

M. Rakova, *Russkoe iskusstvo pervoi poloviny XIX v.* (Moscow: Iskusstvo, 1975).

M. Rakova, *Russkaia istoricheskaia zhivopis'* (Moscow: Iskusstvo, 1979).

D. Sarab'ianov: *Russkaia zhivopis' XIX veka sredi evropeiskikh shkol* (Moscow: Sovetskii khudozhnik, 1980).

I. Shmidt, ed., *Ocherki po istorii russkogo portreta pervoi poloviny XIX veka* (Moscow: Iskusstvo, 1966); also see the accompanying volume edited by N. Mashkovtsev, *Ocherki po istorii russkogo portreta vtoroi poloviny XIX veka* (Moscow: Iskusstvo, 1963).

A. Sidorov, *Risunok starykh russkikh masterov* (Moscow: Academy of Sciences, 1956); *Risunok russkikh masterov* (Moscow: Academy of Sciences, 1960).

E. Valkenier, *Russian Realist Art. The State and Society: The Peredvizhniki and Their Tradition* (Ann Arbor: Ardis, 1977).

Of particular relevance to Russian art in the early part of the nineteenth century is the catalog of the exhibition "The Art of Russia 1800–1850" at the University of Minnesota and other institutions, 1978–79. For the present essay I have used some of the data presented in my introduction to this catalog.

1. Quoted in M. Alpatov, *Aleksandr Ivanov* (Moscow: Iskusstvo, 1956), p. 175. Original source not provided.

2. N. Vrangel', "Inostrantsy v Rossii," *Starye gody* (St. Petersburg), July–September 1911, p. 7.

3. J Schnitzler, *Notice sur l'Ermitage de Saint-Petersbourg* (St. Petersburg: Brieff, 1828), p. 15.

4. For information on the first *pensionnaires,* see A. Trubnikov, "Pervye pensionery", *Starye gody,* April–June 1916, pp. 67–82.

5. All these amusing details are taken from Vrangel's excellent article "Stranichka iz khudozhestvennoi zhizni nachala XIX veka," *Starye gody* May 1907, pp. 155–62.

6. "Dnevnik Kiprenskogo zagranitsei 1817g," *Starye gody,* July–September 1908, p. 426. Edited by N. Vrangel'.

7. Letter from Moller to Aleksandr Ivanov (early 1840s). Quoted in Alpatov, op. cit., vol. 2, p. 24.

8. N. Kukol'nik, *Kartiny russkoi zhivopisi* (St. Petersburg: III Section of His Imperial Majesty's Office, 1846), p. 14.

9. Letter from Viazemsky to A. Turgenev of 17 May 1819. In *Ostaf'evskii arkhiv kniazei Viazemskikh,* ed. V. Saitov (St. Petersburg, Sheremetev, 1899), vol. 1, p. 202.

10. The subject of the Masons in Russia has been disregarded or, at least, misrepresented by Soviet scholars. However, Tat'iana Alekseeva, in her splendid monograph on Borovikovsky, deals with the Masons in an informative and positive manner. See T. Alekseeva, *Vladimir Lukich Borovikovskii i russkaia kul'tura na rubezhe 1890–1990 vekov* (Moscow: Iskusstvo, 1975), esp. chapter V.

11. I. Pnin, *Opyt o prosveshchenii otnositel'no k Rossii* (St. Petersburg: Glazunov, 1804).

12. For information on the Russian salons, see M. Aronson and S. Reiser, *Literaturnye kruzhki i salony* (Leningrad: Priboi, 1929).

13. Vrangel', "Stranichka," p. 161.

14. For information on Tomilov, see N. Vrangel', "Stranichka." Also see A. R. Tomilov, "Mysli po zhivopisi" and T. Alekseeva's presentation of this in her *Issledovaniia i nakhodki* (Moscow: Iskusstvo, 1976), pp. 105–25.

15. D. Blagoi et al., eds., *Dekabristy i russkaia kul'tura* (Leningrad: Nauka, 1975), p. 270.

16. Ibid., p. 271.

17. Kukol'nik, op. cit., p. 75.

18. One of the most detailed sources of visual material concerning the 1812 campaign in Russia is the large catalog to "Vystavka 1812 god," edited by V. Bozhovskii (Moscow: Levenson, 1913). The issue of *Starye gody* entitled "Ocherki po iskusstvu epokhi Aleksandra I" for July–September 1908 should also be consulted.

19. From an article entitled "Glas russkogo" in *Syn Otechestva*. Quoted in V. Turchin, *Orest Kiprensky* (Moscow: Izobrazitel'noe iskusstvo, 1975), p. 120.

20. For more information on Russian caricature and the War of 1812, see chapter 12 of this volume.

21. Louis Reau, *Histoire de l'expansion de l'art français moderne* (Paris: Laurens, 1924), p. 326.

22. Vrangel provides some information on this particular association in his article "Romantizm v zhivopisi Aleksandrovskoi epokhi i Otechestvennaia voina," *Starye gody*, July–September 1908, p. 381.

23. Report dated 10 May 1837. Quoted in Alpatov, op. cit., vol. 1, p. 158.

24. Quoted in F. Iordan, *Zapiski rektora i professora Akademii khudozhestv Fedora Ivanovicha Iordana* (Moscow: n.p., 1918), p. 36.

25. Kiprensky referred to himself as the "king of painting." See Turchin, op. cit., p. 41.

26. Quoted in Turchin, op. cit., p. 56.

27. Vrangel', "Ocherki po iskusstvu," p. 398.

28. Quoted in Turchin, op. cit., p. 42.

29. Ibid., p. 100.

30. Ibid.

31. N. Gogol', "Poslednii den' Pompei" in *Russkie pisateli ob izobrazitel' nom iskusstve*, ed. G. Arbuzov (Leningrad: Khudozhnik RSFSR, 1976), p. 43.

32. A. Gertsen, "A. Ivanov," ibid., p. 72.

33. Letter from Turgenev to P. Annenkov dated 1 December 1857, ibid., p. 55.

34. Quoted in Alpatov, op. cit., vol. 2, p. 112.

35. Ibid., vol. 1, p. 139.

36. Quoted in E. Atsarkina, "Khudozhestvennaia ideologiia Rossii 1840-kh godov," in Friche, op. cit., p. 14.

37. A. Botkin, *Aleksandr Ivanov: ego zhizn' i perepiska* (St. Petersburg, 1880), p. 287.

38. Gertsen, op. cit., p. 69.

39. Letter from Turgenev to P. Viardo dated 21 July 1858 in Arbuzov, op. cit., p. 56.

40. Quoted in Alpatov, op. cit., vol. 2, p. 89. Original source not provided.

41. See, for example, Nikolai Punin's long study of Ivanov. This was published recently as "Aleksandr Ivanov" in *N.N. Punin. Russkoe i sovetskoe iskusstvo*, ed. I. Punina (Moscow: Sovetskii khudozhnik, 1976), pp. 55–112.

42. A. Rozinsky, "V.A. Tropinin," in *Iskusstvo v Yuzhnoi Rossii* (Kiev), 1913, no. 1, p. 4. For information on Tropinin, see G. Kropivnitskaia, *Muzei V.A. Tropinina i moskovskikh khudozhnikov ego vremeni* (Moscow: Sovetskii khudozhnik), 1975.

43. Reported by A. Amshinskaia, *Tropinin* (Moscow: Iskusstvo, 1976), p. 121.

44. (A. Venetsianov), "Pis'mo k izdateliu literaturnykh pribavlenii ot izvestnogo nashego khudozhnika A.G. Venetsianova o kartine: Berlinskii parad, pisannoi Kriugerom." First appearted in *Literaturnye pribavleniia k Russkomu invalidu* (St. Petersburg), 1831, no. 33, pp. 257–61.

45. Quoted in A. Savinov, *Venetsianov* (Moscow: Iskusstvo, 1955), p. 198. Venetsianov saw an 1820 copy of the 1816 original.

46. For information on Soroka, see K. Mikhailova, *Grigorii Soroka 1823–1864* (Leningrad: Russian Museum, 1975) (catalog of an exhibition).

49. For information on the secession, see Valkenier, op. cit.

48. A. Benois, *Istoriia russkoi zhivopisi v XIX veke* (St. Petersburg: Evdokimov, 1902), vol. 2, p. 185.

49. The most detailed source of general information on Repin is still Igor' Grabar's *Repin* (Moscow: Izogiz, 1937), 2 vols.

50. For information on Savva Mamontov and Princess Tenisheva, see John E. Bowlt, "Two Russian Maecenases," *Apollo* (London), December 1973, pp. 44–53.

51. The most reliable source of information on Vrubel is still Stepan Yaremich's *Vrubel'* (Moscow: Knebel', n.d.).

52. See, for example, S. Makovskii, "Vrubel' i Rerikh," in his *Siluety russkikh khudozhnikov* (Prague: Nasha rech, 1922), pp. 110–32.

53. Vasilii Kandinsky often referred to the "inner sound" of painting. For a discussion of this and related ideas, see John E. Bowlt and Rose-Carol Washton Long, *The Life of Vasilii Kandinsky in Russian Art* (Newtonville: Oriental Research Partners, 1980).

54. Kukol'nik, op. cit., p. 5.

55. A. Benois, "Russia," p. 238.

7

Russian Painters and
the Pursuit of Light
Joshua C. Taylor

IT IS SOMETIMES forgotten that Italy, not France, was the international center for artists and patrons during much of the early nineteenth century, and it is with Italy that I shall be concerned in discussing some relationships between Russian and European art. Almost all Russian artists from the end of the eighteenth century to the middle of the nineteenth had either direct or indirect contact with the international artistic circle in Italy, and their interests were many. Rather than to speak in general terms, I have chosen to look at just a few artists, each of whom related rather differently to the art and artists—and non-Russian environment—with which he had contact. This chapter is meant as an introduction to a very complicated but fascinating subject.

When the concept of Western painting was embraced by Russian painters in the eighteenth century, the models were almost wholly contemporary French. With the establishment of the academy of art in St. Petersburg in 1757, however, Russian art took its place in the new movement spreading through Europe that insisted on more exacting training for artists and on greater intellectual discipline in the formulation of works of art. Like the academies being formed or reformed elsewhere at the time, the St. Petersburg Academy based its teaching on sixteenth-century Italian theories and it drew its models from the same selection of ancient sculpture and Italian Renaissance painters as used elsewhere. With a kind of militant insistence, the young Russian painter was brought abreast of the modern academic movement with its strong classical bias and made to become fluent in the lingua franca of international art. Not only style but subject matter followed the revived interest in antique themes, and even when subjects from national history were chosen, the incident—as in England, France, and eventually

6.1 Vladimir L. Borovikovsky, *Portrait of Mariia I. Lopukhina* (detail)

6.2 Orest Kiprensky, *Portrait of Princess Sof'ia Shcherbatova*

6.3 Karl Pavlovich Briullov, *The Last Day of Pompeii*

6.4 Aleksandr A. Ivanov, *The Appearance of Christ to the People*

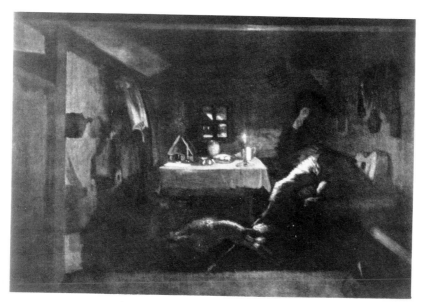

6.5 Pavel A. Fedotov, *Encore, Encore!*

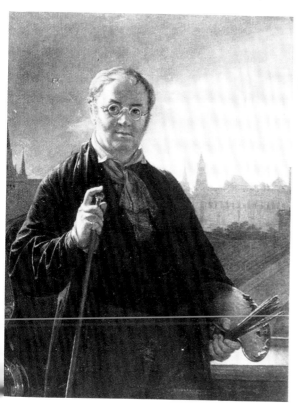

6.6 Vasilii A. Tropinin,
*Self-Portrait against a
View of the Kremlin*

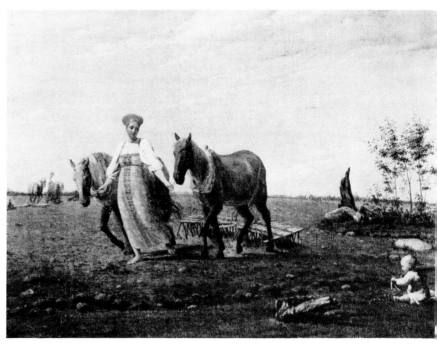

6.7 Aleksei Gavrilovich Venetsianov, *Spring. Ploughing*

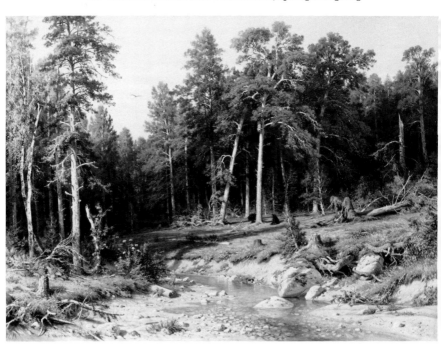

6.8 Ivan I. Shishkin, *Pine Forest in Viatsk Province*

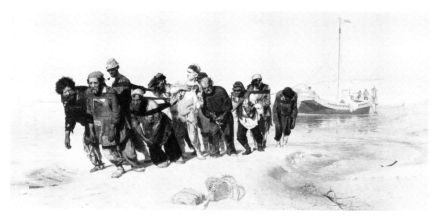

6.9 Ilia E. Repin, *The Volga Boathaulers*

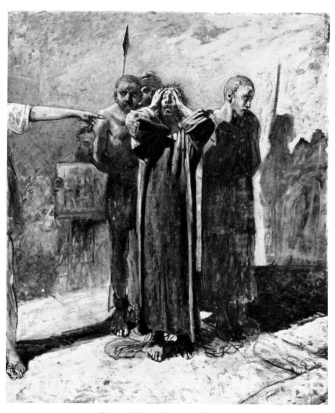

6.10 Nikolai Ge, *Golgotha*

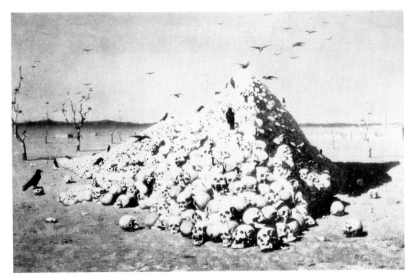

6.11 Vasilii V. Vereshchagin, *The Apotheosis of War*

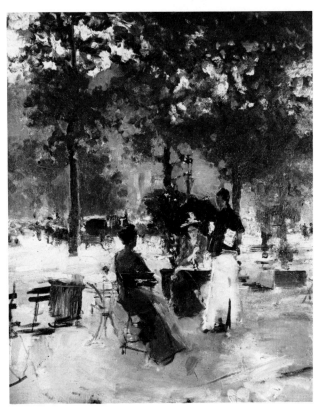

6.12 Konstantin A. Korovin, *Paris Café*

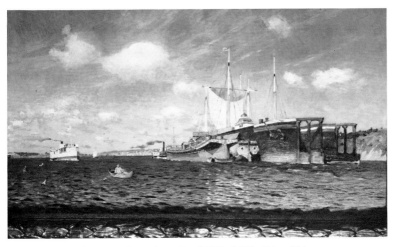

6.13 Isaak Levitan, *Fresh Wind. The River Volga*

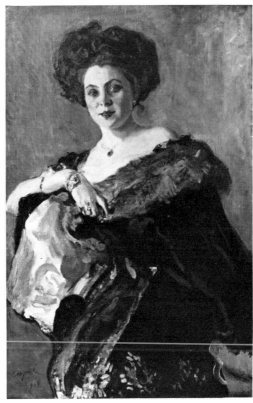

6.14 Valentin Serov, *Portrait of E. S. Morozova,
Wife of the Collector Ivan Morozov*

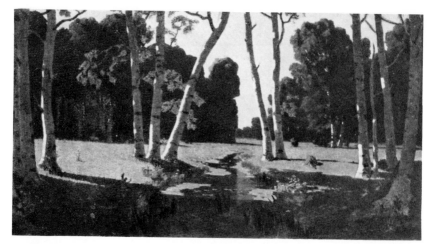

6.15 Arkhip Kuindzhi, *The Birch Grove*

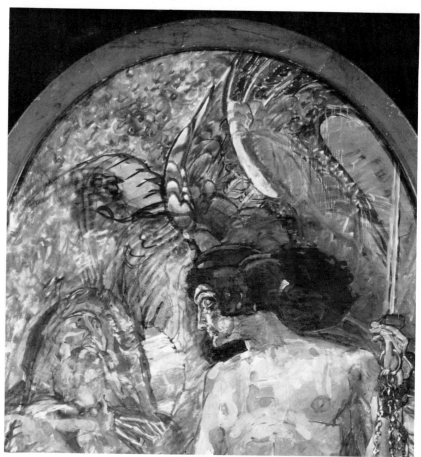

6.16 Mikhail Vrubel, *The Prophet* (detail)

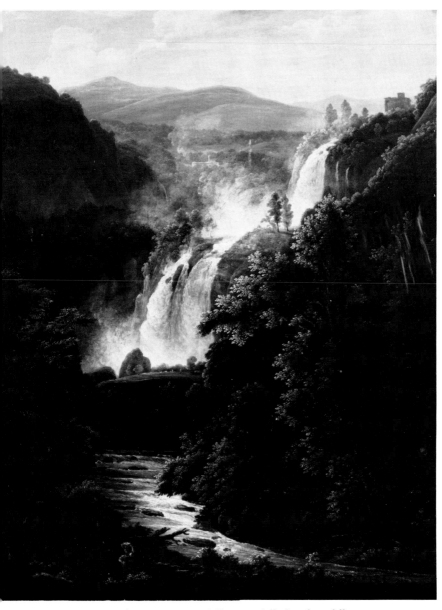

7.1 Fedor M. Matveev, *The Waterfall of Caduta delle Marmore on the River Velino*

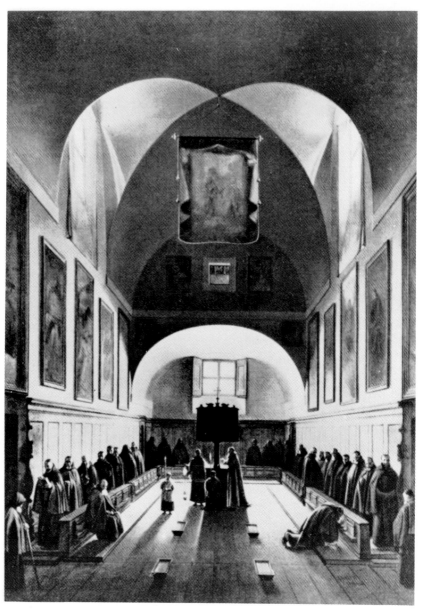

7.2 François Marius Granet, *Interior view of the choir in the Capuchin Church in Piazza Barberini, Rome*

7.3 Aleksandr Gavrilovich
Denisov, *Sailors at a Cobbler's*

7.4 Lavr K. Plakhov,
*Coachmen's Room in the
Academy of Arts*

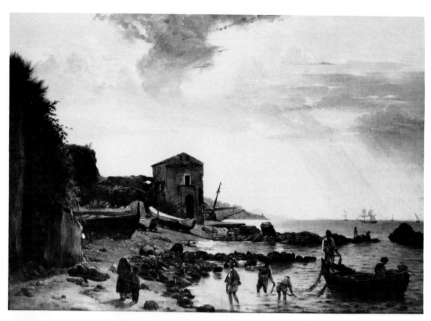

7.5 Silvestr F. Shchedrin,
Fishermen on the Shore

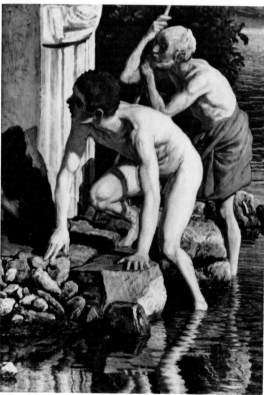

7.6 Aleksandr A. Ivanov,
*Old Man Leaning on a
Stick together with a Boy*

8.1 Pavel A. Fedotov, *A Choosy Bride*

8.2 Vasilii G. Perov, *Easter Procession in the Country*

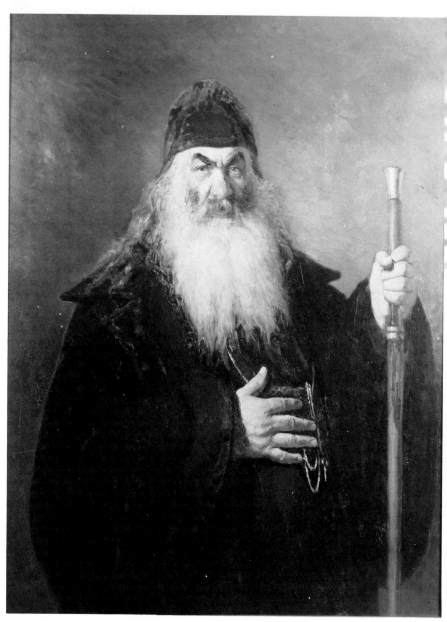

8.3 Ilia E. Repin, *The Protodiakon*

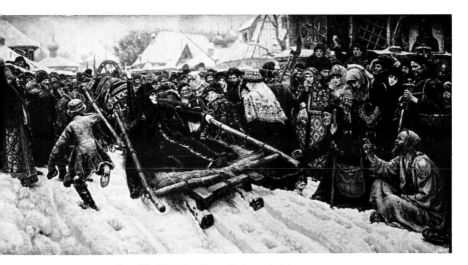

8.4 Vasilii I. Surikov, *Boiarynia Morozova*

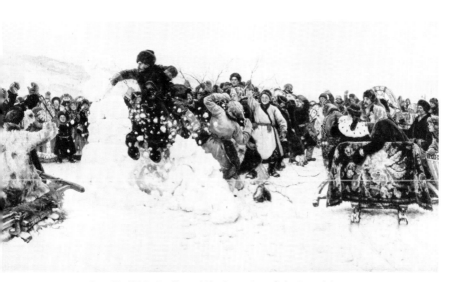

8.5 Vasilii I. Surikov, *The Storming of the Snow Town*

America—was given the heroic detachment provided by reference to traditions of which, as in America, the painters had only recently become a part.

Academic practice was based on systematic, step-by-step learning and on the principle that a work of art was a rhetorical construction based on an established vocabulary of forms. Like a proper child of the Enlightenment, the new academy emphasized the scrupulous study of phenomena, whether nature to be seen or passions to be felt, but looked upon the procedure only as preparation for intellectual formulation. Spontaneity and simple vision were as foreign to a finished work of art as infantile prattling was to poetry.

It seems somewhat ironical that, as the interest in the study of the shifting phenomena of nature increased during the last decades of the eighteenth century, the intellectual formulations of high art, as defined by the popular writings of Winckelmann and Mengs or the discourses of Sir Joshua Reynolds in England, became more rigid. The distinction between observation and construction—seeing and intellectually doing—was emphatically stated, and artistic value was assumed to be derived wholly from the latter. Russian painters, sculptors, and artisans proved themselves no less capable than others of abiding by the classical rule of taste. Only in portraiture, where observation and style-conscious construction had of necessity to come to terms with each other, was the personal vision of the artist allowed to intrude, and it was in portraiture that Russian painters first showed a vitality of their own. The new academic discipline, in fact, helped painters such as Vladimir Borovikovsky (1758–1826) win their way from the elegant but superficial French facility, popular just after mid-century, to the sometimes harsh but tangible likenesses that, at the beginning of the nineteenth century, discovered truth in individuality of character, making possible the emergence of so remarkable a portraitist as Orest Kiprensky (1783–1836), who divided his mature years between Russia and Italy. The seemingly strange opposition between the impersonal, remote aspect of the obligatory historical pieces and the lively particularization in portraiture was not peculiar to Russia; a similar dichotomy occurred in the work of so eminent a historical painter as Jacques Louis David, the American Benjamin West, and the Italian classicist Vincenzo Camuccini. It was a mark of the time.

Little by little, what had been considered only the means to an artistic end—the exact study of nature in all its changing aspects—began to assume what many cautious critics considered to be an undue importance in the artists' preoccupations. To study nature gradually threatened to become more important than to create the ultimate work of art. And to study nature Russian artists began to join their European

colleagues in traveling to Italy. Rome and Naples usefully provided the two qualities the artists required: the monuments of past tradition with their rich historical aura, familiar to all artists from their common academic training, and a beneficent nature that delighted the inquiring eye and satisfied the unhistorical urge to observe nature anew. To look at nature in Italy, where the landscape had been peopled by the ancients and painted by Poussin and Claude, was to make personal, direct contact with that heretofore remote tradition that the academy taught. It is not surprising that the artists who were the most avid seekers after this historical nature were often those from cultures that were deliberately making an effort to acquire a classical past, for example, artists from Scandinavia, Germany, America, and Russia.

In 1781 the twenty-three-year-old Russian painter Fedor Matveev (1758–1826) traveled to Rome, there to study landscape painting with the German painter Phillip Hackert, who had settled there in 1768. He spent the rest of his life in Rome, becoming famous among collectors for his views of the city and its historical environs. That he should have chosen to study with Hackert is as worthy of note as the fact that he was drawn to the painting of landscape (fig. 7.1). Strictly speaking, landscape in the 1780s was usually thought of as the pictorial assembly of natural objects in such a way as to create an environment that would provoke the imagination and delight the eye with its ideal beauty or picturesque form. Although Hackert was not insensible to the powers of compositional form, he was far more drawn to the complexities of visual fact. Like other painters in Rome in the 1770s and 1780s, he studied continually out of doors, but his studies led not to Claudian effusions or histrionic compositions in the manner of Rosa, but to large paintings that remained no less factual than his studies. One critic in 1785 wrote of his work that he introduced "all of the beauties of which he was capable without betraying truth. To extricate oneself from such an intricate labyrinth," said the writer, "is conceded only to one who, as he, has made the most assiduous and sensitive studies from nature." He remarked as well that it was very difficult for painters "when they have to paint a determined place with fidelity without the fantasy's being allowed to add any beauty whatever or correct any defect."[1]

As a follower of Hackert, Matveev was one of the first of the Russian painters to take advantage of the international artistic circle in Italy to free himself, albeit timidly, from the strictures of an art of academic construction. After twenty-five years in Rome he was looked upon by the international colony as a venerable force in upholding the concept of truth to nature in his Roman views. In 1806, the year in which the American Washington Allston was painting his classical landscapes in Rome, a commentator remarking on paintings commissioned from

Matveev by Lord Bristol, Count Demidov, and the Empress Mother of Russia, suggested that his view of Mount Cenis "should be considered a portrait, except for certain small incidental changes insisted on by the patron."[2] By using the term portrait the critic surely meant that attention was drawn to the nature painted, rather than to the structure or to the emotion supplied by the artist. As one critic said in speaking of Hackert (1785), "a young artist must first learn to imitate nature's parts, then learn to compose, and when his composition is mistaken for nature itself then he has arrived at Hackert's goal."[3]

An important key to this kind of painting, in which art became nature rather than a projection of human intellect, was the evocation of light. To painters from the north, the brilliant yet warm Meditteranean sun was in itself a fascination. Many preferred to see the sun through the eyes of Claude Lorrain, as a lodestone drawing the viewer into the magical depths of the painting. But some simply reveled in its pervasive brilliance and clarity. With a seemingly classical relentlessness, the southern sun singled out each shape to resound in a luminous space. Captured in painting, it swept away the shadows of tradition to focus the eye on the pleasures of actual vision. The paintings made in Rome by the Danish painter Christof Wilhelm Eckersberg (1783–1853), the Austrian Josef Rebell (1787–1827), the Italian Gianbattista Bassi, (1784–1852), and others before 1820 might depict traditional monuments, but their true theme was the awareness of sight and the untransformed beauties of the visual world.[4] Their compositions, although as well defined as in a classical landscape, seem to have been perceived, not fabricated. They belong to nature rather than the mind of the artist, as if nature herself—or at least perception of it—had become rational. Thinking and seeing had become one.

This Roman vision traveled far. In 1818 Rome was alive with talk about a new painting shown by a Frenchman who had been resident there for some years. François Marius Granet (1775–1849), who had begun many years before to specialize in interiors,[5] exhibited in that year a large painting evoking the quiet, light-filled space of the choir in the Capuchin church on Piazza Barberini (fig. 7.2). The sense of radiating light was such that a skeptical cardinal had to examine the back of the painting to make sure it was not produced by a trick.[6] The illusion was only part of its impact, however; it advertised that art could be an extension of the normal environment, exploiting the sense, and still offer a content meaningful to the mind. If the construction were perfect, moreover, the artist might withdraw from his work, joining the viewer as an observer. The work stood beyond either rhetorical construction or self-expression, to serve instead as an object of quiet contemplation, a model with which to curb the waywardness of sight.

Granet was forced to make many replicas of the popular painting, which found their way to various parts of the world. In the United States, Thomas Sully made a copy that was widely exhibited, and one of Granet's versions found its way in 1820 to Russia, where it remains. It was seen there by a remarkable painter who found in just this kind of quiet observation a satisfying link between his concern for art as an elevating tradition and his devotion to the simple world around him.

Aleksei Venetsianov (1779–1845) was trained in the usual academic procedures. Although he never traveled outside Russia, Venetsianov was thoroughly familiar with antique models and with the paintings of Claude, Poussin, and their Italian predecessors. He was also familiar with St. Petersburg types and the peasants of the countryside and enjoyed rendering their likenesses, sometimes in caricature. There is no hint of caricature and little of genre in the paintings he produced after 1820. His peasants, isolated in the fields or passively seated in strangely deep interiors, exist in a world no less perfect than that of a heroic landscape, yet in detail it is the material world of his own farm. The critical factor is the effect of pervasive light that seems to articulate each form, no matter how humble the object, in such a way as to give it voice in an artistic harmony. Venetsianov's artistic goals were not untraditional: he was building a poetic harmony of forms. His revolution lay in his becoming aware that the classical goal could be reached effectively within the vocabulary of his own observation, that Russian fields and homely circumstances could, indeed, be seen as art. The trained artist's powers to discern artistically relevant form was the basis of art, not the perpetuation of an external style and subject matter from the past. Like Granet with his monks, he chose his subjects from a realm far from that of his academic models, so that the transformation of the familiar objects in the measured beauty of the work was all the more patent. Seemingly without a change of form, the humbly local became the timeless universal.

Venetsianov's paintings of luminous silence taught others to see the fields and forests and rude serfs as elements of an idyllic, contemplative harmony. The most sensitive of his followers was Grigorii Vasilievich Soroka (1823–64), who carried the thoughtful but sunny perceptions of Venetsianov into more somber realms. Fascination with complex reflected light in tightly bound interiors did not, however, become solely the expression of idyllic detachment. Aleksandr Gavrilovich Denisov's painting of *Sailors at a Cobbler's* (1832; fig. 7.3) is a case in point.[7] The subject is a simple, everyday occurrence. Yet even here, the light, seeming to radiate from within the painting and yet to be contained within its boundaries, freezes the action at a compositionally perfect moment. The quiet of art is suddenly sensed in a thoroughly mundane situation. And that is true as well in Plakhov's *Coachmen's Room in*

the Academy of Arts (1834; fig. 7.4), in which, by way of a Granet-like vaulted grotto, art—certainly with deliberate irony—is found not in the studio of classical casts but in the least art-conscious part of the building.[8]

While Venetsianov in Russia was exploring the artistically transforming effect of light, Silvestr Shchedrin (1791–1830) was confronting quite another aspect of light in Italy.[9] When in Rome, where he arrived in 1818, he was content to paint the picturesque ruins in traditional though sympathetic manner; Naples, however, seems to have transformed his vision. Naples, Sorrento, and Capri furnished a dazzling brilliance of light and color that beggared classical values of restraint. The light, instead of falling in the established way over the artist's left shoulder, seemed always to be radiating from behind objects, reducing objects to colored silhouettes with sharply lighted edges (fig. 7.5). At least this is how Shchedrin and his fellow painters saw it.[10] The Dutch painter Antonio Schminck van Pitloo (1790–1837), almost the same age as Shchedrin, had arrived in Naples in 1815, after studies in Paris and Rome, with his patron, Count Orlov.[11] Forgetting his classical training, he set about catching the total effect of the radiant light with the simplest means possible.

No one knows who affected whom, but by the time of Shchedrin's death in Naples in 1830 a school of painting had been established that was to have a far-reaching influence. During the decade of Shchedrin's stay, visitors to Naples included, among many others, the Englishmen Turner (1819–28) and Bonnington (1824), the Norwegian Johan Christian Dahl (1821–26), and the Frenchman Camille Corot (1828). Although earlier painters had concentrated on the classical ruins and erupting Vesuvius, the painters now looked upon Naples as the embodiment of light. They viewed the bay through the Grotto of the Posillipo or from the heights and painted over and over again the shores of Sorrento and the house of Tasso, haunted by the long shadows of the setting sun. Freed from the compositions of Claude or the necessity of translating their observations into a system, they were content to revel in the infinite variations of light as it rendered matter transparent and transformed things into mosaics of color. Shchedrin was certainly a major contributor to this exuberant school of landscapists, which would continue in effect until well after mid-century. It was the beginning of a kind of painting based on the direct impression of nature seen as a whole at a given moment, which underlay the work of the Florentine Macchiaioli from 1860 and eventually that of the French painters called impressionist. Its value is to be found, however, not simply in the works of its following, but in its bold, striking effect that established a new kind of identity between the artist and the nature around him.

Another Russian painter who found a source for pictorial exuberance in Naples was of very different temperament from Shchedrin. This was Karl Briullov (1799–1852), who was much too assertive a personality to lose himself in the radiant effects of the Neapolitan sun. Briullov had already made his mark as an extraordinarily able academic painter possessed of dazzling facility before he came to Italy in 1822, and the color and light served him in an expanded expression of his personal sense of well-being. Like the landscapists, he became fascinated with the richness of color to be found in half shadow or reflected light, although he never ceased to be a draftsman, sensitive to precise contours and fully modeled forms. His elegant portraits place his sitters in a translucent atmosphere of glowing color that makes them seem both sensuously present and artistically remote. Like his Italian contemporary Francisco Hayez (1791–1882), who also was a master of elegant portraits, Briullov wished to harness the new observations of color and light for historical painting, making the past as sensuously present as picking grapes in Naples. To make his point, he began a huge canvas in Rome, *The Last Day of Pompeii* (cf. Bowlt, fig. 6.3). The most enthusiastic of his viewers felt that he had indeed successfully bridged the gap between the past and the present, rendering in direct, vivid terms what otherwise might be a lifeless record. Clearly this was a welcome achievement for a public looking for a lyrical, dramatic expression in a context sufficiently remote to pose no problems of personal commitment. Briullov's work succeeded in doing in painting what Italian opera was doing in music. It is wrong to see this painting in terms of Delacroix (his exact contemporary), who painted his bold allegory, *Liberty Guiding the People,* in 1831 and was in Morocco when Briullov was creating his huge painting. Nor is the painting in the exacting factual historical mode of Paul Delaroche in Paris, who had already gained international fame. Briullov steered carefully between an art of self-expression and visual documentation, and the compromise was more readily understandable in his own time than it is today. The generation to follow, in Italy and Russia as well as elsewhere, would drop the lyrical element in its paintings of history to concentrate on an art of direct vision. But Briullov had good company: there was not only Hayez, who shared Briullov's love of Venetian light and color, but also Giuseppe Bezzuoli, who in 1829, after two years of work, had finished his *Entrance of Charles VIII into Florence,* which also shrewdly employed a sound knowledge of light and the virtues of color in shadow to make contemporary a notable moment in Italian history.[12] Briullov was very much a man of his time.

But times were changing, as Briullov himself discovered. By the 1840s neither his brilliantly painted ladies nor his concepts of history painting had the same appeal. A chaste and rigid discipline, well rooted

in the past, was coming to the fore, and there was less and less patience either with brio or with stock histrionics. Already in the painting of Granet there was more than simply a new objective miracle of light. There was also implied a formal asceticism, a self-negating rigor of vision that would stand against any suggestion of expressive bombast or academic facility. Tommaso Minardi's portrait of himself, painted in 1807, is that of a religious hermit rather than a Byronic hero or a classical sage.[13] As did most in his generation, Minardi (1787–1871) began as a classical painter and, as such, enjoyed the support of Canova, but before long his exacting studies of nature, which became almost a religious exercise, made him a symbol of opposition to classical facility. Over the opposition of the older classicists and at the insistence of the students, who were eager for his strict teaching, he was installed as professor at the Accademia di San Luca.

The selective but precise rendering of natural form espoused by Minardi became known in Rome as "purism" (a term earlier used in Italian literature), although it was not defined as such until the 1830s. Its basic principle was a naïve vision, the exact opposite of the classical academy, and its models came from fourteenth- and fifteenth-century Tuscan paintings, that is, pre-Raphaelite. Bound up with this belief in the naïve, as opposed to the schooled eye, was a moral assumption: that truth and goodness are native qualities in man and can be obscured by superficial learning and facility. This thought was echoed from Wackenroder's appealing essays[14] to the purist manifesto of 1843[15] and the early writing of Ruskin in the 1840s. The German painters who settled in Rome in 1810, Overbeck, Pforr, and the others[16]—called Nazarenes by the skeptical classicists—emphasized the humility of the artist in the face of his art, for which the artist was only an instrument of creation. Frederick Overbeck and his Italian colleague Tommaso Minardi spent far more time making studies for paintings than they did painting, because it was in the study, the direct contact with nature, that the artist could overcome his own assertiveness and identify himself with the larger spiritual order represented by nature. Artists in Rome from various countries were persuaded by these ideas and carried the doctrines back to their homelands.[17] Purism, now often confused with the classicism it opposed, was a major tendency in Western art. In Rome it was inescapable, in part because under Pius IX Minardi and his followers and the venerable Overbeck dominated the redecoration of churches and established the image that was to characterize ecclesiastical art for some generations.

It was into this environment in 1830 that a young man came from Russia who was well schooled in the classical academic method but who doubted the virtue of an institutional hold on art. This was Aleksandr

Ivanov (1805–58), whose father was an established academic painter in St. Petersburg. For some four years he worked on a painting of proper classical subject matter[18] and was not insensitive to the lively Roman environment. He showed little interest, however, in the sizable Russian colony or in the more worldly international crowd of artists . Like a true devotee, he preferred to go his own way. He discovered, however, a kinship with those artists who followed a monkish discipline in which art was an expression of religious intensity. In 1835 he completed *Christ Appearing to Mary Magdalene.* By 1837 he was embarked on a huge painting that was to dominate his thinking for the next twenty years. The subject, *The Appearance of Christ to the People* (cf. Bowlt, fig. 6.4), was carefully chosen as being Christian without being ecclesiastical; it represented the revelation of divinity to men of common life. Such a revelation had to occur in an environment of common truth, and Ivanov set himself the task of scrupulously studying the exact particulars of the world around him. As for the other Purists, generalization and improvisation had no place in Ivanov's procedure; spirituality came not through speculation but through concentration.

Ivanov's studies are of two kinds. The first had to do with the specific delineation of people and things. He produced an incredible number of drawings and painted studies that manifest an almost microscopic concentration on the visible fact. His people are not constructed from the bones out, according to an anatomical system such as that favored by the academy; they are rendered as seen under the closest possible scrutiny. A seemingly casual scrap of drapery was subjected to the same thorough examination, as if in the intensity of looking the artist lost all trace of himself. At some point in his single-minded pursuit of visual truth, Ivanov discovered another aspect of his perceivable world that was no less true than the definition of things; that was light and the extraordinary range of color it revealed. Possibly it was Naples that once again transformed the sensibility of the artist, although Venice also had made Ivanov aware of color in painting. He began to use prismatically pure color to depict the Italian hills. He painted innumerable studies of nude boys out of doors in the glaring sun or showed them in the rich colors detectable in the shade through reflected light (fig. 7.6). The Neapolitan landscape and the vistas south of Rome were evoked in transparent blues and greens. Certainly only Ivanov's religious convictions kept him from becoming a true member of the Neapolitan school of landscapists.

Since Shchedrin had painted in Naples, Neapolitan painting had taken on greater specificity without losing any of its intensity of light and color. Giacinto Gigante (1806–76), almost exactly the same age as Ivanov, had inherited the mantle of Pitloo and, with a palette akin to

that of Turner, continued to produce painterly landscapes of extraordinary luminosity. For all their airiness, however, his paintings have a specificity of texture that holds them fast to the earth. This is even more impressively the case in the paintings of Filippo Palizzi (1818–97), who settled in Naples in 1837. His devotion to nature as seen was as great as Ivanov's, and he shared with Ivanov a full range of hue, although rather less intense than that of his Russian colleague. He established a poetry of common nature revealed by light quite different but not unrelated to that evoked by Ivanov's brilliant studies. It too had its spiritual implications, but Ivanov, even though by now he had come to doubt the success of his huge religious painting, was not yet ready to accept the sensuous aspect of nature as his primary spiritual source.

In 1838 Ivanov had come to know Gogol, who had begun what was to be a series of Roman sojourns the year before.[19] The two men found much in common, and Gogol, who had earlier praised Briullov, now discovered in Ivanov qualities that he found in no other Russian painter in Rome. Both men were going through lonely religious struggles, trying to reconcile a delight in the world with a belief in an ascetic religious morality. Early in his stay in Rome, Gogol had met Giovachino Belli (1791–1863), the vernacular poet of Rome, and had been delighted by his salty, irreverent sonnets. He knew, moreover, the equally lively illustrations by Bartolomeo Pinelli (1781–1836), whose works probably inspired Ivanov's efforts at Roman genre in 1838. The incisive works of Belli and Pinelli, deeply rooted in the character and traditions of the Trasteverine, who were assumed to be the hardy remnants of the early Romans, would understandably appeal to Gogol, but Rome was for him, as for Ivanov, both an irresistible stimulus and a mortal threat. He could lose himself in the joys of the mild and beautiful Roman nature at the villa of the fascinating Zenaide Volkonskaia[20] (who in town lived in a palazzo just behind the Trevi Fountain) and could watch with fascination and irony the teeming activity of Rome, but moral doubt began to gnaw at the very foundations of his art. He regarded his shrewd and worldly observations of character as frivolous and repudiated all he had done that was not of specific and rather narrow moral import. He was persuaded by his religious advisors that to destroy himself as an artist was the ultimate virtue. Gogol died in 1852. Ivanov was still laboring on his religious epic with a waning belief in its power to transform the world. It was finally shown in St. Petersburg, to which Ivanov returned in 1857, and met with little enthusiastic acclaim, although the effort was considered commendable. The St. Petersburg public now had other interests in art, strongly affected in part by the writing of Chernyshevsky on esthetics and social reality. Ironically, the studies that reflect the side of Ivanov that responded to the sensuous

beauty of Italy embody for the modern eye a greater promise of spirituality than his immense depiction of divinity revealed to the common folk. For all his individuality, he was caught in a dilemma characteristic of his time: he could not reconcile the traditional conception of meaning—in this case high moral meaning—with his transformed vision. He was at odds with himself.

By the 1850s directions had materially changed in Russian art: Paris supplanted Rome as the artistic center, and in Russia as elsewhere a new wave of national consciousness was affecting the artist. In the second half of the century Italy was only a place for reminiscence, its lessons having been well learned by earlier generations. In Russia, as in the United States, art now had the confidence of a rapidly acquired past and busily took its place in a far more complex and sophisticated society. Arguments about native versus international character in art became as powerful as discussions of aesthetics, as did the uses of art for social change. Much that now happened depended on those earlier years when artists had once more discovered the world, revealed to them by the penetrating, unfettered brilliance of natural—Italian—light. But although the discovery of the world in art could calm and reassure, some artists became aware that the new illumination could also cast the shadows of a new anxiety.

NOTES

1. *Memorie per le Belle Arti,* Rome, I (April 1785), p. 54.
2. Giuseppe Antonio Guattani, *Memorie enciclopediche romane sulle belle arti, antichita, etc.,* I (1806), p. 43. I have chosen to discuss Matveev not because he was the best of the Russian landscape painters of his time but because, breaking with the Venetian tradition of view painting, well developed in Russia, he symbolizes the beginning of the new Roman-related trend.
3. *Memorie per le Belle Arti,* Rome, I (December 1785), p. 191.
4. Useful examples of all three are to be found in the Thorwaldsen Museum, Copenhagen. I have discussed these early perceptual painters in "La fotografia e la macchia," in my *Vedere prima di credere* (Florence: Quaderni di Storia d'Arte, Universita di Parma, 1970).
5. In 1807 a critic wrote with some wonder of Granet's interior of the cloister in the church of Gesu e Maria on the Corso,

> It is not enough to try to give an account of or render in chatter this master's paintings: they have to be seen. With very little or nothing he does everything. There is hardly any color, simple actions, few figures; on the other hand, the episodes are happily chosen, the customs exact, the inven-

tion bizarre. In his paintings he has need only of a compass and light. Through his manipulation of these he gives every object relief and makes it stand out, enlarges that which is small, surprises, interests, and pleases without betraying or substantially altering the places he depicts.

Guattani, *Memorie enciclopediche sulle belle arti* . . . , II (1807), p. 112.

6. Emile Ripert, *François Marius Granet, 1775–1849, Peintre d'Aix et d'Assise* (Paris: Librairie Plon, 1937), p. 72. For a contemporary description, see *Giornale Arcadico di Scienze, Lettere, ed Arti,* Rome, I (1819), pp. 156–58. The painting was shown also in 1819 at the Paris Salon.

7. Denisov (1811–34), who studied with Venetsianov in the late 1820s, died young, leaving very few paintings, of which *Sailors at a Cobbler's* (1832) is the best known. There is a sharp difference between the works of Venetsianov and his followers, and the tightly drawn, often brightly colored, paintings of German painters trained under Nazarene discipline. This latter kind of painting was also known in Russia.

8. Lavr Kuzmich Plakhov (1810–81) studied with Venetsianov in 1829 and later studied in Germany. *The Coachmen's Room in the Academy of Arts* (1834) was painted while he was studying at the academy. One of the most prominent Italian painters of shadowy vaults was Giovanni Migliara, who painted in and about Milan, but painters of many nationalities adopted the "Grotto" form.

9. Silvestr Feodosevich Shchedrin went to Italy in 1818 as a pensioner of the academy.

10. Some of the many well-known artists painting luminous scenes of Naples and Sorrento during these and the preceding years were the Italian Gianbattista Bassi (1784–1852), the German Franz Catel (1778–1856), the Viennese Josef Rebell (1787–1827), and the Norwegian Johan Christian Dahl (1788–1857).

11. On Pitloo, see Raffaello Causa, *Pitloo* (Naples: Mele, 1956). Shchedrin's presence in Naples is discussed briefly by Raffaello in *Causa in Napoletani dell' 800* (Naples: Montanino Editore, 1966).

12. Francisco Hayez (1791–1882) was hailed as a romantic—and thus patriotic—painter in 1822, when he exhibited his *Pietro Rossi* in Milan. His most famous historical work, *I Vespri Siciliani,* first painted in 1822, went through many versions until his most ambitious rendering in 1846. Giuseppe Bezzuoli (1784–1855) was considered the initiator of romantic painting in Florence from the early 1820s and, like Hayez and Briullov, was much impressed by the light and color of Venetian painting. The *Entrance of Charles VIII* is in the Palazzo Pitti.

13. The portrait remained in the painter's home city, Faenza, until 1913, when it was made part of the Uffizi's collection of artist portraits.

14. Heinrich Wilhelm Wackenroder, *Herzensergiessungen eines kunstliebenden Klosterbruders,* published in 1797.

15. *The Purist Manifesto* was signed by Minardi, Overbeck, and the sculptor Tenerani.

16. Johan Friedrich Overbeck (1789–1869) and Franz Pforr (1788–1812), having laid plans with others for their Lukasbund at the academy in Vienna, came to Rome in 1810 and set up residence from 1812 in the cloister of Saint Isidoro. Pieter Cornelius joined the group in Rome in 1811, Karl Philipp Fohr and Franz Horny in 1815. In 1816 the Nazarenes painted a famous set of frescoes in the Casa Bartholdy, well known by Ivanov.

17. The Academia de San Carlo in Mexico was reorganized by students of

Minardi and Tenerani in the late 1740s, a purist group was established in Barcelona, and various painters carried the ideas to England and France.

18. *Apollo, Hyacinth, and Zephyr,* 1831–34.

19. On Gogol in Rome, see Daria Borghese, *Gogol a Roma* (Florence: Sansoni, 1957).

20. The Villa Wolkonsky, outside the Porta Maggiore, was later taken over by the British Embassy to the Quirinale.

8

The Intelligentsia and Art
Elizabeth Kridl Valkenier

INTRODUCTION

THE DISPOSITION to consider art not as an autonomous realm but as intertwined with "life"—as primarily expressing extrinsic moral, civic, or national values, not intrinsic esthetic qualities—is a pronounced Russian trait. That ethos, in turn, is attributable to the intelligentsia. But what is the intelligentsia? There is no single definition that can encompass the range of attitudes and the numerous roles that the group has played in the course of Russian culture.

Perhaps the aptest definition is one paraphrased from Pavel Annenkov: a dedicated order of knights without a written charter but nevertheless' acting, by some tacit agreement, as the conscience of the nation.[1] It best conveys not only the spirit of passionate dedication to ideas but also the *engagement* in the national cause, no matter how that was perceived. The widespread tendency to restrict the intelligentsia to persons operating within the liberal-radical spectrum[2] is misleading because it creates the impression that the intelligentsia was mainly preoccupied with indicting the existing social and political order. Although that aspect of the intelligentsia's involvement cannot be denied, it should be seen in a proper perspective, for it was only one of the manifestations of the overriding concern for the quality of national life, a preoccupation that manifested much more of an affirmative attitude toward things Russian than is generally recognized.

Accordingly, I propose to examine the intelligentsia's attitudes toward art in a context that encompasses their search for a genuine expression of national spirit as well. This broader compass permits an examination of the 1840–90 period, when the place of Russian culture in Europe was under discussion. The emergence of the intelligentsia coincided with Russia's becoming recognized as a major factor in European politics, following the Napoleonic wars. But the nonmilitary ac-

153

complishments entitling the country to such prominence were not as readily apparent either to Europeans or to the Russians themselves. Consciousness of that gap created gnawing doubts among Russians that persisted until about 1890. By the last decade of the century the level of education and modernization had risen sufficiently so as to lessen the urgency of this particular problem and to transform most of the intelligentsia into salaried professionals (including professional art critics).

The same fifty years cover a cohesive period in the history of art as well. They witnessed the birth and the development of a realist school dedicated to Russian issues and scenes. The more or less simultaneous emergence of the intelligentsia and of a national school of art perforce associated Russian visual expression with many preoccupations marking intellectual discourse and infused art with an intense sense of its own time.

Though the fifty-year period has a marked unity, it nevertheless lends itself to four distinct subdivisions. During the 1840s, the specificity of Russian life and culture was under discussion. During the 1860s, the nation's institutions were subject to critical examination. In the 1870s, the relationship of Russian culture to its own people was explored. And in the 1880s, national peculiarities and accomplishments per se began to be cultivated. During each phase the work of one or two painters reflected the prevailing definition of "Russianness." In the 1840s, it was Pavel Fedotov; next came Vasilii Perov, to be followed by Ivan Kramskoi and Ilia Repin in the 1870s and by Vasilii Surikov in the last years of the period.

Before we turn to an account of these stages, it is appropriate to remark upon Vissarion Belinsky's thoughts on the role of art in national life. As the creator of social criticism, and in that sense father of the Russian intelligentsia, he set the tone and the bounds of discourse for the period. But more than that, his writings also exemplified the unresolved dilemma between the critical and the affirmative approaches to Russian reality that bedeviled so much of the perennial discussion.

Belinsky's famous open letter to Gogol (1847) made abundantly clear that the function of Russian writers was to deliver their country from autocracy and obscurantism. It neatly encapsulated one aspect of the intelligentsia's views about the aim of creative endeavor. Belinsky held that despite "Tatar censorship," literature (and by extension the other arts) was the only forum for expressing progressive ideas. Hence, society expected writers to be, and revered them as, heralds of "civilization, enlightenment and humanitarianism" who would defend these principles against the "black night of autocracy, Orthodoxy and [official] nationalism."[3]

But Belinsky's criticism pursued other aims as well. He was also concerned about formulating the national character and content of Russian

literature. He held that during his own lifetime literature had fully emerged from an "imitative" stage and achieved a mature, independent status. Until Pushkin, its development had "consisted of striving to become original, national, Russian." It was Pushkin who, combining European influences with native elements, created a truly great and original national literature. Pushkin, of course, had been recognized as a writer of genius before Belinsky. But it was Belinsky who interpreted his genius as having specific Russian traits and attributes. And he judged other writers according to their ability to "depict Russian life."

As a matter of course, Belinsky assumed that a genuine Russian literature should set forth "the strivings of Russian society toward self-awareness" and bring about "its awakening." Yet on enough occasions he would forget about this aspect of literary endeavor and praise something merely on account of its ethnic quality; he would express his preference for one work over another not because it had a didactic intent but because it was simply a genuine Russian story. The sense of the ethnic locus, the characteristic Russian reality, was so central to the thinking of this leading Westernizer that he could admit siding with the Slavophiles against the cosmopolites, who ignored the issue of *narodnost'*. Belinsky was well aware of the ethnocentricity of his concerns, and he had no qualms in stating: "We ourselves, in ourselves and around ourselves—that is where we should seek both the problems and the solutions."[4]

The dilemma of what constituted the essence of "the national"—whether it was to be affirmative or critical, self-sufficient or European-oriented—perplexed not only Belinsky but many another *intelligent*. The contradictory pull marked the writings of other prominent spokesmen in the arts and formed as well a dividing line between hostile groups claiming the service of art for their particular vision of Russia. Over the fifty-year span, however, the positive and autochthonous spirit came to prevail over the critical and cosmopolitan one. Russian art concurrently moved beyond its narrower concern with critically examining Russian society and institutions to a broader, more affirmative portrayal of the life of the nation. As a result of this change, realism became recognized as the national school.

THE 1840s

Self-examination dominated the 1840s. Reacting in part to Chaadaev's disquisition on the lack of originality in Russian culture, in part to Custine's critical account of autocractic policies and a moribund society, the educated public became concerned about the essence and the destiny of their country's culture.

It was Belinsky's opinion in 1834 that there was no Russian litera-

ture. Ten years later the same statement could still be made about the visual arts. It was a singularly barren period in the history of Russian painting. Karl Briullov, the recognized master whose *Last Day of Pompeii* created a sensation both in Europe and at home in 1836, was living out his last days. Aleksandr Ivanov, who was to provide the next high point in 1856, was still working in Italy on his great picture, *The Appearance of Christ to the People.* What passed for art were the routine works from the Imperial Academy painted in the pallid neoclassical style. This demonstrable lack of talent and originality was much apparent to the various camps that were arguing the accomplishments and future of Russian intellectual life. Painting certainly was not as central in their debates as was literature. Nevertheless, some of the discussion touched upon the prospects for a Russian school of art.

The official world tried to season the vacuous quality of the academic output with a dash of patriotic pride. In *Kartiny russkoi zhivopisi* (1846), Nestor Kukol'nik (1809–68) conceded that the Russians had not made a single contribution to European art, merely having absorbed the best European traditions. But although Russian art had not evolved any "ethnographic" idiom, it faced a grand future: the continuity of High Art, which had originated in Rome and thence had migrated to France, where it expired with Poussin, would be carried on in Russia.

This lack of "ethnographic" specificity was the very issue that concerned the Slavophiles, on which Aleksei Khomiakov (1804–60) was the principal commentor. Already in 1843, he expressed the hope that painters would take note of what Gogol was creating in literature and derive their "feelings, thoughts and forms exclusively from the depth of their souls, from the treasure-house of contemporary life."[5] As the decade progressed, he became more articulate about the rootlessness of Russian visual expression. "What is there in common between the Russian soul and Russian art?" he asked. "Nourished on alien thought, foreign examples, under foreign influence, does it show any signs of Russian life?"[6] Eventually, in an essay on the prospects of a national school,[7] he insisted even more assertively that painters reject imported accretions and create a genuine national art. But the meaning of "national" was defined in philosophical, not pictorial, terms. Painters were urged to jettison Western individualism and unite themselves with the Russian land and people—a union that would enable them to function as "living parts of a larger organism."

To the Westernizers, the absence of a national spirit implied the lack of civic-mindedness, though not exclusively so. Painting, Belinsky argued, should be handmaiden to society: "To deny art the right of serving public interests means debasing it, . . . for that would mean depriving it of its most vital force, i.e., thought, [and] making it an object of sybaritic pleasure, the plaything of lazy idlers."[8]

Yet the same review that sounded this activist call also urged that art depict the "seething life" of contemporary Russia. Another article praised Aleksandr Agin's illustrations in an almanac for being saturated with the Russian spirit, for "smelling of Russia" the way Pushkin's works did.[9]

What exactly constituted this "smell," this spirit, was left undefined. Nevertheless, one cannot assume that Belinsky and the other Westernizers were solely interested in the political or social use of art. This becomes especially clear from reading *Sovremennik*'s comments on the Academic exhibits. Its reviews often maintained that, instead of perfecting their technique abroad, Russian painters should travel through their native land to study its multiracial cities and countless social groups. From a typical review that urged a painter to render more exactly the different types of fabrics worn by different classes,[10] one can infer that the Westernizers expected painting to fulfill mimetic as well as didactic functions, to convey things in their specifically Russian character and not merely transmit messages. Like Herzen, they were Januslike creatures—on the one hand avid to reform their country on the European model; on the other, intensely involved with, almost mesmerized, by its idiosyncratic ways.

The efforts of Pavel Fedotov (1815–52) to elaborate a new pictorial language and to master new subject matter corresponded in many ways to the preoccupations of the intelligentsia. But his art cannot be pigeonholed as reflecting the views of any particular group. When Fedotov retired from the army in 1844, it seemed he would concentrate on painting military scenes, which offered an assured and lucrative career under Nicholas I. But he soon took the untrodden path of painting urban scenes. The small Dutch genre paintings Fedotov used to copy while on guard duty at the Winter Palace, as well as the works of Hogarth and Willkie, re-engraved for Russian journals, served as his models, but it was the "teeming life" of St. Petersburg that supplied the raw material. In 1849 he exhibited three satirical storytelling canvases: *The Newly Decorated Knight, A Choosy Bride* (fig. 8.1), and *The Major's Courtship*. These meticulous dissections of social climbing and bureaucratic venality gained Fedotov instant public acclaim and an honorific title from the Imperial Academy of Arts.

Some jottings in Fedotov's diary, his reading, and his friendships indicate that he shared the views of the left-of-center intelligentsia.[11] Nekrasov asked him to contribute to one of his illustrated almanacs, and the painter planned to publish a satirical weekly with Evstafii Bernadsky, who was briefly incarcerated in connection with the Petrashevsky affair. But what was uppermost for Fedotov was his métier and the creation of a new art form. He was obsessed with rendering persons and objects in full verisimilitude. "I shan't amount to anything

until I learn to paint mahogany," he once confided to a close friend.[12] He was meticulously insistent that the figures who peopled his canvases properly represent their milieu. For that purpose, Fedotov would wine and dine some ordinary merchant for months to soak up the smallest detail about his home, habits, garments, and physiognomy. Equally painstaking research went into finding the right chandelier to adorn an interior or a fabric to clothe one of his characters.

This obsessive concern with depicting the specific and yet the typical was paralleled in the strivings of such budding realist writers as Dostoevsky, Goncharov, and Ostrovsky. And the intelligentsia's response to Fedotov's depiction of *nouveaux riches* merchants in search of gentry sons-in-law and other illustrations of the changing social scene matched its response to the new wave in literature.

For the Westernizers, literature's discovery of the lower urban classes was a step toward the general democratization of society. Belinsky hailed Dostoevsky for having written *Poor Folk:* "Honor the young poet whose muse loves the people of the garret and the cellar. . . . After all, these are also people, your brothers."[13]

The response to Fedotov's canvases was similar. Writing in *Sovremennik,* Apollon Maikov coupled the three genre scenes displayed at the 1849 Academic exhibit with the new, "democratic" trend in literature. In both, "idealization was replaced by the representation of real phenomena in their entire fullness and truth." Fedotov's paintings were the equivalent of the new subject matter in literature, and Maikov defended their right to full citizenship in the visual arts as well. With reference to *The Newly Decorated Knight,* he argued that "the ire of a clerk at his cook is as worthy of attention in art as is the wrath of Achilles"; anticipating objections from the conservatives, he went on to say that in painting "the force of truth and expression" was so overriding as to permit the rendering of objects that might be entirely "lacking in beauty in the conventional sense."[14]

The Slavophiles' response also was positive. Fedotov was invited to Moscow to exhibit his works, and Mikhail Pogodin proposed to popularize them through lithographic reproduction. Slavophiles did not consider Fedotov's subjects as beyond the pale of art; they welcomed painting on contemporary Russian themes and appraised this new talent very highly. There was, however, some discomfort with its excessively satirical thrust. One reviewer regretted that, unlike Hogarth, who "loved the English people as a whole and exposed only their individual transgressions," Fedotov ridiculed prototypes that represented entire groups in Russian society.[15]

Still, this reservation was not meant as condemnation. In no way did it resemble the objections of the conservatives, such as Fedor Bulgarin,

to the rude intrusion of Russian reality into literature and painting as a
gross violation of the canons of pure art and good taste. The Slavophiles
recognized and appreciated Fedotov's innovations in the creation of a
national art. And after his tragic, untimely death, *Moskvitianin*
suggested that some "patriotically minded publisher" should perform a
service to "our Russian art" by disseminating prints of all of Fedotov's
works.[16]

THE 1860s

The dominant notes sounded in Fedotov's obituaries, whether of
Slavophile or Westernizer provenance, were his dedication to his métier
and the new turn he had taken in the development of Russian art,
pointing in either the democratic social or the liberal nationalist direc-
tion. But already by the end of the 1850s his work and role were being
interpreted anew. No longer was he seen as the observant or biting
critic who informed the Russians about their foibles, but he was made a
"thinking" painter bent on transforming society and its institutions.

Fedotov's legacy was being reassessed in the light of the preoccupa-
tions of the 1860s, a period of reform and renovation that followed
upon Nicholas I's death and Russia's defeat in the Crimean War. The
abolition of serfdom was the basic institutional change that engrossed
all the intelligentsia. Beyond that, the radicals sought to put an end to
autocracy, while the liberals limited their aspirations to the eradication
of other manifestations of serfdom—the tyrannical power of parents
over children, of husbands over wives, of bureaucracy over social ini-
tiative.

Artists, too, were to be liberated from the all-pervading tutelage of
the state—the overarching freedom on which all the intelligentsia were
agreed. In mid-nineteenth-century Russia private patronage was still so
uncommon and erratic that artistic life was almost entirely dependent
on state support and promotion. In consequence, a painter had to pur-
sue his career within the confines of the Imperial Academy of Arts,
which provided him with his training, placed him in an elaborate hierar-
chy of bureaucratic ranks, and distributed the official commissions. Pro-
fessional autonomy, the intelligentsia believed, would make painters
more responsive to national needs and enable them to contribute to the
reform movement.

The intellectuals' changing views on the role of art in public life were
best phrased by what Nikolai Chernyshevsky (1828–89) wrote in *The
Esthetic Relations of Art to Reality* (1855). Probably more than any other
critic, Chernyshevsky caught the spirit of the time when he argued that
the mission of art was not merely to reflect reality but to pass judgment

on it as well. And it should be noted that, unlike Belinsky, he did not posit an inseparable bond between the esthetic and the cognitive. According to one contemporary observer, the generation of the 1860s interpreted Chernyshevsky's writings to mean that the sole "goal of art was to understand and explain reality and then to apply its findings for the use of humanity."[17]

But there was a radical as well as a liberal interpretation of this materialist, utilitarian approach to art. Radicals, like Herzen and Ogarev in London and Dobroliubov or Pisarev in Russia, urged that works of art be enlisted directly in overthrowing the outmoded system. That view was first enunciated with pungent clarity by Ogarev in his obituary of Aleksandr Ivanov, in which he claimed that Ivanov had given up religious and moral concerns and looked to socialism for answers to humanity's problems. And because of this new dedication in Ivanov, Ogarev called on young painters at home "to find the strength to curse" the evil institutions of the Russian Empire. It was not enough to paint some tranquil scenes from the life of the common people in the Dutch manner. Because of the accumulated injustices and the massive inertia of society, Russian painters had to produce "denunciatory" canvases.[18] The young radicals in Russia took their cue from London and, with slight variations, urged that painting evoke "energetic protest and dissatisfaction" or "transmit ideas and decide problems."[19]

The liberals held a much more moderate view of the artists' contribution to national life. They wanted paintings to engender an initiative that would be directed not at toppling institutions but at transforming personal lives and public behavior. The liberals, too, were more interested in the "thought" than in the "technique" of a canvas; but under "thought," in the Aesopian language of the day, they subsumed a moral attitude rather than action. The liberals saw painters as moralists or teachers, not as political activists. Saltykov-Shchedrin's comment on Nikolai Ge's *Last Supper,* shown at the 1863 Academic exhibit, best conveys the romantic notion of service held by the liberal intelligentsia. He interpreted the realistically painted confrontation between Christ and Judas as a statement about conflicting life styles: between those who embraced ideals and those who were preoccupied with petty personal ambitions. Ge was commended for reminding the viewer that there were nobler goals in life than its ordinary pursuits or time-worn traditions and for engendering critical perceptions so that the public, instead of accepting the system blindly, would question it and become concerned about its transformation.[20]

While most of the intelligentsia in the 1860s assumed that what infused Russian art with a national spirit was *subject matter* that dissected contemporary problems, at least one prominent voice dissented. Fedor

Buslaev (1818–97), a scholar of Russian literature and architecture, suggested that a *style* conveying a sense of the shared historical identity reaching back to the Middle Ages would make Russian art truly national and popular. He urged his contemporaries to study the nation's artistic traditions. His advice to young painters was not to ape the newest trends abroad but to study Russia's own legacy, especially the naïve, patriarchal simplicity of presentation exemplified in the medieval epics, in icons, and in church ornamentation.[21]

These arguments were not a throwback to Slavophilism. Buslaev was not interested in probing those elements in Russian culture that were antithetical to the West. On the contrary, he devoted much effort to proving that the patterns of medieval Russian art came from a common European source, Byzantium, and not from the Orient as was argued by Violet le Duc and others. But he was eager to define the national spirit for a new art liberated from classical models. And he was critical of the budding realists for copying the style and composition of contemporary Western luminaries like Delaroche while ignoring the medieval Russian models when art was an integral part of the national spirit.

But the 1860s were an inhospitable time for devising a style expressing a communal ethos that would be intelligible as such to the entire nation. Russia was seen as an aggregate of classes and institutions much in need of analysis and transformation, not as an entity with an inherent, organic life of its own. However, one should note that not all members of the intelligentsia accepted such a definition of the nation or of national art. Moreoever, the foremost painter of the day found it difficult to dissociate his version of Russian reality from a deep involvement with the roots and ramifications of the community.

Vasilii Perov (1833–82) best exemplified the political inclinations of the 1860s. Born an illegitimate son of an impoverished aristocrat, Perov studied at the Moscow School of Painting, Sculpture, and Architecture. Though under the jurisdiction of the Imperial Academy, the School led a semiautonomous existence, and its curriculum gave more attention to rendering real objects and local life than to copying antique plaster casts. It was here that Perov painted *The Arrival of the Police Inspector* (1857): a besotted official about to oversee the flogging of a peasant, with numerous details juxtaposing the innocence of the saintlike victim with the corruption of officialdom and its minions.

The picture marked a radical change in the representation of Russian life. It was a quantum jump from Fedotov's satirical treatment of various classes and their foibles to an exposé of institutions that oppressed the people. This indictment of serfdom was followed by several very explicit pictures exposing the corruption and indifference of the Orthodox church, which the intelligentsia regarded as a principal mainstay

of autocracy. *A Village Sermon* (1861) showed a smug priest preaching to a peacefully snoring landowner, his flirtatious wife, and a crowd of emaciated peasants in rags on the accessibility of the Kingdom of God to the downtrodden and the poor. In *Easter Procession in the Country* (1861; fig. 8.2), drunken priests and villagers are seen setting out to celebrate Easter. And in *Tea at the Monastery* (1862), a well-fed monk refused to give a famished peasant family succor from his overloaded table.

No personal archives have survived from Perov's early life to document his views on the "burning questions of the day." But the subjects he chose and the manner in which he rendered them indicate that he was caught up in the free-thinking, reformist spirit of the decade. Certainly, as references to his canvases by various reviewers show, Perov was regarded as standing in the ranks of those who confronted autocracy. For one, the radicals interpreted the removal of *Easter Procession* from a St. Petersburg exhibit as a sign that art was actively enlisted in political agitation.[22] Likewise, liberals expected Perov to contribute his talents to civic life—even if on a more modest scale. Thus, when in 1868 Perov turned to a more personal vision of life's problems and exhibited canvases of a drowned woman against a cityscape, of a humiliated art teacher, and, of all things, a bona fide Madonna, the journal *Otechestvennye zapiski* expressed shock at his desertion and the fervent hope that he would quickly resume the cause of "thinking art."[23]

What the liberals feared actually did happen. Perov's brush lost its bite, and he began to paint scenes of domestic life in an increasingly "loyalist" vein, producing pictures on such themes as favorite national pastimes—fishing, hunting, or bird catching. The change cannot be wholly attributed to the turn toward reaction after 1864. In part, it was implicit in Perov's conception of himself as a painter of Russian subjects, an attitude that revealed the preponderance of emotional ethnic, not political, commitment. After winning a Gold Medal in 1863, Perov was sent by the Academy of Arts for an additional three years' training in Western Europe. But before two years were up, he reported to the Academy that "not knowing the character and moral life of the [French] people makes it impossible to finish any one of my works. . . ." Therefore, he petitioned to be allowed to return home earlier, for to stay abroad was "less useful than the opportunity to study and work on the countless subjects from the urban and rural life of our fatherland."[24]

Perov's petition succinctly expressed an attitude prevalent among Russian realists, an attitude that could not envisage painting as divorced from the "life" of the nation. Whatever additional professional training Perov could have acquired abroad seemed meaningless without the

ambience of Russian life to give his art real substance. Such an outlook, in turn, made Russian painting and painters easy prey to the manipulations of the intelligentsia, which was even more incapable of seeing art esthetically—as being autonomous from either politics, moral questions, or national destiny.

THE 1870s

The dichotomy between the radical and the liberal views on art persisted during the 1870s. The radical journal *Delo,* which counted Petr Tkachev and Petr Lavrov among its contributors, continued to badger artists to do their share in solving practical problems. On these grounds, the journal would dismiss landscape as "pointless" or state unabashedly that esthetic considerations should be altogether excluded from art criticism. Its reviews harped on whether a work of art enhanced the public's understanding of "truth" and "life"—however these catchwords were interpreted by that particular section of the intelligentsia.[25]

Liberals saw art as an auxiliary to the reform movement, expecting painters to help edify and improve Russia by reminding the public that the reforms, begun in the 1860s, needed to be extended and elaborated. This view was again best expressed by Saltykov-Shchedrin's reading of Nikolai Ge's *Peter and Alexis* (1871) as a confrontation between those who were determined to carry on with the transformation of Russia into an equitable society under the rule of law and those who sullenly opposed any renovation.[26]

The populist movement, however, introduced some new elements into the intelligentsia's discourse. The students' trek to the countryside to awaken the peasantry and the subsequent turn to violence that culminated in the assassination of Alexander II in 1881 embodied the activist, political preoccupations of a minority. Cultural populism, however, was a much more widespread phenomenon, and it fostered interest in popular traditions and values and, by extension, in things uniquely Russian. The new appreciation ranged from the narodnik writings idealizing the virtues of the peasantry to Zabelin's scholarly studies of national customs. In each case, the motive of the description or investigation was not a critical dissection of Russian society for the purpose of transforming it, but an acceptance of its national individuality. Among many liberals and moderates, this new outlook found expression in an altered attitude toward Russian art.

The writings of Adrian Prakhov (1846–1916), art historian and critic, summarized well the new attitude toward Russian art that derived from cultural populism. In his definition, the expression of the national spirit consisted not in the depiction of topical subjects or tendentious com-

ments on social or economic conditions. To be genuine and national, a painter had to convey the spirit of the people as directly and simply as they conceived of it themselves. As one successful example, Prakhov cited Vasilii Maksimov's *The Arrival of a Sorcerer at the Peasant Wedding*—a large canvas that gave the scene serious human dimensions and eschewed a melodramatic treatment in terms of poverty or degradation.[27]

Developments in the world of art paralleled in their own way the dominant intellectual currents. During the 1870s Russian realism attained maturity with the appearance of talented painters who worked out its characteristic themes: the poetic but unassuming beauty of native landscape, the exemplary portraits of nationally prominent figures, and the documentation of the nation's political tribulations, its social and economic change. The emergence of a full-fledged realist school coincided with the formation in 1871 of the autonomous Association of Traveling Art Exhibits (*Tovarishchestvo peredvizhnykh Khudozhestvennykh Vystavok*—hence the name "Peredvizhniki" for its members). Its annual shows of contemporary paintings, which circulated to major provincial towns after opening in the two capitals, marked the end to the official monopoly of patronage and its prescription of content and style. Because of these exhibits, Russian art at last became truly popular.

But it had become popular more in the cultural than in the political sense. This contradicts another mistaken notion about the links between Russian art and the intelligentsia. The popularization of art via traveling art exhibits is commonly described as a counterpart to the students' trek to the countryside to bring either liberation or enlightenment to the peasantry. The Peredvizhnik exhibits, however, were not meant for the lower classes, which were much too diffident and repressed to appear at such events and much too poor to afford the price of admission. Actually, the Association's shows exemplify the national cultural awakening of the decade: they performed a cultural service for educated society in the provinces where artistic life had hitherto been practically nonexistent. In large part because of the success of the Peredvizhnik exhibits, the future course of Russian art turned from the predilections of the radicals to the much less politicized tastes of the general, literate public.

Such were the results of the association's activities. Even so, the intentions of the painters, it should be noted, did not altogether correspond to the views of the intelligentsia activists either. Ivan Kramskoi (1837–87), one of the association's founders and often called the "philosopher" of the movement, carried on an extensive correspondence with colleagues and younger artists to remind them that Russian painters, unlike those in the West, were not "free as birds" but had the

obligation to be involved in the affairs of their country.[28] That obligation, however, was seen by Kramskoi solely in moral terms, as stated, for example, in his explication of his canvas *Christ in the Wilderness*. It was meant to convey the importance of the moral decision each person had to make in his lifetime—whether to serve an ideal or to succumb to petty interests.[29] In keeping with art's higher obligations Kramskoi considered the crudely political requirements of the radicals as "hostile" to art; painting, he insisted, deserved proper recognition of its autonomy, instead of being "punched in the nose" with importunate demands from journals like *Delo*.[30] (It is symptomatic that there is only one brief reference to Chernyshevsky in Kramskoi's collected writings.)

Equally important in Kramskoi's concerns was his promotion of landscape painting. He devoted as much time and effort to nurturing it as he did to his disquisitions on the moral role of art, for he regarded the poetic representation of the native scene as an essential mark of the Russian school, which was in no way incompatible with its uplifting mission. These two aspects of Kramskoi's labors on behalf of Russian realism demonstrate that in the eyes of the painters themselves service to the nation included a large measure of the nondidactic.

One incident in the early career of Ilia Repin (1844–1930) illustrates nicely the complex interplay between liberal strivings, painterly concerns, and nationalistic stirrings that characterized the course of Russian realism during the 1870s. Without doubt the most talented painter of his generation, Repin astounded the public with his large *Volga Boathaulers* (1873; cf. Bowlt, fig. 6.9) soon after graduating from the Academy. It provoked diametrically opposed political interpretations. Fedor Dostoevsky claimed that the young painter did not wear the "uniform" of the critically disposed intelligentsia and, instead of painting a tendentious canvas on the fate of the masses, had created a picture of their docility and "humble innocence."[31] But Vladimir Stasov, the self-appointed spokesman for critical realism since the 1860s and an ardent promoter of Repin's fortunes, saw just the opposite: namely, the germs of revolt against the "quiet submission" of the older boatmen in the stance of the one young hauler. And he praised Repin for being a "thinker," which, since the late 1850s, was the same as saying that the painter was making a critical comment on the state of affairs in Russia.[32]

Soon after having been thus characterized as the proponent of democratic Russian art, Repin left for a three-year Academic fellowship abroad. In Paris, he quickly discovered the delights of painting for the sheer pleasure of color and communicated this discovery to his teacher, Kramskoi: "I have now quite forgotten how to reflect and pass judgment, and I do not regret the loss of this faculty. . . . May God save Russian art from corrosive analysis."[33] For both Kramskoi and Stasov,

this confession was proof that Repin had been seduced in the West into the doctrine of "art for art's sake." Therefore, right after his return, they packed Repin off to the provinces in the hope that "somewhere inside Russia he will get over [the harmful exposure to Western esthetic standards] and regain his power of a realist, of a national artist . . . fully capable of creating and representing thoroughly Russian types and scenes."[34] They were soon rewarded with the portrait of a clergyman in minor orders, *The Protodiakon* (fig. 8.3).

However, the way *The Protodiakon* was portrayed raises doubts about the effectiveness of the cure. Repin painted the archdeacon with such robust exuberance that the canvas could hardly serve to illustrate Belinsky's denunciation of the Russian clergy (in his open letter to Gogol) as the "symbol of gluttony, avarice, sycophancy, bawdiness." The dry accuracy and explicitness of Perov's denunciatory pictures of the clergy was wholly absent. There is no doubt that Repin shared Belinsky's revulsion for the Orthodox church as one of the pillars of autocracy. But his talent was too great, his personality too expansive, not to respond to the ethnographic colorfulness of the gargantuan character, and he could not give an exclusively negative portrayal. What's more, both Kramskoi and Stasov shared Repin's enthusiasm about this fine specimen of the clergy as the personification of a genuine Russian type.

It should be noted that for all his blustering about the democratic functions of art, Vladimir Stasov (1824–1906) did not look at painting through that prism alone. As early as 1862, he reacted to the dismissive reception of the Russian art at the III International Exhibit in London and began to advocate a distinctive Russian school with a "well-defined national" character that would differentiate it from other European schools and leave its mark in the world. Thereafter, this quintessential exponent of critical realism devoted his prodigious energies to promoting both the social, civic-minded (*narodnyi*) and the national (*natsional'nyi*) spirit in Russian art, never considering the two aspects as incompatible. At first, they were so closely intertwined in Stasov's writings that it is impossible to isolate either one as being predominant. But with time the nationalistic, even chauvinist, element began to gain the upper hand in his thought, becoming quite pronounced by the late 1880s.

The appearance of gifted painters in the course of the 1870s reinforced an element of national pride among the critically disposed intelligentsia. Even more, the works of this talented group fed the appetites of the numerous moderate *intelligenty*, like Adrian Prakhov, who never expected Russian realism to concentrate on its ascribed critical or moral-social functions. Whatever the connections and influences, in the course of the 1870s the "Russianness" of Russian art increasingly meant

appreciative attention to what was distinct or genuinely national about the Russian people and its traditions. Less and less did painting subject Russian reality to critical scrutiny.

THE 1880s

But the evolution toward a more positive view of things Russian did not stop at that point. During the 1880s, the land and people began to be depicted as a nation, an organic community with a common past and a common destiny, rather than as a society composed of various classes with separate identities and clashing interests.

Elements of Russophilia emerged in art and in the public's response. The new phase can only in part be attributed to the reign of reaction that followed Alexander II's assassination and the resulting decline in both revolutionary activities and the democratic movement in general. The shift in attitude toward the "Russianness" of Russian art had already been taking place in the preceding decade. When the new Tsar Alexander III chose to promote a Russian school of art, based on the themes elaborated in the 1870s but cleansed of their democratic skepticism, there was a widespread positive response to his patriotic initiative.

Sections of the intelligentsia were aware that a backing away from the former reformist attitudes was taking place among the painters and, despite severe censorship, managed to express their disappointment. The most leftist journal, *Delo,* argued that it was "a mistake to seek out some original, new Russian paths" that were divorced from the Westernizing commitments of the intelligentsia.[35] Liberals were not intransigently hostile to a lyric or positive expression of Russian themes but did insist that "poetry" should be combined with moral or social insights. What worried them, though, was the disappearance of "meaningful [social] genre," a decline exemplified by such petty subjects as Vladimir Makovsky's *Dance Lesson,* which one commentator found to be devoid of a "single ideological . . . statement."[36] The "poverty of thought," according to the liberals, had reached such proportions that there was no difference between the official academic and the unofficial, autonomous Peredvizhnik exhibits. At neither show in 1886 could one find a "single idea, . . . a single civil thought, . . . a single historically significant canvas."[37]

It is indicative that the critic mentioned historical painting, for this particular genre more than any other reflected the changing concept of what was nationally significant and useful. Kramskoi, representing the first-generation realists who by and large had retained their vision of art's moral or social mission, urged a choice of edifying historical topics

that would shed light on the present and give the viewers "food for thought."[38] But the spirit in which Nikolai Ge had painted *Peter and Alexis* no longer obtained either among the moderate intelligentsia or among the younger painters.

A review in *Istoricheskii vestnik* of the historical paintings at the 15th Traveling Exhibit indicates well the change that had taken place. The article was outspokenly critical of the "tendentious" depiction of the past in terms of present-day moods and preoccupations. Instead, it urged painters to convey faithfully the spirit of the past, the typical traits of the people and of their epoch, without any latter-day analogies.[39] No matter whether one classifies this statement as "moderate" or "conservative," what is important is that it advocated a liberation of historical painting from politics as they had been hitherto understood.

The interests and *oeuvre* of Vasilii Surikov (1850–1921) were in perfect correspondence with this position. Born and brought up in Siberia, he was much attached to the patriarchal ways that had survived in those distant parts of the empire. After graduating from the Academy, he chose not to go to the West for further training, but moved to Moscow, whose very streets and walls spoke of old traditions. And it was this heritage, in conflict with the modernizing authority of the Petrine state, that supplied the subjects for Surikov's first canvases. *The Morning of the Streltsy Execution* (1881) gave a sympathetic account of the sufferings inflicted on the defenders of autochthonous Russian ways; *Boiarynia Morozova* (1887; fig. 8.4) showed another champion of tradition in a moment of undaunted defiance (as well as the seductive beauty of seventeenth-century costumes); and the subject of *Menshikov in Exile* (1883) was the retribution suffered by one of Peter the Great's henchmen.

Naturally, different sections of the intelligentsia saw their own particular aspirations mirrored in these canvases. The radical Vera Figner identified Morozova with the heroism of Sofia Perovskaya and other revolutionaries. The populist writer Vsevolod Garshin and the liberal journalist Vladimir Korolenko complained that Surikov had chosen a deranged fanatic for a positive hero. But the moderate *Istoricheskii vestnik* applauded Surikov for portraying a typical Russian woman faithful to the principles of her forebears (but, in keeping with the tenor of the decade, those principles were confined to their seventeenth-century milieu, leaving the ethos of the 1860s unmentioned).[40]

What is significant is not the more or less predictable reaction of the various groups among the intelligentsia but the intentions of Surikov himself, or, rather, the extent to which they reflected the changing concept of the national. Although his own political convictions were not very articulate, there is no doubt that he was truly animated by a love of

Russia's pristine past and also deeply moved by the human drama that accompanied the process of Westernization.[41] This fascination with pre-Petrine times, when Russian society had not been rent in two by the forceful introduction of European ways, postulated an organic concept of the nation as a people united by a common heritage. Such a reading of Russian history entailed more than turning one's back on the obsession with Westernization that had agitated the intelligentsia since the 1840s. It signified coming to terms with Russia as a country with its idiosyncratic traditions and mores that could be enjoyed (as they were in *The Storming of the Snow Town*, 1891; fig. 8.5) or glorified (as they were in *Yermak's Conquest of Siberia*, 1895) instead of being eternally subjected to critical analysis or unfavorable comparisons, with Western standards calling the tune.

Although Surikov contravened the precepts that had animated Russian realism at the start, his approach was just as firmly rooted in Russian reality, in the sense of dealing with national issues, as was the work of his predecessors. Surikov's interpretation of Russian themes does not mark any sharp break with the methods of Russian realism. For, all along, beginning with Belinsky and appearing later in the writings of such diverse authors as Buslaev, Stasov, and Prakhov, there were strong nationalist undercurrents in the intelligentsia's quest to define the appropriate concerns for Russian art. In varying degrees, these *intelligenty*, as well as much of the articulate public, expressed their love for and fascination with things Russian without scrutinizing them in terms of Western standards of progressiveness but simply accepting them as "ours."

Thus, Nikolai Mikhailovsky's judgment, expressed in 1890, that Russian painters "had turned away from life"[42] has to be seen in perspective. It represents but one segment in the spectrum of opinion, namely, the positivist trend that ascribed a narrow didactic role to art. Other intellectuals conceived the cognitive function of art in a broader way. With time, as the realist school acquired momentum and growing popularity among the educated public, the positivist trend lost its sway. The earlier critical perceptions of Russian reality yielded to the acceptance, even the embrace, of the nation's history and native traditions. As for the primarily esthetic conception of art—that only emerged briefly (and with éclat) in the first quarter of the twentieth century.

NOTES

1. P. V. Annenkov, *The Extraordinary Decade: Literary Memoirs* (Ann Arbor, 1968), p. 138.

2. See Richard Pipes, ed., *The Russian Intelligentsia* (New York, 1961).

3. "Letter to N. V. Gogol" (1847), in *Russian Intellectual History: An Anthology*, ed. Marc Raeff (New York, 1960), p. 238.

4. "A Survey of Russian Literature in 1846," in *Selected Philosophical Works* (Moscow, 1956), pp. 370–420.

5. "Pis'mo v Peterburg" (1843), in *Polnoe sobranie sochinenii* (St. Petersburg, 1900–1904), 3:86–97.

6. "Pis'mo v Peterburg" (1845), ibid., pp. 104–18.

7. "O vozmozhnosti russkoi natsional'noi shkoly," ibid., 1:73–101.

8. "A Survey of Russian Literature in 1847," in *Selected Philosophical Works,* p. 459.

9. "Peterburgskii sbornik" (1846), in *Sobranie sochinenii v trekh tomakh* (Moscow, 1948), 3:91.

10. "Godichnaya vystavka v Imperatorskoi Akademii Khudozhestv," *Sovremennik* 6.1 (1847): 79–80.

11. Ya Leshchinskii's *Pavel Andreevich Fedotov. Khudozhnik i poet* (Moscow-Leningrad, 1946), contains the fullest selection of Fedotov's writings.

12. A. Druzhinin, "Vospominaniya o russkom khudozhnike P. A. Fedotove" (1853), in *Sobranie sochinenii* (St. Petersburg, 1865), 8:693.

13. "Peterburgskii sbornik" (1846), in *Polnoe sobranie sochinenii* (Moscow, 1955), 9:554.

14. "Vystavka v Imperatorskoi Akademii Khudozhestv," *Sovremennik* 11 (November 1849):82–83.

15. P. L., "Esteticheskoe koe-chto po povodu kartin i ekskizov G. Fedotova," *Moskvitianin* 3.6 (1850): 27.

16. "Zhurnalistika," *Moskvitianin* 2.5, pt. 5 (March 1854): 54.

17. N. V. Shelgunov et al., *Vospominaniya* (Moscow, 1967), 1:194.

18. "Pamiati khudozhnika," *Poliarnaya zvezda* 5 (1859): 238–52.

19. I. Dmitriev, "Rassharkivayushcheesia iskusstvo," *Iskra* 38 (October 4, 1863): 521–30.

20. "Kartina Ge" (1863), in *Sobranie sochinenii* (Moscow, 1968), 6:148–77.

21. "Pamiatnik tysiachiletiyu Rossii" (1862), in *Moi Dosugi* (Moscow, 1886), pp. 187–208. See also his "Zadachi sovremennoi esteticheskoi kritiki," *Russkii vestnik* 77 (1868): 273–336.

22. I. Dmitriev, op. cit.

23. P. M. Kovalevskii, "O nashikh khudozhestvakh," *Otechestvennye zapiski* 177.2 (1868): 29.

24. "V. G. Perov," in *Slovar' russkikh khudozhnikov*, ed. N. P. Sobko (Moscow, 1893–99), vol. 3, pt. 1, p. 104.

25. Khudozhnik liubitel', "Na svoikh nogakh," *Delo* 12 (1871):117; Vse tot zhe [pseudonym of Petr Tkachev], "Printsipy i zadachi real'noi kritiki," *Delo* 8.2 (1878): 23–24.

26. "Pervaya russkaya peredvizhnaya khudozhestvennaya vystavka" (1871), in *Sobranie sochinenii* (Moscow, 1970), 10:225–33.

27. "Chetvertaya peredvizhnaya vystavka," *Pchela* 1.10 (March 16, 1875): 121–26.

28. September 28, 1974, letter to I. Repin, in *Ivan Nikolaevich Kramskoi. Pis'ma, stat'i v dvukh tomakh*, ed. S. N. Gol'dshtein (Moscow, 1965), 1:269.

29. February 16, 1878, letter to V. Garshin, ibid., p. 446.

30. July 21, 1876, letter to V. Stasov, ibid., p. 355.

31. "A propos of the exhibition" (1875), in *F. M. Dostoievsky. The Diary of a*

Writer, ed. B. Brasol (New York, 1954), pp. 74–85.

32. "Pis'mo k redaktoru" (1873), in *Sobranie sochinenii* (St. Petersburg, 1894), 1.2: 397–400.

33. October 16, 1874, letter, I. E. Repin, in *Izbrannye pis'ma,* ed. I. A. Brodskii (Moscow, 1969), 1:143.

34. Quoted in V. Stasov, *Izbrannye sochineniya,* ed. P. T. Shchipunov (Moscow, 1952), 1:710.

35. *Delo,* July 1884–April 1885, p. 98. Cited in V. N. Volkova, "Iz istorii russkoi khudozhestvennoi kritiki: 70–80-e gody XIX veka" (kandidat diss., University of Moscow, 1972), p. 98.

36. Bukva [pseudonym of I. F. Vasilevskii], "Peterburgskie nabroski," *Peterburgskie vedomosti* (February 25, 1885).

37. Bukva, "Dve vystavki," *Russkie vedomosti* (March 10, 1886).

38. January 21, 1885, letter to A. Suvorin, in *Ivan Nikolaevich Kramskoi. Pis'ma,* 2:167.

39. Pepo [pseudonym of P. N. Polevoi], "Istoricheskii zhanr na XV vystavke Tovarishchestva peredvizhnykh vystavok," *Istoricheskii vestnik* 28.4 (1887):243–48.

40. Vera Figner, "Zapechatlennyi trud," in *Polnoe sobranie sochinenii* (Moscow, 1928), 1:252–53; V. Garshin, "Zametki o khudozhestvennykh vystavkakh" (1887), in *Polnoe sobranie sochinenii* (St. Petersburg, 1910), pp. 428–40; V. Korolenko, "Dve kartiny," *Russkie vedomosti* (April 16, 1887); "Istoricheskii zhanr na XV vystavke Tovarishchestva peredvizhnykh vystavok," *Istoricheskii vestnik* 28.4 (1887): 244.

41. See S. Glagol, "V. I. Surikov. Iz vstrech s nim i besed," *Nasha starina* 2 (1917): 58–78.

42. "Ob XVIII Peredvizhnoi vystavke" (1890), in *Polnoe sobranie sochinenii* (St. Petersrbug, 1909), 6:748–61.

9

Architecture in Nineteenth-Century Russia: The Enduring Classic
Albert Schmidt

OF THE MANY styles encompassed by nineteenth-century Russian architecture, the one that was the most pervasive and enduring was classicism. Rooted in the romantic classical climate that conditioned European art at the end of the eighteenth century, Russian classicism faded before 1850 only to reappear briefly at the beginning of the present century and in rather grotesque forms during the late Stalin era.

The artifacts of classicism, much in evidence throughout the Soviet Union, are presently in varying stages of deterioration or restoration. While the buildings of central Leningrad and Moscow are continually spruced up in varied pastels, similar buildings in provincial cities are often ignored. Even classical Moscow suffered irreparable damage recently when an extension of the Kalinin Prospekt cut through the old classical city beyond the Arbat. All this notwithstanding, much remains of a classical Russia planned and built some two centuries ago.

ROMANTIC CLASSICISM

Romantic classicism came to fruition in a century that proved a watershed for architectural styles. The dissolution of the baroque, hastened by French rococo and English Palladian intrusions, did not result inevitably in romantic classicism. Rather than build upon a Renaissance-baroque continuum, romantic classicism claimed an authenticity based on historical and archeological research. It recaptured sublimity, elevation, dignity, and honor, where Renaissance classicism had accentuated beauty. Besides having an affinity for Roman and Greek models, romantic classical architects were attracted to Egyptian motifs. Reduced to pure intellect, basic geometric forms, and smooth surfaces, their edifices voided that organic articulation and ornament so commonplace with the baroque.

172

Basic to understanding romantic classical architecture was the constancy of romanticism. Initially, it was joined with classicism in a Roman revival, followed in the early 1800s by a Greek, and then in the 1830s by a more or less Roman one again. By 1840, when this last classical phase had spent itself, romanticism entered a medieval, or Gothic, revival. As if to cement this bond between the classic and Gothic, many practicing architects created in both styles.

If, indeed, the new classicism was both romantic and authentically antique, what was its genesis in the eighteenth century? Fiske Kimball regarded the early romanticism as that mode of feeling which contrasted with Enlightened reason and perceived the early eighteenth-century English garden as a logical forerunner of romantic classicism.[1] As designed by such "artistic amateurs" as Vanburgh and the Earl of Burlington, the *jardin anglais* had departed from the strict formality of that in France, though Grecian temples and Gothic ruins linked it to both the classic and the romantic. The classical temple appeared in it even before the excavations at Herculaneum in 1738 and Pompeii in 1748, events that greatly accelerated the acceptance and validity of romantic classicism.

Acceptance was also spurred by some remarkable publicists and architects. Johann Joachim Winkelmann (1717–68) proclaimed ecstatically the unsurpassed virtues of Greece and Greek art, and Giovanni Battista Piranesi (1720–78) etched romanticized Roman ruins, which inspired young architects to visit Italy. In France Louis-Etienne Boullée and Claude-Nicholas Ledoux, architects of the *style Louis XVI,* turned to forms that "captivate by simplicity, regularity, and reiteration."[2] Although Boullée built classical monuments ranging from public edifices to triumphal arches, Ledoux achieved the wider reputation as an architect. Avoiding both the fanciful and the imitative in his severe style, Ledoux worked in a world of stark spheres, cubes, and pyramids. His new classic, admirably utilitarian, served the current need for banks, hospitals, barracks, stock exchanges, opera houses, and even factories. While neither Boullée nor Ledoux built extensively in Western Europe, their ideas were carried to Russia by an émigré architect, Thomas de Thomon (fig. 9.1), who subsequently designed and built the Petersburg Bourse.

Although in France the *style Louis XVI* surrendered to increased surface ornament during the Bonaparte era, the severe Greek mode prevailed elsewhere. In Germany Karl Langhans—whose Brandenburg Gate drew inspiration from the Propylaea—Karl Friedrich Schinkel, and Leo von Klentze were uncompromising Hellenists. In England this tradition was fostered by John Soane, John Nash, and Robert Smirke, while Benjamin Latrobe, who designed in 1799 an Ionic temple to house the Bank of Pennsylvania, was America's principal practitioner in

the Greek Revival Style. When Nicholas Biddle determined after a trip to Greece that "a chaste imitation of Grecian architecture" would be most appropriate for his new Bank of the United States, he obtained designs from Latrobe and William Strickland, both of whom had used the Parthenon as their model. After Europeans and Americans had tired of Greek Revival, they returned to an ornate and eclectic classicism, but by the 1830s and 1840s even eclectic classicism gave way to the Gothic.

CLASSICISM IN TOWN PLANNING

Just as European architecture entered the world of classicism, so indeed were Europe's cities made to conform to the tenets of order and reason. Architects harkened to Vitrivius, who had much to say about the interaction of building and planning. His ideas, when joined with those of Alberti, particularly suited the tenor of both the baroque and romantic classicism. Among the precepts that most governed town planning since the sixteenth century was the straight line. Acquiring virtually a mystique, it was pronounced by Pierre Lavedan to be "the very expression of human reason and will."[3] Although present in the medieval town, the unwavering line received no theoretical affirmation until the sixteenth century, when acceptance came both in the dominance of the axis and in the new taste for gridiron design. The line as an axis both organized the environment and dominated the square, which served as an extension of the longitudinal axis. Uniform in both their façade elements and their unbroken horizontal roof-line, edifices along the radial streets accentuated this linear precision.

The public square, exemplary of organized space and essential for a monumental perspective, constituted a second invariable in baroque-classical urban design. The classical planner consciously molded this void rather than permit an indiscriminate building mass to arise. He determined that, irrespective of the plaza's shape—oval, circular, rectangular, or square—the monument should be flanked symmetrically by important public buildings, uniform in character. Moreover, he reserved space for greenery that linked the monument to the spatial treatment of the plaza. He directed the radial streets, which converged upon the monument, to the open space in the middle of the square rather than to its corners.

A uniformity and harmony in façade elements, so crucial to the perspective, resulted from the third ingredient of classical urban design—the program. In Lavedan's words, the program was "the obligation imposed on all the houses of a certain part of the town—street, square, district . . . to conform to a general design."[4] Besides this articulation of linear thoroughfares and squares, classical planners inserted bridges and

stone embankments, straightened river beds, paved canals, and gridiron blocks into their programs. Landscaping followed the same urban formula of major and minor axes, which created beds of parterres and terminated at fountains or other monuments. In this instance, hedges or trees clipped to precision substituted for façade uniformity.

Regulated town design in baroque and classical Europe conveyed an unmistakable political message: order, power, absolutism, and secularism. The great palace in the central square stood for power and pageantry. Bureaucratic and military edifices, cloaked in columns and pediments, also occupied imposing sites in the new city, while ecclesiastical ones, by contrast, lost their primacy. This linear development of the city was more than symbolic: besides facilitating traffic flow, wide boulevards and thoroughfares inhibited street revolutionaries and otherwise impeded social intercourse. The new city ceased being the historic haven of the people that its medieval predecessor had been.

CLASSICISM AND RUSSIA

The term "romantic classicism" does not appear in the vocabulary of Russian architecture; rather the common designation is "Russian classicism." Classicism, with its order, geometric urban design, and accent on masonry construction, was antithetical to old Russian building modes, and probably, for these very reasons, baroque classicism won approval from Peter the Great in his building of St. Petersburg, Russia's Western "window."

St. Petersburg, despite its baroque origins and subsequent rococo embellishment by Rastrelli, became by the early nineteenth century the fulfillment of classicism in Russia. Catherine II and Alexander I, in particular, built lavishly there. Catherine's mark was left especially by her architects Giacomo Quarenghi, Ivan Starov, and Vallin de la Mothe, whose Academy of Fine Arts on the Neva (1764–88) was perhaps the initial stimulus to classicism in Petersburg. Alexander I, whose reign coincided with "Empire classicism," inspired an ambitious undertaking that completed Winter Palace Square, the Nevsky Prospekt, and its related architectural ensembles.

Nor did classicism confine itself to the new capital on the Neva. Both Catherine II and Alexander I perceived themselves as builders of cities. Catherine's classical Moscow, the creation of architects like Vasilii Bazhenov and Matvei Kazakov, became a "nest" for the emancipated nobility. Even the conflagration of 1812 struck a positive note: it offered Muscovites an opportunity to build a city to conform to Bazhenov's and Kazakov's ideal. It fell to Osip Bove, the Giliardis, father and son, and Afanasii Grigor'ev to continue the tradition of

Catherine's masters and make Moscow, like Petersburg, Berlin, Munich, and Vienna, an exemplar of romantic classicism.

That Catherine, whose interests were invariably far-ranging, dallied with city-building is often overlooked.[5] In the second year of her reign she had to cope with the destruction of Tver (Kalinin) by fire (fig. 9.2). Her decision to reconstruct it along classical lines spurred her to similar undertakings in Tula, Kolomna, Kostroma, Kaluga, Iaroslavl, and Viatka. Encouraged by Voltaire, she dreamed of civilizing New Russia and the Ukraine. In new Ekaterinoslav (Dnepropetrovsk) on the Dnieper, she envisioned a magnificent center of culture and commerce. On the northern shore of the Black Sea, where ancient Greek cities had once stood, she planted the new classical ones of Azov, Taganrog, Nikolaev, Odessa, and Sevastopol.

Catherine spurred both planning and building through a decree of 1775 intended to improve provincial administration. It directed her governors "to establish towns either where they already existed or in new places," and divided the realm into fifty provinces, each of which consisted of a maximum of twelve districts.[6] Besides "provincial" cities, 493 were designated "district" ones, and 86 were placed under the supervision of the state. Settlements with hardly more than 100 dwellings were often labeled cities. Such instant urbanization stimulated planning and building as nothing else could.

Not content to have decreed the presence of new towns, Catherine II imposed on them her own preference in style and design. In so doing, she resorted to her favorite pastime of appointing commissions. For example, in 1768 she charged the Commission for the Building of St. Petersburg and Moscow *(Komissia dlia stroeniia stolichnykh gorodov Sankt-Peterburga i Moskvy)*, formed six years earlier, to undertake planning throughout Russia; by the end of the century it had completed more than 400 city plans. New town design usually conformed to one of, or some combination of, four types: radial-concentric, fan-shaped, rectangular, and diagonal. Because architects were ever cognizant of fire and hygienic problems, they conceived cities consisting of a center and suburbs with regulated streets and alleys, administrative and commercial squares, blocks, and plots. They designated certain squares for wooden construction, others for masonry. *"Obraztsovye,"* or standardized, façade design assured a programmed classical city and at the same time reduced construction costs.

In Russia, as elsewhere in Europe, central plazas and the radials leading into them were the essence of the new design. Such grand monuments as a kremlin, cathedral *(sobor)*, or palace terminated a radial thoroughfare in a central square. The radial, like the square, conveyed a new sense of space. Whereas old Muscovy's wooden cities, silhouetted

by tent spires and bulbous domes, were essentially vertical, the new classical towns, conforming to a required 2:1 or even a 4:1 street width–façade height ratio, projected a horizontal image. Masonry estate houses of the affluent usually occupied those streets leading into the administrative plazas. Separated from one another by fences and gates, these edifices achieved the effect of a continuous façade, which helped order the streets and plazas.

Catherine's great city-building enterprises, although sometimes majestic, were frequently artificial. Instead of providing an environment for commerce, her "cities" most frequently mirrored aristocratic affluence or served as administrative centers for recently established provincial governments. Under such circumstances, planners often concentrated more on the needs of an aristocracy promenading than on vehicular traffic and envisioned squares for military reviews rather than for commerce. Nor is it a fiction that the classical façades of a regulated street often obscured the misery of old Russia behind it. To a very considerable degree, Catherine's classicism was a façade, a vast "Potemkin village."

Upon Catherine's death in 1796 her son Paul set aside her ambitious city-building plans and abolished the St. Petersburg–Moscow Commission. This latter action greatly reduced the impetus for both developing new plans and implementing those already approved. Only after Paul's assassination and the succession of Alexander I in 1801 was the pattern reversed and a new era of city building inaugurated.

The greatest urban endeavor in nineteenth-century Russia, perhaps Europe, occurred in St. Petersburg during the first third of the century. Success was counted not so much in specific monuments as in the transformation of the city center. The architectural program consisted in linking, one way or other, such expansive ensembles as Thomon's Bourse, Zakharov's Admiralty, Voronikhin's Kazan Cathedral, Stasov's Pavlovsky Barracks, and Rossi's General Staff Building, Senate and Synod, Mikhailovsky Palace, and Aleksandrinsky Theater—to mention only the most important (fig. 9.3). Although Alexandrian Petersburg inherited impressive monuments varying from Trezzini's Twelve Colleges on Vasilevsky Island and his Sobor of Ss. Peter and Paul, Starov's splendid Tauride Palace, and Rastrelli's colossal Winter Palace, the city had not achieved architectural coherence. Giving it that through the medium of classicism was the youthful Alexander's aspiration.

To fulfill his charge, the Petersburg architects turned to the city's topography. A natural axis was the Neva River, with the Admiralty, the Winter Palace, Vasilevsky Island, and the Fortress of Ss. Peter and Paul the principal compositional elements. Yet none of these surpassed the

other as a focal point. Quarenghi had suggested placing a stock exchange in the eastern sector of Vasilevsky Island, but his design was rejected for something more profound; Thomon's Bourse (1805–11), on the other hand, appeared to solve this crucial planning problem. Its location between two symmetrical columns on the "point" of Vasilevsky Island both established its centrality in the new urban design and gave a focus to central Petersburg itself. The exchange, placed high on an artificial terrace, was framed with forty-four Doric columns and crowned in its eastern and western porticoes with monumental allegorical sculptures.

Zakharov, Voronikhin, Rossi, and Stasov also took up the task of reorganizing this sector. In his main Admiralty (1806–23), Adrian Zakharov linked the triradial or fan-shaped street configuration in the city's south end with the Neva ensembles. Voronikhin's Kazan Cathedral (1801–11) and Rossi's Mikhailovsky Palace and Square (1818–40) and his extended Aleksandrinsky Theater complex (1828–34) completed the vast Nevsky Prospekt ensemble below the Admiralty. Rossi, meanwhile, had reshaped Winter Palace Square with his General Staff Building and its magnificent arch, essentially tying it to the Nevsky. His Senate and Synod buildings, which framed Petrovskaia (now Decembrist) Square, fulfilled the ensemble west of the Admiralty. Continuation of the Sadovaia (Garden) Street to the Field of Mars, rebuilding the Mikhailovsky Palace area, and construction of Stasov's Pavlovsky Barracks (1817–20) on the Field of Mars concluded the remaining ensembles in the city center. This grandiose building enterprise placed Petersburg and Russia in the vanguard of the entire neoclassical movement.

Planning a classical Moscow, although obscured by the building in St. Petersburg, proved a notable undertaking nonetheless. In the half century before 1812, planners had tried transforming the city's traditionally wooden and baroque-rococo appearance to one of classicism. An essay in what might have been was the classical Kremlin project by Vasilii Bazhenov in the 1760s and 1770s. That enterprise did not progress beyond leveling some ancient structures on Kremlin hill before the Empress Catherine lost interest. An especially energetic planning endeavor resulted from the plague of 1771 and two destructive fires in 1773. On September 4, 1773, Catherine II stated her intention to create a masonry "city." A so-called Separate Department (*Otdelennyi*) of the Commission for the Building of St. Petersburg and Moscow, noted above, was created to prepare a plan; a Bureau for Masonry Building (*Kamennyi prikaz*) was established to implement it.

The resulting "Project Plan of 1775" envisaged an enlarged and enriched central Moscow—three squares in the Kitai Gorod as well as

an unaltered Red Square. In the Belyi Gorod the plan specified a semicircular chain of squares embracing the Kremlin and Kitai Gorod. Etched in a space cleared of ancient defenses and congested wooden buildings, these squares, originating and terminating with the Moscow River, were intended to reduce the fire hazard and beautify the "city." The planners also intended to regulate the Neglinnaia from where it entered the Zemlianoi Gorod in the north to its confluence with the Moscow River beneath the Kremlin.

In addition, the planners called for a Boulevard Ring—lined with plantings and with plazas where the radial highways had pierced the old city gates—on the site of Belyi Gorod ramparts. While the ring and its squares were conceived for administrative and residential purposes, two commercial squares for the grain market were projected in *Zamoskvorech'e,* south of the Moscow River. The plan specified that these have necessary commercial stalls, granaries, and plantings as well as a good port and harbor.

Flooding of the Moscow River was a recurring problem. To facilitate drainage of the river's right bank, opposite the Kremlin and Foundling Home, the 1775 plan allowed for a system of drainage canals. Projected from the Great Stone Bridge to the Krymsky Ford, it was to have been separated from the main channel of the Moscow River by two islands. As with the Neglinnaia, the planners contemplated ordering the Moscow River, reinforcing its embankments with stone, and leveling the banks alongside the newly planted thoroughfares (fig. 9.4).

The four decades from 1775 until the great fire of 1812 were years of revision, with some implementation but much inaction. The principal architect in Moscow during these years was Matvei Feodorovich Kazakov, Bazhenov's successor in the Kremlin Department. Despite some notable accomplishments, Kazakov and his colleagues did not radically alter the city's general appearance. It remained for the fire of 1812 to do so and, by so doing, to resurrect the 1775 plan.

That conflagration demolished the Kitai Gorod and the Belyi Gorod west of the Kremlin from the Neglinnaia River to the Boulevard Ring. Only parts of the far northern and northeastern sections remained intact; in the south Zamoskvorech'e lay devastated. Even substantial parts of the city beyond the Zemlianoi Gorod burned. Never in the city's long history of fires had any been so destructive.

A NEW PLAN FOR MOSCOW AFTER 1812

The architect charged with restoration of Moscow was a Scotsman named William Hastie. Hastie had arrived in Russia in 1784 and worked in the Crimea, Ekaterinoslav, St. Petersburg, and Tsarskoe Selo

before his appointment in 1811 to coordinate planning for all Russian cities.[7] Despite his other responsibilities, Hastie assumed personal direction for Moscow's renovation. The plan that he completed by mid-July 1813 proved impractical and was ultimately set aside by the Commission for Building (*Komissiia dlia stroeniia v Moskve*). It did, however, precipitate a lengthy critique from the commission. Moving from this critique the commission finally submitted its own general plan on January 14, 1815. Altered several times before receiving approval on December 19, 1817, the Project Plan of the Capital City of Moscow of 1817 served as the basis for restoring and renovating the city.[8]

The conflagration of 1812, more than any calamity in Moscow's torturous history, erased the old city. Although timber dwellings quickly reappeared, masonry—new and restored—greatly multiplied. Hastie's plan and the Plan of 1817, both markedly influenced by the design of 1775, attested to the continuity of classical planning in Moscow for over a half century. The elimination of historic Moscow landmarks and the unfolding of a new urban design allowed for a flowering of new architecture. Classical Moscow, to the extent that it was to be, rose from the ashes of 1812.

RUSSIAN CLASSICISM IN ARCHITECTURE

The classical mode became the vehicle for buildings that identified with both old and new Russia.[9] Such traditional structures as monasteries, cathedrals, belfries, churches, chapels, and clerics' residences suddenly took on a "modern" look. The adoption of classicism for administrative and government buildings and courts, on the other hand, testified to the expansion of civil bureaucracy. In the same vein, guard houses, officers' meeting houses, barracks, riding schools, arsenals, and warehouses reflected the current military emphasis. The accelerated construction of classical prisons, schools, theaters, post stations and turnpikes, fire stations, hospitals, bourses, almshouses, hotels, city halls, consistories, bridges, factories, post offices, banks, and commercial arcades related the style to Russia's increasingly complex social fabric. Classical monuments also abounded: arches of triumph, columns, rotundas, fountains, monuments to individuals, mausoleums, and grave markers. Finally, Greek and Roman motifs continued to find the same fulfillment in private homes, country estates, pavilions, summer houses, palaces, governors' mansions, and nobles' meeting houses that they had in the previous century.

St. Petersburg evidenced Russia's classical apogee in Thomon's Stock Exchange and Zakharov's new Admiralty. Considered by many scholars as the founder of "high classicism," Adrian Zakharov fashioned an Ad-

miralty that was really a reconstruction of existing buildings: he retained their old walls and merely added porticoes to them. The Admiralty's principal function was ship building, which occurred in the interior buildings ringing the courtyard. Those exterior rooms and buildings which faced the city squares housed the Admiralty administration, college, library, auditorium, and other rooms—all splendidly furnished. The building's marvelous simplicity was derived from its expansive façade articulated only by alternating six- and twelve-column Doric porticoes. At each end of this façade rose the Nevsky pavilions, beneath which a canal once passed. The columns of the porticoes, compactly arranged, were set against the flat surfaces of the walls. Zakharov actually used the base of the existing tower but changed both its outline and architectural finish. The building's great mass forced the architect to design an original façade, symmetrical with the tower. In doing so he created a landmark in Russian classicism.

Another Alexandrian monument was Vorinikhin's Kazan Cathedral on the Nevsky Prospekt. Although given an extended semicircle of quadruple colonnades at both the front and rear, the church acquired its distinction on the Nevsky side, where its portico as well as colonnades determined the space around the cathedral. Voronikhin's death left the colonnade on the side opposite the Nevsky unfinished, and so it remained. The architect used the Corinthian order and induced Russia's best sculptors to adorn the mighty edifice.

The Admiralty, Bourse, and Kazan Cathedral preceded the events of 1812 that heightened Russian nationalism and infused her arts with heroic sentiment. After the war with France a succession of majestic architectural ensembles and monuments were erected in St. Petersburg to extoll Russia's victory over Napoleon and her military might. In the eyes of the Emperor Alexander an embellished capital city encapsulated this imperial glory. He established in 1816 the Committee of Buildings and Hydraulic Works "to raise this capital's architecture to that level of beauty and perfection which, corresponding in all respects to its attributes, would unite the public and private good."[10] Placed under the direction of the French military engineer Augustin de Béthencourt, this committee undertook to change even more the face of central Petersburg.

Just as Zakharov and Voronikhin had dominated the Petersburg scene in the decade before 1812, Béthencourt's committee, which included Vasilii Petrovich Stasov and Karl Ivanovich Rossi, also left its mark on the city. Stasov's versatility was evidenced in his barracks, court stables, cathedrals, food warehouses, triumphal arches, market buildings, palaces, and mansions. Having studied and apprenticed in Moscow with Bazhenov and Kazakov and sojourned in Italy, he re-

turned to Petersburg, where before 1812 he worked with Voronikhin, Zakharov, and Quarenghi. In the postwar period he became the foremost architect on the Committee of Building and Hydraulic Works, reconstructing between 1817 and 1823 the old court stables of Peter near the Moika and building the Pavlovskie Barracks in the Field of Mars. Stasov's barracks, in conjunction with Rossi's Mikhailovsky Palace, effectively continued the Sadovaia to the Field of Mars.

Karl Rossi (fig. 9.5) was the other outstanding Petersburg architect of the postwar period. As a member of Béthencourt's committee, he built or planned many of the principal Petersburg architectural ensembles. The son of an Italian ballerina who had been invited to St. Petersburg, Rossi studied under the architect Brenna and learned from Bazhenov, Stasov, and Quarenghi. By 1801 he held the rank of architect and after that studied at the Academy of Florence. He subsequently worked in the Kremlin Department in Moscow, in Tver, and, after 1815, in St. Petersburg, where he spent the next decade and a half.

One of Rossi's masterpieces was the Mikhailovsky Palace, built for the emperor's brother, Mikhail Pavlovich. Rossi began his design in 1817; eventually a site between the Nevsky Prospekt and the Field of Mars was selected for it. The palace was oriented both toward the courtyard and plaza before it and toward the garden behind it. The majesty of this great Corinthian palace was accentuated by its marked contrast with the modest buildings in the square. The garden façade, like that in front, bore a colonnade, pediment, and sculptures and was visible from the Field of Mars. Finished in 1825, the palace became the Russian Museum in 1895, one of the two principal repositories of Russian art in the Soviet Union today.

Rossi's reorganization of Winter Palace Square, begun in 1819, represented his most important accomplishment. In order to open a passage into the square opposite the Winter Palace, the architect built a monumental arch that joined the ministry and General Staff buildings. It spanned approximately fifty-six feet and rose nearly ninety-two feet discounting its sculpture. Crowned with a chariot carrying Glory and drawn by six horses and warriors, the General Staff arch became in every sense a triumphal one, the apotheosis of romantic classicism. That the square became a careful balance of Rastrelli's rococo and Rossi's classicism made it a splendid show place. The wholeness of composition, unity of scale, and the façade divisions easily compensated for the differences in architectural style.

Few architects had the opportunity to alter a city's appearance as Rossi did in classical Petersburg. Perhaps his best ensemble creation was that which began with the Alexandrinsky Theater, an elegant building enhanced by splendid Corinthian porticoes on each of its sides. Designing a new theater on the Nevsky led Rossi to ponder the entire area

flanked by the Fontanka and Sadovaia Street and extending from the Nevsky to present-day Chernyshev Square. He set the theater back from the Nevsky, placing before it a pleasant plaza. On one side rose the graceful Anichkov palace with two exquisite pavilions; on the other stood the public library.

Behind the theater Rossi created to a length of 722 feet Theater (now Rossi) Street, which he led into a new semicircular square intersected by various radial thoroughfares. Looking back along Theater Street, a viewer today will perceive how Rossi used the theater to close the perspective, the effect of which, incidentally, is enhanced by the horizontal divisions of Rossi's buildings on both sides of this street.

Rossi's Senate and Synod was less successful than his previous Petersburg ventures. Ill and unable to supervise construction of this massive complex between St. Isaac's Cathedral and the Neva, Rossi allowed another architect to substitute for him. This personnel switch resulted in the Senate and Synod's having greater ornament and intricacy than was customary with Rossi's creations. Yet, like his other structures, it was possessed with true magnificence. The arch over Galernaia Street and the glistening semicircular colonnade at the turn of the building toward the Neva made it memorable, whatever its other failings. Planned in 1828, this Senate and Synod was the last of Rossi's works before he was forced into retirement.

Monuments reflecting martial glory consumed the energies and talents of Alexander's architects. Both Rossi's General Staff and Senate and Synod creations were in part triumphal arches faced and topped with heroic sculptures. The so-called Narva Gate, originally a wooden construction from a plan by Quarenghi, was an arch erected on the Peterhof road in 1814 to honor returning Russian troops. Between 1827 and 1833 Stasov was responsible for moving it to a new location, where it was enlarged, rebuilt of stone and brick, and lined with sheet brass. Thus, it received a monumentality that it previously lacked. Stasov was also responsible for a Doric victory arch of heavy proportions on the Moscow turnpike to commemorate Moscow's defiance of the French. Perhaps best known of Petersburg's war monuments is Montferrand's Alexander Column in Winter Palace Square. Seen with greatest effect through Rossi's General Staff Arch, this monolith of granite rests on a massive base and rises about 156 feet (fig. 9.6). That it should have been the central ornament in the midst of the great military reviews then held in the square further identifies classicism with martial pageantry in Alexandrian Russia.

Despite the scope of Moscow's building problems after 1812, planning there exhibited neither the daring nor extravagance characteristic of Petersburg. Buildings and ensembles generally were smaller in scale

and displayed greater warmth than those in Petersburg. Moscow required essentials; the measures taken to provide housing indicated as much.

The key to housing design in Moscow, as in much of Russia, was the model façade. Used sparingly early in the eighteenth century, it had become by late century an integral part of the entire classical planning and building endeavor throughout the empire. Standard designs prepared by Petersburg experts and backed by the force of law guided local builders, speeded production, reduced costs, and maintained high-quality building. When model façades combined with similarly standardized town, city, block, and plaza designs, the classical program was assured. The success and comparative speed in restoring Moscow after 1812 was traceable, in part, to this standardization.

The reconstruction of central Moscow after 1812 was on a scale quite beyond standard designs. Removal of the Neglinnaia River and of the earthen bastions built by Peter around the Kremlin and Kitai Gorod made possible an enlarged Red Square, the Aleksandrovsky Garden, and a vast Theater Square. Besides these, Cathedral *(Sobornaia)* Square within the Kremlin and Resurrection Square, which linked Red and Theater Squares, also acquired new form. The plaza chain proposed in 1775 achieved a measure of reality. Spacious squares appeared at intersections of the boulevards and radial streets after both the Boulevard and Garden Rings were completed during the 1820s and 1830s.

Classical houses, both masonry and wooden, and splendid architectural ensembles increased beyond the number standing before 1812. The English traveler William Rae Wilson observed that the city was not so bizarre as formerly: "There is something captivating in this display of Grecian and Palladian architecture intermingled among the old national structures. . . . It would not be amiss if a few of our architects were to pay a visit to the two capitals of Russia which certainly contain many structures that deserve to be more generally known than at present."[11]

The rebuilding of Moscow brought forth a new generation of architects, the most prominent of whom were Osip Ivanovich Bove, Dementii (Domenico) Ivanovich Giliardi, and Afanasii Grigor'evich Grigor'ev. They undertook both broad city planning and design of specific buildings. Bove, in particular, was involved in shaping central Moscow. His work on Red and Theater Squares, the Bol'shoi Theater, and the Manezh determined the city's character from that day until our own.

In Red Square (fig. 9.7) Bove supervised the razing of the shops along the Kremlin wall and around St. Basil's and gave a classic façade to the bazaar along the east side of the square. He embellished the façade with twin columns, which appeared to support the arcade's ar-

chivolt, and elevated the building's center. Both portico and cupola, which served no functional purpose, formed a diametrical axis with the cupola of Kazakov's Senate Building within the Kremlin across the square. In accenting the length of the building by introducing an architrave across the arcade and dividing it into three harmonious divisions, Bove remained faithful to the current architectural tenet that elegant commerical buildings should not be obscured. Work on this classical arcade was completed in 1815, and so it stood in Red Square until replaced later in the century by the Slavic Revival edifice that we know today as GUM.

Moscow's second great plaza, Theater Square, finally became a reality after 1812. Although long contemplated, the actual sculpturing of this expanse had been delayed by the meandering Neglinnaia. After the fire the Commission for Building in Moscow decided that insufficient water flow and pollution warranted enclosing the stream in an underground pipe. This was done between 1817 and 1819; shortly thereafter work on the Theater Square commenced. Theater Square (fig. 9.8) surpassed even St. Peter's and the Place de la Concorde in size. On its two long sides this square was enveloped by four low buildings, which, except for the Malyi (Little) Theater on the northeast side of the square, have been demolished. Their corners, where the streets pierced the square, were cubed, their middle floors had shallow loggias with half columns, and the lower story, a small arcade.

In designing Theater Square, Moscow architects had an unusual opportunity; they dealt with vast and hitherto unused space, thereby avoiding the need to reconcile their creations with existing ones. Bove and Andrei Alekseevich Mikhailov conceived of a monumental theater dominating the square. The height of the projected edifice—98 feet—was based on a 1:6 ratio with the square's length. By lowering all lateral wings and buildings to a uniform height, the architects balanced the plaza's horizontality against the verticality of the theater.

The Bol'shoi Theater, built between 1821 and 1825, was originally rectangular in plan and embellished in front with an eight-column Ionic portico, some fifty feet in height. Its low lateral parts were divided into three stories with plain façades except for horizontal rustication. The middle of the building was heightened and overlapped by a hip roof, beneath which a straight cornice traversed the entire building. On the main façade, this elevated portion of the corpus possessed a blank wall with a deep semicircular niche in the center. From the depths of this arch burst forth Apollo in his chariot, crowning the portico. A grand staircase, main foyer, five-tier audience hall, and stage completed the interior. When the theater burned in the 1850s, basic changes were made in its structure. The simple Ionic portico was transformed into a

more intricate façade by adding windows and pilasters to the lateral parts and rusticating the entire lower portion; all the detailed outer trim was replaced, and the hip roof was exchanged for a gable with a pediment.

The hand of Osip Bove was also involved in changing the environment along the Kremlin's west wall. There, on what had been the banks of the Neglinnaia, he set out the Aleksandrovsky Garden, called by Robert Lyall "a magnificent ornament and an elegant promenade."[12] These grounds, nearly twenty-two acres in all, took their name from the tsar, who, after visiting Moscow in 1820, determined that such a garden should be laid out; eventually three were, each of which opened in the early 1820s. An iron gate and fence bordered the garden in Resurrection *(Voskresenskaia)* Square, where a decorative paving of the walks and cobblestone streets also enhanced the entrance. Beneath the Arsenal Tower, Bove constructed a small Doric grotto that became an integral part of Moscow classicism.

Opposite the Aleksandrovsky Gardens rose the expansive Manezh, central to a new plaza. Intended by Alexander I to house and drill an infantry regiment and provide space ample enough for cavalry to exercise their mounts, it was perceived by the rest of Europe as a kind of secret Russian weapon. As a building, the Manezh was massive in scale, although quite simple in design. Conceived by Béthencourt, it was constructed by another French general, P. L. Carbonier. According to plan, it measured 545 by 147 feet. Thick walled, especially at its foundation, where the columns rested, this building was distinguished by an enveloping Doric colonnade (the walls being between the columns) and an expansive ceiling, which from within had no columnar support. Powerful, arched apertures, either windows or doors, pierced the thick walls between the columns. In 1824 and 1825 Bove added sculpture and stucco ornament to both the inside and outside of the Manezh. The martial theme in these decorations reflected the usual heroic and romantic sentiment of the era.

Opposite the Manezh, as part of the greater Resurrection Square ensemble, stood restored Moscow University. Initially designed and built by Matvei Kazakov in the 1780s, it was remarkably restored in 1817 to 1819 by the architect Dementii Giliardi. He strengthened and raised the central portico and topped it with a flat cupola. More notably, he substituted an eight-column Ionic colonnade for a Doric one with raised parapet. By removing the pilasters, the architect left the great façade expanses smooth except for columns, cubicles, and bas-relief sculptures. Giliardi's masterful restoration of the university overshadowed such elements in that classical assemblage as Grigor'ev's University Pharmacy and Evgraf Dmitrievich Tiurin's University Church at the corner of the Mokhovaia and Nikitskaia. The latter's "crown of col-

umns," a colonnaded Doric half rotunda, compositionally linked the semicircular wing of Giliardi's main building to the Manezh across the plaza. In this sense, Tiurin's work consummated this entire ensemble.

Central Moscow's radial thoroughfares, long occupied by the nobility and the wealthy, changed variously after 1812. Burned palatial mansions were replaced or reappeared in much altered form. On the Prechistenka the homes were among the most elegant in Moscow, although they differed from those designed by Bazhenov and Kazakov a generation earlier. The Seleznev mansion, supposedly the work of Grigor'ev, was perhaps the most splendid of Moscow's Empire residences. In its Prechistenka setting, it was notable for the asymmetric composition of its central structure, wings, and auxiliary buildings. The main corpus, located at the street corner, had two street façades. The one on the Prechistenka, which carried a six-column Ionic portico resting on the lower half story, acquired a monumental appearance. Conversely, the alley façade was one of greater intimacy, enhanced by a decorative portico of eight columns arranged in pairs, and a metal grille that followed the line of the verandah. A pediment, level with the roof of the first story, crowned the alley portion. The street portico contained, in place of a pediment, an open balcony with a receding mezzanine, which was covered with a two-slope roof. The garden façade engendered warmth and simplicity, both of which were accentuated by a small garden pavilion nearby.

At the other end of the radial network from the Prechistenka lay the Solianka, and on it rose a building of a different sort. This was the Adoption Council, a loan bank for financing the nearby Foundling Home, built between 1823 and 1826 by Dementii Giliardi and probably Grigor'ev. Facing the Solianka, this ensemble consisted of three two-story buildings, the main corpus and two wings. These wings, linked to the central structure by a stone wall and smaller buildings in back, approximated a square. The main section, which boasted a massive eight-column portico stretching across a bare wall, was capped by a flat cupola. Notable for its simplicity and clarity, this building rested on a rectangular base and lay latitudinally on the regulated line of the street. Steps led into the portals at the base of the massive portico, while the striking cupola enveloped the vestibule rather than the main hall. The building's plain texture was balanced by sculptures on each side of the stairway and bas-reliefs behind the columns, in the frieze, on the pediment, above the window in the cupola drum, and over the windows of the building's lateral façade. Moscow's radial thoroughfares, beginning with the Prechistenka and ending with the Solianka, exhibited the best of Moscow's classical artifacts, of which the Adoption Council was one.

Two of Moscow's most successful projects after 1812 were the

Boulevard and Garden Rings. Although the Belyi Gorod walls and gates had disappeared around 1750, it remained for the fire to clear the mushrooming structures that were an obstacle to a Boulevard Ring. Within two decades the ring and its squares became a reality. New and restored masonry houses also lined this spacious boulevard to make it an ever popular place for strolling. The Garden Ring rose on the ramparts of the Zemlianoi Gorod. After 1812 the authorities decided to replace the decayed or partially dismantled fortifications with a regulated and concentric boulevard with great plazas; however, translating ramparts and moats into such a Garden Ring proved long, arduous, and expensive. Such a spectacular enterprise involved a major financial commitment, even before the Boulevard Ring was completed. Projected for 197 feet in width, the Garden Ring required paving, lighting, cleaning, and maintenance. The economic question was finally resolved by laying streets and sidewalks that were only 69 to 82 feet wide. The remaining footage was left for residents to use for flower gardens— hence, the Garden Ring.

Demolition of the Zemlianoi Gorod fortifications in the 1820s invited construction of architectural ensembles in the cleared space. One of the most important was Vasilii Stasov's group of provision warehouses near the Krymsky rampart. The provision warehouses, so crucial for the well-being of the populace, consisted of three virtually identical buildings. The central one faced the street with its longitudinal side, the others with their latitudinal façades. Large doors, semicircular windows, and rustication enlivened their smooth walls, yet these same walls, doors, and a precisely etched frieze and cornice accentuated the buildings' mass. The Stasov warehouses exemplified a unique utilitarian application of the classic in restored Moscow.

Garden Ring mansions superbly displayed Empire elegance. Bove completed one for Prince N. S. Gagarin in 1817, and another for the Volkonskies in 1809. The latter, distinguished by a four-column Doric portico and bas-relief sculptures on its main façade, has retained its original charm amidst the bustle of the ring today. East of the expansive Hostel for Indigents (*Strannopriimyi Dom*) rose an exquisite estate house, High Hills (*Vysokïe Gory*). Backing on the Iauza River, this mansion and park of the Usachevs was the creative effort of Dementii Giliardi and Grigor'ev in 1829–30. In their work they combined the features of a town and rural estate house. Characteristically, this Empire edifice lay astride the Garden Ring rather than in the rear of the park. The architects gave to it a severe main corpus, also typical of the time. Closed, elongated, and two stories in height, the house possessed a rusticated lower story and a very plain upper one, where the windows were without jambs. An imposing eight-column portico was accentuated by a background of smooth-textured walls. Among the most pleasing aspects

of the Usachev house was its setting on the high bank of the Iauza. Giliardi planted a magnificient park, which descended toward the river by means of terraces and stone staircases. Along the axis of the main lines of trees the architect placed pavilions richly adorned with sculpture. A teahouse, resembling a toy, contained finely drawn columns that formed colonnaded porticoes, or a semirotunda, and decoration in sculpture. With such mansions as this, the ring unfolded in a certain elegance in the quarter century after the great fire.

The Garden Ring was perhaps the most extensive and visionary undertaking by Moscow planners and architects at this time. When completed, it became a delightful garden area with diverse buildings. The squares and the boulevard, more spacious than the Boulevard Ring, were less conducive to aristocratic promenades. The great breadth of the Garden Ring, with its traffic-bearing potential, looked to the future, and, like the boulevards of Paris, imposed a measure of control on the populace.

Beyond the Garden Ring the fire of 1812 had destroyed perhaps 70 percent of the buildings, most of which had been of wood. Within five years many of these had reappeared, again wooden. There were, however, some notable classical exceptions. One such exception was a triumphal arch, designed by Bove, commemorating Russia's victory over Napoleon. Placed on Moscow's main arterial highway, the Tverskaia, this arch (1827–34) gave Moscow a monumental entrance from Petersburg. Constructed of brick and faced with white stone, it was embellished with pairs of Corinthian columns on all four sides. The capitals and bases, the carved friezes and cornices, architraves, and the sculptured figures were all of cast iron. The sculptures consisted of warriors between the columns, flying glories on the sides of the arch, female figures in the background of the high parapet, and a group symbolizing Victory on a six-horse chariot crowning the entire structure. This complex, until it was removed and subsequently relocated during the Soviet period, stood in the middle of a small oval plaza and closed the perspective of the Tverskaia from Red Square.

Near the Garden Ring on the Kaluzhskaia Highway, a new City Hospital rose between 1828 and 1833. Planned by Bove, it was intended as an integral part of Kazakov's Golitsyn Hospital ensemble. Bove initially projected a main corpus with two wings embracing a central court. The wings were to have matched the central building in severity, except for a massive eight-column Ionic portico and a broad staircase. A flat cupola for the hospital chapel at the main entrance and circular hall ringed with an Ionic colonnade beneath a windowed cupola were other prominent features. Because Alexander's mother, Maria Fedorovna, was dissatisfied, the plan required numerous changes. When Bove's hospital was finally completed in the summer of 1833, it fell

short of the elegant complex that he had originally envisioned; nevertheless, it stood impressively beside Kazakov's Golitsyn on the Kaluzhskaia.

THE WANING AND CONSTANCY OF CLASSICISM IN RUSSIA

Classicism in Russian architecture, as in that of Western Europe, had run its course by the 1830s and 1840s. While in Europe an increasingly eclectic classic bowed to a more vibrant Gothic, in Russia even the Gothic was overshadowed by a not very original Russo-Byzantine revival. This tastelessness in architecture was compounded by diminution of architectural talent and a lessening of interest in city building on the part of a new tsar. Russia's future by the second third of the nineteenth century, moreover, was determined less by the aristocrat than by the new men in commerce and industry. With the rise of the entrepreneur, the beauty of both central Petersburg and Moscow became subordinated to the needs of industry, St. Isaac's notwithstanding.

There remains, however, a positive postscript for Russian classicism. Two generations after this demise of romantic classicism a notable revival occurred.[13] Classicism's reemergence in the early twentieth century, its eclipse again during the 1920s, when constructivist ideas prevailed, and its overbearing return during the late Stalin era link the architecture and planning in this century to that of the early nineteenth. Nor surprisingly, classicism revived at the beginning of the twentieth century because a sprawling and unplanned industrialism menaced central St. Petersburg. In the city where Peter I had banned wooden construction, 65 percent of the new construction in 1890 was of wood! Artists and architects like Alexander and Leontii Benois and Ivan Fomin promoted classicism as a bulwark once again against disoriented building—this time in the city's historic center. Like their predecessors a century earlier, they also believed that imperial greatness should be expressed through the monumentality of Russia's cities, large in size and rational and ordered in design.[14]

NOTES

1. "Romantic Classicism in Architecture," *Gazette des Beaux Arts* XXV (1944): 95–112; Henry-Russell Hitchcock, *Architecture: Nineteenth and Twentieth Centuries* (Baltimore, 1967); and Robin Middleton and David Watkin, *Neoclassical and Nineteenth Century Architecture* (New York, 1980). The debate

over the meaning and validity of the term Romantic Classicism is endless and highly controversial. While I have used the term, I have no wish in this essay to focus on stylistic theory; rather the stress is on classical architecture as an artifact in nineteenth-century Russia.

2. Boullée, as quoted in Emil Kaufman, *Three Revolutionary Architects: Boullée, Ledoux, and Lequeu, Transactions of the American Philosophical Society,* n.s., vol. 423, pt. 3 (Philadelphia, 1953), p. 471.

3. Pierre Lavedan, *French Architecture* (Baltimore, 1956), p. 237.

4. Ibid., p. 238.

5. See especially Hans Blumenfeld, "Russian City Planning of the Eighteenth and Early Nineteenth Centuries," *Journal of the Society of Architectural Historians* IV (1944): 22–33. Hereafter cited as *JSAH.*

6. See ibid., p. 27.

7. See Miliza Korshunova, "William Hastie in Russia," trans. Larissa Haskell, *Architectural History* XVII (1974): 14–21; and Albert J. Schmidt, "William Hastie Scottish Planner of Russian Cities," Proceedings of the American Philosophical Society CXIV, iii (1970): 226–43.

8. Hastie had proposed enlarging Red Square, creating a semicircular chain of squares enveloping the Kremlin and Kitai Gorod, and planning anew the Zemlianoi Gorod. Squares beyond the Zemlianoi Gorod, like those within, were to have served commercial, transportational, and decorative functions. Unique features of the plan were eleven squares projected where the radial highways pierced the gates of the Zemlianoi Gorod, and the emphasis placed on the area beyond the Zemlianoi Gorod. Many of the twisting streets and alleys there were given precision and proportion. Besides the eleven Zemlianoi Gorod squares, Hastie argued for fourteen more where the main arterial roads passed through the Kamer Kollegia wall. Although such extravagance did not deter Emperor Alexander (who approved the plan on September 29, 1813), it did the commission. The commission pointedly criticized Hastie's transportation scheme and rejected many of his squares on the two outer rims of the city. In fact, it regarded all fourteen squares along the Kamer Kollegia wall as superfluous. Their remoteness from the city center suggested that Hastie had emphasized decor more than utility. Squares nearer the center were similarly scrutinized and modified. In all, the commission recommended the elimination of twenty-six of Hastie's forty-seven squares; conversely, of those it allowed, most already existed and required only altering. The commission concurred with Hastie in razing the shops and filling the moat along the Kremlin wall but recommended retaining in the north end of the square the wooden buildings that defined the limits of the squares at the Resurrection Gates. It questioned the disposition of buildings around St. Basil's. Whereas Hastie had planned to open the basilica on all sides and clear the area to the river, the commission advised demolishing only those buildings adjacent to St. Basil's and those shops which encroached upon the Execution (*Lobnoe*) Place.

9. The varieties are discussed in George K. Lukomskii, *Arkhitektura russkoi provintsii* (1916).

10. *Ocherki Istorii Leningrada,* 2 vols. (Moscow, Leningrad, 1955), I, 574.

11. *Travels in Russia,* 2 vols. (London, 1828), I, 52–53.

12. *The Character of the Russians and a Detailed History of Moscow* (London 1823), p. 525.

13. For an inclusive bibliography, see S. Frederick Starr, "Writings from the 1960s on the Modernist Movement in Russia," *JSAH* XXX (1971): 172–74

especially. See also S. Frederick Starr, *Melnikov: Solo Architect in a Mass Society* (Princeton, 1978), pp. 23–30.

14. In 1916 Alexandre Benois took before the Duma a proposal "On the Question of Planned Development of the Construction of Petrograd and Its Surroundings." Initially intended to save the city's center, Benois's plan eventually embodied the entire metropolitan region. Although, unexpectedly, the Duma approved it, the action proved inconsequential because of the war. Afterwards, classicism received no sanction from the Bolsheviks; instead, the constructivists dominated the 1920s. Classicism's eclipse was, however, brief; Stalin's triumph spelled doom for experimentation. Fomin and his students were called back, this time to build monuments of steel and concrete to extoll the New Class and the proletarian state. Formal squares and soaring pseudo-classical edifices, albeit often ill-proportioned and grotesquely eclectic, reappeared. Classical architects and planners once again stamped their mark on urban Russia, especially Moscow, in the 1930s. Ivan Fialko's axial walks and Roman temples in restored Stalingrad (Volgograd) and eclectic Moscow University, unfolding in the 1950s in the midst of geometric street and garden patterns and with a classical portico, strikingly exemplified the trend. And what Soviet city today does not possess wide thoroughfares, parks, squares, and columnar edifices—both old and new? Those which survived and those recently constructed all reflect classicism's durability two centuries after Russia's initial essay in romantic classicism. See also S. Frederick Starr, "The Revival and Schism of Urban Planning in Twentieth Century Russia," in *The City in Russian History,* ed. Michael F. Hamm (Lexington, Ky., 1976), 222–42; and Kathleen Berton, *Moscow: An Architectural History* (New York, 1977), pp. 192–93.

BIBLIOGRAPHY

Arkin, D. *Zakharov i Voronikhin.* Moscow, 1953.

Beletskaia, E. A. *Arkhitekturnye Al'bomy M. F. Kazakova.* Moscow, 1956.

Beletskaia, E. A., et al. *"Obraztsovye" proekty v zhiloi zastroike russkikh gorodov xviii–xix vv.* Moscow, 1961.

Brunov, N. I., et al. *Istoriia russkoi arkhitektury.* Moscow, 1956.

Budylina, M. "Planirovka i zastroika Moskvy posle pozhara 1812 goda." *Arkhitekturnoe Nasledstvo* I (1951): 135–74.

Bunin, A. V. *Istoriia gradostroitel'nogo iskusstva.* Moscow, 1953.

Egorov, Iu. A. *Ansambl' v gradostroitel'stve SSSR.* Moscow, 1961.

Fedorov-Davydov, A. A. *Arkhitektura Moskvy posle otechestvennoi voiny 1812 goda.* Moscow, 1953.

Gol'denberg, P. I. *Staraia Moskva.* Moscow, 1947.

Grabar, I. E., et al. *Istoriia russkogo iskusstva,* VI. Moscow, 1961. VIII, i. Moscow, 1963. VIII, ii. Moscow, 1964.

Grimm, G. G. *Arkhitektor Andreian Zakharov.* Moscow, 1940.

Hamilton, George Heard. *The Art and Architecture of Russia.* Baltimore, 1954. 2d ed. 1975.

Il'in, M. *Moskva Pamiatniki arkhitektury XVIII–XIX veka.* 2 vols. Engl. text. Moscow, 1975.

Kiparisova, A. A. *Kazakov.* Moscow, 1957.

Mikhailov, A. I. *Bazhenov.* Moscow, 1951.

Nikolaev, E. V. *Klassicheskaia Moskva.* Moscow, 1975.

Oshchepkov, G. D. *Arkhitektor Tomon.* Moscow, 1950.

Petrov, A. N., et al. *Pamiatniki arkhitektury Leningrada.* Leningrad, 1953.

Piliavskii, V. I. "Gradostroitel'nye meropriiatiia i obraztsovye proekty v rossii v nachale xix veka." *Arkhitekturnaia praktika ia istoriia arkhitektury* (Leningrad, 1958): 75–108.

———. *Stasov.* Moscow, 1963.

———. *Zodchii Rossi.* Moscow, Leningrad, 1951.

Schmidt, A. J. "The Restoration of Moscow after 1812." *Slavic Review* XL (1981): 38–48.

Shkvarikov, V. *Ocherk istorii planirovki i zastroiki russkikh gorodov.* Moscow, 1954.

Snegirev, V. *Arkhitektor V. I. Bazhenov.* Moscow, 1937.

Sytin, P. V. *Istoriia planirovki i zastroiki Moskvy,* II. Moscow, 1953.

Tverskoi, A. M. *Russkoe gradostroitel'stvo do kontsa xvii veka.* Moscow, 1953.

Zombe, S. A. "Proekt plana Moskvy 1775 goda i ego gradostroitel'noe znachenie." *Ezhegodnik instituta istoriia iskusstv 1960* (Moscow, 1961): 53–96.

10

The Neoclassical Ideal
in Russian Scupture
Janet Kennedy

OF THE VARIOUS ARTS, sculpture offers the most vivid illustration of the rapid Westernization of Russian art in the course of the eighteenth century. Since images in the round traditionally were proscribed by the Orthodox church, sculpture was a relatively undeveloped art in Russia before the eighteenth century, although a limited amount of religious sculpture did exist.[1] Among the changes wrought in Russian life by Peter I was the importation of sculpture from Western Europe. Peter's Summer Garden, laid out between 1706 and 1718, was lined with allegorical figures and busts of classical heroes commissioned in Italy by Russian ambassadors. In 1720 an antique Venus that had been unearthed two years before in Rome was placed in a special gallery near the river bank.[2] Peter is credited with having imported some three hundred marble statues during his reign.

The appearance of these elegantly draped, and undraped, figures on the chilly banks of the Neva gave rise to astonishment and in some cases to scandalized comment. Even today there is something incongruous about the exposure of nude marble figures to the harsh Russian climate. It is a measure of the success of state patronage and of the academic system, which was given definitive form under Catherine II, that by the end of the century sculpture had become an integral part of Russian art. Sculpture furnished the imperial residences and enlivened the façades of St. Petersburg buildings. The sculpted portrait, grave monument, and public statute were all well-established forms. The neoclassical style that swept Europe in the last third of the century found admirable practitioners in the Russian sculptors Fedor Gordeev, Fedosii Shchedrin, Mikhail Kozlovsky, and Ivan Martos.

Nearly all prominent Russian sculptors of the end of the eighteenth and the first half of the nineteenth century were products of the

194

Academy of Arts in St. Petersburg.[3] As was the practice in European academies, all students at the Petersburg academy spent their first years of study drawing—first from engravings and then from the collection of casts that had been established at the academy in 1748.[4] Only after a student's taste had been formed through exposure to good examples of art was he allowed to work from life. Those students selected for training in sculpture proceeded toward their goal in a similar series of measured steps, first modeling simple ornamental motifs in relief, then progressing to the human figure (also in relief), and finally proceeding to sculpture in the round and to life models. Generally assignment to a particular division of the academy was at the choice of the student, unless places needed filling or other considerations intervened. Ivan Terebenev, for example, was transferred from painting to sculpture against his own wishes.[5]

A relief representing *Sculpture* (fig. 10.1) designed by Ivan Martos for the main stairway at the Academy of Arts illustrates the hierarchical method of study. The central figure, Sculpture herself, is seated with a chisel before a replica of the Belvedere torso; a fragment of the Laocoön rests on the floor. Youths and children at various stages of the sculptor's education surround her—two are drawing, one modeling in relief, and two working in the round. By proceeding in these stages, with the antique sculpture always in view, the student gradually acquired the knowledge and skill that then enabled him to work from nature while preserving a vision of ideal form. Thus, the study of antiquity was, in academic practice, a means of understanding and assimilating universal principles of form, proportion, and harmony, which the diversity of nature might obscure.

For a successful student, the culmination of academic study was a sojourn in Rome as pensioner of the academy. Rome afforded various opportunities: work with skilled craftsmen, consultation with some of the leading figures in European art, and, above all, firsthand experience of ancient art. A report made in 1773 by Arkhip Ivanov and two other Russian pensioners in Rome expressed the necessity of study from the antique in terms that would have been familiar to artists of many other nationalities when working in Rome:

> Formerly we thought, as did many others, that even without this [study from antique models] it is possible to attain perfection, having good precepts from a master and combining these with indefatigable efforts and constant study from nature. But now we see that we were very mistaken and that nature alone blinds us, being so various and containing so very much that is poor instead of that beauty which the antique so happily reveals to us in its works.[6]

Fledgling sculptors of all nationalities expressed the same feelings—
the overwhelming awe inspired by the antique and the desire to master
nature through the example provided in classical sculpture. The Swede
Johann Tobias Sergel, who arrived in Rome in 1767, realized that "it
was necessary to begin afresh, to study as a child being taught its basic
principles. . . . Antiquity in the daytime and studies from life in the
evening."[7] The Russian Mikhail Kozlovsky pursued a similar program of
life-study classes and visits to museums. He diligently visited the Vati-
can, Capitoline Museum, Barberini Palace, Borghese Gallery, and other
collections containing classical sculpture and some Renaissance and
baroque works. A journal submitted by Kozlovsky to the Academy of
Arts in 1776 details his activities in Rome.[8] While Russian sculptors
universally expressed praise for the antique, they frequently assumed an
attitude of superiority toward contemporary Italian art. Kozlovsky
noted in the concluding paragraphs of his report to the academy the
weakness of contemporary Italian sculptors if compared with the an-
tique. He remarked, too, that Rome was a "truly philosophical place"
but undermined the elevated sentiment by adding that absence of avail-
able amusements enforced this condition.

 In Europe as a whole belief in the antique as the most important
guide to artistic perfection gathered force during the last third of the
eighteenth century. Winckelmann's *Gedanken über die Nachahmung der
griescheschen Werke* appeared in 1755, followed by his *Geschichte der
Kunst des Altherthums* in 1764. Joseph-Marie Vien, director of the
French Academy in Rome between 1775 and 1781, likewise champi-
oned the cause of the antique to his students, among whom was the
painter Jacques-Louis David. In England Charles Townley and William
Weddel amassed collections of antique sculpture, and sculpture galleries
were created at great houses like Newby Hall and Syon House. In the
same years in Russia Catherine II acquired a considerable amount of
antique sculpture, some from Gavin Hamilton, the artist-dealer who
sold to Townley and Weddel. The Cavaliers' Hall at Pavlovsk, created in
1798 by Vincenzo Brenna as a reception hall for the Knights of the
Maltese Order, was conceived as a sculpture gallery housing antique
works, principally Roman sculpture of the second and third centuries
A.D., purchased by Catherine from an English collection.

 At Tsarskoe Selo and Pavlovsk Catherine was an early patron of
neoclassical architecture and sculpture. Charles Cameron decorated the
Agate Pavilion at Tsarskoe Selo with low reliefs on the exterior, while
the interior reception rooms contained sculpture by various masters and
reliefs on mythological subjects by Dominique Rachette. Although an
indifferent sculptor, Rachette, who was trained at the Copenhagen
Academy of Art, has been credited with bringing the teachings of

Winckelmann to Russia.[9] At the Pavlovsk palace Ivan Martos headed a workshop, which produced a set of four reliefs, at least two of which were closely based on antique sources known to the sculptor through engravings.[10] Paul I continued the direction of his mother's artistic interests. In the 1880s a young sculptor, Fedor Gordeev, was commissioned to make copies of the Apollo Belvedere, the Farnese Hercules, and other famous works for Pavlovsk and Tsarskoe Selo; of these the Apollo was a specific request by Paul himself.

Sculpture galleries made their appearance not only at imperial residences but at various estates, for example the Italian Pavilion at Ostankino or the Antique Hall at Arkhangelskoe, which contained works excavated at Pompeii. The decorative sculpture of this period was marked by delicacy and refinement of taste. This is visible, for example, in the reliefs commissioned from Fedor Gordeev in the 1780s for the Sheremetev estate at Ostankino. Gordeev's *Marriage of Cupid and Psyche* (fig. 10.2) has the elegance and cool purity of Wedgwood pottery. Possession of sculpture in the classical style was a badge of education, taste, and affluence; it signified membership in an international community of connoisseurs. Many works singled out for admiration by Russian patrons, for example the Farnese Hercules, were also proposed by Thomas Jefferson for an ideal sculpture gallery that he planned for Monticello around 1771.[11] In Russia a decision was made at the Academy of Arts in 1798 to make casts from antique sculpture available for sale to the public in order to disseminate "good taste."[12]

The treatises on art that appeared in Russia at the close of the eighteenth century accepted as an established fact the virtues of antique art and the greatness of the Greek people, as extolled by Winckelmann.[13] Winckelmann had cited the climate, morals, and social order of the Greeks as the conditions contributing to the greatness of their art. Russian treatises of the late eighteenth century frequently named freedom as a condition for the development of art and stressed at the same time that art reflected the grandeur of the state and the people that give it birth. According to Dmitrii Golitsyn, in a letter submitted to the Academy of Arts, despotism would inhibit the successful development of art, while enlightened monarchy would facilitate it. Following the lead of Diderot, Golitsyn and other writers argued, too, the power of art to educate and to raise the moral level of the viewer.[14]

Petr Chekalevsky's *Razsuzhdenie o svobodnykh khudozhestvakh s opisaniem nekotorykh proizvedenii Rossiskikh khudozhnikov,* published in St. Petersburg in 1792, was by the author's own admission simply a digest of foreign writings on the nature and function of art. The book contains long citations from Winckelmann—his descriptions of the Apollo Belvedere and the Laocoön. Other passages closely parallel the

articles on painting and sculpture from the *Encyclopédie* of Diderot and
D'Alembert. According to Chekalevsky, art would be greatest when
determined not by the caprices of an individual patron but by the will
of an entire nation. The fine arts in general harness the forces of beauty
in the service of truth and virtue. Nature's beauty, acting on the senses,
awakens both reason and feeling [*razum i serdtse*]. Sculpture, which is
probably the oldest of the arts, demands greater knowledge and sure-
ness than painting because of the material difficulties it presents, most
notably the impossibility of serious revision. Despite the difficulties of
the medium, Chekalevsky offers the opinion that contemporary
sculpture may have surpassed that of the ancients in refinement of taste,
an achievement made possible by the development of reason and sci-
ence in the modern age.[15]

The advent of the neoclassical style in Russia may be witnessed in the
careers of Fedosii Shchedrin (1751–1825) and Mikhail Kozlovsky
(1753–1802). Both represent a generation in uneasy transition from
the baroque tendencies of the mid-eighteenth century to a more strin-
gent classical simplicity of style. Shchedrin entered the Academy of
Arts in 1764, Kozlovsky in 1766. Both appear in academy records in
1767 enrolled in the sculpture class of Nicolas Gillet, a French sculptor
who had been brought to St. Petersburg a decade earlier. Finally, both
spent time as pensioners abroad—Shchedrin in France, Kozlovsky in
Rome. Their differing experience abroad determined the shape of their
respective careers.

Shchedrin was sent abroad in 1773, but his career as a pensioner
commenced inauspiciously. Ordered to Florence, he enrolled in the
academy there. However, he found the Florentine academy disappoint-
ing and the local collections inhospitable to young artists. Shchedrin
requested a transfer to Paris or—failing that—to Rome. As there was
no immediate reply from St. Petersburg, the young sculptor took the
advice of the Russian ambassador and proceeded to Rome, where he
was to work for nearly a year until reassigned to Paris. Shchedrin then
lingered in Paris for ten years, first as a pensioner, later supporting
himself by commissions. While in Paris he studied at the French
academy under the highly respected Christophe-Gabriel Allegrain and
received awards and recognition from the French. During this time the
free baroque style visible in Shchedrin's struggling *Marsyas* (1776,
Leningrad, Academy of Arts) gave way to the simpler and broader
forms of his *Sleeping Endymion* (1779, Leningrad, Russian Museum).

Shchedrin took this *Sleeping Endymion* back to Russia in 1785, hoping
the work would earn him the rank of academician, but it was not until
1794 that he was awarded academic rank, for his famous *Venus* (fig.
10.3). The similarity of Shchedrin's *Venus* to the *Venus Bathing* (1767,

Paris, Louvre) of his teacher Allegrain has been noted by more than one author. Although Shchedrin eliminated some of the prettiness and delicacy of Allegrain's figure, many hints of a French orientation remained in the Russian sculptor's work. His *Diana* (Leningrad, Russian Museum) or the closely related figure of the river Neva for the Grand Cascade at Peterhof possess a Gallic daintiness and charm. In later years the artist was awarded a number of public commissions: façade sculpture for Thomas de Thomon's Bourse, reliefs for the Kazan Cathedral, and the large and impressive sea nymphs supporting globes outside the central block of the Admiralty. All these sculptural groups by Shchedrin are remarkable for gracefulness of line and a harmonious union of sculpture and architecture.

The career of Mikhail Kozlovsky initially took a different course. Kozlovsky's time as a pensioner abroad was spent in Rome (1774–79). There, although he faithfully studied antique sculpture, the influence of Michelangelo was most immediately apparent in works like the Russian sculptor's *Shepherd with a Hare* (fig. 10.4). Kozlovsky's work may be compared, too, with that of his slightly older Swedish contemporary Sergel, who was in Rome during the 1770s. After leaving Rome in 1779, Kozlovsky briefly visited Paris and then, returning to Russia, he assumed a respected position in St. Petersburg art circles. Among his works are reliefs and architectural sculpture for Tsarskoe Selo, Pavlovsk, and other palaces. Kozlovsky's *Vigil of Alexander of Macedon* was singled out for attention in Chekalevsky's *Razsuzhdenie o svobodnykh khudozhesvakh* as one of the outstanding examples of Russian art.

In 1788 Kozlovsky was sent to Paris to supervise the remaining pensioners working there. Letters from Kozlovsky to the academy council drew attention to the painting of Jacques-Louis David, whom Kozlovsky cited as a desirable "example to all sculptors," although Kozlovsky's own art continued to partake of both baroque and classicizing tendencies. During his stay in France the artist witnessed the French Revolution of 1789. It has been suggested that Kozlovsky's sculpture *Polycrates* (fig. 10.5), richly baroque in form, was in some measure a response to revolutionary events, since Polycrates had been identified by Diderot as a tyrant who, knowing no measure in greed and vanity, deserved death at the hands of jealous gods.[16]

Upon his return to Russia, Kozlovsky appears to have been received with some suspicion; yet in 1794 he, like Shchedrin, received the rank of academician. Among the various commissions that occupied him in the last years of his life were the monument to Suvorov in the Field of Mars (1799–1801) and the central group of Samson and the Lion on the Grand Cascade at Peterhof. Although his art inclines toward the classical ideal, Kozlovsky, like many of his French contemporaries at

the end of the eighteenth century, defies any convenient division be-
tween neoclassicism and the baroque.

By contrast, Russian sculpture in the first decades of the nineteenth
century reveals a thorough assimilation of neoclassical ideas by the suc-
ceeding generation of artists and close contacts between Russian
sculptors and the international community in Rome. Fedor Tolstoi, Vice
President of the Academy of Arts from 1828 until his death in 1873,
exemplifies a firm commitment to neoclassicism. Even his apartments at
the Academy of Arts were decorated in Greek style. With the aid of
serf craftsmen Tolstoi constructed a rotunda with cupola, columns, and
pseudoclassical furniture—including a magnificent bed that later ap-
peared in the artist's engraving of Psyche in her bedchamber.

Of aristocratic background, friendly with the Decembrists and close
to Pushkin, Zhukovsky, and other prominent figures in the arts, Tolstoi
was among the most learned and influential artists of his day. His med-
als of the Napoleonic Wars earned him international repute. One of
these, severely simple and expressive in design, represents the Triple
Alliance (fig. 10.6), conceived as a group of classical warriors joining
their raised arms in an oath. In his writings Tolstoi advocated the study
of Greek history and archeology so as to achieve verisimilitude in ren-
dering armor, clothing, and other detail. To Tolstoi the decorative fan-
tasies of rococo art were artificial or unnatural by contrast with the clar-
ity and intelligibility of the classical style. He argued for elimination of
excess ornament, that is, the overload of decorative motifs like cupids
and garlands, from medals and relief sculpture. Indeed, Tolstoi consid-
ered it desirable that an observer be able to understand the identity and
significance of the figures on a medal without recourse to explanatory
inscriptions.[17]

In a similar vein of classical austerity, Samuil Galberg, who spent
1819 to 1821 in Rome as an academic pensioner, condemned the Ital-
ian sculptor Antonio Canova for producing work that was too much like
a life study, full of mistakes derived from virtuoso imitation of nature.
This opinion was shared by Winckelmann and by Quatremère de
Quincy, who praised Canova's *Theseus* (1804–19, Vienna, Kunsthis-
torisches Museum) precisely because it represented a conversion from
the vulgarity of the artist's earlier work to the simplicity of the *beau
idéal*.[18] Among contemporaries Galberg praised the Danish sculptor
Berthel Thorvaldsen for the clarity, simplicity, and relieflike qualities of
his sculpture—closer, Galberg claimed, to the antique ideal than was
Canova's illusionistic treatment of marble. While Galberg's own
sculpture has these same properties of clarity and simplicity, the slightly
younger Russian sculptor Boris Orlovsky felt the influence of Thor-
valdsen even more directly. During his years as a pensioner in Rome

(1822–29), Orlovsky worked in Thorvaldsen's studio, and later the two men carried on an extensive correspondence. Orlovsky's *Paris* (fig. 10.7) closely approximates the deliberate simplicity and impersonality of Thorvaldsen's *Ganymede* (1804, Copenhagen, Thorvaldsens Museum). These beautiful standing youths represent the neoclassical ideal at its purest.

That sculpture should manifest dignity, simplicity, and stillness was maintained by Galberg in a dispute with his patron, Prince I. A. Gagarin, over the appropriate pose for a *Faun Hearing the Sound of a Reed Flute* (1824, Leningrad, Russian Museum). Gagarin had suggested that the faun be shown drawing back in surprise from the first notes. Galberg objected that an effect of movement would be inappropriate and that a "middle" pose of quiet attention would be more "statuesque."[19] The simplicity thought to be a natural property of sculpture was urged on all the arts by Galberg's contemporary, the sculptor Mikhail Krylov: "Painting, confounded and gazing with envy on the successes of sculpture, shamed by its advantages . . . demanded to replace the artificial style with a natural one whose principal quality is simplicity."[20] In this statement, Krylov, like Fedor Tolstoi, claimed simplicity as the hallmark of naturalness, as opposed to the decorative excess of rococo.

While a certain degree of native talent and manual dexterity was deemed necessary for the sculptor, training and discipline were considered more important. Perfection could be attained through an education founded on universally valid principles, that is, through systematic study of both nature and the antique. The sculptor was expected to subordinate his personality to the ideal. Galberg praised Thorvaldsen's sculpture for the effacement of the artist's personality. Boris Orlovsky informed one of his students that he had achieved his own success "through labor and effort, not possessing any unusual talent."[21] The instructions received by Galberg from the academy before he set off for Rome recommended an attitude of humility. Not only was the young sculptor enjoined to comport himself in such a way as to bring credit on all Russians, but he was also advised to "bear always in mind that modesty in the judgment of one's own capabilities and a proper respect for the talents of other artists is an appurtenance of outstanding gifts and inextricably bound up with true genius."[22]

The career of Ivan Martos (1754–1835) deserves special examination since it spans the rise and assimilation of neoclassicism in Russia. Martos was a major figure in the first generation of classicism, yet by the time of his death there had been significant challenge to the neoclassical ideal. Martos entered the Academy of Arts at the age of ten, at which time instruction in sculpture was under the direction of Nicolas Gillet. During the years Martos was a student, the rococo naturalism of Gillet's

style began, however, to pass out of favor, while ancient sculpture became the preferred model. In 1769 the collection of casts at the academy was enlarged, at the initiative of I. I. Shuvalov, and given a more prominent role in the curriculum. In the same year a number of academic pensioners studying in France were transferred to Rome and placed under the guidance of Shuvalov and of the antiquarian and dilettante Johann Friedrich Reiffenstein, who was, like Shuvalov, an admirer of Winckelmann.[23] Martos spent five years in Rome (1774–79) as pensioner of the Academy of Arts. During this time he made use, in his own words, "of the advice of several French pensioners and other good artists who show me this [service] out of friendship."[24] Among those whom Martos encountered in Rome were Pompeo Battoni, who directed the nature class of the Capitoline Academy, Carlo Albacini, a connoisseur and restorer of antique sculpture, Anton Raphael Mengs, the eminent neoclassical painter, Joseph-Marie Vien, director of the French Academy in Rome (Vien expressed admiration for Martos's work), and Berthel Thorwaldsen, in whose studio Martos worked for a time.

During his lifetime, however, Martos was more often compared to Canova than to Thorwaldsen; he was even nicknamed "the Russian Canova." This reputation persisted to the end of the nineteenth century, when Martos was cited in Mrs. Julia A. Shedd's *Famous Sculptors and Sculpture* as an artist whose "works are marked by nobleness of conception and life-like expression. . . . In the treatment of drapery he is regarded as superior even to Canova."[25] Although the surfaces of Martos's sculpture are generally less seductive than Canova's, the delicate linear quality of his work justifies the comparison.

Upon his return to Russia in 1779 Martos was appointed a professor at the Academy of Arts, a post he held until his death in 1835. He also had a hand in the creation of sculptural decoration for Tsarskoe Selo, working in concert with Charles Cameron. For the imperial family and for various aristocratic patrons, Martos did a large number of portrait busts and grave monuments in a classical style. In contrast to the liveliness and naturalism of portraits by Fedor Shubin, the most eminent portrait sculptor of the mid-eighteenth century in Russia, Martos presented his sitters, for example N. I. Panin and wife (1780, Moscow, Tretiakov Gallery), in the sober guise of Roman patricians.[26]

Among Martos's grave monuments, one of the most beautiful is that for M. P. Sobakina (fig. 10.8). A flattened pyramid in delicate low relief bears a portrait medallion of the deceased, and below that two allegorical figures, a mourning woman and a winged genius with an extinguished torch, flank a rose-strewn sarcophagus. In refinement of both composition and execution, this work may be favorably compared with

the European works in Russian collections—for example, Augustin Pajou's relief *Princess of Hesse-Homberg as Minerva* (1761) in the collection of Catherine II—or with Jean-Antoine Houdon's tombs for two members of the Golitsyn family in the Donskoi Monastery, Moscow (1774).

In the first decade of the nineteenth century Martos received a number of important public commissions. Most prominent of these was the monument to Minin and Pozharsky (fig. 10.9), heroes of the defense of Moscow against the Poles in 1612. The idea for the monument originated in 1803 with the Free Society of Lovers of Literature, Sciences, and the Arts. Martos enthusiastically began work on sketches and models, although the commission was not formally awarded him until 1809. According to a contemporary observer, Martos undertook the sculpture aware of the Greek and Roman custom of erecting statues to heroes, but he believed that Minin and Pozharsky had even surpassed the ancient heroes in stature.[27] This emphatic patriotism pervades much of the contemporary comment on the monument.

The costume and hairstyles of the two figures conceived by Martos represent a subtle blend of classical prototypes with discreetly deployed Russian details, such as the embroidery of the tunics. In the case of Minin, the source for the vigorously modeled head is an antique Jupiter, a copy of which appears at the far right in Martos's relief on the art of Sculpture (fig. 10.1). The hairstyle, however, has been adjusted to resemble a Russian type. Minin, although not Pozharsky, wears trousers, which in classical art appeared only in works representing Scythians or other barbarian peoples. In an early model for the monument Pozharsky had a dramatically billowing cloak, and both figures gesticulated more freely. In the final version the billowing cloak disappeared and Minin's figure was given a new degree of prominence, apparently to emphasize the role played by Minin, the "Russian Plebeian," as opposed to the warrior-noble Pozharsky.[28] The monument was finally erected in Red Square in 1818, following the defeat of Napoleon. The dedication was attended by large crowds, who swarmed to the roof of the Gostinnyi Dvor and climbed the Kremlin towers in order to watch the ceremony.

Despite its enthusiastic reception, the monument did provoke some mildly satiric commentary. A popular print (fig. 10.10) shows members of different social classes gathered in front of it. Examining the enormous bulging figures, one of the lower-class men naïvely remarks on their size under the impression that the heroes themselves were equally enormous. His friend assures him that they were deliberately made larger than life "to show their great courage and great love for the Fatherland."

While work on the monument to Minin and Pozharsky was in progress, Martos was forced to defend some of his other works from attack. In a letter written in 1813 to Petr Chekalevsky, Vice President of the Academy of Arts, Martos attempted to refute critics who objected that the proposed classical poses and near nudity of his sculpted evangelists for the Kazan Cathedral were not appropriate to the religious subject.[29] Martos marshaled various arguments concerning the symbolic importance of nudity in both pagan and Christian art and also appealed to a patriotic motive. He cited the extraordinary nature of recent events in Russia as the inspiration for a new, heroic style. In keeping with this heroic ideal, Martos based the attitudes and anatomy of the four evangelists on Michelangelo's sculpture. He defended the nudity of his figures as more timeless than any possible clothing and as more worthy of the sculptor's art. To depict the human body, the supreme accomplishment of nature, "woven by God's fingers," was a task that surpassed in Martos's view the cold craftsmanship involved in sculpting drapery.

Not only did Martos defend the neoclassical ideal of sculptural beauty; he also held strongly the view that sculpture was a public art with a duty to inspire action and heroism. In writing about his works for the Kazan Cathedral—the evangelists and reliefs on Old Testament subjects—Martos explained that:

> By means of his artifice he [the sculptor] has the opportunity to converse with all viewers in a secret hieroglyphic language reminding them of the circumstances, times, and persons contributing to the sculpture of a particular object. He has the exclusive right . . . not to dreamy, but to elevated ideas. . . . Through difficult bends of the human body the previously difficult situation of the beloved fatherland in the present war can be conveyed . . . and finally, in the general and harmonious composition of my groups every zealous Russian can with especial pleasure understand the expression of a decisive union of classes [*soiuz gosudarstvennykh soslovii*] manifesting an unshakable firmness.[30]

The severe and heroic side of neoclassicism was most clearly revealed in works by artists like Tolstoi, Galberg, Orlovsky, and Martos. The functions of sculpture in this period were not, however, limited to the heroic ideal. There was, in addition, a more graceful and decorative side to the neoclassical style. Often the distinction between sculpture and the decorative arts was not clearly marked—for example, the graceful union of sculpture and architecture occuring in the caryatids, garden statuary, and sculpture-filled niches of various palaces and estates. In addition to the noble emotions singled out in theoretical discussions, there was a more sentimental side to early nineteenth-century sculpture. This is exemplified in Petr Sokolov's *Milkmaid with a Broken Jug* (1807) for the park at Tsarskoe Selo. This sculpture was the subject

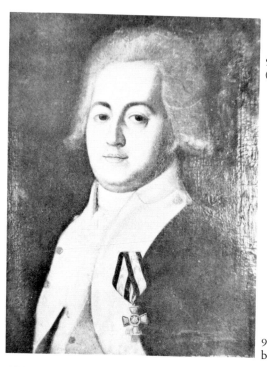

9.1 Thomas de Thomon
(1750s–1813)

9.2 Tver (now Kalinin) at the
beginning of the twentieth century

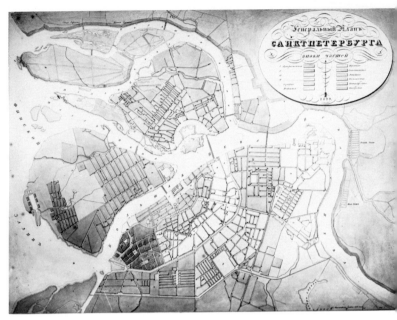

9.3 Map of St. Petersburg, 1829

9.4 Moscow Kremlin Embankment about 1825

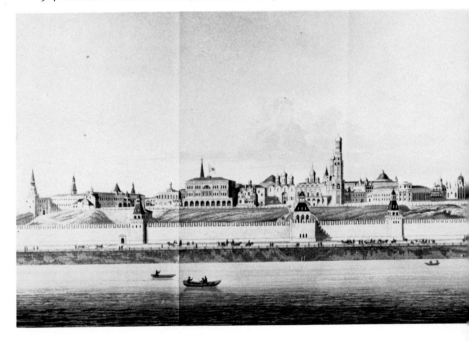

9.5 Karl Ivanovich Rossi
(1755–1849)

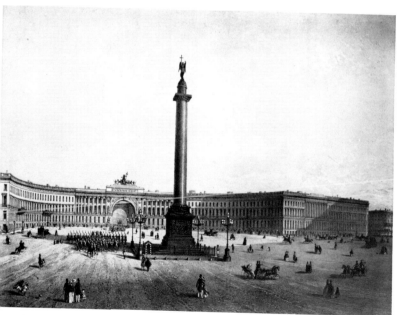

9.6 The Alexander Column (Montferrand) and General Staff Arch (Rossi)

9.7 Red Square after the Fire of 1812

9.8 Bolshoi Theater (Osip Bove and A. A. Mikhailov)

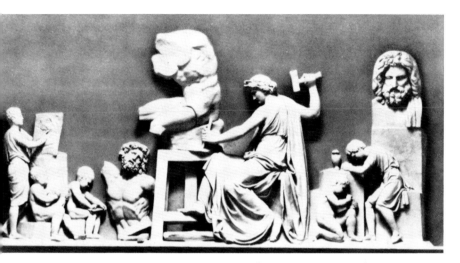

10.1 Ivan Martos, *Sculpture*

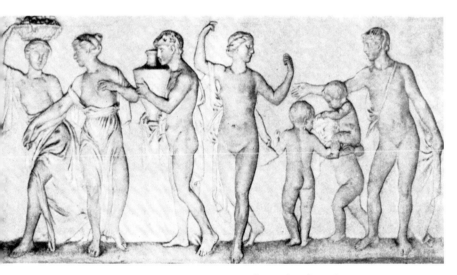

10.2 Fedor Gordeev, *Marriage of Cupid and Psyche*

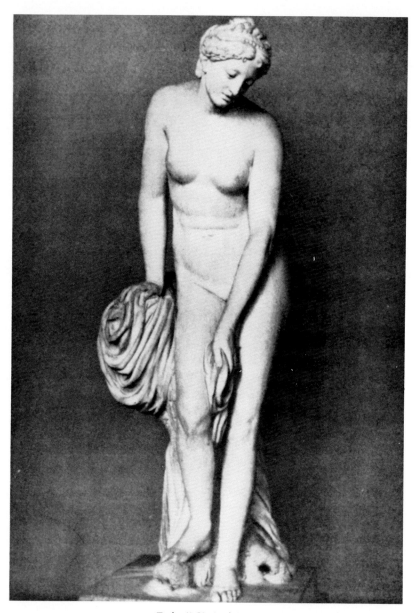

10.3 Fedosii Shchedrin, *Venus*

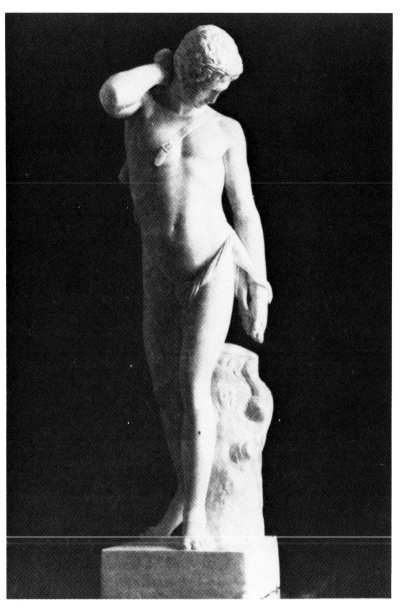

10.4 Mikhail Kozlovsky, *Shepherd with a Hare*

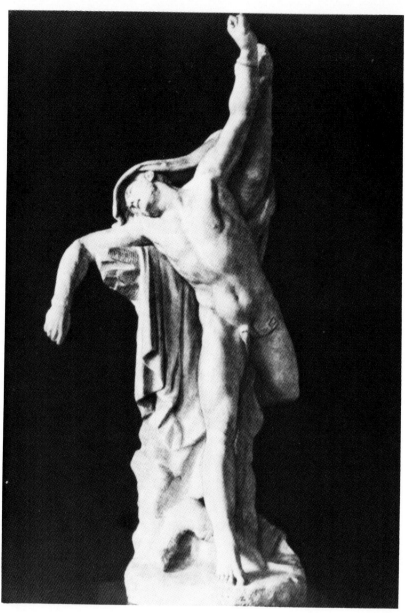

10.5 Mikhail Kozlovsky, *Polycrates*

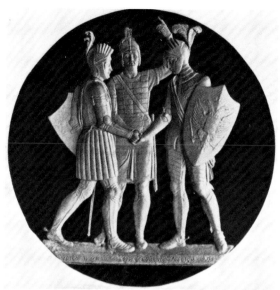

10.6 Fedor Tolstoi, *Triple Alliance*

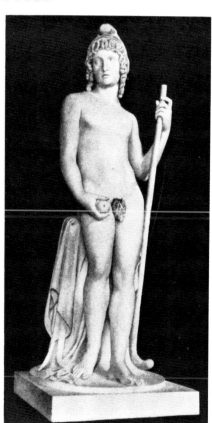

10.7 Boris Orlovsky, *Paris*

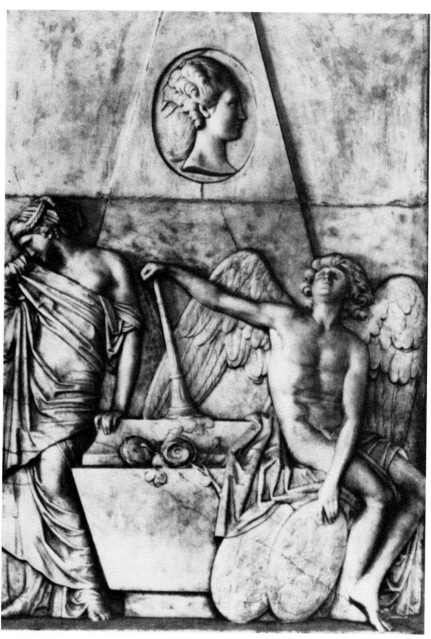

10.8 Ivan Martos, *Grave Monument for M. P. Sobakina*

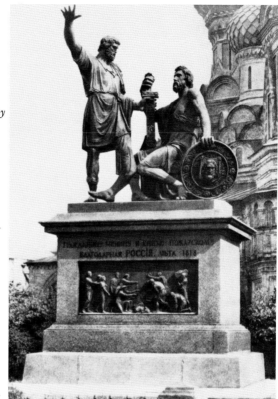

0.9 Ivan Martos,
Monument to Minin and Pozharsky

10.10 Russian popular print

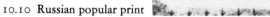

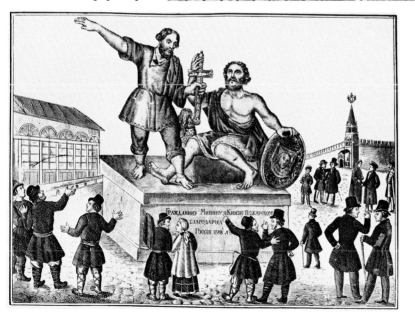

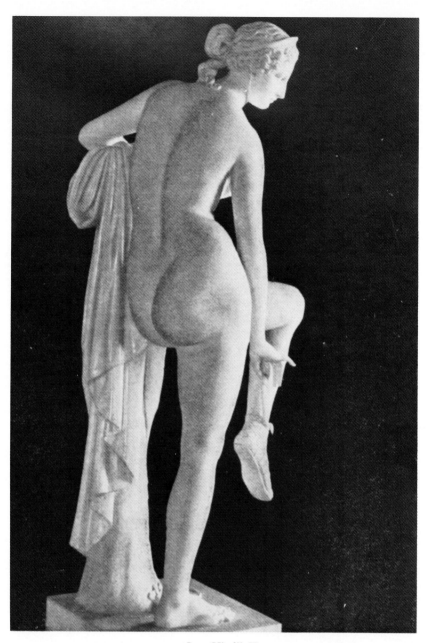

10.11 Ivan Vitalii, *Venus*

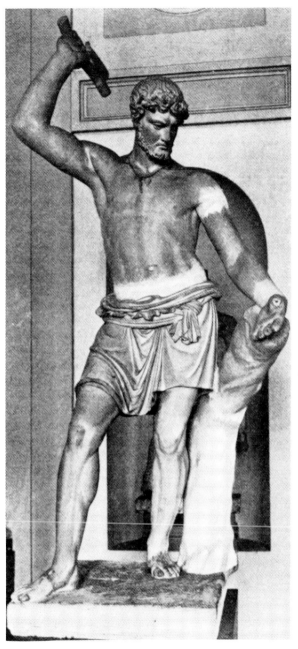

10.12 Vasilii Demut-Malinovsky, *Russian Scaevola*

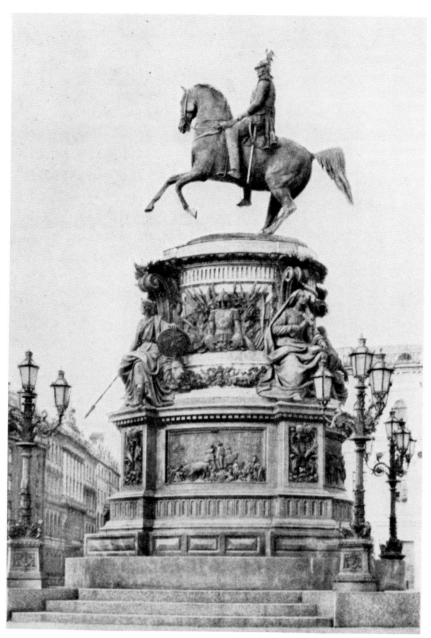

10.13 Petr Klodt, *Monument to Nicholas I*

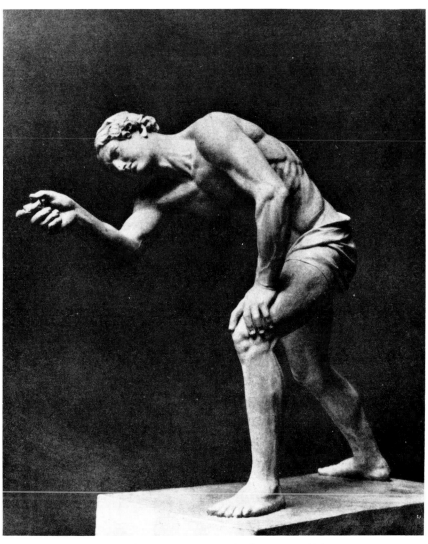

10.14 Nikolai Pimenov, *Youth Playing Knucklebones*

10.15 Nikolai Pimenov, *Boy Asking Alms*

of a poem by Alexander Pushkin, later set to music by Cesar Cui: "The maiden sits sadly holding the jug in vain. / A miracle! The water does not cease to pour from the broken urn. / Forever, the maiden sadly sits above the endless stream."

By the 1830s qualities of gracefulness and charm were more pronounced than in the earlier phases of neoclassicism. The *Venus* of Ivan Vitalii (fig. 10.11) is more openly sensuous in its appeal than Shchedrin's *Venus* from 1792. During this period children appeared frequently as subjects: Nikolai Pimenov's *Boy Asking Alms,* Petr Stavasser's *Boy Fishing* (1839, Leningrad, Russian Museum), or Fedor Kamensky's *Young Sculptor* (1866, Leningrad, Russian Museum). Finally, in certain works around mid-century a cloying degree of prettiness emerges, for example in Konstantin Klimchenko's *Girl with Mirror* (1840s, Leningrad, Russian Museum).

The heroic aspect of sculpture was, on the other hand, emphatically maintained in monumental sculpture. A motif already depicted in a popular print by Ivan Terebenev, the "Russian Scaevola" (cf. Bowlt, fig. 12.2), took on an uncompromisingly heroic form when interpreted in sculpture by Demut-Malinovsky. Although the figure is provided with a Russian ax and an Orthodox cross, the nudity and the contrapposto pose of the sculptural version of the *Russian Scaevola* (fig. 10.12) are entirely classical in type. This work, which earned its author the rank of professor, is one of a number in the same period, for example Martos's *Minin and Pozharsky* and Vitalii's relief of the *Liberation of Moscow* (1829–30) for Osip Bove's Triumphal Gates, which accommodated specifically Russian details within a classical context.

At mid-century a new degree of naturalism appeared. This is visible in Petr Klodt's memorial to I. A. Krylov (1848–55) in the Summer Garden in St. Petersburg. The figure, cast in bronze, wears a nineteenth-century suit and is comfortably seated in an armchair. Indeed, with Klodt the neoclassical concept of form has largely lost its sway. Klodt's equestrian monument to Nicholas I (fig. 10.13) represents the tsar not as a classical warrior but in the uniform of the Russian guard. The horse is modeled with the anatomical fidelity for which the sculptor was renowned, and in the narrative reliefs on the base of the monument, frock-coated figures celebrate the opening of the Petersburg-Moscow railway and other contemporary events, which are presented with a minimum of mythological or allegorical embellishment.

The monument to Nicholas I illustrates official taste, since Alexander II transmitted personal instructions and criticism to the artist through the council of the Academy of Arts. The first sketch of the monument, with a standing horse, was rejected as too pedestrian (perhaps the example of Klodt's much-admired rearing horses for the Anichkov

Bridge was still fresh in the emperor's mind). Alexander remained dis-
satisfied even with the next-to-last variant and directed certain altera-
tions: "to change the gait of the horse from left leg to right, to make the
plume on the helmet smaller, to place the helmet farther back on the
head, to make the boots softer, the epaulets and right sleeve fuller."[31]

An interest in national subject matter was also gathering force. This
occurred most strikingly in the 1830s, when three sculptors, Nikolai
Pimenov, Alexander Loganovsky, and Anton Ivanov, each exhibited a
work representing a youth playing a Russian game. Pimenov and
Loganovsky, both students at the Academy of Arts, exhibited together
in 1836. The latter's *Boy Playing Nail and Ring* (Leningrad, Russian
Museum) is closely based, in its pose and its anatomical detail, on the
Borghese Warrior, an important Hellenistic work of which there was a
cast in the academy collection.[32] In spite of the obvious derivation of
Loganovsky's figure and Pimenov's *Youth Playing Knucklebones* (fig.
10.14) from classical athletes and warriors, the impact of the Russian
subjects was sufficient to move Alexander Pushkin, visiting the exhibi-
tion, to exclaim: "Thank Heaven, finally even sculpture in Russia has
become native [*narodnaia*]," and to compose a brief poem on each of
the two works. Further, both Pimenov and Loganovsky received large
gold medals for their pieces, an unusual doubling of the award. The
popularity of the new subject matter is also attested by the fact that in
1838 copies of the two works, in cast iron, were placed outside the
Alexander Palace at Tsarskoe Selo.[33]

Nikolai Pimenov's career offers an illustration of various tendencies
that prevailed around the middle of the century: nationalism, natu-
ralism, and also renewed interest in Byzantine art. Son of the well-
known academic sculptor Stepan Pimenov, Pimenov the younger, as he
was called, entered the Academy of Arts in 1825. After studying in the
studio of Galberg and earning a gold medal for *Youth Playing
Knucklebones,* he spent the years 1837 to 1850 abroad, mostly in Italy.
In Rome Pimenov's *Boy Asking Alms* (fig. 10.15) attracted the favorable
attention of the painter Alexander Ivanov and, dispatched to St.
Petersburg, earned him the rank of academician.

Among other works of Pimenov's Roman period is a small statue of a
young man (1844, Leningrad, Russian Museum), probably a portrait of
a fellow artist. The seated figure has almost nothing classical about it. It
is clad in trousers and coat, nonchalant in pose. Even the base is not the
conventional plinth but is scored to represent a floor. This burgeoning
naturalism bore only minor fruit in Pimenov's own art, but Pimenov
became the teacher of two younger artists, Matvei Chizhov and Mark
Antokolsky, who introduced a strong realist tendency into Russian
sculpture.

Pimenov also received a number of commissions for religious sculpture. Works like his *Triumph over the Waters* and *St. George* (1854–55) are part of a general revival of Byzantine iconography and compositional types. In 1859, during one of the periodic reorganizations of the Academy of Arts, a division of Byzantine art was established in order to serve the needs of the church building campaigns initiated under Nicholas I, in particular the colossal St. Isaac's Cathedral. Thus, by the middle of the century, both an increasing naturalism and the demands of religious art had thoroughly undermined the preeminence of the neoclassical style.

Further, with the rise of romanticism, sculpture gradually lost the central place that it had occupied among the arts. For the academic theoretician at the end of the eighteenth century, sculpture, as the most perfect achievement of ancient art, played a major role in the artist's education. Sculpture was believed to demand the utmost degree of discipline and skill, even surpassing painting in this respect. While the sculpture division of the Academy of Arts lost students in the 1830s, it was still a powerful force within the academy, fighting to maintain the predominance of traditional academic principles.[34] Yet comparisons between the arts made by literary figures writing in the 1820s and 1830s, reveal that sculpture had lost its central position. According to the poet Dmitrii Venevitinov, writing in 1827, sculpture could claim an honorable place as the oldest of all the arts; sculpture was as fundamental to art as mountains and valleys are to nature. However, for Venevitinov sculpture lacked the sense of life and movement that may be successfully conveyed in painting and music.

Gogol's essay "Sculpture, Painting, Music" (1831) characterized sculpture as the perfect reflection of the pagan ideal but an unsuitable art form for a Christian people. Sculpture could not provide "those mysterious, limitless sensations which awaken endless reverie." Nikolai Stankevich in "Three Artists" entirely omitted sculpture from consideration. The favored arts were poetry, painting, and music. The sensations conveyed by each are those unattainable by sculpture: a sunset, a face in shadow, a distant castle—all these experiences produce an inexpressible emotion that brings tears to the eyes of the three brother artists of the essay.[35] In the romantic period there was little sympathy for an art predicated on diligence, restraint, and imitation of the past. The most drastic condemnation of sculpture was pronounced by the French poet Charles Baudelaire in his essay "Why Sculpture is Boring" *(Salon of 1846)*. To Baudelaire, sculpture suffered not only from its burden of classicizing conventions but from the excessive literalness demanded by its brute three-dimensional material.

The changes that took place in Russian sculpture in the course of the

nineteenth century paralleled those which occurred in painting, although sculpture remained on the whole more closely bound to past models than did painting—a situation that prevailed in Western Europe as well. Yet as one passes in review Russian sculpture of the late eighteenth and early nineteenth centuries, a considerable diversity does emerge, in spite of the rigid boundaries within which the artists operated. Few could deny the beauty of the grave monuments by Ivan Martos or the grandeur of the Alexander Column with its triumphant angel by Boris Orlovsky. Perhaps the most appealing aspect of sculpture in this period is its integration into a natural or architectural setting. Sculpture provided a focal point in urban spaces and, as the poetry of Pushkin attests, a human presence and an opportunity for reflection in the wooded parks of Pavlovsk and Tsarskoe Selo. As part of these settings neoclassical sculpture remains a vital feature of the Russian landscape.

NOTES

1. See N.E. Mneva et al., "Rez'ba i skul'ptura XVII veka," in *Istoriia russkogo iskusstva,* ed. Igor Grabar' et al., 13 vols. (Moscow, 1953–68), 4: 305–42. Also N. Vrangel', *Istoriia skul'ptury,* in the incomplete *Istoriia russkogo iskusstva,* ed. Igor Grabar' (Moscow, 1909–13), 5: 9–36 (hereafter cited as Vrangel', *Istoriia skul'ptury*).

2. The so-called Tauride Venus was presented by Catherine II to Grigorii Potemkin and is now in the Hermitage. The statue was originally purchased by Iurii Kologrivov, supervisor of a group of Russian artists in Rome. Because of the prohibition on export of antiquities imposed by Pope Clement XI, Kologrivov had to appeal to Peter, who arranged to exchange the remains of St. Birgitta for the Venus: Iu. G. Shapiro, *Ermitazh i ego shedevry* (Leningrad, 1973), pp. 35–37. On the Summer Garden and Peter's importation of sculpture, see G. M. Presnov, "Skul'ptura pervoi poloviny XVIII veka," *Istoriia russkogo iskusstva,* 5: 438–39.

3. A few sculptors like Ivan Vitalii received their training by working for the stonecutting firm of Augustin Triskorni in Moscow and by assisting established artists on public monuments. However, the more ambitious of these went on to study at the Academy of Arts.

4. Diderot, on a visit to the Russian Academy in 1773, remarked on the absence of a large-scale anatomical model but praised the collection of casts. N. Moleva and E. Beliutin, *Pedagogicheskaia sistema Akademii Khudozestv XVIII veka* (Moscow, 1956), pp. 296–324. See p. 388, n. 12 for a list of the casts in the academy collection.

5. A. L. Kaganovich and V. M. Rogachevskii, "Skul'pturnyi klass Akademii Khudozhestv v XVIII veke," in *Akademiia Khudozhestv SSSR. Voprosy*

khudozhestvennogo obrazovaniia, Vypusk VI (Leningrad, 1973), pp. 39–68. Vypusk VII (1973) and VIII (1974) contain articles by the same authors on the sculpture class in the nineteenth century.

6. *Mastera iskusstva ob iskusstve,* ed. A. A. Guber, A. A. Fedorov-Davydov, et al., 7 vols. (Moscow, 1970), 6: 111.

7. Dyveke Helsted, "Sergel and Thorvaldsen," in *The Age of Neo-Classicism,* ex. cat. (The Royal Academy and The Victoria & Albert Museum, London, 1972), p. lxxxiv.

8. *Mastera iskusstva ob iskusstve,* 6:98–101.

9. Vrangel', *Istoriia skul'ptury,* p. 134. Rachette received his training at the Copenhagen Academy and later in Paris under Vien. He was invited to Russia in 1779 and eventually became a professor at the Academy of Arts.

10. E. V. Korolev, "Chetyre barel'efa raboty I. P. Martosa i ego masterskoi v pavlovskom dvortse," in *Pamiatniki kul'tury: Novye otkrytiia. Ezhegodnik 1978* (Leningrad, 1979), pp. 347–54.

11. Seymour Howard, "Thomas Jefferson's Art Gallery for Monticello," *Art Bulletin* 59 (1977): 583–99.

12. Kaganovich and Rogachevskii, "Skul'pturnyi klass Akademii Khudozhestv v XVIII veke," p. 61.

13. I. F. Uranov, *Kratkoe rukovodstvo k poznaniiu risovaniia i zhivopisi istoricheskogo roda, osnovannoe na umozrenii i opytakh* (St. Petersburg, 1973); P. P. Chekalevskii, *Razsuzhdenie o svobodnykh khudozhestvakh* (St. Petersburg, 1789). Perhaps the frankest acknowledgment of the authority of the antique was Anton Losenko's "Obiasneniie kratkoe proportsii cheloveka, obosnovannoe na dostovernom issledovanii raznykh proportsii drevnikh statui," which advocated the measurement of antique sculpture in order to arrive at a perfect standard of proportion for the human body.

14. Moleva and Beliutin, *Pedagogicheskaia sistema Akademii Khudozhestv XVIII veka,* p. 72. As an acquaintance of Diderot's, Golitsyn not surprisingly placed major emphasis on the study of nature as well as the antique.

15. For specific comments on the art of sculpture, including a list of the best classical examples, see Chekalevskii, *Razsuzhdenie,* pp. 39–60.

16. V. N. Petrov, "M. I. Kozlovskii," in *Istoriia russkogo iskusstva,* 6: 421.

17. After exhibition of the series of twenty medals, Tolstoi was elected to all the major academies of Western Europe. An offer from the British crown to purchase the medals (with supplementary designs depicting England's role) was refused by the artist: Elena Mroz, *Fedor Petrovich Tolstoi* (Moscow-Leningrad, 1946), and E. V. Kuznetsova, *Fedor Petrovich Tolstoi* (Moscow, 1977). For Tolstoi's opinions on art, see *Mastera iskusstva ob iskusstve,* 6: 217–21, and N. Moleva and E. Beliutin, *Russkaia khudozhestvennaia shkola pervoi poloviny XIX veka* (Moscow, 1963), p. 163.

18. Gérard Hubert, "Early Neo-Classical Sculpture in France and Italy," in *The Age of Neo-Classicism,* p. lxxxii.

19. *Skul'ptor S. I. Galberg v ego zagranichnykh pismakh i zapiskakh 1818–28,* ed. V. Eval'd (St. Petersburg, 1884), pp. 146–47. Galberg's "quiet" conception of the faun may have been inspired, at least in part, by the Italian sculptor Pietro Tenerani's *Faun Sounding a Pipe* (1823). Galberg knew and admired Tenerani's *Psyche Abandoned,* having singled this out as the only worthwhile thing at an exhibition of sculpture in Rome in the summer of 1818 (Ibid., p. 97). Tenerani's *Faun* is illustrated in Oreste Raggi, *Pietro Tenerani* (Florence, 1880).

20. Moleva and Beliutin, *Russkaia khudozhestvennaia shkola*, p. 144.

21. *Russkoe iskusstvo; Ocherki o zhizni i tvorchestve khudozhnikov pervoi poloviny XIX veka*, ed. A. I. Leonov (Moscow, 1954), p. 380 (hereafter cited as *Ocherki*).

22. Elena Mroz, *Samuil Ivanovich Gal'berg* (Moscow-Leningrad, 1948), p. 4.

23. J. F. Reiffenstein (1719–1793) was an antiquarian and a dilettante in various fields of art. He served both the Russian and Saxon courts as privy councillor supervising artist-pensioners studying in Rome.

24. Vrangel', *Istoriia skul'ptury*, p. 162. Joseph-Marie Vien, director of the French Academy in Rome, had a considerable reputation and was extended an invitation to come to Russia. Vien's most famous pupil, Jacques-Louis David, was in Rome concurrently with Martos. On the French Academy under Vien, see Henry Lapauze, *Histoire de l'Académie de France a Rome*, 2 vols, (Paris, 1924), 1: 348–81.

25. Mrs. Julia A. Shedd, *Famous Sculptors and Sculpture*, rev. ed. (Boston–New York, 1886), p. 227.

26. Shubin did, upon occasion, adopt a more classicizing form for his busts, for example in his portrait of F. N. Golitsyn from the 1770s, but without the impression of weight and massiveness that characterizes Martos's portraits of the Panins.

27. H. Storch, *Russland unter Alexander dem Ersten* (St. Petersburg, 1805), 5, pt. 8: 142–43. The section concerning Martos first appeared in serial form in October 1804. Cited by N. N. Kovalenskaia, T. V. Alekseeva, and V. N. Petrov, "I. P. Martos," in *Istoriia russkogo iskusstva*, 8, pt. 1: 300.

28. A distinction between the roles of Minin and Pozharsky was made by Semon Bobrov in 1806 in the periodical *Litsei*, published by the Free Society of Lovers of Literature, Sciences, and the Arts: see Kovalenskaia, Alekseeva, and Petrov, "I. P. Martos," p. 302.

29. *Mastera iskusstva ob iskusstve*, 6: 175–79.

30. Ibid., p. 178.

31. *Ocherki*, p. 469.

32. A drawing from this cast by A. P. Briullov in 1812 is illustrated by Moleva and Beliutin, *Russkaia khudozhestvennaia shkola*, plate 3.

33. *Ocherki*, pp. 441–42.

34. Moleva and Beliutin, *Russkaia khudozhestvennaia shkola*, p. 296.

35. D. Venevitinov, "Skul'ptura, zhivopis' i muzyka," in *Polnoe sobranie sochinenii* (Moscow-Leningrad, 1934), pp. 127–30. N. V. Gogol', "Skul'ptura, zhivopis' i muzyka," *Polnoe sobranie sochinenii*, 11 vols. (Leningrad, 1952), 8: 9–12. N. Stankevich, "Tri khudozhnika," in *Stikhotvoreniia, tragediia, proza* (Moscow, 1890), pp. 174–75. The existence of these essays was brought to my attention by James Billington's *The Icon and the Axe: An Interpretive History of Russian Culture* (New York, 1966).

11

A Survey of Trends in the Russian Decorative Arts of the First Half of the Nineteenth Century

Paul Schaffer

THE RUSSIAN decorative arts produced in the first half of the nineteenth century are often of higher quality than similar ones produced in the eighteenth century or in the second half of the nineteenth. Quality is, of course, subjective and difficult to define, but in terms of conception, historical perspective, and especially execution, the early nineteenth century produced works of top quality in several areas, most notably porcelain and glass. The seeds for this lie ultimately with Peter the Great a hundred years before, whose Westernization led to increasing numbers of European craftsmen settling in Russia. The question, of course, is whether these imported craftsmen imported their tastes as well as their talent, thereby converting the Russian decorative arts to a European standard, or whether their influence was a beneficial one in which their skill was the catalyst allowing native Russian tastes to flower.

It is often assumed that the former is more nearly the case and that Russian decorative arts produced during this period were nothing more than slavish imitations of the West. This, however, is only partially true, as Western influence and its effects varied from field to field. Certain indigenous arts, such as lacquer, bone, and steel work, were hardly affected, and others, such as porcelain and glass, benefited greatly from Western technical innovations. In precious metalwork of this period, however, Western taste was not always accompanied by Western technical skill, and quality, therefore, was erratic.

The areas to be discussed, chosen mostly for their visibility in the West, will be presented in an attempt to outline some of the main aspects of the Russian decorative arts and to analyze some of their origins and whatever foreign influences may be applicable. Until now, Western interest in the Russian decorative arts has been basically confined to

Fabergé and Russian enamels, especially in the United States, and it seems logical therefore to start by discussing decorative precious metalwork first. Second, this discussion will deal with porcelain and glass, which, despite foreign formative influences, appear in the first half of the nineteenth century to have more of a Russian national identity than most of the metalwork, the niello excepted. Last, an attempt will be made to discuss some of the other decorative arts that are almost uniquely Russian.

The discussion of precious metalwork divides itself logically into two main groups—niello, and gold and silverwork; the niellowork because of its long use in Russia and its image of being typically Russian, and the gold and silverwork because of strong Western influence. Furthermore, in the first half of the nineteenth century, with the exception of important gilt pieces made for the church or for imperial use, nielloed articles were generally of a higher quality than silver pieces of the period.

Niello (or *chernovoye serebro,* blackened silver) is an ancient Byzantine method of decorating metal, which is known to have existed in Russia as early as the tenth century. A fusible alloy consisting of silver, copper or pewter, lead, and sulphur is fired onto the metal and then polished to provide a contrast between the resulting black and the silver alongside it.

The production of niello was centered in two main regions, Moscow and Siberia. Important works were executed in the Kremlin workshops from the sixteenth century on. Although Moscow continued to produce niello until the Revolution, objects of fine quality were being made only through the first half of the nineteenth century (fig. 11.1). Beginning in the eighteenth century, there were several centers producing niello in Siberia, but at the end of the eighteenth century and the beginning of the nineteenth, the town producing the most sought-after wares was Velikii Ustiug (the midpoint on the trade route between Arkhangelsk and Moscow). As in Moscow, the Siberian wares declined in quality after the middle of the century. Names of individual silversmiths are known from both areas. Although some of the designs and decor relate to Western European styles, partly owing to special orders from the capital, the general subject matter is typically Russian, reproducing local views and designs, and the execution is on a high artistic and technical level.

The late seventeenth- and early eighteenth-century examples are distinguished by the fact that the niello, applied in tiny floral patterns, is used exclusively as a background, against which are placed, most often, engraved and gilded flowers of Ukrainian origin. From the middle of

the eighteenth century, however, the elements of decoration—figures, buildings, landscapes and flowers—are themselves nielloed and displayed against a contrasting stippled or engraved gilded silver background. In the finest works of the first quarter of the nineteenth century, especially those from Velikii Ustiug, there is a minimum of gilded silver background, such that the entire surface appears to be nielloed, and, given the high polishing that was done at this time, the smooth decoration takes on a mirrorlike look (fig. 11.2). In terms of technique, the niello produced in the first quarter of the nineteenth century tends to be better made than that produced during the period of Peter the Great, as in the earlier period the standard of silver was often that of coin silver, or about sixty-two parts silver out of ninety-six, as compared to eighty-four parts out of ninety-six, the standard required since the time of Peter the Great. As a result, the metal in the later pieces is more malleable and takes a higher polish.

Although rococo and neoclassical designs were incorporated into nielloed articles of the eighteenth and nineteenth centuries, the nielloed work still maintained its traditional Russian character (i.e., with the Byzantine and Eastern overtones of pre-Petrine Russia), and it was in the non-nielloed silver that rapidly changing, newer, Western influences were particularly visible. Beginning with the reign of Peter the Great, who established St. Petersburg as the capital in his attempt to Westernize Russia, and who, as part of his monetary reforms, standardized the hallmarking system, European baroque, rococo, and neoclassical styles permeate Russian silver. And, despite obvious Russian stylistic input, a quick survey of Russian eighteenth-century silver gives the impression that the Russian articles were but copies of Dutch, German, or French styles.

But this is an oversimplification, and further analysis underscores the importance of the rise of St. Petersburg as the cultural capital of Russia, and the resulting difference in the types of articles produced there from those produced in Moscow, the former capital. Through the eighteenth century, one can discern several characteristics of the silverwork made in the two capitals. Moscow pieces produced by Russian smiths were baroque and provincial, while the pieces produced in St. Petersburg by foreigners were linear, sophisticated, and generally superior, both in style and execution, to those from Moscow. Many fine pieces were made in Moscow, of course, but as St. Petersburg was the center of court life, it attracted more foreign workers than did Moscow. The foreign influence was dominant from the beginning of the eighteenth century to the middle of the nineteenth century, when the publication, in 1852, of *Antiquities of the Russian Empire* by Nicholas I stimulated silversmiths to become interested once again in Muscovite Russia.

These two styles, Western and traditional, can easily be seen in the work of the late nineteenth-century court jeweler, Fabergé, whose work first called attention to the important tradition of Russian precious metalwork.

In 1714, the first guild of foreign gold and silversmiths was established in St. Petersburg (similar guilds were to be established later in Moscow and elsewhere) and was composed mostly of Swedes, Finns, and Balts. (So numerous were the Swedes working in Russia that a book devoted solely to St. Petersburg silversmiths and their marks was published in Sweden,[1] long before the first general reference book on Russian marks was published in Russia.[2] Besides the Scandinavians working in St. Petersburg since Peter the Great's victory over Sweden, other Europeans, notably Swiss and French, were imported by Elizabeth and Catherine to work on jewels for the crown. Duval, a Frenchman, produced many of the crown jewels, and Pauzie and Scharff, a Swiss and a German, made gold boxes for both Elizabeth and Catherine. Thus the influence on precious metalwork in St. Petersburg was of a sophisticated and formative kind that was not paralleled in Moscow and the provinces.

By the beginning of the nineteenth century, therefore, European styles are commonly found in Russian silver and goldwork. In the first half of the nineteenth century, three main styles, roughly corresponding to the European ones, are apparent: a neoclassical or French Empire style, an evolved neoclassical or romantic style (fig. 11.3), and Gothic and rococo revivals (fig. 11.4) reminiscent of English and French silver of the period. By the 1840s Russian silversmiths from Moscow and the provinces were producing wares similar in style to those produced in St. Petersburg, although still, by and large, of inferior quality. By 1850, therefore, style was less a distinguishing characteristic than was quality.

The best goldsmith's work continued to be produced in St. Petersburg by foreigners—for example, the Swiss Ador and Theremin at the end of the eighteenth century and the German Keibel, who was commissioned to make the imperial orders, in the first half of the nineteenth. Keibel was the first to use platinum (discovered in Russia in 1824 and first used in coinage in 1826) in his work. He made gold boxes that incorporated platinum in areas where, in a French box, white gold would have been used. Keibel was but one of a number of Germans working in St. Petersburg in the nineteenth century as goldsmiths, miniaturists, and portrait artists. Besides Keibel, the firm of Nichols and Plinke, established in St. Petersburg in 1829, executed imperial commissions (fig. 11.5), and this shop, known fashionably as the *Magasin Anglais,* not only sold fine wares but also employed fine individual silversmiths, including Samuel Arndt, who in 1849 established himself independently.

In the second half of the nineteenth century, firms like Sazikov (established in Moscow in 1840 and in St. Petersburg in 1842), Ovchinnikov (Moscow, 1853), and Khlebnikov (in Moscow sometime after 1870) worked in the "old Russian style," either copying pieces reproduced in *Antiquities of the Russian Empire* (fig. 11.6) or creating highly popular interpretations of seventeenth-century styles in the cloisonné enamels known in the West as Russian enamel. At the same time, many Baltic silversmiths were working either independently or for Fabergé, who, as mentioned earlier, produced fashionable works in St. Petersburg and Russian revival works in Moscow.

In silverwork, therefore, the first half of the nineteenth century was a time of continuing integration of European techniques and styles into Russian work, setting the stage for Fabergé and those silversmiths making Russian enamels to develop an *oeuvre* that would gain international attention.

Owing to the special requirements of emigration, the items of greatest value and portability are taken out of a country in the greatest numbers, so that Russian porcelains, because of their fragility, and some of the other Russian decorative arts, because of their lower value, are less available for study in the West than are examples of precious metalwork. But as far as the porcelain is concerned, sufficient quantities were produced in the various factories to give the Western world a good idea of its production.

The most important factor in the production of porcelain in Russia in the first half of the nineteenth century was the patronage of Alexander I and Nicholas I. This period, which witnessed the highest achievements of the Russian porcelain manufactories, was followed by a general decline that set in after the middle of the nineteenth century, partly because of the emancipation of the serfs and the resulting disappearance of cheap labor.

Starting later than the Meissen factory, the Russian Imperial Factory (founded in 1744) reached its apogee thanks to imperial commissions during the reign of Nicholas I, at a time when the Meissen and Sevres factories had already reached their heights. During the same period, the private factories, benefiting from Alexander's protective tariff of 1806,[3] were able to expand their production.

Stylistically, the production of the Russian Imperial Factory began to achieve consistency with the appointment in 1779 of Dominique Rachette, a Frenchman, as director, and from the classical style of this period through the Empire style of Alexander I, the romantic style of Nicholas I, and the rococo revival at the end of Nicholas's reign, the French influence remained strong. In the first half of the nineteenth century, especially during the reign of Alexander I, there seemed to be little to distinguish the productions of the Imperial factory from those

of France, just as in the eighteenth century Meissen and Berlin models had dominated Russian porcelain. Foreign craftsmen were needed for their technical skill in the chemistry, modeling, baking, and decorating of porcelain (French and English clay and glazes were even imported and mixed with the local ones to give the Russian wares a French look), but, as the factory approached its height under the reign of Nicholas I, native Russian influence was increasingly seen in subject matter, form, and decoration.

Probably the best works produced in the Imperial factory in the first half of the nineteenth century were the palace vases (fig. 11.7) and the military plates depicting the favorite regiments of Nicholas I (fig. 11.8). Both exhibit the highest quality of modeling, painting, and gilding. Though perhaps too garish for Western eyes, they not only satisfied the militaristic taste of Nicholas but also fulfilled the artistic and technical potential of the Imperial factory, whose achievements were not equalled at this time in the West.

Private factories in Russia also reached their peak during the first half of the nineteenth century. The most notable of these was the Gardner Factory (founded near Moscow in 1766), known in the eighteenth century for the order services commissioned by Catherine the Great (the forms were taken from two German services but decorated with the trappings of the Russian orders of Saints George, Alexander Nevsky, Andrew, and Vladimir), and known in the 1820s for commemorative gilt and decorated tea and coffee services in the Empire style (some based on the War of 1812) and for figurines based on Venetsianov's *Magic Lantern* illustrations. In the middle third of the nineteenth century, the Popov Factory (founded 1806), too, was known for its figurines of the working class, and toward the middle of the nineteenth century, the Kornilov Factory (founded 1835) was especially noted for its bold rococo revival designs (fig. 11.9). The Kornilov Factory manufactured porcelain of sufficient quality and quantity that it was commissioned to make replacements for some of the imperial services. After about 1893 the factory maintained an export trade to the United States, via Tiffany & Co. Together with the Kuznetsov Porcelain Combine, which took over the Gardner factory in 1891, the Kornilov Factory survived into the twentieth century, long after the emancipation of the serfs in 1861 had made cheap labor, the most important Russian raw material in the production of porcelain, unavailable. The secret of their success was the extensive production of commercial porcelain, which was not made by the smaller factories producing quality wares.

In analyzing Russian taste in the first half of the nineteenth century, we should mention two small factories, although their wares are not often seen. Prince N. Yusoupov, a former director of the Imperial fac-

tory, established a private factory at his estate near Moscow (1814–31), which manufactured porcelain for his own use. For some of his wares, he imported paste, undecorated objects, and even workmen from Sèvres.[4] This resulted in excellent-quality sophisticated porcelain after his own designs, often taken from books in his own library (fig. 11.10). Yusoupov's creations provide an interesting contrast in taste with the porcelains of the small Batenin factory (St. Petersburg 1812–39). This factory's porcelain, of limited quantity but of fine quality, typified the "Russian taste for strong colors and slightly bulbous, overfull outlines" (fig. 11.11). Despite the location of the factory, the Batenin porcelain was mostly found outside of St. Petersburg, as it was not Western enough for the St. Petersburg world.[5]

The manufacture of glass in Russia, of course, predates that of porcelain, and the histories of the two industries differ in many respects, but stylistically, many similarities exist. In the middle of the eighteenth century, the engraved pokals (covered chalices) bearing portraits of the empresses betrayed a German influence, not unlike some of the porcelains of the period, and from the end of the eighteenth century through the first half of the nineteenth, glassware evolved, as had porcelain, from classic and Empire styles through Gothic and rococo revivals. Furthermore, as in the case of the porcelain factories, a number of private glass factories coexisted with the Imperial Glass Factory, which, however, did not enjoy the same market dominance that the Imperial Porcelain Factory did (both were under the same administration, and the glass factory was eventually absorbed by the porcelain factory in 1890). The private factories were equally important and gave the Imperial factory such competition for wares made to be sold on the open market that in 1802, N. A. Bakhmetiev, the owner of the largest private factory, was tempted to try to lease the Imperial factory from the government. Artistically, both the Imperial and private factories produced excellent wares during the first half of the nineteenth century.

The late eighteenth-century pictorial representations, often on tinted glass, gave way, in the beginning of the nineteenth century, to clear, cut, lead crystal pieces, including palace vases and lighting fixtures, and a large series of objects, executed both by the Imperial and the Bakhmetiev factories, commemorating the War of 1812. Although romantic in inspiration, these smaller items are neoclassical in style, and include a remarkable series of crystal plates based on the wax models of the classical medalist and sculptor, Count Fedor Tolstoi (fig. 11.12). By the 1840s, the use of color, abandoned at the end of the eighteenth century, returned, as new colors and techniques for layering glass were developed and used in many pieces, largely of Gothic inspiration. After 1840, in response to economic pressures, the Imperial factory also pro-

duced soda-lime glass, which was not of the quality of the lead crystal, but which found a ready demand among the new industrial middle class. Many of the more inexpensively produced glasses, in a rich variety of colors, with silver and gold decoration, and with transfer decoration (fig. 11.13), were sold on the open market. As was the case with the porcelain factories, the second half of the nineteenth century witnessed a decline in the quality of glass, especially in the case of the Imperial factory, which, however, continued to function through the reign of Nicholas II.

Besides silver, porcelain and glass, the Russian minor art of the first half of the nineteenth century best known in the West was lapidary work, which reached grand proportions during the reign of Nicholas I. Although known here primarily through malachite vases and other decorative objects, the most important examples are the architectural elements in Russia in the Winter Palace and St. Isaac's Cathedral. Peter I had already established a lapidary factory at Peterhof, and another was established in Ekaterinburg in 1765, but this distinctive Russian art achieved international renown in the nineteenth century, largely because of Italians working in Russia. Not only did they make many of the mosaic tables filling the Winter Palace, but the Italian architects, including Rossi, who also designed monumental crystal for the Imperial Glass Factory, took advantage of native materials and incorporated them into their palatial designs. And Alexander Briullov, Karl's architect brother, designed the malachite hall in the Winter Palace as part of the 1837 restorations. Malachite, lapis lazuli, jasper, nephrite, and rhodonite were among the stones used in the manufacture of many types of vases, lamps, inkstands, and other decorative objects. The sumptuous imperial gifts to European royalty—large vases, tables, and even chairs—were made of finely figured malachite, which was, at that time, plentiful in the Urals (fig. 11.14). The result was an art that, because of the beauty of the native material and the interpretation of inspired designers, acquired universal admiration. The manufacture of monumental stone articles diminished in the second half of the nineteenth century, but until the Revolution, small articles, many with exquisite detail reminiscent of Fabergé, were still being produced by the Lapidary Works at Ekaterinburg.

Another of the minor arts, the manufacture of lacquer wares, was known for its extensive and fine production in the nineteenth century. The lacquer factories owed their success to the skill of the former icon painters who worked for them and who produced numerous objects of utility, including boxes and desk articles, which were decorated with scenes from middle-class and peasant life. Many of these scenes are reminiscent of the *Magic Lantern,* and, owing to the talents of the icon

painters, the general aspect is completely removed from Western styles, despite the fact that the founder in the late eighteenth century of the most important lacquer factory, P. Korobov, had gone to England to study the methods of the Brunswick Lacquer Factory.[6] Korobov's factory became better known by the name of his son-in-law, P. Lukutin, who in 1828 received the Imperial Warrant, and whose family directed the production until 1904. Although the earlier pieces (fig. 11.15) are often more charming and better executed, the capabilities of the factory were still such that Fabergé, in the late nineteenth century, ordered boxes from Lukutin that were then mounted in gold for special effect. Throughout the nineteenth century, the quality was generally high, so that a considerable number of articles were exported, enabling the factory to achieve commercial success. This manufacture of lacquer ware still survives today, with much of it being exported successfully, but the current subject matter, proselytizing political scenes and bland interpretations of fairy tales, lacks the spontaneity of the earlier genre subjects and has little appeal.

Other forms of the decorative arts of this period are less well known in the West. Objects in steel and bone were created in Tula and Arkhangelsk, respectively. Although special orders in fashionable Western taste were executed, these art forms, together with the lacquer work and the niello manufactured in Velikii Ustiug, most classicially reflect traditional Russian taste and were but little influenced by Western design.

The fact that the Imperial Porcelain Factory required each foreign workman employed to train two Russians[7] implies, correctly, that foreign techniques and styles were integrated—perhaps unevenly, but surely—into the Russian decorative arts. This integration, most closely identified with the decorative arts influenced by the court in St. Petersburg, should not be considered, however, as imitation, but rather as an attempt to take advantage of the best that the West had to offer to improve the cultural standing of the court, and as testimony to the skill of foreign designers in reinterpreting traditional arts. Furthermore, the emulation of the achievements of another country in the arts is certainly not without precedent and needs no apology. After all, German porcelain, which so influenced the eighteenth-century Russian porcelains, was itself the result of the Court of Saxony's having discovered the secret of the manufacture of porcelain in order to equal the fashionable Chinese porcelains. And, as in Germany, once the technical problems had been overcome, the Russian porcelains acquired their own national character. Furthermore, this maturation occurred during the reigns of Alexander I and Nicholas I, and this period includes some of the best examples of

Russian porcelain, as well as some of the best of the other Russian decorative arts. These included glass, stone, lacquer, bone, steel, and niello, all of which, despite varying degrees of foreign input, evinced a truly national style. With some exceptions, however, as far as precious metalwork was concerned, it was only at the end of the century that pieces of sufficient quality to attract international attention to Russian art were produced by gold and silversmiths. During a period when the other decorative arts were in a general decline, the colorful and popular Russian enamelware, the natural culmination of the publication of *The Antiquities of the Russian Empire,* and the splendid works of Fabergé (fig. 11.16) were unequalled in the world.

In conclusion, therefore, despite many foreign influences, both of styles and of immigrant craftsmen, the Russian decorative arts exhibit a recognizable national style. During the period of Alexander I and Nicholas I, when Russia was already firmly established in the European mainstream, not only was this individuality refined and sustained, but it also produced works of art comparable to anything produced in the West.

NOTES

1. Bäcksbacka, *St. Petersburg, Juvelerare, Guld-Och Silversmeder 1714–1870* (Helsinki: Konstsalongens Forlag, 1951).

2. T. Goldberg, F. Michoukov, N. Platonova, and M. Postnikova-Losseva, *L'Orfevrerie et La Bijouterie Russes Aux SV-XX Siecles* (Moscow: Nauka, 1967 and 1974).

3. Richard Hare, *The Art and Artists of Russia* (London: Methuen, 1965), p. 145.

4. Marvin C. Ross, *Russian Porcelains* (Norman: University of Oklahoma Press, 1965), p. 158.

5. Ibid., pp. 161–62.

6. Hare, p. 257.

7. Ibid., p. 145.

12

Nineteenth-Century
Russian Caricature
John E. Bowlt

THE RUSSIAN GRAPHIC ARTS

THE FOCUS of this chapter is the evolution of the Russian caricature, particularly of the first half of the nineteenth century and within the broader context of the Russian graphic arts in general. The development of the Russian graphic and illustrative arts from the eighteenth through the twentieth centuries has been neglected at the hands of Western critics, and we should take this opportunity to help redress an obvious historical imbalance. Even Russian discussions of the subject have not always been comprehensive—for example, the collector and senator Dmitrii Rovinsky ignored wood and steel engraving and lithography in his imposing *Podrobnyi slovar' russkikh graverov (Detailed Directory to Russian Engravers)* of 1895. Unfortunately, an investigation into the eighteenth- and nineteenth-century graphic arts in Russia does not reveal a treasure house of artistic talent, except for the Napoleonic caricatures of 1812–14. Rather, it reinforces the general assumption that secular Russian art of the eighteenth and nineteenth centuries was largely derivative from Western models. Soviet historians tend to disregard these sources and stimuli, but pre-Revolutionary critics such as Nikolai Vrangel and Vasilii Vereshchagin were fully aware of Russia's status as apprentice rather than mentor, and their many excellent essays published in the journal *Starye gody (Bygone Years)* or under the patronage of the St. Petersburg Circle of Lovers of Fine Russian Editions are still reliable guides to the history of the Russian graphic arts.[1]

A few words on the general position of the Russian graphic arts in the eighteenth century and before are necessary before we can approach the more specific discipline of caricature. It is generally held that the first Russian wood engraving for a book was of the Apostle Luke for an *Apostol (Books of the Apostles)* of 1564, and throughout the late sixteenth and seventeenth centuries, numerous ecclesiastical books were

published with engravings, most of them dependent on Western images borrowed from Italy, Germany, and Holland. As a matter of fact, these early Russian book illustrations perhaps belong more to a Polish and Ukrainian tradition than to a Russian one, and this point should be emphasized, for, until the end of the eighteenth century, if not later, leading "Russian" artists were more often than not Ukrainian. But however we categorize these first engravings, they are often identifiable by a curious duality: on the one hand, they rely on conventional Western models imported mainly through Poland; on the other, they retain a spontaneity and naïveté typical of the effusive, folkloristic spirit of Slavic art. This combination of sophistication and simplicity is particularly evident in the eighteenth-century wood and metal engravings of the Ukrainians Ivan Migura and Grigorii Levitsky (father of the portrait painter Dmitrii), and it dominates the Ukrainian and then Russian graphic arts at least until the Napoleonic caricatures. This dichotomy is reflected further in the parallel traditions of the Russian visual arts— the vulgar, primitive *lubok* or broadsheet with its tawdry imagery and blatant message coexisted comfortably with the academic, classical portrait.

It would be wrong, however, to think wistfully that the *lubok* was exclusively Russian. Many of the *lubok* compositions were borrowed from the West, especially from the German *Flugblätter* and the English broadsheets: the favorite motifs of current fashions in clothing and scenes of overindulgence or compromising behavior often derived from such sources. Of course, there were some original and distinctive *lubki,* such as the famous "Mice Burying the Cat" (fig. 12.1) or "An Old Believer Having His Beard Cut Off," both of the early eighteenth century. The former is actually a parody of Peter the Great's funeral and contains sardonic illusions to his innovations and reforms. One mouse smokes a pipe and pulls a barrel of tobacco (Peter prohibited the free sale of tobacco), some mice represent regions conquered by Peter during the Russo-Swedish War, and there is a one-wheeled carriage (new in Russia and Peter's favorite mode of transport). Although we can assume that other *lubki* might offer political translations just as astonishing, "Mice Burying the Cat" was an exception and, in fact, was not deciphered until the mid-nineteenth century (by Rovinsky). But in the light of its allegorical function and critical purpose, this particular *lubok* might be regarded as the first Russian political cartoon and departure point for social and political caricature.

As for the professional graphic arts of Russia in the eighteenth century, especially book illustration, Western influence was also paramount. Under Peter the Great a number of Dutch and German engravers settled in Russia and were among the first artists there to

favor secular subjects, mostly battle scenes, firework displays, and atlases of the world. They, in turn, introduced copper engraving into
Russia, and the important engraver and etcher Aleksei Zubov, working
in the early eighteenth century, owed much to these foreign masters.
This imposed Western tradition of the graphic arts was maintained
throughout the eighteenth century, mainly as a result of the continuous
importation of Western artists, especially after the foundation of the St.
Petersburg Academy of Fine Arts in 1757. French engravers such as Le
Lorrain, Le Prince, and Moreau illustrated Russian books, headed Russian workshops, and compiled textbooks for draftsmen during their
long or short residences in St. Petersburg. Their principles were reinforced by the steady influx and translation of Western European books,
sometimes illustrated with original Russian prints. Russian subject matter was certainly used for engravings and etchings in the eighteenth
century, but, again, it was treated and interpreted through a peculiarly
Western vision. In fact, one reason for the "mysteriousness" of Russia,
as conceived by the Western public from the eighteenth century onward, is to be found in the exotic and often ludicrous renditions of
everyday Russian life that foreign artists in St. Petersburg engraved and
sold abroad: the exuberant portraits of Russian peasants dressed in fantastic clothes, wearing Greek sandals, or dancing with bears that continued to be produced into the twentieth century find their genesis in the
heady, if not diseased, imaginations of those zealous, but bored,
Frenchmen living in St. Petersburg in the mid-eighteenth century.

 Why did the professional graphic arts remain secondary in Russia
throughout the eighteenth century? The answer to this question is to be
found not only in the lack of competent Russian engravers and etchers
but also in the cultural backwardness and crass ignorance of eighteenth-century Russian society. Essentially, that society did not read
and was not interested in the fine arts. In the mid-eighteenth century,
even the Moscow Synod Publishing House was so overburdened with
unsold books that it was forced to donate whole warehouses of books
to paper factories, and the so-called St. Petersburg Academic Bookstore
had such a large unsold stock that civil servants were forced to buy
books there by having 5 percent deducted from their salaries.[2]

 By the beginning of the nineteenth century, things had changed for
the better. Books began to appear with illustrations by fine Russian
engravers, who relied on a disciplined, classical elucidation of the text
rather than on the rococo allegories and mythological motifs used in
many eighteenth-century Russian books and reminiscent of a latter-day
Boucher or Watteau. With the consolidation of the academy program in
St. Petersburg, an important generation of graduates in engraving (Ivan
Chesky, Stepan Galaktionov, et al.) began to advance their careers as

book illustrators and as engravers of topographical views and portraits. The period of the 1780s–1800s, of course, marked the flowering of the engraved portrait rendered after Russian portraits (by Fedor Rokotov, Levitsky, Anton Losenko, and Vladimir Borovikovsky) or, more frequently, after Western portraits (by Roslin, Torelli, Tocqué, et al.). In the 1810s, with the appearance of Aleksandr Orlovsky, who arrived in St. Petersburg from Poland in 1802, Ivan Terebenev, and Aleksei Venetsianov, the book illustration and decoration achieved unprecedented heights in Russia, especially after Orlovsky's application of the lithographic process from 1816 onward.[3] Important publications date from this period, such as the 1824 edition of Pushkin's *Bakhchisaraiskii fontan (Fountain of Bakhchisarai)* with illustrations by Galaktionov, and the periodicals *Poliarnaia zvezda (Polestar)* of 1825–26 and *Nevskii al'manakh (Nevsky Almanac)* of 1826–29. All these items carry vignettes, head- and tailpieces, and capitals engraved by Chesky, Galaktionov, etc., but the number of full-scale illustrations is limited, rarely exceeding five per book. But this custom changed in the 1840s, when a number of copper-engraved albums and suites were undertaken by St. Petersburg and Moscow publishers, even though they were expensive, were not very popular, and often were not completed (such as the unfinished *Dead Souls* cycle drawn by Aleksandr Agin and engraved by Estafii Bernadsky in the 1840s). By the 1860s the traditional engraving, whether copper, steel, or wood, had begun to yield to the cheaper processes of zincography, phototype, and photoengraving. The result was a rapid and broad dissemination of the image, a process that accounts for the sudden flowering of the social caricature journal in Russia at this time.

RUSSIAN CARICATURE BEFORE 1812

At this juncture it is appropriate to turn attention to the development of caricature per se and to examine it within the framework of the graphic arts. A peculiar feature of Russian caricature, as of the graphic and illustrative arts as a whole, is that it is a relatively recent development. While Hogarth, for instance, was already creating his masterpieces of the 1730s, or Fragonard was deriding French mores under Louis XV, Russia could boast no counterparts. In other words, before 1800 a tradition of professional caricature did not exist, but there were occasional attempts to criticize the status quo by artistic and literary methods—although these were vulgar and imitative and derived frequently from Western sources such as Piscator's *Theatrum Biblicum,* introduced by Peter the Great, Kopievsky's important *Simvoly i emblemata (Symbols and Emblemata,* Amsterdam, 1705), and Picard's engravings to

Ovidievye figury (Figures from Ovid, St. Petersburg, 1721). Also relevant to this context, although outside the accepted understanding of political and social caricature, was the *lubok,* a medium that played a key role in the dissemination of motifs and ideas connected with ecclesiastical, social, and military life. However, the *lubok* rarely made a direct reference to a specific dignitary or a particular order, inasmuch as the censorship laws, however uneven and inconstant, forbade contravention of the "law of God, the Government, morality or the personal honor of any citizen."[4] The presence of the censorship in the eighteenth and nineteenth centuries also serves to explain, in part, why the Russian fine arts resorted to inordinate flattery and delusion rather than to the exaggeration of negative features. This might explain in turn why Russian caricature, such as it existed, including the *lubok,* used general themes or supported an Aesopian interpretation of persons and events. "The Mice Burying the Cat" is a case in point. Krylov's fables of the early nineteenth century constitute a literary extension of this method.

Suddenly, with the onslaught of the Napoleonic campaign of 1812, Russian caricature flowered with exceptional strength. How can this unexpected development in the Russian graphic arts—from a desultory and derivative condition at the end of the eighteenth century to a high esthetic standard in the 1810s—be explained? One answer to this question lies in the change in attitudes toward the drawing, the sketch, and the cartoon that was witnessed in Western Europe and in Russia at the end of the eighteenth century.

During the eighteenth century, at least within the perimeters of the St. Petersburg Academy of Fine Arts, the arbiter of Russian taste, the drawing was regarded as the basis of the painting, a preparatory and component part of the finished oil. Orthodox artistic practice entailed drawing exclusively from plaster or live models, thus providing the necessary details for the mythological or historical subject and for the portrait—the braced muscle, the outstretched arm, the noble head. Inasmuch as academy painting disregarded "real life," it had no need for the rapid documentation of the passing scene that the pen or pencil can achieve. However, the 1790s brought a new mood to the academy, and both faculty and students turned increasing attention to *nature.* Andrei Ivanov, father of the painter Aleksandr, who began teaching at the academy in 1798, even went so far as to assert that the understanding of nature and the literal re-creation of nature on the pictorial plane was the aim of art.[5] Priorities shifted as the laws of nature and the physical world attained primacy over the laws of design. On a philosophical or perhaps psychological level, Russian society seemed now to reject its introspective, contemplative mood of the eighteenth century and to take up the European fashion for *plein air* and spontaneous sentiment.

This was paralleled by a number of auspicious technical improvements in the 1800s and 1810s. For example, the introduction into the academy of the rubber eraser in place of the traditional pellet of bread, and the new diversity of instruments and paper (Italian and lead pencil in place of sanguine; white, erasable paper in place of toned paper) prompted a wider recognition of the graphic art in Russia. With the ascendancy of Karl Briullov, Orest Kiprensky, Orlovsky, et al. during the 1810s–20s, the pencil drawing achieved independent status.

By 1810 Russian artists were ready to redefine the criteria and demands of the visual arts. The graphic method supplied them with an alternative tradition, just as the eighteenth-century caricaturists of England provided an esthetic or, rather, antiesthetic parallel to the arguments of Sir Joshua Reynolds and the Royal Academy in London. Dissatisfaction with the established order—artistic as well as social—was manifest in Venetsianov's *Journal of Caricatures for 1808*. This collection was "unartistic" not only because of its concentration on the present tense (which entailed the dismissal of classical perspective, the classical positive hero, and the historical genre) but also because of its complete dependence on the graphic art.

NAPOLEON AND RUSSIAN CARICATURE

The Napoleonic caricatures, therefore, did not appear in a vacuum. It was as if a satirical force, previously latent, suddenly unleashed itself with an acuity second only to that of Gillray or Rowlandson. As the critic Vereshchagin wrote a century later: "In an atmosphere charged with malice and hate, artistic satire could only have been biting and unpleasant."[6] After the Aesopian tradition of the caricature, such as it had existed in Russia, the figure of Napoleon provided an exceptional and acceptable target for caricature, a subject supported by the Russian government. About 200 hundred caricature sheets of Napoleon and his entourage, etched and colored by hand, were produced in Russia during 1812–14, bringing to the fore the first generation of professional Russian caricaturists, led by Ivan Terebenev, Ivan Ivanov, and Aleksei Venetsianov.[7]

A common feature of such caricatures was that these artists combined academic or classical principles with certain elements of the *lubok*. For example, Terebenev's and Ivanov's caricatures reflect Western attitudes toward graphic illustration, especially in the endeavor to present correct proportion and perspective, to follow harmony and measure in composition, and to paraphrase classical heroes, but they also rely on the sharpness of the *lubok* coloring and line. This gave the Russian caricatures a clarity and conciseness often absent in the more complicated

English counterparts, which, to a large extent, owe their effect as much to verbose captions as to the drawings themselves. Establishment of an immediate link with the *lubok* ensured that the Napoleonic caricatures became directly comprehensible to the Russian populace. Indeed, just as the Russian peasant suddenly enjoyed official favor and acknowledgment in 1812, thanks to his patriotic harassment of the retreating French army, so he became a subject worthy of artistic interpretation and recognition. In the same context, one might contend that this "democratic" effect of 1812 on Russian society contributed to Venetsianov's establishment of the naturalist school of painting in the 1820s, in which artists from the lower classes played a crucial role.

The very proscription of the personal caricature in Russia during the seventeenth and eighteenth centuries might explain the disproportionate attention that Terebenev, Ivanov, et al. gave to the figure of Napoleon rather than to the French nation as a whole. The first Napoleonic caricatures passed the censor in Moscow in July 1812 and in St. Petersburg in August, and by early 1812 they were available in large numbers. It is dangerous to generalize, but the finest pieces seem to have been produced in St. Petersburg, while the Moscow ones were often vulgar imitations of *lubki,* useful as posters rather than as subtle commentaries on personalities and events. Despite assumptions to the contrary, Western caricatures of Napoleon did not come to Russia in substantial quantities, and many of the Russian pieces were original in subject and intention. Certainly, Terebenev owed some of his ideas to English caricature, especially to Rowlandson, but many of Terebenev's caricatures were published in England and one, at least, was later copied by Cruikshank.[8]

In his forty Napoleon sheets, Terebenev, like Ivanov, followed two essential approaches. Either he exaggerated the positive, national characteristics of the Russians, contrasting them with the dismal condition of the Grande Armée, or he exposed the foibles of Napoleon himself. Terebenev's several versions of "The Russian Scaevola"—a Russian peasant at the center of the composition is about to chop off his arm branded by his French captors as they react in horror and incredulity—belong to the former category (fig. 12.2). This immediacy and simplicity of idea and design are evident in Terebenev's caricatures of Napoleon such as "The Consultation," in which doctors announce that Napoleon's "tongue is off-white (as a punishment for telling so many lies in his bulletins); his pulse is hardly beating (from too much bloodletting); his head is in an awful fever (because of the failure of his crazy plans)"; Napoleon replies that he ought, therefore, to return to Paris as quickly as possible since the Russian climate was not entirely beneficial to him. In contrast to such ridicule of Napoleon, the common French

soldier is presented in a more sympathetic, more human light. Terebenev and Ivanov regarded the French army as the victim of Napoleon's transgression rather than a manifestation of an innate cruelty or lust for power. The caricatures of the retreating army show soldiers eating birds and sporting absurd clothes, such as ladies' high-heeled shoes and bonnets, in their desperate endeavor to alleviate their hunger and cold. But the sheets also depict the Russians giving food to their French prisoners, or jovial scenes such as French soldiers fleeing from a *babushka* who, in response to their demand for food, says *koza* (goat), which they misinterpret as *kazak* (Cossack).

To a considerable extent, the above characteristics are also identifiable with the work of Ivanov, an artist of uneven talent whose caricatures have sometimes been misattributed to Terebenev. Ivanov's interpretations of Napoleon demonstrate the deep national resentment toward the invader and progenitor of human suffering. For example, "Napoleon Forms a New Army from Various Freaks and Cripples" shows the figure of Napoleon at the axis of the composition elevated on a mound of earth and encircled by a group of maimed or insane mercenaries. In "Hospitality Is a Distinctive Feature of the Russian Character," however, Ivanov shows the traditional Russian virtue of hospitality being extended to French prisoners, one of whom kisses his warder as the latter guides him to a tureen of soup. Ivanov did not possess Terebenev's artistry, but his caricatures are still "action packed," transmitting a sense of rapid movement through the inclusion of several strata of narrative: in "Napoleon Forms a New Army" Napoleon is not only at the center of the formal and thematic structure, but he is also the main link in the zigzag progression of events—from enforced conscription and mobilization to imminent entry into battle. In his dependence on a rhythmical sequence of "stills," Ivanov provides a diversity of commentary and interpretation within the frame of a single cartoon, thus anticipating the modern-day comic strip.

While Terebenev tended to rely on understatement and Ivanov on the varied narrative, both artists attained their goals with remarkable effect. Their incisive wit is encountered only occasionally in the caricatures and cartoons of their less familiar contemporaries such as Martynov and Shifliar. With notable exceptions (Martynov's "Napoleon's Guard Marches Back via Vilnius" and Shifliar's "Triumphant Entry into Paris of the Unconquerable French Army), their work suffers from excessive detail or script. Terebenev and Ivanov were rarely guilty of these defects, and it is to their credit that most of their caricatures can be readily understood without reference to a supporting story, even though many of the sheets appeared as illustrations in the journal *Syn Otechestva (Son of the Fatherland)* and thus relied on an accompanying elucidation.

It is not generally appreciated that Venetsianov was a gifted caricaturist and that his more famous paintings of serene rural life reflect only one aspect of his artistic career. Venetsianov's caricatures were not concerned with specific political themes but interpreted issues of a more universal nature, especially Russian Gallomania, which he depicted in several scenes from 1812 onward. By that time Venetsianov had considerable experience as a social satirist, since in 1808 he had prepared the first and only number of his *Zhurnal karikatur na 1808 god* (*Journal of Caricatures for 1808*). The contents immediately provoked the censor's objection because of one picture in which an aristocrat (unidentified, but, no doubt, an actual personage) is asleep beside his mistress while petitioners wait in the anteroom and a cat plays with their letters. Because of this particular item, evidently, Alexander I himself demanded that the journal be closed, recommending that Venetsianov "direct his talents to a much better subject and use his time more advantageously to school himself in his employment."[9] Despite the premature death of the caricature journal (it was never published), Venetsianov continued to ridicule certain aspects of the Russian upper class, especially their love of French fashions, of which "A French Pomade and Perfume Shop" and "The Expulsion of the French Actresses from Moscow" are typical. Still, these later pieces (1813) had little of the sardonic humor found in Terebenev and Ivanov and, in some instances, were no more than genre scenes. Indeed, Venetsianov's second experiment in popular editions—*Volshebnyi fonar', ili zrelishche S.-Peterburgskikh raskhozhikh prodavtsev, masterov i drugikh prostonarodnykh promyshlennikov, izobrazhennykh vernoiu kist'iu v nastoiashchem ikh nariade i predstavlennykh razgovarivaiushchimi drug s drugom, sootvetstevenno kazhdomu litsu i zvaniiu (The Magic Lantern, or Spectacle of St. Petersburg Hawkers, Artisans and Other Common Manufacturers Depicted by an Accurate Brush in Their Authentic Costumes and Presented Conversing with Each Other as Befits Their Person and Station)*— published in 1817, was an innocent panopticon of city types. Despite his initial service to the development of Russian caricature, Venetsianov is now remembered for his landscapes and portraits, assertive not subversive; idealized, not ironic.

DEVELOPMENTS IN RUSSIAN CARICATURE AFTER 1812

Venetsianov's concern with documentary description of social types was indicative of the relative neglect into which Russian caricature fell after 1814. As the Napoleonic campaign passed into history, a key stimulus to political caricature and satire also disappeared, although *lubki* connected with the period continued to be published throughout the nineteenth century. After the Decembrist revolt of 1825, Russian cen-

sorship was considerably tightened, culminating in the so-called Cast Iron Statute, and not until October 1905, with the tsar's edict of liberties (which included the ostensible freedom of the press) did the Russian political caricaturist use the frankness and acuity that he had used during the Napoleonic era. Thereafter, at least until the late nineteenth century, Russian political and social caricature survived in the form of book and periodical illustration, particularly after the appearance of Gogol's *Dead Souls* in 1842. However, the lack of a solid and continuous tradition of Russian book illustration and design made itself known in the low level of graphic technique and the frequent lack of coordination between the visual image and the text, defects identifiable, for instance, with the nineteenth-century editions of Pushkin.

Still, mention should be made of Aleksandr Agin, who illustrated *Dead Souls* (1846–47), Mikhail Bashilov, who illustrated Griboedov's *Woe from Wit* (1862 edition) and worked on ilustrations for Tolstoi's *War and Peace* in 1866–67 (original plates destroyed by fire). The Agin illustrations to Gogol are worthy of attention, especially the group scenes, (fig. 12.3), and they work well as commentaries on Chichikov and the gallery of landowners. Between 1846 and 1847 Agin published seventy-two separate illustrations lithographed by the engraver Estafii Bernadsky. Although Agin (curiously enough, he was a former student of Briullov's) is credited with the production of all the sheets, it is essential to remember that Russian caricaturists and book illustrators of the mid-nineteenth century did not work in isolation but in groups. Agin, Bernadsky, Pavel Fedotov, and Nikolai Stepanov formed a close association in the 1840s, and they were in communication with Vladimir Dal', Dostoevsky, Ivan Panaev, etc. The exact role of Fedotov in this fraternity has yet to be delinated, but suffice it to say that a number of illustrations and cartoons by Agin and other graphic artists of the 1840s and 1850s echo the thematic and formal concerns of Fedotov's paintings and drawings, especially of his *Scenes from Everyday Life* (1840s).

Of course, the above endeavors were beyond the immediate confines of political caricature. The Crimean War (1853–56) and the Russo-Turkish War (1877–78) did provide brief occasions for the restoration of the caricature and cartoon as vehicles of political criticism, although the vacillations in government policy made the visual and literary distortion of enemy officials an unreliable venture. The Crimean War did not prompt a repetition of the success of the Napoleonic caricature, but it did coincide with a period of intense publishing activity in the late 1850s and 1860s that saw the establishment of several caricature journals and albums. These included Stepanov's *Znakomye* (*Acquaintances,* 1856–58), an improved revival of Mikhail Nevakhovich's *Eralash*

(*Jumble,* 1846–49), and his more famous *Iskra* (*Spark,* 1859–72).[10] *Iskra* deserves separate examination, for it expressed in graphic form the delusions of foibles of the Russian intelligentsia and the middle class. Stepanov, its chief editor, was also its main caricaturist, and he produced about 1600 individual caricatures during the period 1859–64. But, in contradistinction to the Napoleonic caricatures, the *Iskra* pieces were rarely political and treated more of the musical and artistic worlds, of the St. Petersburg press and the new industrialist class. Unfortunately, most of the *Iskra* caricatures, like those for contemporaneous magazines, were badly executed and banal, even though Stepanov himself had professional training as a draftsman and direct experience as a bureaucrat in the State Exchequer in St. Petersburg. Stepanov's intimate caricatures of friends and colleagues such as Briullov, Dargomyzhsky, and Aleksandr Serov are probably of more value and amusement than his often hurried contributions to *Iskra.*

One of the most successful illustrators and caricaturists of the new generation was George Wilhelm Timm, a Lithuanian by birth, who attained a high level of proficiency.[11] Although influenced by Daumier and Gavarni, Timm was obliged to resort to the genre tradition of Venetsianov and Fedotov rather than to outspoken political caricature, and his endeavors *ridendo castigare mores* invite comparison with the more genial parodies of *Punch* (fig. 12.4). Still, even with Timm, Russia could boast no counterpart to Daumier, Gavarni, or Philipon, and during the late nineteenth century the Russian artists and writer labored under conditions that discouraged criticism of the political machine. What Alexander II said when he came to the throne in 1881 summed up the position very well: "A Constitution?" he exclaimed, "That a Russian Tsar should swear allegiance to a bunch of cattle?"[12]

Only at the end of the nineteenth century did Russian caricature again assert itself as an independent and potential art form, functioning neither as a decoration to a text nor as a simple source of entertainment for an idle public. A gifted fin-de-siècle caricaturist was Pavel Shcherbov, whose renditions of celebrities such as Sergei Diaghilev, Princess Mariia Tenisheva, and Fedor Shaliapin appeared under his pseudonym "Old Judge" in the magazine *Shut* (*Buffoon*), making a key contribution to the renaissance of the Russian arts at this time.[13] Shcherbov's caricatures of literary and artistic contemporaries deserve a prominent place in the gallery reserved for the works of Western masters such as Beerbohm and Gulbransson, and they prepared the way for caricatures of a more political persuasion. Shcherbov, in fact, was a close associate of the St. Petersburg World of Art group (fig. 12.5), whose artists such as Alexandre Benois, Lev Bakst, Ivan Bilibin, Mstislav Dobuzhinsky, Evgenii Lancéray, and Konstantin Somov helped refurbish Russia's

decorative and illustrative arts at the beginning of the twentieth cen-
tury. Moreover, some of the World of Art members, including Bilibin,
Dobuzhinsky, and Lancéray, were directly involved in political carica-
ture for the revolutionary journals of 1905–1906, as well as in the
stage and book designs for which they are more famous.[14]

CONCLUSION

In 1905 the St. Petersburg censor received a cartoon intended for pub-
lication in *Strekoza* (*Dragonfly*), a dissident journal. It depicted a man of
bourgeois status playing solitaire and bore the caption: "For the life of
me, I can't understand all this, but it's certainly very interesting." The
censor rejected this drawing on the grounds that it was a "tendentious
illustration of the indeterminateness of the present internal situation of
Russia."[15] This drawing and the censor's reaction have a broad symbolic
meaning. Russian caricature of the nineteenth century, like Soviet cari-
cature of the twentieth, operated under a totalitarian regime. It is logi-
cal to assume, therefore, that the venom directed at Napoleon, the ex-
posure of a depraved landowning class and a *dachnaia burzhuaziia*, are
but the products of a subtle, psychological game, and that Russian cari-
cature was, and is, directed not so much at an external or an isolated
enemy as at the corrosive forces within the whole of Russian society. As
the Mayor shouted at the end of Gogol's play *The Inspector-General,*
"What are you laughing at? You're laughing at yourselves."

But even beyond this element of inversion, there seems to be a
further characteristic identifiable in particuar with nineteenth-century
Russian caricature—i.e., caricature as the parody of an established ar-
tistic esthetic. In this context, a favorite term of the twentieth-century
Russian avant-garde can be employed with some benefit—that of *sdvig*
(shift, displacement)—and application of this concept to Russian cul-
ture of the first half of the nineteenth century brings surprising results.
The essence of caricature is displacement or deliberate misplacement of
emphasis. This element of distortion or rupture can be associated with
many literary and artistic phenomena of eighteenth- and nineteenth-
century Russia, from the *parsuna* to Gogol's *Dead Souls*. When these
works first appeared, they were deviations from the norm—"displaced"
vis-à-vis the accepted esthetic, creating in turn an "antiesthetic." The
distorting mirror in Venetsianov's drawing of an aristocrat beside his
mistress might be taken as an allegory of this entire procedure.

How did the caricature manifest this alternative esthetic? It did so by
breaking with academic canons, which meant rejecting the past tense in
favor of the present, concentrating on factual reality and not on
abstracted history, exaggerating certain features and thereby undermin-

ing pictorial harmony and symmetry. Consequently, the caricature emerges not only as the interpretation of a given personage, e.g., Napoleon, but also as the caricature of the fine arts themselves, the parody of an entire genre. This notion of the pictorial caricature as artistic parody finds immediate parallels in nineteenth-century Russian literature, where many of the central masterpieces of fiction are also distortions or hyperboles of the genres they represent. For example, Pushkin's *Evgenii Onegin* (1823–30) is a long poem, although it is subtitled a "novel in verse"; Lermontov's *Hero of Our Time* (1840) defies literary categorization inasmuch as it incorporates elements of the travelogue, the diary, and the picaresque novel; Gogol's *Dead Souls* (1830s–40s), subtitled *poema* (epic poem), can hardly be accommodated under the rubric of novel.

Thematically, all three of the above literary works depend on caricature as a narrative device: Onegin is the caricature of the St. Petersburg gentleman, Pechorin of the romantic hero, Chichikov and his acquaintances of their real-life counterparts. In *Hero of Our Time* and *Dead Souls,* in particular, the "antiesthetic" principles identified with pictorial caricature are central to the progression of the texts: both rely substantially on the present tense, both pretend to describe actual situations, both distort that reality. Moreover, just as the pictorial caricature deals with a single, specific item of transient importance, so *Hero of Our Time* and *Dead Souls* depend largely on the episode or "still" for their effect, so that page sequence is of secondary value and separate sections can be interchanged without harming the textual fabric. Other elements of the pictorial caricature can be readily associated with *Hero of Our Time* and *Dead Souls.* In the Napoleonic caricatures, Napoleon is the center of a gigantic deception, although he himself is not aware of ridicule or incongruity. Similarly, Pechorin, in the chapter entitled "Taman'," is unable to recognize the real nature of his environment and is duped by the blind boy and his sister. The landowners described in *Dead Souls* are doubly grotesque since they do not perceive their own absurdity and degradation. Finally, if pictorial caricature operates by a constant interchange of affirmation and negation (e.g., "Napoleon Forms a New Army—from Various Freaks and Cripples"), both *Hero of Our Time* and *Dead Souls* function in the same way, with negative modifiers playing a crucial role in the progression of the text. In *Hero of Our Time,* for example, we read: "I spare you a description of the mountains, I spare you exclamations that express nothing, pictures that depict nothing particularly for those who have not been there, or statistical remarks that absolutely no one will read. . . ."[16] The constant detonation of the image reaches absurd proportions in *Dead Souls,* which, as its title suggests, makes extensive use of the double negative ("he was not a

handsome man, but was not ugly either, he was not too fat and not too thin"; "And often unexpectedly, in a remote, forgotten out-of-the-way place, in an uninhabited place without people").[17] The result is a displaced, perverse world in which normal sequences are broken, in which insignificant phenomena take on hyperbolic proportions.

If *Dead Souls* marked the culmination of the literary "antiesthetic" in the first half of the nineteenth century, then what was its visual counterpart? The answer to this question is to be found in the last drawings of Fedotov, an artist who satirized Russian mores in paintings such as *The Major's Marriage Proposal* (1849). Fedotov's pencil studies for his canvas *The Gamblers* (1852; fig. 12.6), executed shortly before his death, contain the same progression of negations evident in *Dead Souls.* The only difference lies in the fact that Gogol provides light relief and exotic entertainment whereas Fedotov forces the viewer to remain within a claustrophobic interior. As if in a dream or distorting mirror, each component in these drawings is affirmed and then immediately negated: in "Gambler at the Table" the table misses a leg, the gambler and his chair are out of line, his companion has no head. This work is a parody of pictorial rules, just as *Dead Souls* is a paraody of literary form.

The nineteenth-century Russian caricature, whether as a direct sociopolitical comment or as a critical paraphrase of the fine arts, constituted an alternative and dissident tradition. One might even argue that Russian realism of the 1860s–80s, indebted to Fedotov, was the culmination of this process of parody. By its very nature, Russian realism was antiesthetic, a distortion of the sacred and noble art, even though its content, or course, was "true to life." In other words, nineteenth-century Russian caricature assumed the role formerly allotted to the *lubok* and other popular arts and contributed directly to the whole notion of "antiart," including realism and the twentieth-century avant-garde.

NOTES

1. Mention should be made of the following: N. Vrangel', *Orest Adamovich Kiprenskii* (St. Petersburg: Sirius, 1912) (exhibition catalog); *Venetsianov* (St. Petersburg: Sirius [1911]) (exhibition catalog); "Stranichka iz khudozhestvennoi zhizni nachala XIX veka," *Starye gody* (St. Petersburg), May 1907, pp. 155–62; "Dvenadtsatyi god i inostrannye khudozhniki XIX veka v Rossii," ibid., July–September 1912. Vereshchagin's critical works are of particular value to the study of the Russian graphic arts. See *Russkie illiustrirovannye izdanniia XVIII i*

XIX stoletii (St. Petersburg: Kirshbaum, 1898); *Russkaia karikatura: V.F. Timm* (St. Petersburg, 1911); *Russkaia karikatura II: Otechestvennaia voina* (St. Petersburg: Sirius, 1912); *Russkaia karikatura III: A.O. Orlovskii* (St. Petersburg: Sirius, 1913); *Pamiati proshlogo* (St. Petersburg: Sirius, 1914). Of the several editions issued by the Circle of Lovers of Fine Russian Editions in St. Petersburg, Vereshchagin's *Materialy dlia bibliografii russkikh illiustrirovannykh izdanni,* 1908–10, is of considerable value. For a list of relevant editions, see V. Vereshchagin, "Kruzhok liubitelei iziashchunykh izdanii," in *Vremennik Obshchestva druzei russkoi knigi* (Paris, 1928), no. 1, pp. 73–84.

2. This according to Vereshchagin. See his *Russkie illiustrirovannye izdaniia,* p. XIX.

3. Orlovsky was one of the first artists in Russia to produce caricatures of prominent personalities and, beginning in 1816, to reproduce satirical scenes in lithograph. Among his more famous caricatures is the one of the architect Quarenghi of 1810–12. For information on Orlovsky, see Vereshchagin, *Russkaia karikatura III;* E. Atsarkina, *Aleksandr Orlovskii* (Moscow: Iskusstvo, 1971); *Alexander Orlowski (1777–1832): A Slection of His Works from the Collection of Dr. R. Krystyna Tolcznska Dietrich and the Late Albert George Dietrich* (Hanover, N.H.: Dartmouth College, 1973) (exhibition catalog).

4. I. Andreevskii, ed., *Entsiklopedicheskii slovar'* (St. Petersburg: Brokgauz and Efron, 1890–1904), vol. 74 (1903), p. 951.

5. This according to N. Moleva and E. Beliutin, *Russkaia khudozhestvennaia shkola pervoi poloviny XIX veka* (Moscow: Iskusstvo, 1963), pp. 82–83.

6. Vereshchagin, *Russkaia karikatura II,* p. 97.

7. The most detailed source of information on all three artists is Vereshchagin's *Russkaia karikatura II.* See also T. Cherkesova, "Politicheskaia grafika epokhi Otechestvennoi voiny 1812 goda i ee sozdateli," in *Russkoe iskusstvo XVIII-pervoi poloviny XIX veka,* ed. T. Cherkesova (Moscow: Iskusstvo, 1971), pp. 11–47; A. Kaganovich, *I. I. Terebenev* (Moscow: Iskusstvo, 1956); A. Savinov, *Venetsianov* (Moscow: Iskusstvo, 1955). Information and illustrations concerning the Russian caricatures of the Napoleonic era will also be found in J. Bowlt, "Art and Violence: The Russian Caricature in the Early Nineteenth and Early Twentieth Centuries," in *20th Century Studies* (Canterbury, England, 1973), no. 13–14, pp. 56–76 (the present article uses some of the data published there); A. Sidorov, *Risunok starykh russkikh masterov* (Moscow: Akademiia nauk, 1956); *Russische Graphik des 19. und 20. Jahrhunderts* (Nürnberg: Albrecht Dürer Gesellschaft, 1977) (exhibition catalog).

8. The titles of the Terebenev caricatures published in England are given in Cherkesova, p. 46, note 40. Cruikshank copied Terebenev's *Napoleonova slava* (*The Glory of Napoleon*).

9. Quoted from Vereshchagin, *Russkaia karikatura II,* p. 58. It seems probable that this particular caricature, entitled *Vel'mozha* (*The Grandee*), was a free illustration to Gavriil Derzhavin's ode of the same name (1794). For information on this possible parallel, see Savinov, *Venetsianov,* p. 28.

10. For information on these illustrated satirical journals, see S. Trubachev, "Kratkii ocherk istorii karikatury v Rossii," in *Istorria karikatury,* ed. A. Shevyrov (St. Petersburg: Panteleev, 1903), pp. 369–404; K. Kuz'minskii, *Russkaia realisticheskaia illiustratsiia XVIII i XIX vv.* (Moscow: Izogiz, 1937); G. Lebedev, *Russkaia knizhnaia illiustratsiia XIX v.* (Moscow: Iskusstvo, 1952); A. Sidorov, *Risunok russkikh masterov* (Moscow: Akademiia nauk, 1960); *Russische Graphik.*

11. For information on Timm, see Vereshchagin, *Russkaia karikatura: V.F. Timm.*

12. *Dnevnik A. S. Suvorina* (1923). Quoted in V. Botsianovskii and E. Gollerbakh, *Russkaia satira pervoi revoliustii 1905–1906* (Leningrad: Gosudarstvennoe izdatel'stvo, 1925), p. 11.

13. For information on Shcherbov, see A. Savinov, *P. E. Shcherbov* (Leningrad: Khudozhnik RSFSR, 1969).

14. For information on their contributions to the 1905–1906 journals, see Botsianovskii and Gollerbakh, *Russkaia satira;* V. Shleev, *Revoliutsiia 1905–1907 godov i izobrazitel'noe iskusstvo* (Moscow: Izobrazitel'noe iskusstvo, 1977).

15. The incident is reported in Botsianovsky and Gollerbakh, *Russkaia satira,* p. 13.

16. M. Lermontov, *Geroi nashego vremeni* (Moscow-Leningrad: Detskaia literatura, 1948), p. 80. I am indebted to Professor Frantisek Galan for drawing my attention to the incongruous literary form of this literary work and to the disproportionate number of negatives.

17. N. Gogol'; *Mertvye dushi* (Moscow: Khudozhestvennaia literatura, 1964), pp. 5, 333.

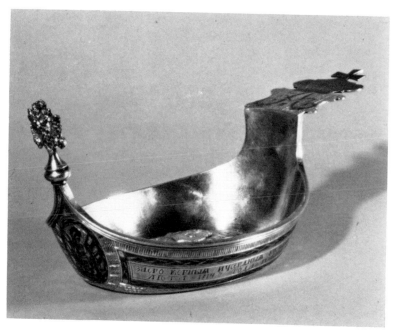

11.1 Vasilii Popov, Gilded silver and niello kovsh presented by Alexander I to Ataman Mikhailov

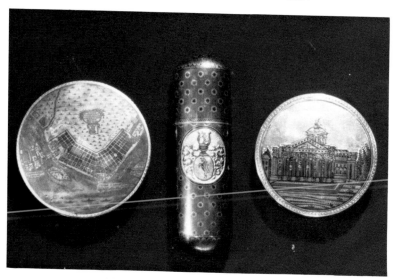

11.2 Three gilded silver and niello boxes, one including a view of Arkhangelsk

11.3 Ivan Zaitzov, Gilded silver "coronation" platter intended for Grand D Konstantin Pavlovich

11.4 D. Andreyev, Monumental silver icon of the "Tsar of Tsars"

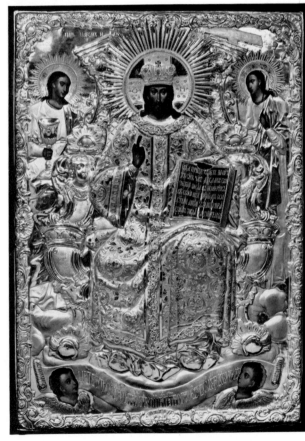

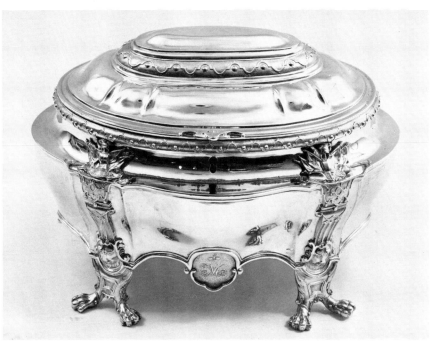

11.5 Carl Johann Tegelsten for Nichols and Plinke, one of a pair of silver jewel chests made for the marriage of Grand Duchess Maria Nikolaevna, eldest daughter of Nicholas I, and the Duke of Leuchtenberg

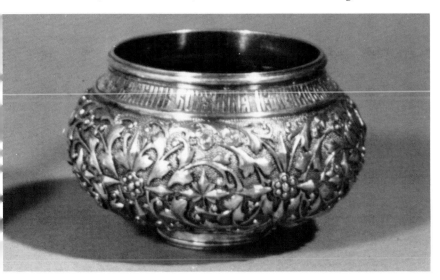

11.6 Pavel Sazikov, Gilded silver "copy of the Bratina of the Boyar Izmailov conserved in the Moscow Arms Palace"

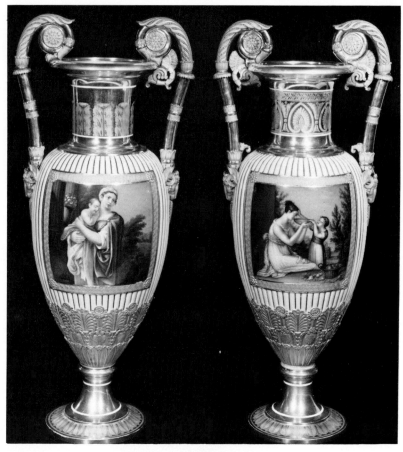

11.7 Russian Imperial Porcelain Factory, Pair of
Alexander I gilded and painted porcelain urns

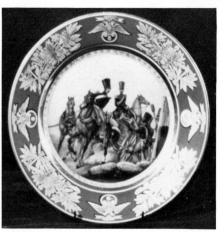

11.8 Russian Imperial Porcelain
Factory, Gilded and painted military
plate with green border

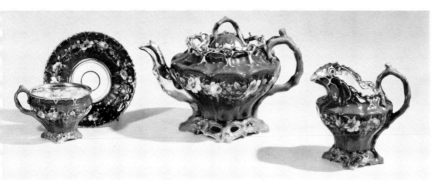

11.9 Kornilov Porcelain Factory, Rococo revival
porcelain tea set—blue, coral, and gilt with flowers

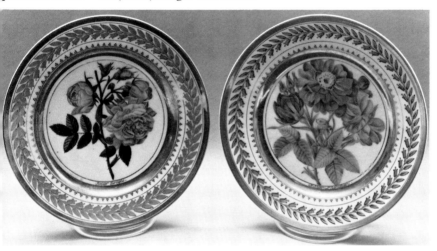

11.10 Yusoupov Porcelain Factory, Porcelain plates
decorated with roses after Redouté

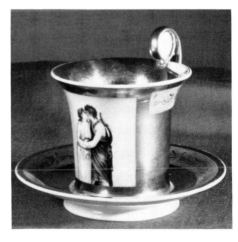

11.11 Sergei Batenin Porcelain
Factory, Gilded and painted porcelain
cup and saucer

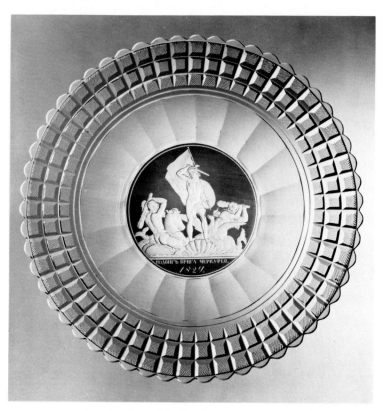

11.12 Russian Imperial Glass Factory, Cut crystal plate
with yellow center depicting the "Victory over the Brig
Mercury, 1829," modeled by Count Fedor Tolstoi

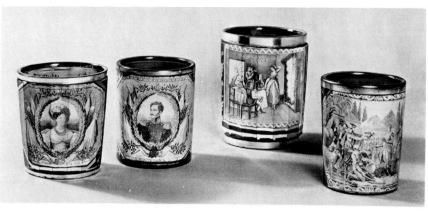

11.13 Russian Imperial Glass Factory, Blue glass transfer-decorated beakers

11.14 Peterhof Lapidary Works, Large malachite vase made to commemorate the wedding of Grand Duchess Maria Nikolaevna and the Duke of Leuchtenberg

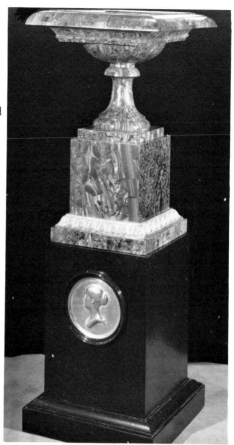

11.15 Lukutin Factory, Two lacquer boxes

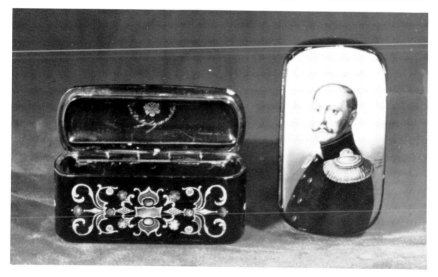

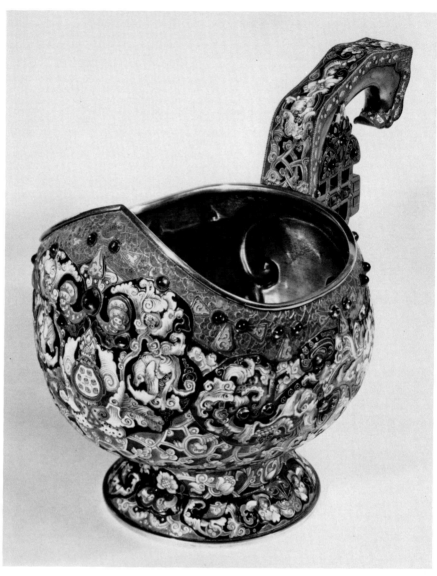

11.16 Fabergé, Jewelled cloisonné enamel kovsh
executed in the seventeenth-century style

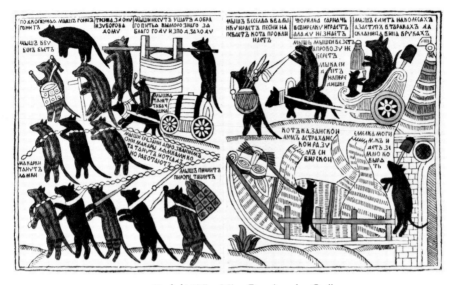

12.1 *(Lubok)* "The Mice Burying the Cat"

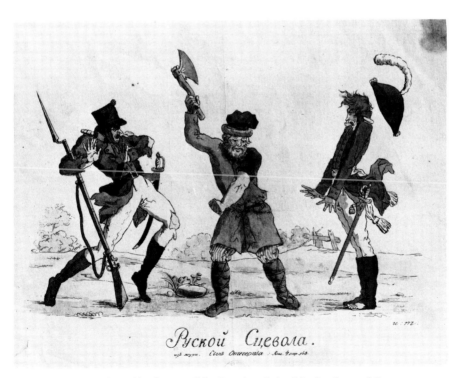

12.2 Ivan Terebenev, "The Russian Gaius Mucius Scaevola"

12.3 Aleksandr A. Agin,
Illustration to Nikolai
Gogol's *Dead Souls*

12.4 George Wilhelm Timm,
"Artists' Ball, 9 December 1860"

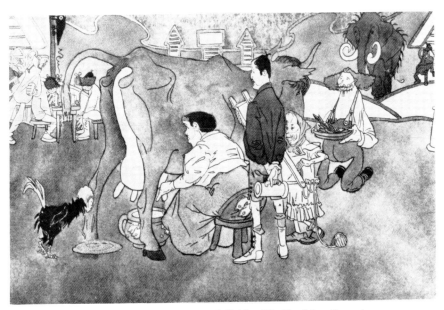

12.5 Pavel E. Shcherbov, *Idyll* (The World of Art Group)

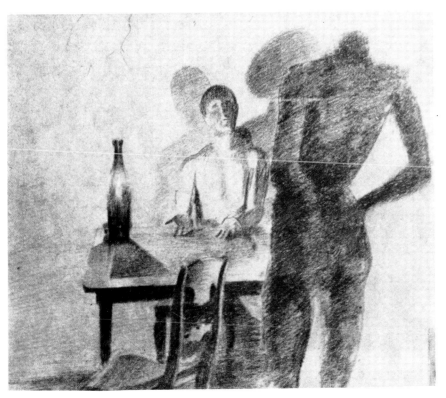

12.6 Pavel A. Fedotov, Study for *The Gamblers*

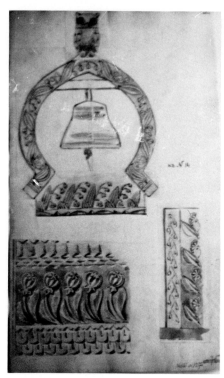

13.1 Elena Polenova, Ornamental motifs from Russian peasant carving

13.2 Embroidered towel border

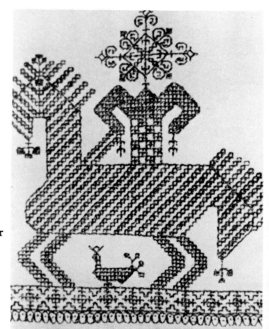

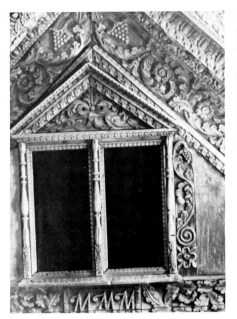

13.3 Carved pediment and window frame

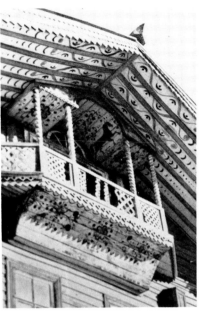

13.4 Carved and painted eaves of a village house

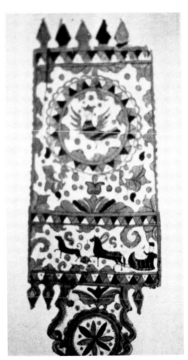

13.5 Distaff (detail), "Sirin"

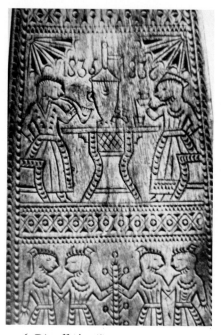

13.6 Distaff (detail)

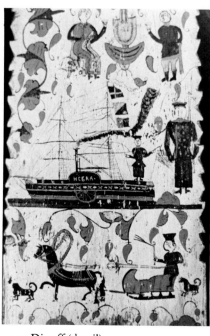

13.7 Distaff (detail)

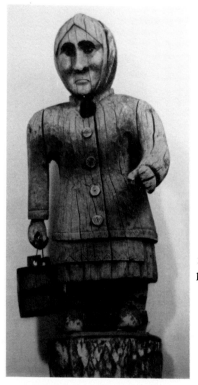

13.8 Starling box in the shape of a
peasant woman (one of a pair)

13.9 Vasilii A. Raev, *View of Ostankino Park*

13.10 Vasilii A. Tropinin,
Boy with a Zhaleyka (Pipe)

13.11 Ignatii S. Shchedrovsky, *Landscape with Hunters*

13.12 Grigorii V. Soroka, *A Chapel in the Village of Ostrovki*

13

Russian Folk Art and "High" Art in the Early Nineteenth Century
Alison Hilton

INTRODUCTION

"OUR GOAL is to capture the still living creative spirit of the people and give it the opportunity to revive."[1] The words of one of the artists who took part in efforts to preserve Russian folk arts in the 1880s and 1890s reflect a concern for national artistic traditions that stimulated comparable efforts in Western Europe countries. An outgrowth of romantic historicism, the concept of a homogeneous "folk" community with a continuous artistic tradition was already anachronistic at a time when industrial and commercial development and the new requirements of cities and towns had already affected the traditional crafts of rural Russia. For example, the town of Sergeievo (now Zagorsk), which had grown up around the Trinity-Sergius Monastery, was the center of a successful toy-making enterprise, with over three hundred shops employing a thousand artisans; in the year 1879 alone, the town produced and shipped to Moscow well over 750,000 pounds of wood and papier-mâché toys. Other traditional crafts, formerly based in peasant villages, were also subject to pressures for quantity of production at the expense of quality and originality. At the same time, machine-made products were beginning to supplant handcrafted items, such as the painted and lacquered dishes from Khokhloma, which could not compete in the marketplace. Indeed, one of the chief concerns of the early collectors and students of folk art was to protect the traditional crafts from the dual threats of exploitation and neglect.

The first major steps toward the protection of folk art were taken at Abramtsevo, a country estate only a few miles from Sergeievo; its owner, the businessman Savva Mamontov, invited some of the leading artists of the period to live and work there.[2] Elizaveta Mamontova, Elena Polenova, and others founded carpentry and crafts workshops in order to provide training for local peasants, to give them both a pride in their

own traditions and a practical livelihood.[3] The artists also collected examples of folk art and recorded, by means of sketches and photographs, the stylistic variety of architectural decoration, painted and carved ornamentation on utilitarian objects, and regional costumes—in Polenova's words: "that which was taken directly from the soil, . . . examples which I managed to collect in the villages, the isolated provincial towns and the monasteries."[4] Polenova and her pupils used these records as the basis for new ornamental patterns for cupboards and chair-backs and even for book illustrations and stage settings (fig. 13.1). Although they were later criticized for adulterating their sources by applying forms taken from architecture to embroidery or those from embroidery to furniture, this practice was not wholly foreign to the spirit of folk art. As even the limited collection at Abramtsevo would show, there were a few basic ornamental motifs, which could be found in all types of folk art. The most important contribution of the Abramtsevo workshops was the reintegration of ornamental with utilitarian forms and the reintroduction of traditional esthetic values, familiar to the peasants, into the tools and tasks of everyday life.

The role of the applied arts in the eyes of the major painters who worked at Abramtsevo was important from another point of view as well. Whereas the image of the peasant had become a significant thematic element in Russian realist painting in the mid-nineteenth century, it is generally assumed that the styles of the folk arts were appreciated only very late in the century, by such artists as Polenova and Viktor Vasnetsov, and that an identifiable "folk esthetic" began to play a role only with the development of neoprimitivist styles by Natalia Goncharova, Mikhail Larionov, Kazimir Malevich, and other artists early in the twentieth century.[5] Nonetheless, signs of a subtle interrelationship between folk and "high" art may be seen much earlier in the nineteenth century in the work of a small group of trained "serf artists" and, in a more general way, in some areas of the applied arts where the rural Russian and the urban, Western-oriented artistic traditions ran parallel to or intersected one another. One aim of this chapter is to explore some aspects of this area of intersection. The first part will describe the traditional folk arts of woodcarving and painting on wood, with excursions into other media, such as weaving and embroidery, to show the range of certain motifs and styles. The second section will concern the makers of folk art, the peasants and village craftsmen and the serf artisans employed by aristocratic property-holders, and will discuss the relationships between the makers and users of handcrafted objects. The final section will raise the question of the position of folk art in relation to the dominant culture in Russia and will suggest how, if at all, the folk arts may have influenced the styles of "high" art in the first half of the nineteenth century.

FOLK ART TRADITIONS IN WOOD

The crafts and skills needed to make the dwellings, clothing, and farming and domestic implements basic to peasant life were, of course, practiced from earliest times. The more specialized arts of ornamental carving and painting, pattern-weaving and embroidery, pottery and stove tile-making, metalwork, and bone-carving developed over the centuries in distinctive ways in the various regions of Russia. Until the eighteenth century, the isolation of rural areas insured the preservation of local decorative motifs and techniques and local preferences for certain color combinations, geometrical or foliage forms of ornament, or for particular materials. Although itinerant craftsmen and peddlers brought about some diffusion of forms and styles, there was very little change in the regional styles. Indeed, the conservative nature of the folk arts has made it possible for scholars to classify pieces according to their geographical origins. Dating involves different problems. Most of the basic motifs used by peasant craftsmen came from a common stock of symbolic and ritual images—such as the Tree of Life or heraldic mounted figures (fig. 13.2) dating from pre-Mongol and even pre-Christian times. New forms appeared, generally speaking, in response to specific events or changes, such as Peter the Great's westernizing campaign, the invasion of Russia by Napoleon, and the emancipation of the serfs. Scholars in the field of Russian folk art have suggested that if one overlooked the specific, topical motifs related to events of the seventeenth and nineteenth centuries, what would remain in the pool of forms would be those which originated in pagan Russia.[6] These ancient forms have been extensively studied.[7] However, the new motifs that appeared alongside them in more recent times were, to a great extent, what gave to Russian folk art the vitality and spontaneity so highly valued by late nineteenth- and twentieth-century admirers. The distinctive qualities of the newer elements and the conjunction and interaction of the traditional with the topical in the eighteenth and nineteenth centuries are equally important to an understanding of folk art. The terms "folk art," "peasant art," "popular art," and "handcrafts" are used interchangeably for objects made by peasants for their own use or, in the case of more specialized crafts, for barter with other peasants. They may also refer to objects made by professional artisans in towns for sale or trade, such as the satirical or didactic broadsides known as *lubki.*[8] The term "serf art," on the other hand, applies to a wholly different category of works that were made for wealthy, cosmopolitan landowners by serfs who were specially trained in such arts as scroll-carving, gilding, wood inlay, or painting, just as other serfs were trained in singing, dancing, dressmaking or pastry-cooking. A purist approach to folk art might exclude the third category or even the second. But in the late

eighteenth and nineteenth centuries, the three areas came into frequent contact, which resulted in some sharing of motifs and mutual influences in styles.

The traditional folk arts include the following primary types: (1) woodworking, including architectural ornament (carved window and door frames, pediments, and roof edging), carts, sleds, furniture, and implements for domestic use (distaffs, mangles, storage chests, cradles, boxes, bowls, gingerbread molds); (2) textiles for clothing, towels, valances, and other special functions; (3) work in other media such as ceramics, iron and steelwork, toy-making, and printing of textiles and *lubki,* which were not so widely practiced as the primary wood and textile crafts. While this discussion will focus on only a small selection of wood objects, it will attempt to illustrate the distinctive stylistic elements of Russian folk art that are found in all its branches. These characteristics include: (1) a deep-rooted respect for the material and its organic nature; (2) a close connection between the plastic form of an object and the kinds of ornamentation on its surface; (3) the prevalance of a distinct repertoire of forms from nature (e.g., the sun, tree, horse, snow leopard, and lion) as well as fanciful forms (the male and female figures with fish tails, the *sirin* or woman-faced bird, all beneficient beings), which may be stylized or even reduced to geometrical forms and either used as central decorative elements or worked into border ornament; and (4) the mingling of such traditional, symbolic forms with figures, animals, and objects from everyday life.

The major stylistic changes that occurred in the eighteenth century may be summarized only in a most general way: (1) An increasing ornamentalism, partly attributable to the incorporation of baroque and rococo ornamental forms (and, early in the nineteenth century, the contrasting influence of the Empire style) becomes especially evident in architectural ornament. (2) Surface decoration becomes more profuse and independent of traditional shapes of utilitarian objects. (3) The traditional symbolic images are accompanied and gradually replaced by genre scenes, such as tea-drinking, promenading, and riding in carriages or sleighs, and quite specific details of costume, gesture, and surroundings replace the schematic and conventionalized floral or geometrical patterns of earlier work. While they do not account for the enormous variety of regional and individual styles, these observations offer a focus for identifying distinctive changes in the styles and kinds of imagery found in traditional folk art.

Architectural wood sculpture of the region along the Volga and the north provides the only existing examples of large-scale folk art. Carved and sometimes painted horizontal and vertical boards decorated the façades of long houses and accented their structural articulations—the

windows, doors, pediments, corners, and sometimes gates (figs. 13.3, 13.4). Depending on regional custom and individual preferences, the builders either confined the decoration to a few key areas, thus creating a contrast between these zones and the large, flat areas of wall (this was common in the north, where houses had to be large enough to hold entire households, complete with livestock, in the winter), or they might fill nearly an entire façade with carving. Designs and images were cut in deep relief so that they could be seen from some distance. The carvers took advantage of both the grain of the wood and the shadows cast by the sun to produce emphatic contours.

Among the traditional motifs, the most frequent are the *beregini* or protectors, fantastic creatures derived from mythological sources, usually in the forms of male or female figures with fish tails, or a creature with a woman's face on a bird's body.[9] Lions and other animals, which may originally have had protective or apotropaic functions, are frequently seen cavorting with almost playful expressions on their highly individualized faces. Besides the figures carved in relief, most houses in the north displayed three-dimensional figures of houses, deer, ducks, or mermaids, which were carved from or attached to the end of the projecting ridge beam of the roof. The horse was by far the most popular form; similar, schematized horses were made as children's toys and as functional but decorative parts of tools for daily work. Often found on distaffs, looms, and other women's tools, these horse forms may be related to the ornaments and ritual objects found in pagan burials, which were apparently exclusively related to women.[10] In general, though, they may be seen as benign and protective beings that, in the course of time, came to be taken for granted as customary and necessary architectural elements.

Russian architectural ornament features some details derived from Byzantine sources (e.g., the motif of two birds flanking a bunch of grapes is similar to some pierced stone capitals at Ravenna), by way of icons, printed designs, or even details of carving in Russian churches. But to complicate matters, elements that are surprisingly similar to those of European Renaissance, baroque, and Empire styles of architectural ornamentation frequently appear in some façades; zoomorphic and floral ornaments similar to those found on other types of folk art are juxtaposed with columns, cartouches, swags, vases, bunches of grapes, pomegranates, and acanthus leaves evidently seen on European-style town dwellings or in prints showing such styles. The eclecticism does not detract from the most remarkable quality of Russian folk architecture: the complete integration of a variety of decorative forms and the expression of the main elements of structure and function through the visual elaboration of key architectural forms.

One of the most widely distributed types of domestic implement was the distaff or *prialka* used to hold wool or flax for spinning thread (fig. 13.5). Its basic form and method of use remained unchanged for centuries, as can be seen in representations on icons, in children's toys and on the distaffs themselves. As the chief tool for one of women's most important domestic tasks, the distaff was lovingly and elaborately decorated, often made as a gift from a young man to his fiancée or from a father to his newly married daughter. It was a symbol of the young woman's assumption of the responsibilities of family life. Decoration was important for another reason as well. Girls and women often did their spinning together, making a festive occasion at which young men would entertain them with songs. They would wear their best clothes, and the carving or painting on the distaffs would count as part of their finery.

Most distaffs consist of a large, usually flat upright blade (*lopastka*) joined at the right angle to a base (*dontse*) on which the spinner sat and balanced the blade by the weight of her body. In the Iaroslavl region, the upright portion was generally in the form of an intricately carved tower or ladder, but in other regions it was usually flat and rather broad. Both the blade and the base offered ideal surfaces for embellishment, and the multiplicity of variations achieved by the use of standard decorative forms provides a rich field for the study of traditional techniques and styles.[11] The earliest and most important means of decoration was relief carving; three basic technqiues were used, as in almost all traditional woodwork. The most widespread was based on pyramidal or wedge-shaped incisions, which could be arranged in various ways to create rosettes, chains of zigzags or diamonds, overall diaper patterns and many other geometrical forms. Similar patterns were used in block-printed textiles. The second method involved scraping or planing to develop forms in shallow relief. The third and most adaptable was contour or outline cutting (*uzor*) with a sharp knife, which could produce a silhouette effect, particularly vivid in foliage patterns, or vigorous calligraphic lines. All these techniques were used in various combinations, sometimes with the addition of special regional variations, such as the use of inlay or incrustation practiced in the Gorodets region, in which thin veneers of oak, water-seasoned to raise the grain, were cut out to fit major areas of design, such as a horse and the cloak of its rider.

Painting was not as universal as carved decoration, but it also varied in style from region to region.[12] The main types included: representational painting of individual scenes, sometimes with dates or other personal inscriptions; decorative painting featuring stylized floral, animal, and human forms along with abstract shapes, painted quite freely in bright, unmodulated colors (chiefly red, yellow, and green); painting

with clear, emphatic contour lines, which sometimes take on an expressive function almost independent of the colored forms, filling most of the surface with a lively interplay of curving and straight lines and patches of color; and finally, a comparatively late and simple manner of decorating, in which geometrical designs were filled in with various colors (red, yellow, and green were gradually replaced by blues, lilacs, yellows, and softer pinks in the nineteenth century). Several styles may appear in a single piece. The motifs used to decorate distaffs are quite varied but seem to adhere to certain established conventions. Traditionally, the upper section of the blade shows a comparatively formal composition of older motifs, such as the tree of life flanked by two figures on horseback, while the lower section may contain a genre scene.[13] One example from the North Dvina region combines the traditional and genre elements in a remarkably natural way and is especially interesting because it shows a distaff in use. The domestic interior, in which two women work while their dog begs for attention, is enlivened by a luxuriantly twining vine bearing enormous blossoms (an example of the contour-line style mentioned above). Above the room, framed by a geometrical border, is a frieze of pigeons on a flower-strewn ledge (a domestic detail given an ornamental function), and above them, flanking the roof-peak, are two heraldic birds, which derive from a much earlier tradition. A painted distaff from Gorodets dating from the 1870s displays two scenes, one traditional and the other contemporary, separated by a band of flowers on a dark blue ground. Above, a tree with elaborate blossoms (the ancient tree of life) supports a brightly plumed bird and is flanked by two riders. This heraldic composition may be found in many other distaffs and in other media, most frequently in embroidered towel borders. Below the floral border is a tea-party scene with a hostess pouring tea from a samovar for her husband and inlaws, who have just arrived. Although the chair and table are only barely indicated, the details of costumes and such obviously prized possessions as the chime clock are carefully depicted.

In some cases genre scenes such as tea-drinking seem to take on almost ceremonial importance. In contrast to the informal but highly particularized party just described, a carved distaff from the Iaroslavl region, dating from 1835–36, shows a man and wife at either side of an enormous samovar, almost like heraldic figures flanking a tree of life. (fig. 13.6). The stylization of the figures contributes to the overall formality of the effect. The main features of the costumes and furniture are indicated with precisely the same abstract patterns used to enliven the borders, and this device, which is also used to define the paired figures of girls in the quadrille scene below, keeps the genre element firmly within the framework of the geometrical composition.

Sometimes the decorations on distaffs present amusing combinations

of the traditional and the modern, the formal and the casual. One example from the remote Arkhangel region (late nineteenth century) combines two vigorous outdoor scenes—a paddle-boat with smoke streaming and flags waving above a horse-drawn sleigh flanked by two dogs—with a formal samovar motif (fig. 13.7).

Other objects for domestic use illustrate the ingenuity and inherent sense of style by which specific forms were made to express particular functions. For instance, a *rubel* in the Zagorsk museum, a tool for smoothing homespun linen, displays the full range of geometric patterns based on the traditional three-edged incision, and these patterns also echo the grooves on the utilitarian underside of the *rubel*. The handle on this piece was made in the shape of a horse, which might be imagined to gallop across the linen with the rocking motion of the tool. Saltcellars and dippers were frequently made in the shape of a duck with extended neck and beak. The shape is peculiarly appropriate to such vessels in both the formal sense and the more fanciful metaphorical sense: one might readily visualize a full-bodied duck floating on a lake or dipping under the water. Among the most individual examples of Russian wood sculpture are a beehive in the shape of a standing bear and two unique starling houses (a pair, dated 1870, fig. 13.8), which might well be portraits of the couple who owned them.

Even the few examples of traditional carved or painted woodwork that we have surveyed give evidence both of the artists' notation of new phenomena, such as the steamboat and the rifle, and of their ability to integrate these new images into their traditional repertoires. Because the symbolic forms of earlier art—the tree of life, the bird, horse, mermaid, and so on—had lost their original religious or cult meanings and acquired new associations by the eighteenth century, it was possible for peasant artists to make use of these forms as primary design elements or even, without undue confusion, to bring them up to date (as in the hunting scenes with rifles or promenades with displays of recent fashions). Thus the iconographical elements were transmitted and preserved as decorative rather than symbolic forms.

It is also worth noting another aspect of traditionalism in folk art. Once the new genre scenes became established, they changed scarcely more than the most traditional motifs. The same kinds of scenes—tea-drinking, going for walks or rides, a few interludes of domestic work—were repeated again and again, while other likely scenes, for instance, cooking or plowing, seem to be ignored. It is probable that some of these preferences for certain subjects were reinforced in the nineteenth century by the growth in importance of the regional markets at which craftsmen could sell distaffs, bowls, and other utensils.[14] They would tend to repeat favorite motifs for trade, in order to fulfill a known demand.

The pioneering studies of Russian folk art by Voronov, Vasilenko, Nekrasova, and others stressed the fact that the arts of the Russian peasants were not static and unchanging, though they were slow to change. The preservation and repetition of certain traditional designs, special color combinations, and motifs, as well as the gradual adoption and integration of new forms, also seems to show something about the nature of peasant life in Russia: isolated from centers of activity and change, it had its own natural pace of development. Hard as the lot of the peasants was, no sense of disjunction or disharmony between the ancient and the recent or between the natural materials and the man-made decoration of their houses, clothing, and tools is to be found in the traditional peasant crafts.

SERF ARTISANS AND ARTISTS

Changes in the style and artistic level of Russian folk art in the late eighteenth century have been related to increasing contact between rural villages and large towns and trade centers and to the development of markets for particular handcrafted products. These markets were rapidly brought under the control of jobbers, who arranged sales and shipments (they bought wooden utensils and toys by the pound rather than the piece) and paid craftsmen small fixed wages for their work. The decline in quality that resulted from mass production was aggravated by the introducton of cheap, factory-made china and glass utensils in the second half of the nineteenth century. Wooden ware could not be made by hand at competitive prices, and many of the peasant artisans who, after the Emancipation decree of 1861, had left the land to work in village shops, were forced to migrate to the cities.

Paradoxically, a vogue for so-called *style russe* among the urban bourgeoisie in the late 1880s brought about a brief respite for the declining arts of woodcarving and painting. But the situation of the artists and the quality of production scarcely improved; the market for pseudo-Russian furniture and utensils was quickly absorbed by entrepreneurs, who paid artisans fixed wages and put them into an assembly-line production system based on the replication of designs (by pricking out the outlines from a paper pattern) and left no room for the invention of designs by individual artists. Even the well-meaning efforts of the Abramtsevo group to counteract the decline in the folk arts by giving peasants thorough training and maintaining standards of quality were inevitably self-defeating. Direct patronage, whether exploitative or enlightened, meant a loss of independence for the peasant artist.

From the point of view of patronage, the differences between peasant art and serf art are self-evident. Serfs were, by definition, required to fulfill the orders of their masters. Whereas the peasant carver of door

frames or distaffs used techniques and motifs handed down through several generations, the serf artisan employed skills that he had been taught for purposes unfamiliar to him. Thus the integrity of authentic folk art—the natural harmony of folk art and peasant life stressed by admirers of the traditional Russian arts—was not relevant to serf art.

For practical reasons, the use of serfs was essential to the development of the luxury applied arts in Russia. As a case in point, the Englishman Francis Gardner, founder of the first porcelain factory in Russia, was eager to acquire serfs because he was afraid that free artisans, once they had received specialized training, would leave him to set up on their own.[15] In the course of the eighteenth century, the rapidly expanding porcelain industry required many highly trained serfs and free peasants as well. One firm, actually founded by free peasants, made a commercial success of the manufacture of ordinary plates and bowls for use in inns.[16]

On a very different level were the palaces and country houses of aristocrats that were built, furnished, and cared for by serfs. The most spectacular and best-known example was the Ostankino Palace built by the serfs of Count Sheremetev at the end of the eighteenth century. The Sheremetev family was already known for its patronage of the arts, especially for its outstanding corps of serf singers and actors. Though singled out for their abilities and certainly better off than most serfs, these men were not expected to take joy in their work for its own sake, as the report on the building of Ostankino Palace (fig. 13.9) submitted by Count Sheremetev's steward makes all too clear. "Our bonded artisans are working with all conceivable speed, idling neither on holidays nor Sundays, and toiling by candlelight from four o'clock in the morning until ten o'clock at night. And to expedite their labors, a hussar . . . has been detailed to supervise them."[17] The style of the palace and its furnishings presents an intriguing combination of Russian classicism and native ingenuity and fantasy. Built almost entirely of wood, like other great palaces of the period, it was decorated to suggest stonework and plaster. Columns carved from whole tree trunks were painted and burnished to look like marble; wood scrollwork, plinths, vases, and chandeliers were finished with bronze and gilt. The splendid inlay floor, an outstanding feature of the palace, combined a variety of purely formal patterns with designs from nature—flowers, ears of grain, lions, and human figures—in a way that might suggest some elements of traditional peasant woodcarving.

Affinities with the designs found in folk art raise the question of the individuality of the serf artisan and his opportunity for independent creative expression. The question of artistic autonomy did not, of course, mean all that it came to signify later in the nineteenth century.

Nevertheless, even though the majority of the serf artists have remained anonymous, there is evidence that by the early nineteenth century some of the proven masters were allowed some leeway in executing and even designing architectural ornament and furniture. Some pieces, while conforming to neoclassical taste in overall design, feature ornamental details resembling the rosettes and sunflower patterns of folk carving rather than the acanthus leaves and palmettes of European ornament (one such example was made by a serf of the Goncharov family in the 1820s).[18] The presence of such motifs may indicate the owners' taste rather than a feeling for such forms on the part of the artists. There is general agreement, however, that the magnificent design and execution of the architectural ornament, furniture, and other accessories at Ostankino, Pavlovsk, and Tsarskoe Selo represent more than the mere mechanical labor of artisans who followed the requirements of imposed, imported styles.

Decorative and applied art on a scale demanded by the imperial court and aristocracy of the eighteenth century required the training of hundreds of specialists in such arts as ornamental woodcarving, gilding, plasterwork, marquetry and metalwork, goldsmithing, and cameo-cutting, all necessary for the furnishing of the great palaces. Whole cadres of artisans, both free and bonded to the court, received practical training in specialized factories such as the Imperial Porcelain Factory, the Lapidary Works, and the Glass Works, and on major building projects. Those who worked at Tsarskoe Selo and Pavlovsk were supervised by the major architects and masters of the period and were thus directly exposed to both the most recent court styles and the highest standards of quality.[19] In addition, there arose a demand for serfs trained in oil painting, so that masterpieces could be copied when they could not otherwise be obtained. Such training was sponsored by the government, first in a special branch of the Academy of Sciences and later, from 1764, at the Imperial Academy of Arts.[20]

In contrast to the applied arts, painting required not only the mastery of specific techniques but also an acquaintance with historical and mythological subject matter; the profession of painter, in the eighteenth-century sense of historical painter, was beyond the educational opportunities of most serfs. Indeed, to reinforce the distinction between the applied arts, which were still associated with the guild system, and the liberal arts of painting, sculpture, and architecture, the statutes of the Academy of Arts expressly prohibited the enserfment of any graduate of the Academy.[21] Despite enormous difficulties, some artists who were born into serfdom managed to achieve some degree of recognition and, having been granted their freedom, were even able to attend the Academy. It is worth noting, however, that among the

known artists of serf background—Yurii Krylov, G. Kanoshenkin, Vasilii Raev, Vasilii Sadovnikov, Fedor Slaviansky, Grigorii Soroka, Vasilii Tropinin, and Sergei Zarianko among others—some specialized in the "minor" media of graphics and watercolors and painted mainly landscape and genre subjects, whereas none became known as a painter of historical scenes. In fact, a large proportion of their works belong to what might be considered a special category of subjects suitable for serfs: portraits of members of the owners' families, views of estates with the masters' houses, chapels, and peasant villages. There are also a few examples of scenes from the lives of the serfs—field work, a wedding feast, and, in an understandably sympathetic but laconic painting by an unknown artist, the selling of a female serf. Most of these works are reminiscent of *lubki* in composition—figures are lined up across the foreground; gestures and action are limited to a simple sign language; the setting is provided by a few standard forms of trees and houses. Some of the artists were undoubtedly complete amateurs, who modeled their work on a few samples of art in their owners' possession and relied a good deal on observation. But there are many paintings by serf artists that show the effects of careful instruction in the principles of drawing and composition and the handling of colors.

The Academy and the esthetic standards of Western Europe had become almost universally accepted by the late eighteenth and early nineteenth centuries—even provincial towns had their drawing schools taught by graduates of the Academy—and the pervasiveness of the academic system played a role in reducing stylistic naïveté and provincialism. Even the itinerant artists, who often combined the functions of peddler, storyteller, barber, portrait painter, and icon painter, and who were certainly outside the academic bailiwick, seem to have been touched by notions of professionalism. In the 1850s, a certain Trofim Chaplygin, an itinerant tailor and painter, entertained the young Ilia Repin and his friends with his lifelike (and mouth-watering) paintings of watermelons and other fruits and his fascinating portrayals of real people and mythological creatures. He also took pains to stock his small studio properly and to refer to his pigments by their special names (lazure, gamboge, tuche, and so on)—a habit that impressed the young Repin.[22] By the mid-nineteenth century, most of those artists from serf or lower-class background who, like Repin, were fortunate enough to study at the Academy and so obtain the civil rank necessary for personal advancement, were anxious to disassociate themselves from serfdom and its deprivations and adapt themselves to the requirements of academic art as quickly and thoroughly as possible.[23]

Two special cases of artists who received training in the academic tradition and yet did not lose their connection with their serf origins

stand out in the art of the 1830s and 1840s. Vasilii Tropinin, born a serf, trained at the St. Petersburg Academy, was well known for his attractive portraits of both gentry and peasants and his delicately sentimental genre paintings (fig. 13.10). Aleksei Venetsianov, a small property owner who retired from his minor bureaucratic job in order to teach painting to the serfs on his own and neighboring estates, founded a distinctively Russian school of genre painting. Venetsianov, in particular, not only introduced new images of peasant life into Russian nineteenth-century painting but to some degree encouraged the qualities of freshness and immediacy of peasant art as he educated his pupils' native talents.

CONCLUSION. FOLK ART AND EARLY NINETEENTH-CENTURY GENRE: STYLE AND IMAGERY

Can we say that the traditional arts of the Russian peasants had some direct influence on the styles of early nineteenth-century painting? The question might be approached in a variety of ways. Numerous details in paintings by Venetsianov and his pupils show the artists' awareness of traditional handcrafts, costumes, and activities of peasant life. Some artists drew or painted subjects related to those favored by the makers of distaffs and peasant toys (the lithographs of Kapiton Zelentsov, Pavel Aleksandrov and Aleksandr Orlovsky, for instance, have their counterparts in *lubki* and clay and wooden toys). But European travelers in Russia also made accurate and sympathetic renditions of characteristic scenes from peasant life.[24] One cannot assume that the peasant background of certain artists imparted a native sensitivity for this genre. Instead, we might examine some aspects of the styles and imagery of early nineteenth-century genre painting in much the same way that we looked at a key aspect of traditional folk art of the period. Specifically, we can observe the assimilation of artistic practices and ideas derived from the academy, on the one hand, and the incorporation of typical features of folk art (color, treatment of figures, composition, decorative elements) on the other.

The work of Venetsianov himself shows his respect for the human dignity of his peasant subjects through a carefully wrought balance between realist observation and idealist harmony of forms. One of his early paintings, *Threshing Barn* (1821–23, Russian Museum), was, first and foremost, an attempt at scrupulous naturalism. The artist had one of the walls of the barn removed to admit light so that he could work on the spot with natural lighting instead of in the studio. Nonetheless, the clarity and calm of the scene, the harmonious arrangement of figures within the space, and the easy balanced poses and gestures cor-

respond to the esthetic standards of neoclassical art and to the attitudes of the eighteenth-century Enlightenment about the natural goodness and integrity of rural life.[25] Several of Venetsianov's portraits of peasants, such as *Girl Wearing a Shawl* (1830s, Russian Museum) and *Fortune Telling with Cards* (1842, Russian Museum), while certainly careful and sensitive likenesses, tend at the same time to subordinate individual features to a more general image of the Russian peasant woman: an image of classical calm and wholeness, reinforced by the central focus and the broad dominant curves of the compositions. A painting showing the interior of Venetsianov's studio as it appeared in 1827 by his pupil Aleksandr Alekseev, a freed serf, sheds light on the classical features of these portraits. The room contains a number of plaster casts from ancient sculptures as well as a live model—a peasant woman clothed in the traditional sarafan, blouse, and headscarf—and Venetsianov's pupils are depicted working from both types of models. Venetsianov clearly intended his pupils to relate their observations of the particular model to their understanding of classical proportions and to associate the ordinary beauty of the peasant woman with the timeless beauty of antique sculpture. In a group of paintings of the 1830s, including *Spring. Plowing* (cf. Bowlt, fig. 6.7) and *Summer. Harvest* (both Tretiakov Gallery), Venetsianov developed the theme of the unity of the peasant and the land. The image of the young peasant woman leading a pair of horses across the fields, her baby growing up literally in the furrows, points to the continuity and measured pace of rural life, and the harvest scene, which shows no exertion but visually melds the laborers with the shocks of grain, focuses on a peasant woman seated in the foreground as a personification of the bounty of nature.

The works of some of Venetsianov's pupils—most of them born serfs—present a similar harmonious image of the daily lives of peasants of central Russia.[26] The most talented, Grigorii Soroka, belonged to a landowner who, despite all of Venetsianov's pleading, refused to give up the distinction of having his very own serf artist. Only with the Emancipation decree of 1861 did Soroka gain his freedom, but his life ended, tragically, a few years later. He was involved in an illegal movement to improve the lot of freed serfs and was arrested in 1864; sentenced to corporal punishment, he committed suicide. Despite the harshness of his own life, Soroka's paintings, *Fisherfolk* (1840s, Russian Museum) and his views of Moldino Lake and his owner's estate, betray no anguish or even discontent (see fig. 13.12). Even more than Venetsianov's landscapes, these vistas, with their wonderful liquid reflections, luminous atmosphere, and the perfect harmony of architecture, landscape, and figures, represent an ideal image of peaceful, self-sufficient, and esthetically satisfying country life.

There is some irony in the fact that the first artists to take peasant life as the main subject of their art, Venetsianov and his pupils, though intimately familiar with all aspects of peasant life and committed to painting, as Venetsianov frequently said, *"à la nature,"* never really freed themselves from the idealization of rural life that was so much a part of the eighteenth-century outlook. In these same works, however, we can find certain affinities with the formal elements of traditional folk art. Scenes of provincial towns and country estates, such as Evgraf Krendovsky's *Square in a Provincial Town* (1830s, Tretiakov Gallery), Ignatii Shchedrovsky's *Landscape with Hunters* (late 1830s; fig. 13.11), and Grigorii Soroka's *A Chapel in the Village of Ostrovki* (1840s; fig. 13.12), and interiors such as Soroka's *Study at Ostrovki* (1840s, Russian Museum) and Lavr Plakhov's *Coachmen's Room in the Academy of Arts* (1834; cf. Taylor, fig. 7.4) show a feeling for the unity of an image and the subordination of small parts to the whole. These artists present details of a setting in all their variety of shape and texture and yet maintain the clarity of spatial relationships. The simple compositions based on firm horizontal divisions of the surface and clear vertical accents have much in common with the traditional arrangements of decorative borders around more open, central images in the ornamentation of distaffs and even on house façades. The attention to discrete details and the awareness of the organic relationship of details to structural form evident in these works suggest that an innate sense of design in these peasant artists was trained and encouraged, and not wholly altered, by the teaching of Venetsianov and, in some cases, exposure to academic art.

Although an appreciation of the visual and thematic affinities between traditional folk art and peasant genre painting of the early nineteenth century rests largely on a general sensibility rather than on direct evidence of the use of folk motifs by Venetsianov's pupils, the strength of these affinities is impressive. From the perspective of only a few decades, the inherent unity of an identifiable folk esthetic and peasant life becomes still more clear. Paradoxically, it was the realist genre painting of the *Peredvizhniki* that seems to have disrupted the harmonious interrelationship of style and theme. Realism, as a philosophical attitude and as a style, did not allow for the omission of jarring details and the harmonious integration of the parts of an image to the whole. On the contrary, the critical intent of much of nineteenth-century realist art (in Europe as well as Russia) required the development of special stylistic devices most readily associated with verbal rather than visual expression.[27] In contrast, the esthetic and moral outlook of the earlier nineteenth century, which seems to have been shared by the humble painters who were Venetsianov's pupils as well as by intellectu-

als familiar with the ideas of the Enlightenment, stressed harmony between man and nature and supported a degree of idealization necessary for harmony in the visual arts. In a curious way, the naïve expression of the peasant's inherent feeling for the harmony of functional form and ornamentation in a wide variety of traditional arts may be seen to complement the more sophisticated and esthetically conscious integration of observation and idealization in the works of artists like Venetsianov and Soroka.

In a more general sense, the capacity of the folk artists of the eighteenth and nineteenth centuries to assimilate new experiences and phenomena and to integrate the specific details of everyday life into a visually coherent framework based on forms and patterns from the distant past—illustrated by a variety of decorations on distaffs—points to the essential vitality of the folk tradition. The role of a "folk esthetic" —which, as we have seen, must be a very elastic concept—in other aspects of nineteenth-century Russian art is a question for further investigation.

NOTES

1. Elena Polenova, letter to P. D. Antipova, April 16, 1885, in E. Sakharova, ed., *V. D. Polenov, E. D. Polenova: Khronika sem'i khudozhnikov* (Moscow, 1964), p. 11.

2. Polenova, Elizaveta Mamontova, and other artists who stayed at Savva Mamontov's estate Abramtsevo, about 50 km. east of Moscow, began collecting folk art in the early 1880s, after having seen a peasant hut with a magnificent carved frieze in a nearby village; they started the carpentry workshop in 1883. The other major effort to revive traditional arts and crafts was undertaken by Princess Maria Tenisheva at her estate Talashkino near Smolensk. On both these art colonies, see John E. Bowlt, "Two Russian Maecenases. Savva Mamontov and Princess Tenisheva," *Apollo* (December 1973): 444–53. The Museum of Folk Art in Moscow, based on the collection of crafts shown at the All-Russian Exhibition of 1883, was opened in 1885 and represents a more official aspect of efforts to preserve national arts; cf. N. Ivanova et al., *Muzei narodnogo iskusstva* (Moscow, 1972).

3. On the general goals of the Abramtsevo workshops, see Polenova, letter to Stasov, October 1894, in Sakharova, pp. 505–508. A similar idea was behind the founding of a craft workshop in the 1890s by the Moscow Provincial government and in the years just after the 1918 Revolution by the Soviet government.

4. Polenova, letter to V. Stasov, November 12, 1894, in Sakharova, p. 513.

5. The realist critic Vladimir Stasov published on Russian folk ornament in 1872 and articles on Russian architectural decoration and Slavonic and Oriental

ornament in 1884–87; he corresponded with Polenova in preparation for an article he later wrote on her work. Cf. letters of Polenova and Stasov, May–November 1894, in Sakharova, pp. 502–13; V. Stasov, *Stat'i i zametki, ne voshedshie v sobranie sochinenii*, 2 vols. (Moscow, 1954). The interest of a number of early twentieth-century writers and artists in ancient Slavic and Russian folk sources for art is exemplified by the theoretical writing of Aleksandr Shevchenko (e.g., *Neo-primitivizm* [1913], reprinted in *Russian Art of the Avant-garde: Theory and Criticism, 1902–1934*, ed. John E. Bowlt [New York, 1971], pp. 44–54). Appreciation of folk art as expressive of national esthetic characteristics became widespread at about the same time that Russian icons were being rediscovered, cleaned, and exhibited, around 1913.

6. V. S. Voronov, "Krest'ianskoe iskusstvo" (Moscow, 1924), reprinted in V. S. Vornov, *O krest'ianskom iskusstve* (Moscow, 1972), pp. 28–129, was the first thorough discussion of this idea.

7. Among the major studies of traditional motifs and their relation to forms found in pagan art and artifacts are: Voronov; V. M. Vasilenko, *Russkaia narodnaia rez'ba i rospis'* (Moscow, 1947); Vasilenko, *Russkaia narodnaia rez'ba i rospis' po derevu XVIII-XX veokov* (Moscow, 1960), revised and reprinted in V. M. Vasilenko, *Narodnoe iskusstvo. Izbrannye trudy* (Moscow, 1974), pp. 19–149. (cf. esp. pp. 44–57 on sources for imagery of architectural deocration). G. K. Vagner, *Mastera drevnerusskoi skul'ptury: Rel'efy Iur'eva-Pol'skogo* (Moscow, 1966), pp. 29–30, notes affinities of iconography and style between ancient stone sculpture and folk sculpture. Vasilenko, "Narodnoe iskusstvo pervoi poloviny XIX veka," in *Istoriia Russkogo Iskusstva* 8.2 (Moscow, 1964): 567–616, esp. pp. 576, 585–89, discusses the question briefly.

8. *Lubki* are discussed by John E. Bowlt in chapter 12 of this book, "Nineteenth-Century Russian Caricature." Because the term "popular art" may be misleading through its association with the "popular imagery" of broadsides and printed books, it is not used here.

9. The *beregini* and their derivation from early Slavic water deities are discussed by Vasilenko in *"Russkaia narodnaia rez'ba"* (1960), pp. 36–49, and in *Istoriia Russkogo Iskusstva*, p. 585, and by O. Kruglova, *Russkaia narodnaia rez'ba i rospis' po derevu* (Moscow, 1974), pp. 8–9.

10. Cf. Kruglova, *Russkaia narodnaia rez'ba*, pp. 19–20.

11. V. S. Voronov was the pioneer in the classification of *prialki* on the basis of regional styles and techniques of decoration. Cf. Voronov, *O Krest'ianskom iskusstve*, pp. 204–28. Other major studies include: Vasilenko, *Russkaia narodnaia rez'ba* (1960); S. K. Zhegalova, "Khudozhestvennye prialki," in *Sokrovishcha russkogo narodnogo iskusstva* (Moscow, 1967); O. V. Kruglova, "Severodvinskie nakhodki," *Dekorativnoe iskusstvo SSSR* (1960), no. 3, and Kurglova, *Russkaia narodnaia rez'ba*, pp. 10–23.

12. The transition from carving to painting as the primary decoration of *prialki* has been connected with the important role of icon painters in the region along and to the east of the Volga—both those painters attached to monasteries (around which regional markets were held) and itinerant icon painters, who were often in close contact with peasants. In particular, one Ogurechnikov is said to have taught a number of peasants the "secrets" of painting on a prepared ground with egg tempera in the 1870s. Cf. M. A. Nekrasova, "Istoki gorodetskoi rospisi i ee khudozhestvennyi stil'," in *Russkoe iskusstva XVIII veka*, ed. T. V. Alekseeva (Moscow, 1973), pp. 156–77, esp. pp. 158, 166, referring to D. Prokop'ev, *Khudozhestvennye promysly Gor'kovskoi oblasti* (Moscow, 1933).

13. Nekrasova, p. 167. The author discusses the sources and importance of the figure on horseback, p. 171, which she relates to the cult of the bogatyr hero Egor the Bold (whose affinities with St. George may also be significant for folk art).

14. Vasilenko, *Narodnoe iskusstvo,* p. 38, and *Istoriia Russkogo Iskusstva,* pp. 601–602, notes the importance of markets and cites descriptions of a foreign doctor, traveling in the Nizhninovgorod region in 1805, of quantities of Khokhloma ware and other handcrafted goods, which were then being sold from a central market. Cf. G. Reman, "Makar'evskaia iarmonka," *Severnyi arkhiv* (1822), no. 9.

15. Cf. Marvin C. Ross, *Russian Procelains* (Norman, Okla., 1968), p. 37.

16. V. A. Shelkovnikov and T. N. Iakovleva, "Dekorativnoe i prikladnoe iskusstvo pervoi poloviny XIX veka," *Istoriia Russkogo Iskusstva* 8.2 (Moscow, 1964): 543.

17. Quoted in Alexander and Barbara Pronin, *Russian Folk Arts* (New York, 1975), p. 84.

18. Shelkovnikov and Iakovleva, p. 524.

19. Ibid., p. 519.

20. I. A. Pronina, "O prepodavanii dekorativno-prikladnogo iskusstva v XVIII veke," in Alekseeva, ed., *Russkoe iskusstvo XVIII veka,* pp. 76–78, 82–86, gives a detailed account of the organization of the schools and the training.

21. Elizabeth K. Valkenier, *Russian Realist Art. The State and Society: The Peredvizhniki and Their Tradition* (Ann Arbor, 1977), p. 3.

22. Repin describes several encounters with this folk artist in his autobiography, I. Repin, *Dalekoe blizkoe* (Moscow, 1953), pp. 55–56, 64, 75.

23. Valkenier has discussed this point in relation to artists of peasant and lower-class background in the mid-nineteenth century, *Russian Realist Art,* pp. 10–16.

24. Cf. G. Komelova, *Stseny Russkoi narodnoi zhizni kontsa XVIII—nachala XIX vekov* (Leningrad, 1961), illustrating engravings by J.-B. Le Prince, Christian Geisler, John Atkinson, and others now in the Hermitage, Leningrad.

25. I discussed this subject in an unpublished talk, "Representation of the Peasantry in Early Nineteenth-Century Russian Art," at the annual meeting of the American Society for Eighteenth-Century Studies, University of Virginia, Charlottesville, April 10, 1976.

26. On the work of Venetsianov and his pupils, see especially G. Iu. Smirnov, *Venetsianov and His School* (Leningrad, 1973). On Soroka, see K. V. Mikhailova, *Grigorii Soroka,* exhibition catalogue, Russian Museum (Leningrad, 1974).

27. The Russian realist painters did not emulate the "naïve" forms of folk art, in contrast to mid-nineteenth-century French realists, particularly Gustave Courbet and his circle, whose interest in popular imagery and in traditional provincial customs was reflected in a deliberate stylistic primitivism in some of their works. (See Meyer Schapiro, "Courbet and Popular Imagery. An Essay on Realism and Naivete," *Journal of the Warburg and and Courtauld Institutes* 4 [1941]:164–91.)

CONTRIBUTORS

John E. Bowlt is Professor and Chairman of the Department of Slavic Languages and Literatures at the University of Texas at Austin. He is author of *Russian Art of the Avant Garde* and *The Silver Age: Russian Art in the Early Twentieth Century and the World of Art Group* and translator and editor of Benedikt Livshits, *The One-and-a-Half-Eyed Archer*.

Malcolm Hamrick Brown is Professor of Music at Indiana University. Editor of *Musorgsky: In Memoriam, 1881–1981* and author of numerous articles on Russian music, he is preparing a book on the life and work of Sergei Prokofiev.

Donald Fanger is Professor of Slavic and Comparative Literature and Chairman of the Department of Slavic Languages and Literatures at Harvard University. He is author of *The Creation of Nikolai Gogol* and *Dostoevsky and Romantic Realism: A Study of Dostoevsky in Relation to Balzac, Dickens, and Gogol*.

Alison Hilton is Assistant Professor of Art History at Wayne State University. She has published articles on Russian art and on Russian women artists and is currently preparing a book on Russian folk art.

Janet Kennedy is Assistant Professor of Fine Arts at Indiana University and author of *The "Mir Iskusstvo" Group and Russian Art*. She is completing a book on the Russian symbolist painter Mikhail Vrubel.

Sidney Monas is Professor of History and of Slavic Languages and Literatures at the University of Texas at Austin. His publications include *The Third Section: Police and Society in Russia under Nicholas I*, *The Selected Works of Nikolai S. Gumilev*, and *Osip Mandelstam: Selected Essays*.

Nicholas V. Riasanovsky is Sidney Hellman Ehrman Professor of European History at the University of California, Berkeley. His publications inlcude *Russia and the West in the Teaching of the Slavophiles*, *Nicholas I and Official Nationality in Russia, 1825–1855*, *A History of Russia*, and *A Parting of Ways: Government and the Educated Public in Russia, 1801–1855*.

Paul Schaffer, a specialist in Russian antiques, is President of A La Vieille Russie, Inc., New York City, and former President of the National Antique and Art Dealers Association of America. He has lectured at the Cooper-Hewitt Museum, the New School for Social Research, and the National Association of Watch and Clock Collectors, Philadelphia and New York.

Albert J. Schmidt is Arnold Bernhard Professor of History and Law at the University of Bridgeport. He is completing a book entitled *The Image of Classical Moscow: Architecture and Planning 1760–1840*.

S. Frederick Starr is President of Oberlin College and former Secretary of the Kennan Institute for Advanced Russian Studies. His publications include *Decentralization and Self-Government in Russia, 1830–1870, Melnikov: Solo Architect in a Mass Society,* and *Red and Hot: Jazz in the USSR.*

Theofanis George Stavrou is Professor of History at the University of Minnesota. His publications include *Russian Interests in Palestine, 1882–1914: A Study of Religious and Educational Enterprise; Russia under the Last Tsar;* and *Russian Orthodoxy under the Old Regime.*

Joshua Taylor was Director of the National Collection of Fine Arts, the Smithsonian Institution, at the time of his death in 1981. Among his publications are *Learning to Look: A Handbook for the Visual Arts; To See Is To Think: Looking at American Art; America as Art;* and *The Fine Arts in America.*

Elizabeth Kridl Valkenier is Assistant Curator of the Archives of Russian and East European History and Culture at Columbia University and an associate of the Russian Institute, Columbia University. She is author of *Russian Realist Art, the State, and Society: The Peredvizhniki and Their Tradition.*

CREDITS

Chapter 6 (Bowlt)

6.1 Vladimir L. Borovikovsky, *Portrait of Mariia I. Lopukhina,* 1797, oil on canvas, Moscow, Tretiakov Gallery.

6.2 Orest Kiprensky, *Portrait of Princess Sof'ia Shcherbatova,* 1819, Italian pencil and sanguine, Leningrad, Russian Museum.

6.3 Karl P. Briullov, *The Last Day of Pompeii,* 1830–33, oil on canvas, Leningrad, Russian Museum.

6.4 Aleksandr A. Ivanov, *The Appearance of Christ to the People,* 1837–57, Moscow, Tretiakov Gallery.

6.5 Pavel A. Fedotov, *Encore, Encore!,* 1851–52, oil on canvas, Moscow, Tretiakov Gallery.

6.6 Vasilii A. Tropinin, *Self-Portrait against a View of the Kremlin,* 1844, oil on canvas, Moscow, Tropinin Museum.

6.7 Aleksei G. Venetsianov, *Spring. Ploughing,* 1830s, oil on canvas, Moscow, Tretiakov Gallery.

6.8 Ivan I. Shishkin, *Pine Forest in Viatsk Province,* 1872, oil on canvas, Moscow, Tretiakov Gallery.

6.9 Ilia E. Repin, *The Volga Boathaulers,* 1873, oil on canvas, Leningrad, Russian Museum.

6.10 Nikolai Ge, *Golgotha,* 1892, oil on canvas, Moscow, Tretiakov Gallery.

6.11 Vasilii V. Vereshchagin, *The Apotheosis of War,* 1871–72, oil on canvas, Moscow, Tretiakov Gallery.

6.12 Konstantin A. Korovin, *Paris Café,* oil on canvas, Moscow, Tretiakov Gallery.

6.13 Isaak Levitan, *Fresh Wind. The River Volga,* 1895, oil on canvas, Moscow, Tretiakov Gallery.

6.14 Valentin Serov, *Portrait of E. S. Morozova,* 1908, oil on canvas, Moscow, Tretiakov Gallery.

6.15 Arkhip Kuindzhi, *The Birch Grove,* 1879, oil on canvas, Moscow, Tretiakov Gallery.

6.16 Mikhail Vrubel, *The Prophet,* 1898, oil on canvas, Moscow, Tretiakov Gallery.

Chapter 7 (Taylor)

7.1 Fedor M. Matveev, *The Waterfall of Caduta delle Marmore on the River Velino,* 1819, oil on canvas, Leningrad, Russian Museum.

7.2 François Marius Granet, *Interior view of the choir in the Capuchin Church in Piazza Barberini, Rome,* 1818, oil on canvas, Leningrad, Hermitage.

7.3 Aleksandr G. Denisov, *Sailors at a Cobbler's,* 1832, oil on canvas, Leningrad, Russian Museum.

7.4 Lavr K. Plakhov, *Coachmen's Room in the Academy of Arts,* 1834, oil on canvas, Leningrad, Russian Museum.

7.5 Silvestr F. Shchedrin, *Fishermen on the Shore*, 1820s, oil on canvas, Leningrad, Russian Museum.

7.6 Aleksandr A. Ivanov, *Old Man Leaning on a Stick together with a Boy*, 1840s, oil on paper on cardboard, Moscow, Tretiakov Gallery.

Chapter 8 (Valkenier)

8.1 Pavel A. Fedotov, *A Choosy Bride*, 1847, oil on canvas, Moscow, Tretiakov Gallery.

8.2 Vasilii G. Perov, *Easter Procession in the Country*, 1861, oil on canvas, Moscow, Tretiakov Gallery.

8.3 Ilia E. Repin, *The Protodiakon*, 1877, oil on canvas, Moscow, Tretiakov Gallery.

8.4 Vasilii I. Surikov, *Boiarynia Morozova*, oil on canvas, Moscow, Tretiakov Gallery.

8.5 Vasilii I. Surikov, *The Storming of the Snow Town*, 1891, Leningrad, Russian Museum.

Chapter 9 (Schmidt)

9.1 Thomas de Thomon, from G. D. Oshchepkov, *Arkhitektor Tomon*, Moscow, 1950.

9.2 Tver, Shchusev Museum of Architecture, Photo Archive in Donskoi Monastery, Moscow.

9.3 Map of St. Petersburg, Shchusev Museum of Architecture, Photo Archive in Donskoi Monastery, Moscow.

9.4 Moscow Kremlin Embankment, from Robert Lyall, *The Character of the Russians and a Detailed History of Moscow*, London, 1823.

9.5 Karl Ivanovich Rossi, from V. I. Piliavskii, *Zodchii Rossi*, Moscow and Leningrad, 1951.

9.6 The Alexander Column and General Staff Arch, Shchusev Museum of Architecture, Photo Archive in Donskoi Monastery, Moscow.

9.7 Red Square after the Fire of 1812, Shchusev Museum of Architecture, Photo Archive in Donskoi Monastery, Moscow.

9.8 Bolshoi Theater, 1821–24, Shchusev Museum of Architecture, Photo Archive in Donskoi Monastery, Moscow.

Chapter 10 (Kennedy)

10.1 Ivan Martos, *Sculpture*, 1819–20, plaster, Leningrad, Academy of Arts.

10.2 Fedor Gordeev, *Marriage of Cupid and Psyche*, 1890s, plaster, Ostankino.

10.3 Fedosii Shchedrin, *Venus*, 1792, marble, Leningrad, Russian Museum.

10.4 Mikhail Kozlovsky, *Shepherd with a Hare*, 1789, marble, Pavlovsk, Palace Museum.

10.5 Mikhail Kozlovsky, *Polycrates*, 1790, plaster, Leningrad, Russian Museum.

10.6 Fedor Tolstoi, *Triple Alliance*, 1821, wax, Leningrad, Russian Museum.

10.7 Boris Orlovsky, *Paris*, 1824, marble, Leningrad, Russian Museum.

10.8 Ivan Martos, *Grave Monument for M. P. Sobakina,* 1782, marble, Moscow, Museum of the Academy of Construction and Architecture.

10.9 Ivan Martos, *Monument to Minin and Pozharsky,* 1804–18, bronze, Moscow, Red Square.

10.10 Russian popular print, Moscow, 1889, I. D. Sytin and Company.

10.11 Ivan Vitalii, *Venus,* 1852–53, marble, Leningrad, Russian Museum.

10.12 Vasilii Demut-Malinovsky, *Russian Scaevola,* 1813, plaster, Leningrad, Russian Museum.

10.13 Petr Klodt, *Monument to Nicholas I,* 1856–59, bronze, Leningrad, St. Isaac's Square.

10.14 Nikolai Pimenov, *Youth Playing Knucklebones,* 1836, plaster, Leningrad, Russian Museum.

10.15 Nikolai Pimenov, *Boy Asking Alms,* 1842, marble, Leningrad, Russian Museum.

Chapter 11 (Schaffer)

11.1 Vasili Popov, kovsh, Moscow, 1821, gilded silver and niello, courtesy of A La Vieille Russie, New York.

11.2 Three boxes, Velikii Ustiug, 1800–16, gilded silver and niello, courtesy of A La Vieille Russie.

11.3 Ivan Zaitsov, "coronation" platter for Grand Duke Konstantin Pavlovich, Moscow, 1826, gilded silver, courtesy of A La Vieille Russie.

11.4 D. Andreyev, icon of the "Tsar of Tsars," St. Petersburg, 1843, silver, courtesy of A La Vieille Russie.

11.5 Carl Johann Tegelsten for the Magasin Anglais of Nichols and Plinke, jewel chest, St. Petersburg, 1840, silver, photograph by Steven Tucker, courtesy of A La Vieille Russie.

11.6 Pavel Sazikov, "Copy of the Bratina of the Boyar Izmailov conserved in the Moscow Arms Palace," Moscow, 1874, gilded silver, courtesy of A La Vieille Russie.

11.7 Russian Imperial Porcelain Factory, pair of Alexander I urns, ca. 1820, gilded and painted porcelain, courtesy of A La Vieille Russie.

11.8 Russian Imperial Porcelain Factory, military plate, 1841, gilded and painted procelain, courtesy of A La Vieille Russie.

11.9 Kornilov Porcelain Factory, rococo revival tea set, circa 1860, gilded and painted porcelain, courtesy of A La Vieille Russie.

11.10 Yusoupov Porcelain Factory, plate decorated with roses after Redouté, 1826, porcelain, photograph by Steven Tucker, courtesy of A La Vieille Russie.

11.11 Sergei Batenin Porcelain Factory, cup and saucer, St. Petersburg, 1812–39, courtesy of A La Vieille Russie.

11.12 Russian Imperial Glass Factory, plate depicting the "Victory over the Brig Mercury, 1829," modeled by Count Fedor Tolstoi, 1830s, cut crystal, courtesy of A La Vieille Russie.

11.13 Russian Imperial Glass Factory, four beakers, ca. 1840, transfer-decorated blue glass, courtesy of A La Vieille Russie.

11.14 Peterhof Lapidary Works, vase commemorating the wedding of Grand Duchess Maria Nikolaevna and the Duke of Leuchtenberg, 1840, malachite, courtesy of A La Vieille Russie.

11.15 Lukutin Factory, two lacquer boxes, ca. 1840, courtesy of A La Vieille Russie.

11.16 Fabergé, kovsh in the seventeenth-century style, Moscow Workshop, 1908, jewelled cloisonné enamel, courtesy of A La Vieille Russie.

Chapter 12 (Bowlt)

12.1 "The Mice Burying the Cat," *lubok,* eighteenth century.

12.2 Ivan Terebenev, "The Russian Gaius Mucius Scaevola," 1812, engraving with watercolor, Moscow, Pushkin Museum of Fine Arts.

12.3 Aleksandr A. Agin, illustration to Nikolai Gogol's *Dead Souls,* ca. 1846.

12.4 George Wilhelm Timm, "Artists' Ball, 9 December 1860," from *Russkii khudozhestvennyi listok,* 1861, no. 4, St. Petersburg.

12.5 Pavel E. Shcherbov, *Idyll* (The World of Art Group), 1899, watercolor, Leningrad, Russian Museum.

12.6 Pavel A. Fedotov, Study for *The Gamblers,* 1851–52, pencil and crayon, Leningrad, Russian Museum.

Chapter 13 (Hilton)

13.1 Elena Polenova, ornamental motifs from Russian peasant carving, 1880s, pencil on paper, Abramtsevo Museum.

13.2 Towel border, northern Russia, second half of nineteenth century, embroidery, Moscow, Folk Art Museum.

13.3 Carved pediment and window frame, Gorky region, 1882, wood, Zagorsk, State Museum of History and Art.

13.4 Carved and painted eaves of a village house, Arkhangel region, nineteenth century, wood.

13.5 Distaff (detail), "Sirin," Arkhangel region, nineteenth century, painted wood, Zagorsk, State Museum of History and Art.

13.6 Distaff (detail), Iaroslavl region, 1935, carved wood, Zagorsk, State Museum of History and Art.

13.7 Distaff (detail), Arkhangel region, second half of nineteenth century, painted wood, Zagorsk, State Museum of History and Art.

13.8 Starling box, Moscow region, 1870, wood, Zagorsk, State Museum of History and Art.

13.9 Vasilii A. Raev, *View of Ostankino Park,* n.d., oil on canvas, Moscow, Tropinin Museum.

13.10 Vasilii A. Tropinin, *Boy with a Zhaleyka,* early 1820s, oil on canvas, Moscow, Tretiakov Gallery.

13.11 Ignatii S. Shchedrovsky, *Landscape with Hunters,* ca. 1830, oil on canvas, Leningrad, Russian Museum.

13.12 Grigorii V. Soroka, *A Chapel in the Village of Ostrovki,* late 1840s–early 1850s, oil on canvas, Leningrad, Hermitage.

Index